BIRDS, STRANGERS AND PSYCHOS

Praise for Maxim Jakubowski

'A well-written sharp, incisive crime story (much like a dagger thrust should be) is a thing of beauty. There are many in this anthology. Read and enjoy'
Frost Magazine* on *Daggers Drawn

'Quality and variety... are guaranteed'
Morning Star* on *Daggers Drawn

'There's something for everyone in this volume'
Publishers Weekly* on *Invisible Blood

'For fans of crime fiction short stories on the dark side, this anthology delivers again and again'
Booklist* on *Invisible Blood

'Sometimes a brief zap of great writing is just what you're in the mood for or have time for. That's when anthologies like *Invisible Blood* are ideal... intellectually outstanding'
New York Journal of Books* on *Invisible Blood

'The daggers are drawn, business ends out. An absolute must-read for all crime fiction fans'
Advance the Plot* on *Black is the Night

'A truly fabulous and satisfying read'
Lovereading* on *The Perfect Crime

'[A] collection of cunning, suspenseful and dark crime stories'
CBC Radio on *The Perfect Crime*

'An absolute delight! *The Perfect Crime* is the most original, and captivating, short fiction anthology to come along in ages. The diversity of voice, of setting, of sensibility, of approach to storytelling is wondrous! I don't usually say this about compilations, but this book is a one-sitting read'
Jeffery Deaver, bestseller author of *The Midnight Lock* on *The Perfect Crime*

'Huge talent, wide horizons, endless fascination – this is the best collection I have seen for ages... maybe ever'
Lee Child, bestselling author of *Better off Dead*, on *The Perfect Crime*

Recent Anthologies Edited by Maxim Jakubowski

The Book of Extraordinary Historical Mystery Stories
The Book of Extraordinary Amateur Sleuths and Private Eye Stories
The Book of Extraordinary Impossible Deaths and Puzzling Deaths Stories
The Book of Extraordinary New Sherlock Holmes Stories
The Return of Sherlock Holmes
The Book of Extraordinary Femmes Fatales and Dangerous Women
Invisible Blood
Daggers Drawn
Ink and Daggers
Black is the Night
The Perfect Crime (with Vaseem Khan)
Reports from the Deep End

BIRDS, STRANGERS AND PSYCHOS:
NEW STORIES INSPIRED BY
ALFRED HITCHCOCK

EDITED BY
MAXIM JAKUBOWSKI

NO EXIT PRESS

First published in the UK in 2025 by No Exit Press,
an imprint of Bedford Square Publishers Ltd,
London, UK

noexit.co.uk
@noexitpress

© Maxim Jakubowski, 2025

All stories © 2025 by the individual authors

The right of Maxim Jakubowski to be identified as the author of this work has been asserted in accordance with the Copyright, Designs and Patents Act 1988. All rights reserved. No part of this book may be reproduced, stored in or introduced into a retrieval system, or transmitted, in any form or by any means (electronic, mechanical, photocopying, recording or otherwise) without the written permission of the publishers.

Any person who does any unauthorised act in relation to this publication may be liable to criminal prosecution and civil claims for damages.
A CIP catalogue record for this book is available from the British Library.
This is a work of fiction. Names, characters, places, and incidents either are the product of the author's imagination or are used fictitiously, and any resemblance to actual persons, living or dead, businesses, companies, events or locales is entirely coincidental.

ISBN
978-1-83501-222-2 (Hardback)
978-1-83501-223-9 (Trade paperback)
978-1-83501-224-6 (eBook)

2 4 6 8 10 9 7 5 3 1

Printed in Great Britain by CPI Group (UK) Ltd, Croydon CR0 4YY

The manufacturer's authorised representative in the EU for product safety is Easy Access System Europe,
Mustamäe tee 50, 10621 Tallinn, Estonia
gpsr.requests@easproject.com

Contents

Introduction	1
Peter Swanson/STRANGERS ON A SCHOOL BUS	5
Vaseem Khan/THE HUNTER	23
Sophie Hannah/DANIELLE'S THE DEAD ONE	38
S A Cosby/SPLIT YOUR SILVER TONGUE	52
Guy Adams/PSYCHO GEOGRAPHY	59
Ana Teresa Pereira/IT'S RAINING VIOLETS	67
David Thomson/LIKE A BUN AT BEWLEY'S	83
Lee Child/THE BIRDS ON A TRAIN	96
Denise Mina/THE KARPMAN DRAMA TRIANGLE	104
Xan Brooks/THE MOUNTAIN EAGLE	120
Lily Samson/HITCHCOCK BLONDES HAVE MORE FUN	135
Keith Lansdale & Joe R Lansdale/COAT CHECK	153
Peter Lovesey/KILLING HITCH	166
Anne Billson/THE MARK	192
Kim Newman/HITCHCOCK PRESENTS	210
Jeff Noon/THE NEST	218
M W Craven/THE MIGRATORY PATTERN OF BIRDS	234
Donna Moore/CAMEO	259
James Grady/EMPIRE BUILDER	268

A K Benedict/PRIVATE BROWSER 287
Jerome Charyn/RUSSIAN HILL 300
Ragnar Jónasson/CHEST 317
Nadine Matheson/THE FALCON HOTEL 322
William Boyle/ARLENE 343

Author Biographies 363

Introduction

'Hitchcockian.'

Has any other film director become so famous that he has also become an adjective? Or that an image of his silhouette would be recognised anywhere on the planet?

In his long and varied career, East London-born Alfred Hitchcock directed fifty-three movies over fifty years of filmmaking, in addition to countless TV episodes, many of which he also produced.

His name has become universally synonymous with suspense, and although he did create a handful of movies in other genres, in particular during his early years, when you ask any filmgoer they will automatically associate the Hitchcock name with crime, mystery and even horror, and they will no doubt also be capable of reeling off a handful or two of classic movies within the genre: *Psycho, Vertigo, North by Northwest, Frenzy, Strangers on a Train, The Lady Vanishes, The Lodger, The Birds, Rear Window, Dial M for Murder, Rebecca, Shadow of a Doubt, Notorious, Rope, To Catch a Thief, Marnie, The 39 Steps* and on and on. Everyone who enjoys the movies has a favourite Hitchcock film.

Hitchcock was also a great reader and appreciator of mystery and gothic literature, and a great majority of his films adapt famous novels and short stories, in addition to plundering the

Introduction

pulp magazines for inspiration and material for his long-lasting *Alfred Hitchcock Presents* TV series, and editing countless paperback print anthologies in which he was given the opportunity to showcase not just some of the stories that he turned into movies, but also hundreds of other tales of mystery and suspense that he felt had earned larger public recognition. He was, for instance, one of the first US editors to highlight the short fiction of Roald Dahl.

Authors he championed and adapted include Robert Bloch, Daphne du Maurier, Patricia Highsmith, Agatha Christie, Winston Graham, Marie Belloc Lowndes, John Buchan, Cornell Woolrich, Boileau-Narcejac, David Dodge, Ethel Lina White, Josephine Tey, Patrick Hamilton, Somerset Maugham, etc…

Alfred Hitchcock's influence persists to this day, with his complete filmography (including his silent films) and much of his TV output ever available in DVD and Blu-ray format or on streaming platforms, and many modern movies, and successful ones at that, are often pale imitations of his work or directly inspired by him, his narrative and visual techniques. When in doubt, copy the Master!

Not bad for a short, plump man from London's East End when it comes to legacies, no?

There have been well over a hundred volumes written about Hitchcock and his films, but ironically no one has, to the best of my knowledge, turned things around and sought to pinpoint contemporary (as well as older) mystery and suspense authors who have been visibly influenced by Hitchcock.

When I did a quick survey of writers of my acquaintance in the crime and mystery field, each and every one openly admitted to particular favourite Hitch movies and stories, narrative techniques, and his undoubted influence on their writing, as well as intimate memories about the circumstances when they first saw and were affected by Hitchcock films. It was like opening a box of wonders.

Introduction

Which is how this collection came about. I asked them all, 'Would you like to write a brand-new story inspired by Hitch and his films?' and very few declined the invitation. Authors from both sides of the gender divide, from a variety of countries and backgrounds, all determined to reflect what the king of suspense meant to them.

Twenty-four stories by masters of the genre, each a small gem, some with obvious lineage to one movie or another, others more oblique and sometimes personal; in some tales, Hitch appears in an obligatory cameo (how could he not?), while in others he is even a significant character; but even in absence, his presence presides!

On a personal note, I still remember the first time Alfred Hitchcock entered my own life and, in all probability, was partly instrumental in making me who I became as a future writer with a soft spot for blondes! I was fourteen or fifteen and living in Paris, where I grew up. On a Sunday, after lunch, my parents and family would invariably slip me a few francs and ask me to take my younger cousin Betty (who was three years younger than me) to the movies. Normally we would watch comedies or historical epics in that then wonderful new format CinemaScope, but on this occasion we couldn't find a suitable movie, so we wandered down the Grands Boulevards in search of a cinema and alighted on a fleapit where *Vertigo* was playing in a dubbed version. I'm unsure what my younger cousin made of it, but I left that screening in a daze, for the very first time aware of the sheer emotional power the movies could generate, and that a film could be so much more than mere entertainment. I have seen *Vertigo* many times since and it still has the same effect on me, indelibly branding my mind with images of stairs, locks of hair, immortal trees, the streets of San Francisco, the two faces of Kim Novak, the music of Bernard Herrmann and the terrible realisation that love was fleeting and painful. I blame

Introduction

you, Hitch, for all those forlorn but magical femmes fatales in my books and stories!

So, close the curtains, but keep the lights on and savour these wicked tales of the imagination while holding tight to your chair or your bedsheets!

<div style="text-align: right;">Maxim Jakubowski</div>

Strangers on a School Bus

Peter Swanson

'Are you Jane?' Detective Marchand asked after entering the interrogation room and shutting the door behind her.

The hunched-over girl looked up, nodded. She had dark hair that hid her face, and she was practically being swallowed up by a baggy sweatshirt.

'Hi, Jane. I'm Detective Marchand. I was wondering if I could ask you some questions.'

Jane straightened her back a little and looked at the detective. 'Sure, why not? Everyone else is.'

'You've been interrogated a few times, I'm guessing.'

Jane held up a fist and unfurled a finger for each person she described. 'Detective with the huge forehead, detective with the red moustache, lawyer who wore the same perfume my mom wears, then lawyer who looked like a teenage boy. And now you.'

'Now me.'

'Detective with the fancy nails.'

Rosalie Marchand looked down at her nails. It was true that she'd been to the manicurist just two days earlier. 'That's how you'll remember me?'

Jane shrugged.

Detective Marchand had come over from the neighbouring town of Saltwick in order to interrogate Jane Weir. New Essex had only

one female detective and she was currently on her honeymoon in Turks and Caicos, and Lieutenant Mark Acosta, Chief of Detectives for New Essex (and, yes, he *did* have a particularly large forehead) had thought that a female detective might have a better chance of getting the truth out of this girl.

'Jane, do you think you could talk a little more to me about Lisa…?' Detective Marchand hesitated, intentionally blanking on the surname.

'Lisa Kelly,' Jane said.

'Right, Lisa Kelly. She's a senior, like you, isn't she?'

'Yes, but she's new to our school. I didn't really know her, before, you know…'

'Before you had a conversation on the school bus.'

'Right,' Jane said, pushing back a hank of her long, limp hair, and Marchand, who always noticed people's skin, saw that Jane was in the middle of a pretty virulent breakout.

'That was the first time you'd seen her?'

'I'd seen her around. But the bus was the first time that we'd talked.'

'Jane, do you think you can tell me a little bit about what you talked about that day?'

The teenager took a breath that seemed to shift her whole body. 'I've already—'

'I know, I know. Just humour me. I'd like to hear it directly from you.'

'Okay. We talked about Macy, obviously. I mean, that's why I'm here, right?'

'What did she say about Macy?'

'You mean, besides that she'd kill her for me?'

'Yes, besides that. Tell me everything you talked about.'

Jane had almost skipped out on the Saturday school trip to Boston to visit the Museum of Fine Arts, but her mom had told her that

if she didn't go then she would have to attend her little brother's ice hockey game, so it was a no-brainer. Jane called her dad, knowing he'd be happy to come over and pick her up, drive her to the high school. He dropped her off in the east parking lot, where the yellow school bus was waiting under a dark, swollen sky. 'Do they still have those plastic green seats and no seat belts?' her father said.

'They have seat belts now,' Jane told him.

The driver saw her approaching and the door opened with a hydraulic hiss. Mrs Haggerty, the art teacher, checked Jane's name off on her clipboard, then Jane looked down the length of the bus, keeping her face neutral, searching for an empty two-seater that she could grab for herself. There was one, all the way at the back. As she began to walk, Caroline Penske, wearing a crop top not much bigger than a sports bra, called Jane a 'slut' in a voice low enough that Mrs Haggerty simply looked up, but didn't say anything. But the ten or so kids who heard Caroline all laughed.

Jane took a seat in the last row. Across from her, also sitting alone, was Alan Furman, another pariah, but at least it was a role he was used to. Jane, until two months earlier, had not exactly been popular, but she'd been happily invisible. All that had changed when she'd stupidly agreed to go to Macy Aster's indoor swimming pool party on New Year's Eve. She'd ended up drinking too much tequila and messing around with Macy's older cousin, not knowing that Macy's best friend had a massive crush on him. Since then, Macy had turned the entire school against Jane, spreading one rumour after another, so that now everyone seemed to believe that she'd somehow destroyed the romance of the century. Jane had decided to just keep her head down and hope that Macy would get bored and unleash her minions on some new target.

It was a few minutes after nine and Jane felt like she'd probably

be sitting alone for the hour-long drive into Boston, which was fine with her, but then a girl she didn't know worked her way down the aisle and sat down next to her. 'Sorry,' the girl said, straightening her skirt, 'you probably thought you had this seat to yourself.'

'It's okay.'

'I'm Lisa Kelly. I just transferred to his hellhole and I'm probably going to transfer again before the end of the year, so don't feel the need to make friends with me.'

'Oh, no worries,' she said. 'I'm Jane, anyway.'

'Jane Anyway is your name?'

'No. It's Jane Weir.'

'Yeah, I'm just kidding. I know who you are.'

'How do you know who I am?'

'You're the "fugly slut" that fucked Macy Aster's cousin, right?'

'Word gets around, I guess.'

'Yeah. I don't really know anyone in this school, but I do know that.'

'You're probably wrecking your reputation just by sitting here next to me.'

Lisa sat up in her seat and peered down the bus. 'No one seems to care,' she said. 'And like I said, I'm not long for this town.'

They were quiet for a moment, Lisa opening the white purse she was holding on her lap and removing a tube of lipstick. She wasn't dressed like a typical high-school girl. She wore a pleated moss-green skirt and a matching top that was embroidered. She had shoulder-length blonde hair and even though the day was lousy with rain, a pair of round white plastic sunglasses perched on her head. Her skin, with barely any make-up besides the lipstick, was flawless.

Jane was taking earbuds out of her own backpack when Lisa said, 'What exactly *did* you do to earn their wrath?'

The bus was merging onto the southbound highway that would

bring them to Boston. Icy rain was pelting the windows, which somehow made it feel cosy in the final row, both girls slunk down, almost invisible. Jane told Lisa everything, how her and Macy had been best friends from kindergarten all the way through eighth grade. Well, maybe not best friends, because Macy was the type of girl who liked an ever-revolving cast of girls to fill that role. But they were definitely close. It was when they had both opted to go to Billington-Eccles High School two towns over (it was a school choice thing) that things changed. Once there, Macy made a new group of friends, wealthier girls, and began to pretend she barely even knew Jane. It hurt, but Jane decided to just let it go. Macy had always unnerved her anyway, and Jane fell in with a group of art kids, not the choicest group at Billington-Eccles but better than having no friends at all. Then something changed again in junior year. Macy was suddenly paying attention to Jane again, saying hi to her in the hallways, asking her to join her at lunch, even implying at times that it was Jane who'd dropped the friendship when they changed schools in their freshman year. It didn't occur to Jane at the time, but this all started to happen after Jane won a State of Massachusetts student-artist award that came with an appearance on a local news broadcast and a $10,000 scholarship to a college of her choice. Macy kept saying things like, 'You're really talented, aren't you? I mean, I knew you were, but now this proves it.' Or she would say, 'I don't really get your paintings, but I get that you're really good at them.'

All of this should have been a warning to Jane, somehow, but she was just happy to have her friend back. And then she was invited to the indoor swim party, billed by Macy as a pretty exclusive event. 'My parents won't be there, but still, I don't want more than ten kids at this party, or maybe fifteen.'

In retrospect, Jane had decided that on the night of the party she'd been set up. When she arrived at Macy's enormous house on Goose Neck, Macy made Jane do a shot of tequila in the kitchen

before bringing her down to the subterranean pool (everyone kept saying how amazing it was, but Jane had always thought how creepy it was down there). The rest of the night was pretty blurry, Jane being handed shots to drink, and then all the ceiling lights were turned out so that it was only the pool that was illuminated from below. When Tyler, Macy's cousin, started talking to Jane, she was relieved. He was in college now, but she'd known him her whole life. After Tyler asked Jane about her award, he reached out and touched her hip, snapping at the band of her bikini bottom. 'You're all grown up now, huh?'

'I guess so. So are you.'

'Oh, yeah?' he said, then flexed his muscles.

Jane laughed. She'd never really liked Tyler, not in a romantic kind of way, but it was true that somewhere along the way he'd gotten pretty hot. And then they were alone in the steam room that was attached to the swimming pool area. There was no steam ('Macy said it hasn't worked for years') and it smelled like mould in there, and Jane remembered thinking, *Jesus, am I going to lose my virginity in this room?* But before things went too far, the door crashed open and Macy was standing there alongside her new best friend from high school, Darcy Pendegrast, who was yelling something into the tiny steam room, tears streaming down her face.

'You got set up,' Lisa said, the bus lurching up and down as it neared Boston.

'Yeah, I think so, too.'

'Maybe not by Tyler and maybe not by Darcy, but Macy wanted the whole thing to happen. She just wanted to bring you down a peg, humiliate you.'

Jane was nodding, a little annoyed that the whole traumatic experience was back in her head, playing on repeat.

'There're girls like her at every school,' Lisa said. 'Trust me. Do you know what a sociopath is?'

'Yeah,' Jane said.

'Macy's one of them.'

'Honestly, I just want to forget the whole thing happened, survive the rest of this year and next year, and get on with my life.'

'Or else...' Lisa said.

Jane turned to her and saw that her seatmate was smiling. Her teeth were perfect. 'Or else what?'

'Or else you let me kill her for you.'

'So Lisa was the one who suggested killing Macy?' Marchand said.

'Yeah.'

'And what did you think when she suggested it?'

'I mean, I guess I thought she was joking. Kids say stuff like that all the time.'

'Do they? You talk about killing other kids all the time?'

Jane appeared to think about it. As she'd been talking, she'd been sitting more and more upright, the detective thought, and now appeared to be almost enjoying telling the story. 'You know what I mean. Like, *I'm going to kill you*. Or, *I could kill her for saying that*. It's like saying you're so hungry you could eat a horse.'

'But is that what you heard when Lisa said those words to you? Did you think she was just exaggerating?'

'Yeah, at first. I said something like, *Yes, please, can you do that*. And then I laughed.'

'What did she do?'

'She shrugged, I think, told me that the offer was on the table if I changed my mind.'

'And that was that?'

'That was that on the bus into Boston. But we talked more that day.'

It was still raining when the bus pulled up to the front of the MFA. Mrs Haggerty waited for everyone to quiet down so that she could

explain how she expected the students to be on their best behaviour in the museum. 'Those of you in my class, please wait in the rotunda for me to join you. Everyone else, you're on your own. Just don't leave the museum, and at least pretend to look at some of the art. We'll meet back up in the courtyard in exactly two hours.'

Jane had taken Mrs Haggerty's art class the year before, but this year she was doing film history for her elective. It was one of the reasons she'd signed up for the museum trip. There was a special exhibit called *The Art of the Film Poster*, and her teacher, Mr Shapiro, had promised extra credit for any student who attended. So once Jane was past the ticketing counter and had clipped the orange pin to her shirt that meant she was allowed in any part of the museum, she peeled herself away to go find the film posters. There weren't a lot of other visitors in the two dedicated rooms, and it gave her a sense of calm.

The first poster that she looked at in the collection was from a film called *Metropolis* that she'd never heard of. But the second poster was *The Bride of Frankenstein*, one of the movies they'd watched in class. It had been a good one – weird, though – and the poster was very cool, in colour even though the film wasn't. Jane took a picture of it with her phone to show Mr Shapiro. The only other poster in the exhibit that was from one of the films they'd watched was *The Graduate*, and Jane took a picture of that as well. Most of the other films she didn't recognise, although she'd heard of *Vertigo*, since they'd talked a lot about Alfred Hitchcock in the class.

After all the students were back on the bus (it took forever because Tommy Brodie-Stevenson forgot what time it was, and Mrs Haggerty had to go look for him), they were taken to Quincy Market for lunch. Jane looked around for Lisa but didn't see her anywhere. She'd probably made friends with Caroline Penske and her crew and would be eating with them and talking about her. It didn't matter. Jane wandered through the food hall and bought

herself clam chowder that came in a bread bowl, because that was what her father always got when they came here.

So Jane was surprised when Lisa dropped into the seat next to her again on the bus ride back to Eccles. Lisa looked exactly the same as she had in the morning, not bedraggled and wet like all the other students. Even her hair – that blonde bob – was exactly the same, held in place by those sunglasses she didn't need.

'Where were you all day?' Lisa said.

'I just did my own thing. How about you?'

'Same. Museum was cool but Quincy Market was kind of lame. I took a walk and found a French bistro to hang out in.'

'Really?' Jane was impressed.

'Yeah. What'd you eat in Quincy Market?'

'Clam chowder,' Jane said, and Lisa made a face.

When they were back on the highway, Lisa said, 'I've been thinking about Macy and what she did to you. What a psycho, right?'

'I'm over it already,' Jane said. 'It's not like I'm losing out on being her friend, and why would I want to be friends with her friends? No loss.'

'I like your attitude,' Lisa said. 'But I still think she shouldn't get away with what she did.'

'Killing her is a little extreme,' Jane said.

Lisa laughed. 'Did I say that earlier? Well, only because it would be so easy.'

'Why would it be easy?'

'At first I thought it would be easy because she has an indoor pool,' Lisa said. 'Pools are dangerous. She might drown in it. But you know, then you'd have to find a way to sneak in when she was swimming, and she's probably a pretty good swimmer if her family has a pool. So, I scrapped plan A. Now I think the best way to kill her is to push her off that tall ledge at the front of her house during low tide. I mean, don't just push her, but hit her on the head first

to make sure she's dead, and then throw her off. It would look like an accident.'

Lisa was no longer smiling but her pale blue eyes were wide open, their colour reminding Jane of the sea water when her grandmother took her to Aruba that one time. She said, 'How do you know where her house is?'

'Well, for one, I don't live that far away. But, honestly, I've been checking it out. Like I told you, I heard about all about Macy Aster before I met you this morning. I've scoped out the situation.'

'How would you get her out to the back of her house?'

Lisa smiled. 'She goes there every night around midnight and smokes a cigarette. Like I said, I've been scoping the situation. It's a cinch. Even if the police figure out that someone bopped her on the head, they'd never think of me.'

'No, they'd think of me.'

'Exactly, but you'll be at home, tucked up in bed with a solid alibi. It would be perfect.'

The bus lurched a little and Jane looked out the window. They were on an off-ramp. 'It's a nice thought,' Jane said.

'Meaning you'll think about it?' Lisa said.

'That's not what I meant.'

'Why not?'

'Why not think about it? Because I hate Macy Aster but that doesn't mean she should die.'

'Do you think she'll change?'

'What do you mean?'

'When she grows up, do you think she'll be different, or do you think she'll be the same bitch she is now?'

Jane thought about it. She remembered her mother once telling her that people don't change. Of course, why should she trust her mother, who just made her father move out of the house after twenty years of marriage so she could date random men. Still, Lisa

was right about Macy Aster. Even in kindergarten, Macy had been a little backstabber. She was going to have a long life of making people miserable.

'I'll think about it,' Jane said.

'So how did you leave it?' Marchand said. She could tell that Jane was tired, her voice starting to get raspy.

'We didn't talk much about it again. Not on the bus, anyway.'

'But you saw her again? Around school?'

'A little bit. I mean, I saw her, but she pretended not to know me. Sometimes she would give me a look, but we never spoke.'

'Jane, you seem tired. Can I get you something from the vending machine? Maybe a Coke or a candy bar?'

'I'll take a Diet Coke, I guess.'

When she was on the other side of the two-way glass, Lieutenant Acosta said, 'Well, she's talking more to you than she did to me. That's for sure.'

'She is,' said Dr Trout, the consulting child psychiatrist. Marchand, when she'd first been introduced to Linda Trout earlier in the day, had thought that if you were making a movie and one of the roles was Consulting Child Psychiatrist, this was the exact woman you'd cast, with her lavender sweater, her long grey-streaked hair, her black-rimmed eyeglasses.

'Oh, good. I feel like I'm losing her, though.'

'No, keep going the way you're going,' Linda said. 'Don't overthink it, but see if you can get her to tell you more about Lisa.'

'I'm trying my best.'

One of the officers came back with two cans of Diet Coke and Marchand brought them back into the room, popped them both open and slid one over to Jane.

'Is my father here?' Jane said.

'Yes, he's still here. And your mother, she's here as well.'

'Hope you've got them in separate rooms.'

Marchand smiled at the girl. 'You okay if I ask you a few more questions? Just between the two of us?'

'I guess so.'

'What I want to know is when did you see Lisa again? Was it before or after what happened to Macy?'

'She came to my house.'

'When did she come to your house?'

Jane was quiet for so long that Marchand thought that she was done speaking, but finally she said, 'You know the morning after the snowstorm?'

Her mom had made her go out to shovel the front sidewalk. The bad news was that it was freezing outside, the wind from the cove cutting right through her winter coat. The good news was that the snow was light and powdery, and Jane was nearly done with the whole sidewalk, when Lisa, dressed in one of her cool retro outfits like it wasn't zero degrees outside, was suddenly there, next to her. Jane hadn't been surprised to see her, exactly. All through the night, and the morning as well, she'd had a strange feeling, as though something was happening that she couldn't control.

'Look at you, the good daughter,' Lisa said.

'Hi, Lisa. Why am I the good daughter?'

'Doing your chores. If my mom asked me to shovel our sidewalk, I'd hit her in the head with a shovel.'

'I'm not you, I guess.'

Lisa was looking into the middle distance, out towards Goose Neck peninsula. There were a few white strips of cloud on the horizon, but it was a sunny day and she was squinting. 'Look,' she said, and Jane suddenly knew what she was going to say, knew what she was doing here this morning. 'Macy Aster might have had a bad accident last night.'

Jane forced herself to try and sound normal as she said, 'What do you mean?'

Strangers on a School Bus

'From what I heard, she went out last night to smoke a cigarette, which was a stupid thing to do, really, because it was the middle of a freaking snowstorm. She must have slipped off that ledge at the front of her lawn and hit the rocks below.'

Jane didn't think it was possible to get colder, but Lisa's words seemed to enter her body and lower her temperature. 'Why are you telling me this?'

'It's just inside information. What I really came here to tell you is that my own demonic mother has met some new random guy and we are packing up to move again. Maybe you don't want to hear this, but I think we could have been friends.'

Jane could no longer feel her hands that gripped the snow shovel, and her lungs felt like they were filled with ice.

'Bye, Jane. One day you'll thank me. One day the whole world will thank me for what I've done.'

Lisa walked away in the direction she'd come from, and Jane turned to look at her house, saw her mother standing in the window watching her. Had she seen Lisa, as well?

'That was the last time you saw her?' Marchand said.

'That was the last time I saw her, yes.'

'Jane, what do *you* think happened? Do *you* think Lisa killed Macy?'

'I've already answered all these questions,' Jane said, rubbing hard at the back of her neck. 'I've told you everything I know. I mean, it sounds like she did it, but I wasn't there.'

Marchand was quiet for a while, feeling the presence of Acosta and Trout behind the glass. 'Was there ever any talk, Jane, about a swap?'

'What do you mean?'

'You know, like Lisa did you a favour by killing Macy, so maybe you'd do a favour for her.'

'You're thinking of that movie.'

'Which movie?'

'The Hitchcock film.'

'You studied Alfred Hitchcock in your film class, didn't you?'

'Yeah, we did like two whole weeks on him.'

'And did you watch that movie? It's called *Strangers on a Train*, right?'

'It was on a list of films we could watch for extra credit, but it wasn't one of the films we were required to see.'

'Oh, I see. And did you watch it?'

'Did I watch *Strangers on a Train*? I mean, it was for extra credit, so, yeah, I watched it.'

'It's just that it seems like a similar story – what happened in the movie and what happened between Lisa and you on the bus. That's why I'm asking if Lisa suggested that you do a murder swap. I'm not saying you would have agreed...'

Jane hunched up her shoulders and Marchand could hear the girl's spine pop. 'She did say once that if I wanted to return the favour, I could kill her mother for her. It was something we had in common, I guess, that we both weren't getting along with our moms.'

'And what did you say?'

'About killing her mom? I wouldn't do that. Are you crazy?'

'I'm just asking, Jane. I'm not accusing you of anything.'

'I'm not a murderer. It's not in me.'

They were both quiet for a moment, and Marchand sensed that it was time to wrap up the interview. Before getting up to go, she said, 'Let me ask you one more question. I know you've been asked this before, but do you have any idea where Lisa Kelly is right now?'

Jane was shaking her head, almost violently. 'She left town. I don't know. Does this mean you haven't found her yet?'

Marchand had lunch with Mark Acosta and Dr Trout and Ann Leonard, who was the Chief of Police. They sat in one of the characterless meeting rooms underneath a light that flickered every so

often. Marchand picked at a salad, knowing she should get some food in her despite the fact she had zero appetite. Acosta was working his way through an entire pizza, though, while reading out sections from the preliminary autopsy report on Macy Aster that had just come through that morning. Marchand kept expecting him to drop tomato sauce on the report, but so far he hadn't. And what he was reading out from the findings was only confirming what they all knew. Macy Aster's dead body had been found on the rocks along the shoreline that abutted her family's home. She had been discovered at just after nine o'clock on the morning of the Nor'easter, and the cause of death was blunt force trauma to her head.

'Was she dead when she was pushed over the cliff?'

Acosta shrugged. 'Probably,' he said.

Marchand kept checking her phone all through lunch. After leaving the interview room she'd tried to call up Alex Shapiro, the English teacher at Billington-Eccles who was teaching the film class. Of course, it was a school day and he didn't answer, so she left a message asking him to email or text her a list of the films they'd watched for the class. So far, she hadn't heard anything back.

After they'd all finished eating, they stayed in the windowless room and talked about strategies for interrogating Jane in the afternoon. Both Acosta and Trout agreed that Marchand should continue to speak to Jane alone, that it seemed to be working. Acosta had a transcript from the first interview with Jane, two days after Macy Aster's death, and they were comparing what she'd said then and what she was saying now, when the door to the meeting room crashed open. It was one of the officers, the same guy who'd gotten the Diet Cokes. He said, sounding almost breathless, 'You all need to come with me. I think Lisa Kelly is here.'

Marchand stepped through the door of the interrogation room, standing for a moment. The girl across the table was relaxed, perched on the chair, her back straight, hair tucked behind her ears.

'You must be Lisa,' Marchand said.

Jane smiled back at her, a much bigger smile than the one she'd seen that morning, but with the same child's teeth. 'I am,' she said, her voice notably different, clipped, almost stagey. 'I guess you caught me.'

Maybe because Marchand was still thinking about movies, she wished they were drinking whiskey in Acosta's office instead of chamomile tea. Whiskey would be a cliché, but also far more appropriate. It was dark outside, and it had been a long afternoon in the interrogation room. Lisa/Jane had been very chatty, a surprise to everyone. Lisa had appeared briefly during an earlier interview with Jane, back when Acosta had been asking the questions, but she had declined to answer them. Today she told Marchand everything.

'You okay?' Acosta said, after Dr Trout's departure from his office. Trout had talked a lot, explaining in long, meticulous detail her theories about Jane Weir's split personality and why it had happened when it did. Marchand felt as though she couldn't take in any new information that day.

'I'm exhausted,' she said. 'But strangely calm, even though intellectually I know that what I saw and heard today is going to haunt me for a long time. Forever, I suppose.'

'Yeah,' Acosta said.

Marchand sipped the tea, still wishing it was whiskey.

'Is the doctor with her now?'

'She was, earlier, but Jane's in the holding cell. She's still Lisa, which is good, I suppose, because she's pretty relaxed about everything. Ate all her dinner, I heard.'

'Tomorrow she'll go to the hospital?'

'Yes, it's all arranged.'

'Jesus Christ,' Marchand said. 'Now I am beginning to feel it.' She held out a hand to show that she was trembling.

Strangers on a School Bus

'Did you ever hear back from the film guy at the high school?'

'From Alex Shapiro? I did, actually. He sent me the class syllabus.'

Marchand brought it up on her phone. 'Lots of good films in his class. *Twelve Angry Men. 2001. The Postman Always Rings Twice. Citizen Kane*, naturally. Something called *The Horse in Motion* that I've never heard of. *Jaws. Do the Right Thing.*'

'But no *Strangers on a Train*.'

'Just for extra credit, as we discovered.'

'So what Hitchcock film did they watch?'

'Three of them, actually. *Shadow of a Doubt, Rear Window*, and then, to no one's surprise, *Psycho*.'

Acosta was nodding. 'And Shapiro sent me something else, as well. I haven't read it yet, but it's an essay Jane wrote.' Marchand double-clicked on the attachment, bringing it up. She read the title out loud. '"Alfred Hitchcock's *Psycho*: or Why Two People Are Better Than One."'

'Seriously?'

'Seriously. You think I could have made that up?'

Lisa sat on the edge of her bed in the cell, staring at the painted concrete wall. She wondered how Jane was doing, silly little Jane with her bad skin and terrible hair, destined to go through life letting other people push her around. Well, she'd done her a favour, at least, even though Jane still had her mother left to deal with. It was only a matter of time.

A guard lumbered by, clomping along, loudly chewing gum. She didn't turn to look at him, knowing that he'd be looking back. There'd been enough eyes on her that day.

Jane had told her about that movie class she took, all the ancient films they watched. She even told her how there was a code back then that meant there were certain things you could never show in the movies. No nudity, obviously, or blood spurting like in a slasher film, but there was also a rule that you couldn't show anyone getting

away with a crime. Mr Shapiro told them how Hitchcock had to change some of the endings to the books he adapted because of this rule. Like when he made *Strangers on a Train* and also *Rebecca*. In old movies, criminals had to pay for what they'd done. But Lisa didn't think she would have to pay for what she'd done. Sure, they might find out that Macy Aster had been hit a few times on the head with the edge of a snow shovel, but that didn't mean they'd be able to pin it on her. This wasn't the movies, after all. It was real life, and people got away with murder all the time.

The Hunter

Vaseem Khan

1

The deer, a doe, was between its summer and winter coats.

Nestled in the grass some fifty yards away, they could just about make out the flash of white on the underside of its tail.

'Do you think she's alone?'

'I'm not sure.'

'Shall we try and sneak up on her?'

They had barely risen to their feet when a rifle-shot shattered the silence. The doe's head snapped back; she staggered, fell sideways. Her legs bucked a while, then stopped.

Horror whiplashed through Kal. He looked down at his daughter, the wide brown eyes beneath her beloved Seahawks cap.

The sound of approaching feet.

Turning, Kal saw two white men moving through the brush. Camo jackets and waders. Waterproof hiking boots. Hunters. The taller of the two, wide-shouldered and burly, unkempt beard, peaked cap, held a rifle. The other, jowly, gut like a boulder, had a weapon slung over his shoulder. Stubby legs worked double-time to keep pace with his companion.

They ignored the dead deer, zeroed in on father and daughter.

Kal hesitated, then stuck out a hand. 'Hi. My name's Kal. This is my daughter, Ro.'

They stared at him so long he began to wonder if they had even heard.

Then the taller one spat, sideways, and said, 'Long way off the reservation, ain't ya, chief?'

He blinked. He could feel Ro tense beside him. Instinctively, he moved in front of her. 'We're not Native American—' He stopped. 'Look, we don't want any trouble. We were just headed back.' He found his daughter's hand, began to turn.

The taller guy moved faster than he had any right to. He was behind them, cutting off their route back to the Toyota Sequoia, rifle swinging up in a flat arc.

2

'You gentlemen playing nice?'

The woman had snuck up on them. Feet like a cat's.

She was white, with flame-red hair pulled into a bun, a rifle lodged in the crook of her elbow. Her waxed jacket held the insignia of the Crow Wing State Park ranger's office.

The taller man straightened. She held his gaze. Her eyes were grey, Kal saw, like chips of flint. 'Sir, I'm guessing you have a permit for that deer you just took down.' Her voice was high, sing-song. Per-*mit*.

The fat guy snapped to life. He scrabbled around in the pockets of his jacket, held out a piece of paper.

'Thank you, sir.' She handed it back. 'I guess you'll be on your way now.'

They exchanged a glance, then moved away, the taller one spitting again, muttering something under his breath that was taken by a sudden gust of wind.

She watched them vanish into the tans and browns of the fall

landscape, then said, 'I'm sorry about that, sir. I hope they didn't upset the young lady here.'

'I'm not scared of a pair of redneck assholes.'

'Ro!'

'It's fine. I have a daughter about the same age.' She smiled, revealing even, white teeth. 'My name's Sarah. This your first time in the park?'

Kal nodded. 'We were planning on spending a few days together, out in the wilderness. No phones. No laptops.'

'Just you and Momma Nature.'

'Something like that.'

She shifted on her feet. 'A word of advice. Steer clear of those two, especially the bigger one. They came in last night. Caused a ruckus.' She smiled. 'Most folks here are friendly enough, but they're out here for the same reason I'm guessing you are. To put a little distance between themselves and the rest of humanity.' A beat. 'Having said that, if you get lonely out here, there's a burger bar beside the ranger station. About three miles thataway.' She waved back in the direction they had come. 'I can't promise you fine dining, but Bob's burgers are to die for.'

3

The rain had eased a little as they pulled into the parking lot.

A large wooden building loomed before them, big bay windows, a timber roof, and a neon-lit sign that attracted clouds of insects, even in the wet.

Big Bob's Burger Bar.

They splashed across the muddy lot and into a muggy warmth, a riot of music and raised voices. The sound dipped a fraction as their presence was registered, two dark faces in a sea of white, and then the conversations resumed.

He realised he had been holding his breath, anticipating more

of the welcome they had received from the two good old boys earlier.

But if their journey east had shown them anything, it was that most people were decent and kind. If anything, it was the fact that he and Ro were city folk – and possible Democrats – that was liable to rile them up rather than the colour of their skin.

'Over here!'

Kal saw the ranger, Sarah, waving at them from a booth. She had shed her jacket and was wearing a pale blue shirt, face flushed, a bottle of beer set before her. Potato chips sat in a pile in a wooden bowl. Her hair was tied back into a ponytail.

Kal hesitated, but Ro had already pulled ahead.

They slipped into the booth. The leather squeaked under them, Ro scooting over to the far end. Kal could sense her enthusiasm. His daughter was all about the 'strong female role model'. Kal probably knew more about Taylor Swift than Swift's own mother did.

'I hadn't expected a crowd,' he began. 'Not with all this rain around.'

Sarah smiled. 'Mostly first-time campers and city hotshots. On a night like this the reality of the great outdoors is less enticing than the idea… What'll you have? My treat.'

He refused the offer, but she was insistent.

Orders were placed. Burger, fries, and a beer. A shake for Ro.

'Do you buy all the new arrivals dinner?' Kal asked. 'Or just the ones that look like us?'

She took his mild jab in her stride. 'Nope. You just seemed a little lost, is all. And frankly, what happened earlier… I guess I feel responsible. This is my beat, after all.' She sipped at her beer. 'Where you folks from?'

'Seattle,' said Ro.

They had driven three days, leaving on the Friday, following I-90, then I-94, a straight line east for fifteen hundred miles. Ro had

The Hunter

kept a journal, setting down the place names of the towns they passed through: Spokane, Missoula, Butte, Billings, Bismarck, Jamestown, Fargo.

Names freighted with history.

They had turned south at Brainerd, followed Highway 371 down to the Crow Wing State Park.

It seemed as good a place as any to stop for a day or two.

'You driving coast to coast?'

'Something like that,' Kal said.

'My dad wants me to see some of the *real* America.' Ro rolled her eyes.

Sarah chuckled. 'My dad pretty much did the same thing to me when I was your age, only in the opposite direction. We grew up in the country, up near the Red Lake Reservation. My father wanted me to see the big bad city. Can't say I really took to it.'

'Why were you on the reservation?' Kal asked, genuinely curious.

'Not on. Near. My father taught maths. Used to go into the reservation three days a week.'

Kal picked up his beer. 'Those guys earlier... They thought we were, you know...'

Understanding dawned. 'Native American?'

He nodded, took a slug from the bottle.

She clicked her tongue. 'No accounting for ignorance, I guess.' She turned her smile on Ro. 'You enjoying your road trip, honey?'

Ro hesitated a second longer than Kal would have liked. 'Sure. It's been... an experience.' Old beyond her years.

'No mom along for the ride?'

Ro cut her eyes at her father. 'I'm staying with my dad for a couple of weeks.'

Sarah raised an eyebrow, but said nothing.

A pit opened up in front of Kal. 'We're divorced,' he said. 'It's been almost a year.'

Sarah didn't apologise for her faux pas, as a city dweller might have done. Instead, she murmured, 'Welcome to the club,' then burped genteelly, without a hint of embarrassment, before scrabbling to her feet. 'Back soon.'

They watched her head off to the back of the room.

'She's *kick-ass*!' said Ro. 'I think she likes us.'

'I don't think she's seen many people like us before. Probably gone to call Homeland Security.'

Ro glared at him. 'Now who's being a prejudiced asshole?'

He frowned. 'Haven't we talked about language before?'

She made an insincerely contrite face, then, 'Dad, can I ask you something?'

'Can I stop you?'

'Are you cool with mom getting married again?'

A hole opened in Kal's chest. He looked away. 'It's none of my business anymore, is it?'

'That's not what I asked.'

He forced his lips into a smile. 'I don't regret my time with your mom. Because if we hadn't got together, we wouldn't have had *you*. If she wants to marry some white asshole, that's her problem.'

'Andy's not an asshole. He's a sweet guy. And what happened to the watching our language?' She waited a second. 'And I don't see what Andy being white has to do with anything.'

Kal sipped at his beer to cover his anger. The idea of another man, a white guy, raising *his* daughter…

Sarah returned and settled back into her seat. 'So what do you do… Kal, wasn't it?'

'It's short for Kailash,' said Ro. 'But no one calls him that.'

'I'm a painter.'

'Oh, really? I loved painting in school. Gimme a big old canvas

The Hunter

and a set of paints and watch me go. So… what do you paint? Landscapes? Portraits?'

'Try houses.'

Most folks reacted with surprise when he told them that. An Indian from Seattle? They expected him to be running Microsoft or calling the shots at some venture capital outfit.

'Dad's got his own firm,' said Ro hurriedly. 'It's expanding all the time.'

Kal tamped down on a bloom of embarrassment. His wife – ex-wife – had always derided his lack of ambition. Maybe that's why she had left him for a banker, the sort of douchebag who would hire Kal to paint his weekend lake home, and then chisel him out of a few bucks when it came time to pay the piper.

Before Sarah could reply, the door jangled, turning heads.

A man in a hat and a glistening police poncho looked around the room, then made a beeline for their table.

4

Kal tensed as the policeman approached.

His father had drilled a healthy respect – mingled with a little fear – for law enforcement into him. But this wasn't Seattle, home to the world's politest and most politically correct cops.

The cop arrived at their table, took off his hat, revealing a head of red hair. He nodded at Kal and Ro, and then turned his attention to Sarah. He was tall, lean, and freckle-faced. Raindrops sparkled in a moustache so thick it almost seemed a parody.

Sarah stood. The pair turned aside. A terse, short discussion ensued. Kal struggled to hear, but got nothing.

When they had finished, the guy stuck his hat back on his head and left without looking back.

Sarah returned to her seat, picked up the beer again.

'Everything okay?'

She seemed to debate with herself, and then, perhaps because of the beer – surely not her first – she said, 'They've found a body out near the Old Crow Village.'

Kal knew that the Old Crow Village was a ghost town, situated at the confluence of the Mississippi and Crow Wing rivers. The town had served as a fur-trapper trading outpost, and, later, as the county seat. Once upon a time, it had housed six hundred residents, mainly Ojibwe Native Americans, until they had been resettled by the government.

He looked at Ro. His daughter was a modern kid, a fully paid-up member of the *Grand Theft Auto* generation, ostensibly inured to violence. But this wasn't the big city.

'What happened?' he asked.

'They're still trying to figure it out. A woman's been killed. They found her body in the woods behind the Beaulieu house.'

Kal glanced again at his daughter. They had been up at the Old Crow Village earlier, walking through the pinewood replica of the historic settlement. Overlooking the town, perched on a hill, was the restored Beaulieu house, a white-timbered, grey-roofed manse, framed by dark pines.

He felt his daughter's hand slip into his own, gave it a reassuring squeeze.

'I bet it was those two assholes,' Ro said. 'The ones we met earlier.'

Kal frowned at her. 'It's a long way from bigotry to cold-blooded murder.'

'They killed that deer! And they probably would've done the same thing to us if Sarah hadn't shown up.'

Kal flashed a grim smile, and said, to Sarah, 'I blame pop culture. Overheats their imaginations.'

'Dad!'

But Sarah was staring at Ro, as if she had just said something interesting. 'Hell, I'd forgotten about those two. Might be worth slipping their names to the state troopers.'

The Hunter

Ro looked pleased with herself.

'How come you didn't go with the cop?' asked Kal.

'No need. State police are already out there. They were informing me, as a courtesy. I'll get the word out to the campsites. That's about as much as I can do.' She tapped the side of her bottle. 'We get a few deaths out here every year. Accidents, in the main. City folk getting into trouble on the river, or falling onto rocks. The occasional bear attack. Murder… that's a new one.'

Kal frowned. 'Is there anything we should do? To protect ourselves?'

She raised her chin. 'Are you armed?'

'No. I mean, I'm not carrying a gun or anything.'

'You two sharing a tent?'

'Yes.'

'Well, I guess that's something.' She picked up her bottle. 'Just stay alert. Most likely, whoever did it is probably long gone already.'

5

The rain had eased.

Kal stepped out of the door and splashed across the lot.

Clear of the neon sign, a wash of starlight lit his way. The darkness between the nearby trees was absolute.

The outhouse had a clean cement floor, and running water. He wondered why Big Bob hadn't just built toilets into the restaurant, but he guessed some illusion of roughing it had to be maintained. It was a wonder they hadn't mounted a stuffed bear on the porch, paws outstretched.

The bulb was out, the only light seeping in from windows high on the outhouse's rear wall.

Kal walked to the urinals, unzipped.

The tinkling sound seemed to echo in the semi-dark. He forced

his mind into a blank. But it wouldn't stick. The past few days were a whirl. He thought about his wife, and her fiancé. Darkness crowded in.

The sound of the door scraping back.

Kal turned his head, saw the bigger of the two men from the afternoon walk in, then stop, eyes narrowing.

Kal stepped away from the urinal, zipping hurriedly, drops of piss splattering onto his trouser leg. His heart was suddenly pounding in his ears.

He thought of his daughter, waiting for him in the restaurant.

Kal calmed himself, then put his head down, and tried to walk around the man.

A hand the size of a dinner plate hit his chest, shoving him backwards. Kal tripped, went sprawling. A few seconds of shock, and then he scrabbled to his feet. His blood was pumping. With fear, with adrenalin. He could feel his fists bunched by his sides.

'What's your fucking problem?' The steadiness of his voice astonished his own ears.

'*You're* my problem.'

There was no point challenging the guy. No point in Kal telling him his own father had been born in New Haven, Connecticut; that Kal had been born in Springfield, Missouri; and that his daughter had been born in Seattle in the great state of Washington. Three generations of *Americans*.

Kal had put up with this sort of shit his whole life. Hiding. Staying out of trouble. His father's mantras. 'You can't win, son, even if you *win*.'

His father had always told him to walk away from a fight. But how many times could a man walk away from a fight and still consider himself a man?

Something had changed these past few days. Kal had drawn a line in the sand.

The door opened behind them. An elderly man in a padded

The Hunter

greatcoat and fur hat shouldered his way in, clopping a cane. He barely noticed them, shuffling past to the urinals, cursing as he fiddled with his zipper.

Kal felt the coiled energy of the moment drain away.

What the hell was he thinking?

Ro was his priority, not confronting this asshole.

Kal made to move past the guy, but found a hand clutching at the front of his jacket, the man's voice hissing in his ear. 'Leave. Or I'll come find you. Chief.'

6

Kal's feet squelched over a damp mat of leaves.

Ro had tried to name the trees as they had stomped around here yesterday, on their way down to the river: Bur Oak, Red Oak, White Pine, Red Pine, Jack Pine. Reading excitedly from her guidebook, she had told him that, somewhere in the park, they might encounter not only white-tailed deer, but black bears, coyotes, raccoons, squirrels, beavers, woodchucks, and even turtles. She had made a little chart, intending to tick off each species, displaying a near pathological sense of determination that made him smile.

Kal was glad his daughter had begun to enjoy herself.

When he had first sprung the trip on her, out of the blue, Ro had been stunned.

No time to prep. We leave in an hour.

He had never done anything like this before. Kal wasn't the type to just *take off*, as Ro put it. What she meant was that he wasn't spontaneous. His ex-wife had skewered him for years with the same accusation.

Dependable Kal. Steady Kal. Kal, who liked to plan everything down to the last nut and bolt. Kal, who could boil the fun out of just about anything. Unlike Andy, who, when he wasn't tanking the economy as a master of the universe, took Kal's ex-wife on

romantic weekend getaways to the Cascades. Or surprise rides on his new Harley. Probably. Kal didn't know if Andy had a Harley, but he was just the sort of shitbird who would buy one to impress a girl.

The hardest part had been convincing Ro to give up her phone. To not talk to her mother about the plan, or in the days since.

As he walked through the dark, Kal hoped Ro wouldn't wake while he was gone. He knew, from long experience, that Ro slept the sleep of the dead. Something she had inherited from her mother. It would take an earthquake to return her to the land of the living.

Kal, on the other hand, had never been able to sleep.

On those cold, lonely nights towards the end of their marriage, it had amazed him how his wife had been able to turn her back on him, drift off into the endless opium of night, while he was left to wrestle, wide-eyed in the dark, with his own insecurities.

He swung along at a clip, making good time through the darkness, the beam of his flashlight lighting his way along the marked trail.

Kal knew precisely where he was going. He had followed the big man earlier, after their encounter at the outhouse. He had made a note of the man's jeep, waited for him to vanish inside Big Bob's Burger Bar, then tested the doors.

Open.

Taking Ro's iPhone, he had stuck it under the rear seats, turning off the volume and vibrate functions. Now, all he had had to do was activate the location finder app on his own phone... and it told him precisely where to find his daughter's phone.

The wonders of modern technology.

It took him ten minutes from the spot where he had parked the Sequoia to make it to the clearing.

When he got there, he turned off his flashlight and peered from around the trunk of a pine.

The clearing was bathed in moonlight, revealing two large tents

The Hunter

and the remains of a campfire, set up with a roasting spit that had collapsed in the night.

Kal scanned the ground around him, picked up a stone.

Stepping into the clearing, he hurled it at one of the tents.

Nothing.

His fingers dug in the mulch and he picked up another stone, the size of a baseball.

This time he heard a sound from inside the tent.

He threw a third stone, then ducked back behind the tree.

The tent opened, and a head poked out.

It was the taller man. Bingo.

The man's baseball cap was gone. Moonlight splashed from a bald dome.

Slowly, he eased himself out of the tent, stood up in a pair of shorts and a faded Guns N' Roses T-shirt. 'Someone out there?'

His gaze attempted to penetrate the trees on the edge of the clearing.

Finally, he hawked, spat, and turned, bending down to re-enter the tent.

Kal covered the ten metres to him in seconds, eating up the ground with long easy strides, swinging the hammer as he reached the tent.

The blow struck the big man squarely on the back of the skull, pitching him forwards into the tent.

Kal followed him in, straddling his back, lifting the hammer and striking down a further four times until the skull had completely caved in.

Throughout, the man hadn't made a noise.

It was too dark to see the blood pooling around the head.

Kal eased himself back out and stood in the moonlight, the hammer still gripped in his hand.

His heart was racing, but that was fine. He had almost gotten used to the feeling.

When Kal had killed his ex-wife and Andy, he had immediately collapsed onto Andy's $10,000 couch, shivering uncontrollably, his mind a perfect blank. For the longest time, Kal couldn't even remember what it was that had turned that little switch in his head, that had set the demons loose.

And then it had returned to him, a memory so bright it was almost hallucinatory.

Andy was moving to New York. A new job. After the wedding, he and Kal's ex-wife would fly out there, to begin a new life. With Kal's daughter.

How was a man supposed to turn the other cheek to *that*?

He had stuck the bodies in Andy's wine cellar, left a little note propped up on the burled walnut table in the kitchen: *Gone skiing for the weekend.*

He supposed, if the bodies hadn't been found yet, they soon would be.

The call would go out. The net would begin to tighten.

Whatever happened, they couldn't take *this* away from him.

For once in his life, Kal hadn't taken it lying down. He hadn't walked away from a fight.

He had vowed to himself never do that again.

Take the fat woman who had called Ro something insulting under her breath yesterday at the Old Crow Wing ghost town. Ro hadn't heard, but Kal had heard. He had caught the woman's eyes. The hard, unblinking stare, the squirt of hatred, the arrogance that suggested she knew she could say such a thing to someone else's child because there would be no consequences.

Wrong.

Fifteen minutes later, Kal had spotted the woman walking alone into the woods behind the Beaulieu house. He had left Ro inside the house, jogged into the woods, picked up a rock, and caved in the woman's skull. She hadn't even turned around.

Kal hadn't worked out what he would say to Ro once she found

The Hunter

out. About Andy and her mother. About the woman in the woods. About tent guy.

Kal had always tried to shield his daughter from the horrors of the world. He would do that as long as he was able.

They would move on early in the morning, continue eastwards.

There was plenty of time to work things out.

And, maybe, more hunting on the way.

Danielle's the Dead One

Sophie Hannah

Detective Constable Simon Waterhouse turns out to be tall, wide (beefy without being fat) and craggy-faced, as if someone lightly grated both slab-like sides of his face before allowing the skin to set. He's handsome in an ugly way – in a 'someone tried to create a scary monster but messed up and gave him a beautiful soul' kind of way.

I'm not saying I think DC Waterhouse has a beautiful soul. How would I know? It's his eyes, though. They're large, deeply brown and sort of spellbinding. They seem to be inviting me to conclude there's somebody sensitive inside this hulking flesh container.

He's not as smartly dressed as the other detective who came round, that's for sure. His shirt is wrongly buttoned and hanging out of his waistband on one side.

This isn't how I expected him to look. His voice on the phone made me think he'd be lanky and sensitive looking – what my mum would call 'the doomed poet type'.

His presence here is as unexpected as his appearance, I realise, though it shouldn't be; he texted me half an hour ago to say he was on his way. I think on some level I must have assumed he was joking – maybe because I'd been so certain he would treat the last thing I'd said to him as a joke.

My outrageous request. Had it been a request or a demand? I still wasn't sure.

Danielle's the Dead One

It wasn't any sort of joke, though. I'm not good at humour, so I never attempt it.

'I've watched it,' says DC Waterhouse.

Incredible. For a second, I feel as powerful as a deity. *Get a grip, Jill. All you've done is persuade a policeman to watch an excellent film.*

'And? Did you love it?'

He shrugs. 'I wouldn't say "love".'

I would. In my head, silently, I repeat the word to myself. I love, love, love that this has happened, and thanks to me. *And yes, I love that I have the power to make things happen. I want all the power, even if that means all the guilt too.*

Whatever I'm to blame for, I can also take credit for this: I made sure that an until recently deprived person had the chance to discover one of the greatest movies ever made. Deprived is the only reasonable way to describe someone who has never seen Hitchcock's *Vertigo*.

I couldn't believe it when DC Waterhouse told me he'd never heard of it. How is that possible, when he's at least fifty? He must come from some kind of culturally deprived background. I assumed he was kidding at first, but he wasn't (I suspect he is as innately non-jokey as I am) so I told him how famous and acclaimed *Vertigo* is, that it's regarded by everyone who knows anything about cinema as one of Hitchcock's greatest masterpieces. (Someone once told me that 'masterpiece' has to be singular, not plural – one solitary greatest achievement. Well, I'm sorry, but Alfred Hitchcock made three masterpieces, and that's hardly my fault. (*Vertigo*, *Psycho* and *North by Northwest*, obviously.))

Perhaps deciding that more might be required from him before I'll agree to talk, DC Waterhouse says, 'Yeah, I thought it was good. I didn't guess where it was heading. My wife thought it should've been half an hour shorter, but I liked it the length it was.'

'Tell your wife—'

'I'm not here to talk about *Vertigo*, Mrs McGlade. Can I come in?'

I can hardly say no, given that I promised to tell him everything if he agreed to watch my favourite movie of all time. Though, come to think of it, there's no concrete proof that he's watched it. How easy would it be for him to pretend he had?

Too easy. Too bloody easy. And equally straightforward to look up the film's running time.

What if he's lying, playing 'humour the madwoman'? Not that I'm mad. I have not, in a direct sense, killed anyone. I'm a perfectly sane and legally innocent person.

Once I've made DC Waterhouse a cup of tea and we're sitting opposite each other in my lounge, he says, 'So. I've done as you asked, and now you're going to fulfil your side of the bargain and tell me what happened here last Tuesday.'

I nod. 'I will. I mean, I haven't got much more to tell you than you already know. Except…'

'What?' he asks.

There's a pause. I'm wondering if I need to offer him some information first, before asking him the question that's been burning inside me ever since Danielle died. He might say it's not his area of expertise, but I can't believe he won't have a view on it all the same. As a police detective who must have dealt with countless murder cases over the years – and manslaughters, and negligent endangerments resulting in deaths – he must have an opinion.

I want to know what it is. And he needn't think he'll be the last person I ask, either. I might go to my local church, though I haven't been anywhere near one for years, and ask the vicar there. I might go to a psychotherapist and discuss it with him or her. I want as many opinions and perspectives as possible, in the hope that one of them will click into place in my mind and give me that 'Yes, this is what I believe too' feeling.

'Do you believe in karma?' I ask DC Waterhouse.

'No.'

That's not enough of an answer. It doesn't satisfy me. 'I don't

Danielle's the Dead One

either, in theory,' I tell him. 'I mean, it's an Eastern concept, isn't it? Buddhist. And I'm not a Buddhist. I was brought up Ulster Presbyterian and now I'm... not really anything. But since Danielle's death, I've been thinking about all the things I've noticed happening over the years, to me and to other people, that, when you put them together, really make quite a powerful case for the existence of karma. I bet you could think of loads too if you tried.'

It's mainly my dad I'm thinking of. His fourth wife left him after they'd been married only two weeks, and wouldn't let him have anything to do with their baby once it was born. She'd met and fallen in love with someone else. The thing is, Dad by that point had already left three wives and sets of children, including me and my brother (we were his first), and none of those wives was at all interested in having him back when wife number four abandoned him (yes, he tried to crawl back to each of them in turn). He ended up living alone for the last eight years of his life. I was the only one of his eleven discarded children who visited or kept in touch with him, and I could tell that he ended his days lonely, miserable and full of regrets.

Thinking about Dad, and how karma might have played a part in his suffering, led me to consider my first stepmother: his second wife, Nancy. When I was nine, I went to stay with her and Dad for two weeks during the summer holidays, and I took my beloved pet rabbit with me in his portable cage. He was called Tiptree, named after the jam. One day, while staying there, I was coming down the stairs and I saw Nancy carrying Tiptree under her arm and hurrying to the front door. The lock was really stiff, and she made panting noises as she tried several times to turn the key.

Eventually she succeeded, and threw the front door open. I was about to call out, 'What are you doing?' I could see that poor Tiptree was wriggling and fighting to free himself from her arm's grip – and then suddenly she threw him out onto the pavement, muttering 'Bugger off, rodent,' before slamming the door shut.

She and Dad lived on a busy main road. Tiptree got hit by a car seconds later and died. I saw it happen through the glass pane at the top of the front door. I started to scream, and Nancy pretended to be as shocked and horrified as I was. 'How on earth did he get outside?' she kept saying, making sure Dad heard. 'Jill, you must have forgotten to close the door of his crate. And... who left the front door open? Was it you, Jill? It must have been!' To this day, it baffles me that Dad heard her blurt out this very convenient sequence of lies, as if she was awkwardly reciting lines from a play, and didn't immediately suspect the truth.

I didn't accuse her straight away. I knew that sobbing hysterically wouldn't help me to make my case in the strongest possible way. When I finally told Dad what I'd seen Nancy do, making sure not to sound emotional and to stick strictly to the facts, Dad snorted dismissively and said, 'Don't be silly. Nancy wouldn't do that.'

Except she did. And here's the thing: more than ten years later, Dad told me Nancy had been in a bad car crash and, as a result of her injuries, had lost the use of her hands almost completely. She couldn't write with a pen, couldn't aim or hold a fork easily. Using a tin opener was out of the question – and one thing she certainly couldn't do was open front doors that had very stiff locks.

Was that karma, punishing her for what she had done to Tiptree all those years ago?

Next, I thought about my old classmate and so-called friend, Saffy Maskell, who had oh-so-kindly offered to throw a party at her house, while her parents were away, purely so that I could invite the boy I fancied at the time and have an opportunity to snog him. On the night of the party, seconds after he walked in through the door, she grabbed him, pushed him up against the coat-stand in the corner and started kissing him herself. She continued to do so for the rest of the evening. The following week at school, a delegation of gum-chewing, vacant-eyed girls from the school on the other side of town turned up in our playground, intent on

Danielle's the Dead One

bloodshed. The gang leader, Amanda Lockwood (and praise and thanks to her forever, obviously), grabbed hold of Saffy Maskell's hair and punched her in the face until blood was pouring out of her nose and dripping from her scalp. Amanda Lockwood turned out to be the longtime girlfriend of the boy I'd fancied, who, it turned out, had kept very quiet about the fact that he was already in a committed relationship.

'What does karma have to do with Danielle's death?' Waterhouse's voice brings me back to the present.

If I tell him the true question I want answered, he'll think I'm crazy, but I ask it in my head: who is more responsible for Danielle's death, karma or me?

I want and need it to be karma. Because if it's my fault, that means I need to feel guilty, and there's nothing I can do to lessen that guilt now Danielle's gone. Which would mean I'm karma's main victim, not her, because I'd be the one who was alive and suffering.

'Look, I'm only here because you told me on the phone that you might have killed Danielle Allsopp, which contradicts everything I think I know about her death,' says Waterhouse. 'I know you didn't kill her – her death was an accident – but I'm willing to listen to whatever you've got to say. Then you said you wouldn't talk until I'd watched your favourite movie, which I now have, so—'

'Prove it,' I challenge him. 'Prove to me that you've watched *Vertigo*.'

'How am I supposed to do that? Go to an art gallery and stare for hours at a picture of a woman holding a bunch of flowers? Climb up a bell tower in a nunnery or whatever that place was?'

All right, so he has watched it. He didn't lie. Good.

'So now I'm hoping you're willing to explain the discrepancy,' he says. 'You said on the phone that you violently pushed your friend Danielle out of your house: you shoved her, hard, and she landed in the middle of the road, where the speeding car knocked her

down. Actually, you implied you saw the car coming and shoved her into its path.'

I nod.

Waterhouse shakes his head as if to negate my gesture with his own. 'But that's not true. Two of your neighbours saw Danielle Allsopp leave your house, and they've assured my colleagues and me that no pushing was involved. They saw her close the door and walk out onto the street. They all described her as looking angry and upset and not paying attention to her surroundings, but they were very certain no violent shoving took place.'

I sigh. 'There are some nosy gits round here. All right. It's true. I didn't push Danielle.'

'Then why pretend you did?' Waterhouse asks.

'Because I wanted you to take it seriously: the possibility that I might have killed her, even though I didn't do anything to her physically. Because I'm wondering if that's how karma might see it: that I did, in fact, kill her, even though I didn't.'

Waterhouse's face contorts in disgust. 'Please don't tell me I've driven all the way here to listen to some mystical bullshit. Also, what's karma got to do with the film you made me watch?'

'Let me tell you what happened between me and Danielle last Tuesday,' I say. 'Then you can tell me how guilty you think I am, morally. Or how guilty she is, more to the point! I have to say, I do think she drove me to say what I said—'

'Mrs McGlade,' Waterhouse says, though what he means is *Stop now.*

'I'm not interested in the morality of anything. Legally and from a criminal offence point of view, you did nothing to Danielle Allsopp that requires further police attention. I ought to get up and leave right now.'

'You're not going to, though, are you?' Which has to mean he is interested, in spite of what he's just said. 'All right, I'll make this quick: I said something spiteful to Danielle. Something I probably

Danielle's the Dead One

shouldn't have said. That's why she marched out of my house and straight into the path of that speeding car. So. I pushed her with my words instead of with my hands.'

'What did you say to her?'

'Look, it would never have happened if she hadn't said a million not-quite-right things to me over the years,' I tell him. 'I'm not someone who says cruel things or pushes harsh truths in people's faces. Most of the time I'm the opposite: a compulsive people-pleaser who'll say whatever smooths out a bump in the conversation or cheers anyone up. But Danielle had said so many things over the years that were like little pinpricks, you know? And... eventually I came to the conclusion that she couldn't have been doing that unintentionally. When it gets to, like, the fortieth or fiftieth snide remark... I felt like she was constantly making subtle digs at me. And the thing is, none of my other friends ever say anything that makes me wonder if they're trying to have a go at me under the cover of plausible deniability. Literally, none. Danielle was the only one. And it wasn't just the snide comments, it was also the constant boundary violations. That was what started the trouble on the day she died.'

Waterhouse's face contorts with what looks like annoyance. Then he says, 'Go on,' in a tone that suggests he's conceding defeat.

'Danielle and I were in the middle of doing a leadership and mentoring course. She only signed up for it once I'd told her I'd enrolled, and it really annoyed me. I manage a theatre company, and work were paying for me. Danielle paid for herself, but I mean... why, for God's sake? She had no kind of leadership or managerial role. She's got – she *had* – no one and nothing to lead. She worked in a chemist's shop. She's a shop assistant. Which is fine, but...' I shake my head, try to get back on track. 'Anyway, she made a big production of asking me if I'd mind if she "gate-crashed"' – I make air quotes with my fingers – '"my" course, as she called it. I said I didn't mind, obviously – what the hell else

could I say? And she knew it! I could feel her basking in her power over me. She knew I wouldn't be brave or mean enough to say, "No, actually, I'd prefer it if you did a different course instead of invading mine. I'd prefer it if you'd use your brain for two seconds and realise that I don't want you popping up everywhere, trying to force me to hang out with you when you must have worked out by now that I don't want to."'

Waterhouse's face has unstiffened a little. He just gave a small nod.

'So there we are, me and Danielle, doing the course together, with her undermining pin-prick remarks coming thick and fast… and then one day we're asked to list what we think are our main flaws – the things that have most held us back in our lives and careers so far. The tutor tells us that, if we want to, we can ask trusted friends or family members for their input, but only people we absolutely trust have our best interests at heart. I thought, "Oh, no, this is a disaster." I assumed Danielle was going to try and steamroller me into doing the exercise together, sharing our thoughts about each other's flaws, when the last thing I wanted was to do any kind of honesty-bonding thing with her. She didn't ask, though, and I thought, "Great!" And then last Tuesday, she's round here for coffee, having popped in unannounced, and she suddenly adopts this really solemn manner and says, "Let me tell you what I think your most serious flaws are, Jill. You know, like we were asked to do for the course? I've been thinking about it a lot and I really want to share my thoughts with you. And then you can do the same for me." Next thing I know, she starts bloody listing what she regards as my worst character traits: I don't look after my health enough, I eat all the wrong things, I trust people too much, I'm not honest enough with myself or others… all kinds of derogatory shit. And I hadn't asked her! I very deliberately never asked her to tell me her opinion of me.'

Waterhouse isn't looking as shocked as I hoped he would, so I

Danielle's the Dead One

repeat: 'I *hadn't chosen her and asked her*, as a trusted person. She assaulted me with the information. At that moment, I'll be honest: I did actually want her to die. Only briefly, but the desire was there.'

'So maybe that's why you lied and said you pushed her?' Waterhouse suggests. 'Because you wanted to, and maybe wished you had?'

'Verbally, I definitely pushed her,' I say. 'For once – possibly for the first time in my life – I didn't care about being tactful. It's not that I lost control or lost my temper. It was a deliberate decision. I thought, "I've had enough of listening to all the crap that pours out of your mouth. Get ready to hear some stone-cold truth."'

'And what did you say to her next?' asks Waterhouse.

'Danielle lost her mum three years ago. It was all very sudden. Her mum was relatively young and healthy, and then one day she just fell down dead and it turned out her body was full of cancer that she hadn't known was there. Anyway, Danielle's been really milking it ever since, about how she's lost her mum – joining, like, grief groups online and generally acting all tragic and bereaved, but here's the thing: what she never mentioned to anyone, and basically erased from the story, was that five months before her mum died, she – Danielle – told her she wanted nothing more to do with her. *That* was when she lost her mum – by choice, because there was no more contact after that, despite her mum begging to be forgiven for whatever nonsense Danielle was blaming her for. So... yes, Danielle did lose her mum, entirely voluntarily. She was a horrible, crap daughter and ruined the last five months of her mum's life.'

In case Waterhouse doesn't get it, I ram the point home: 'She had no right to wander around weepily, trying to get as much sympathy and special treatment as possible, pretending it was cancer that lost her her mum. It wasn't. It was her own cruelty and inflexibility. So I challenged her on it. I said, "Your most serious flaw is

that you're completely oblivious to your own defective personality. You always describe yourself as 'painfully honest' and yet…" – and then I came out with everything I've just told you. Danielle turned white, marched out of my house and… well, as you know, she ended up dead. Do I feel like I killed her? Yes, I'll admit it: I do. But what do you think? You're the police, you deal with murders all the time. How guilty am I?'

Waterhouse turns and looks out of the window. 'I only deal with crimes, not moral guilt or innocence.'

'But you must have an opinion,' I say impatiently. 'It's so not like me to say the very cruellest thing to anyone. Opening your mouth and saying what you really think has terrible consequences. It's not something I'd normally do.'

'That must be why you've just lied to me again,' says Waterhouse. 'Danielle Allsopp's mother is still very much alive, and grieving the loss of her daughter. I met her the other day.'

Shit. Didn't get away with that one, did you, Jill?

'You, on the other hand, have a mother who died three years ago,' Waterhouse goes on. 'One of your neighbours mentioned it: your very sad loss.' He leans forward. 'Mrs McGlade, is it possible that you're the one who tries to get sympathy for your loss, and who maybe cut off her mum five months before her death from cancer?'

And that what I've just told him I said to Danielle, she in fact said to me? And what I said afterwards that made her leave in a hurry was that I hated her, that she had a miserable, empty life, and she thought she at least had me, but she didn't because I loathed her and had for years?

'For what it's worth…' says Waterhouse, 'you did, in fact, lose your mum to cancer. That's true, isn't it. You're allowed to be sad about it, whatever you did or didn't do before it happened.'

He sounds as if he feels sorry for me, which is demeaning. Humiliating. I remind myself: Danielle's the dead one. She's the victim, not me.

Danielle's the Dead One

'Oh, I was much sadder when my dog Brolly died than when Mum did,' I tell him. 'Like, *much*. And – oh, my God, I can't believe I didn't say this already, this is the most important bit and why I asked you to watch *Vertigo* – Danielle was utterly vile to me after Brolly died. That's when me hating her really started. Do you know what she said when I got a new dog, Tiptree?'

Seeing the surprise on Waterhouse's face, I can't help smiling. 'Well remembered. Yes, I named my new dog after my murdered pet rabbit.'

'And... what happened to Tiptree?' Waterhouse asks. It's clear from his tone that he's expecting the answer to be something bad.

I laugh. 'Nothing happened to him. He's fine. My husband's taken him out for a long walk, so that you and I can talk uninterrupted.'

'Right.' He nods. 'So how was Danielle vile about your dogs, and what's it got to do with *Vertigo*?'

'About six months after Brolly died, I mentioned to Danielle that I'd been to see a litter of new Lancashire Heeler puppies. That's what Brolly was, and Tiptree is too. Are you a doggy person, by any chance?'

Waterhouse looks alarmed. He shakes his head.

'Well, take it from me: it's quite normal for doggy people to go for the same breed second time round. Like, it's the most normal thing in the world. But Danielle acted as if I was suffering from some kind of mental delirium. She put her hand on my arm and said in this patronising, mock-concerned voice, "Jill, you're scaring me. I hate to say it, but you're acting like Jimmy Stewart in *Vertigo*. You're trying to make your new dog identical to your old dog. It's a little bit sinister." But... it just wasn't! There's nothing psychologically twisted about wanting the same kind of dog, if you've already had one and you loved it. And then when we brought Tiptree home and she met him for the first time, she sort of shuddered and went, "Jill, he looks *identical* to Brolly. I really think you need to talk to

someone about this." He doesn't look identical, though – they're just both Lancashire Heelers. Yet Danielle made regular digs to remind me she thought there was something really creepy about it. My husband laughed in her face when she said it to him, and I did too, but… I mean, what do you think? *Was* I crazy, like Jimmy Stewart's character in *Vertigo*, to want another dog of the same breed? Maybe I *was* trying to replace Brolly, in a way – I mean, I definitely wanted a new dog, but that doesn't mean I'm not perfectly aware that Tiptree is a completely different dog. I love him in his own right, and it's not like I'm avoiding the emotional pain of losing Brolly. I still cry about him most days.'

'Like you say: it's normal,' says Waterhouse. 'My skipper, Sam Kombothekra, has had dark brown Labradors since I've known him. He's on his third, I think. And he's the sanest person I know.'

'Thank you.' I want to say more, so that he knows how grateful I am to him for having said this, but I sense he might not want me to. He's the sort of man who'd want to keep people at a distance, I think. No danger of him violating any psychological boundaries; he's the opposite of Danielle in every way.

'When Danielle said that to me, about my mum, I told her to fuck off and die,' I blurt out.

'You didn't kill her, though,' says Waterhouse.

'No. I didn't.' Maybe there's nothing more to be said than that, and I don't need to feel guilty about anything. 'But what about the karma thing? Did karma kill her – for the way she'd treated me for so many years?'

'I don't believe in karma,' says Waterhouse. 'I do believe in character, though. And that maybe character is destiny.'

'Isn't that just a different way of saying the same thing?'

He shrugs.

I like the idea that Danielle was killed by her own flaws – which she might or might not have listed when we did the flaw-listing task on our leadership course. *My* leadership course. I've no idea

Danielle's the Dead One

what list she came up with, but if I had to place a bet, I would guess that she listed faults that aren't really faults: 'I'm overly empathetic and kind, and just too generous for my own good.'

'You can't go round saying things like Danielle said to me for years and expect to get away with it,' I tell Waterhouse. 'All my life, I've had to put up with so many shitty people. Do you know what Nancy said, after she'd killed Tiptree? Rabbit Tiptree, not Tiptree the dog. I refused to speak to her or look at her for about six months. Then one evening I overheard Dad telling her to give me time, that I needed time and space to process my loss, and do you know what she said? She said, "Process? It's a rabbit, for Christ's sake. Personally, I'd process it into a delicious ragu." She actually said those words. So if I've got a bad character, it's hardly my fault is it? Do you know what I'm going to do?' I laugh as this brilliant idea occurs to me. 'I'm going to find a new friend called Danielle who looks like horrible, dead Danielle, and who maybe has a similar job to her, but who's alive and who's actually nice to me. And then it will be tough luck for Dead Danielle, because I'll be having fun hanging round with her still-alive replacement. That's what I'm going to do! Maybe Jimmy Stewart in *Vertigo* isn't so crazy after all.'

Split Your Silver Tongue

S A Cosby

Tolliver eased his Oldsmobile to a stop in front of the slat-wood house. Plump hens wandered through the yard followed by a huge rooster that was strutting and scratching like he ruled the world.

Tolliver got out and wiped his forehead with a paper napkin from Waffle House. Not for the first time he cursed his car for not having an air conditioner. A 1986 Delta 88 that was only ten years old and yet the AC had never worked since the day he'd first driven it. But he didn't have the money nor the credit to get another car so he suffered in the summer and put it out of his mind in the winter.

The steps groaned under his weight as he stepped up on the porch and knocked on the door. An old beagle, his muzzle grey as stove ash, peered at him from the corner of the porch. The dog decided Tolliver was none of his concern and lay his head back down.

A few seconds passed then the door opened and a tall, wiry older woman stood before him.

'You Mare-Helen?' Tolliver asked.

'You must be Tolliver. Come on in,' she said. Tolliver followed her into the shadowy structure. They came up through a small parlour into a narrow kitchen. She motioned for him to sit at the kitchen table.

'I'll go get it. Be right back,' the woman said. Tolliver watched

Split Your Silver Tongue

her walk up the banister-less staircase. He couldn't help but notice how her hips rolled under her house dress, how her apron was stretched by her bosom. She was probably fifteen years older than him, so that made her about fifty-five, but she still walked like a woman who know how to move in the bedroom.

He chuckled to himself at that.

Mare-Helen came back downstairs holding a small wooden box, about the size of the pencil box he'd used in school. She sat the box on the table and then took a seat herself.

'She used to say how good-looking a man you was. I see she wasn't lying,' Mare-Helen said. Tolliver smiled.

'She was a pretty girl herself. I was sorry to hear about what happened,' Tolliver said.

'Was you now? You didn't come to the funeral,' Mare-Helen said. Her deep brown eyes studied him like a snake studies a bird.

'I... I couldn't get off. I mean they had me running that route from Richmond to Norfolk. And since we weren't married or nothing, they wouldn't let me go,' Tolliver said.

'You make good money driving for Coca-Cola?' Mare-Helen said.

'It's all right. Money is like water in a sieve. Just seems to get away from you,' Tolliver said. He didn't mention how much money he'd spent on the ponies up in Potomac or how much he'd lost playing poker at Tyrus Green's shot house in Red Hill.

'Rose used to say she'd never seen a man dress as fine as you. Guess you didn't want to mess up your good clothes coming out here today,' Mare-Helen said. Tolliver saw a slight smirk slide over her face.

'I see where Rose got her spit and fire from,' Tolliver said. He felt himself stirring below his belt buckle. Something about this woman, who was old enough to be his mama, was getting his hackles up, in a good way.

'I raised that girl like she was my own after her mama and daddy died in that fire. She was my sister's girl so I felt like it was my duty. I tried my best to teach the old ways and the new ones,' Mare-Helen said.

'Like I said, she was a nice girl. I can't believe she left something to me though,' Tolliver said.

The rooster crowed like a clarion. Tolliver glanced at the clock on the wall.

'He's a might late, ain't he. You gonna have to fire him,' Tolliver said with a smile.

Mare-Helen smiled back.

'She said you had a silver tongue. Said Tolliver Minkins could talk lightning out of striking him,' Mare-Helen said.

Tolliver laughed.

'Lord, I don't know about that,' he said. He almost reached out for the box but he forced himself to stay his hand. It was his, he'd come all the way out here in the middle of nowhere Charon County. He could wait a few more minutes. He was enjoying Mare-Helen's company. He could already see her naked on top of him, sweat glistening on her breasts.

'You talked her right out of her panties, didn't you? That tongue must be silver,' Mare-Helen said.

Tolliver smirked.

'What else she tell you about me?' he asked.

Mare-Helen leaned back in her chair.

'She said you was the first man she ever been with. Said it was so big it hurt. I told her they all hurt the first time. Ain't no judging a bull's horns if it's the first one you seen,' Mare-Helen said. Tolliver felt his heart began to pound against his ribs. This old woman was trying to get something going all right. He could smell it coming off of her like a dog in heat.

'I don't know if you ever seen a bull like me, darling,' Tolliver said.

Split Your Silver Tongue

'Mayhap I haven't but I've seen my share,' Mare-Helen said. She scooted the box over to him.

'They all there. Take a look,' Mare-Helen said.

'I can't believe she left me anything,' Tolliver said. He opened the wooden box. There, laying on a swatch of red velvet, were twenty-nine silver coins.

'She said in the note that she wanted you to have them,' Mare-Helen said.

'I don't know what to say. She was a sweetheart. Sorry about what happened.' Tolliver closed the lid.

'I guess you'll be going on up the road now. You got what you came for,' Mare-Helen said.

Tolliver pushed the box to one side.

'You rushing me? I thought we was having a mighty fine conversation.'

'We were. But you used to be with my niece. I think you should go up the road,' Mare-Helen said.

'Is that what you really want me to do? How long's it been since a real man was around here?' Tolliver said.

'You a real man?'

'Only one way to find out, darling.'

'There goes that tongue again,' Mare-Helen said.

'Darling, this tongue is a ticket to heaven. You just gotta be brave enough to take the ride,' Tolliver said.

Mare-Helen smiled.

'You like shine?'

'Ma'am I love shine.'

'I got peach shine. Stay here,' Mare-Helen said.

She went back upstairs and soon came down with a mason jar cloudy with the remains of what appeared to be a peach. She poured him a shot in a jelly jar.

'You not joining me?'

'I will. I like to see a man enjoying himself,' Mare-Helen said.

'You ain't seen nothing yet, darling,' Tolliver said. He killed the shine in one smooth motion. It burned going down but then settled pleasantly in his stomach.

'Did she ever tell you she was pregnant?' Mare-Helen asked.

Tolliver shook his head. 'I never knew nothing about that. One day she was up and gone.'

Mare-Helen smiled at him again. This time she showed all her teeth. 'That silver tongue is forked, huh? I saw the letters she sent you. After you sent her away. She was still in love with you. She had me read the tea leaves, to see if you'd ever come back to her. They said you wouldn't come back till she was in the ground,' Mare-Helen said.

Tolliver flexed his hands. His fingertips were tingling. That shine was potent.

'I didn't send her away,' Tolliver said. The words came out slurred.

'Yes, you did. She told you she had her your seed in her belly and you told her to git. And she came home then I told her you wouldn't come back to her till she was dead. So, she jumped off the Coleman Bridge. When they found her, she was swole up like slug somebody had poured salt on,' Mare-Helen said.

Tolliver tried to stand…

He slipped out of the chair and landed on his knees. He reached out for the table edge and tried to pull himself up but his arms suddenly felt like lank lengths of rope.

'I knew if told you she'd left you something your greedy no-account lying ass would come down here. Twenty-nine pieces of silver cuz you ain't worth the thirty they gave Judas.'

'Youuuuu bitchhh,' Tolliver blurted out.

'You sure you want them to be the last words you ever say? That foxglove I put in the shine gonna shut you down presently.'

Tolliver tried to say something else but he couldn't make his mouth work. He fell face first on the wooden floor.

* * *

Split Your Silver Tongue

Tolliver was staring at the ceiling of Mare-Helen's shack. He could see pinpricks of light through the tar paper. He was lying on a couch. His feet hung off the arm at one end. Mare-Helen was stronger than she looked. She was barely out of breath after dragging him over there.

She stood above him now holding a Crisco can in her arms.

'I bet you think I wanna kill you. I don't. That's not what I use the old ways for. I just don't want you to ever use that silver tongue to take another little girl's virtue and then break her heart,' Mare-Helen said. She set the can down on the floor and leaned over him.

'I'm gonna have to open your mouth for you. I put a little more in there than just foxglove. Here, open up now,' she said. She pried open his mouth. Tolliver could barely feel her touch. She produced a small black glass bottle from the pocket of her apron.

'This gonna taste nasty because it is nasty,' she said. She poured the contents of the bottle in his mouth, all over his tongue and gums. Tolliver couldn't move and could barely feel but he could still taste. And what he tasted made him want to retch.

'You know my mama taught me and Ellie, that was my sister, the old ways. She used to say there weren't nothing on the earth or below that couldn't make things right that's gone wrong. I think she was right.'

Mare-Helen picked up the Crisco can and shook it. Tolliver could hear whatever was in the can scratching against the sides.

'These here is grave beetles. They only eat dead flesh. But like I said, I don't wanna kill. So, I had to put something in your mouth to make it smell dead. You know all about putting things in somebody's mouth, don't you?' Mare-Helen said.

Tolliver tried to move. Tried to scream. But it was like he was just a witness to his comeuppance.

Mare-Helen pulled the lid off the Crisco can.

'She would have been a good mama,' she said.

Then she poured the beetles into Tolliver's mouth.

She put the can on the floor and pulled her rocking chair over to the couch. She began to sing in a high clear voice. A song that made Tolliver's skin crawl. A song about graves and tombstones and the heartaches of the dead.

Tolliver lay there, his eyes wide, watching as the pinpricks of light danced above his face.

He heard the creak of Mare-Helen's rocking chair.

The high lilt of her singing.

And wet moist slurping and crunching of the grave beetles devouring his tongue.

Psycho Geography

Guy Adams

Cinema is magic. Anybody knows that. If they think about it. Which they rarely do.

But this isn't cinema.

'Do you recognise it?' the funny little fellow asks, invading the past with his grubby cell-phone lens. 'How can you not? It's one of the most famous silhouettes in horror cinema, second only to Max Schreck in Murnau's *Nosferatu*, looming large, black ink shadow with nails that could cut through the plaster they're caressing.'

Rhubarb, rhubarb, rhubarb…

'The house on the hill, shoulders hunched like a vulture on the horizon, lazy gable eye, hooded but alert. Who would dare walk up those long, long steps to the Bates Motel? Who would be lucky enough to walk back down?'

And cut. Stubby thumb to phone screen.

Look at him, a face that even the human eye couldn't focus on, let alone a camera. Skin like ration-book suet, eyes like sewer pipes. His moustache cannot be forgiven. His haircut assures us that whatever he may do unto another, worse has been committed to him.

The phone goes into the back pocket of stolen overalls. Nervous looks. Coast is clear. He looks up at the neon sign, dim but for the

glow of 'vacancy'. Perhaps he is reminded of his target audience. Or perhaps he is drawn to the aesthetic lie of the dirt strokes that delineate the other letters. Faux exhaust pipe phlegm painted onto the glass tubes to create the illusion of disuse, of years gone by, badly. Real muck is irregular, pays no heed to the eye's need for aesthetics, obscures too much or too little. Real muck looks ugly. Hasn't the job always been to corral the dirt? To deliver it in a way that makes it beautiful, however much wallowing in it feels so wrong. Wrong but delicious.

He moves to the back of the truck, as stolen as the overalls. *Universal Studios Lot – LA* says the decal on its side. Always useful when set dressing delivers exposition. He opens the rear door and begins to unload.

The steps up to the house, that Gothic transition between the flat, dusty, brightly lit strip of motel rooms and a killer's home, is beautiful on screen. As performative and poetic as Powell and Pressburger's marble escalator, just heading in the opposite direction. It's jagged, thrown by a central kink – aren't we all? It wasn't built for real people to climb. There isn't a practical bone in its body. Of all the things you would hate to carry up them, the worst is a human body.

'Stop wriggling, you bony little fuck,' he huffs, hands hooked under sweating armpits. 'If you weren't such a thirsty little bitch, you'd still be unconscious, amount I injected you with. Metabolism like a horse.' He can't help looking down at the young man's groin. 'And that's the only thing…' he mutters.

The bruised hustler, picked up for a song on Figueroa Street, bucks in his captor's grip, flexing in duct-tape bondage.

'*Now* he's a power bottom!' Having reached the halfway house, the mid-landing bend, he drops the boy to the concrete and delivers steel-toed remonstrations. The boy barks out-of-tune tuba parps against the tape. A rib cracks. A thigh muscle tears. There are tears.

'So behave!'

Psycho Geography

And up he goes again, boy limp, heels bumping and bouncing on step edges.

At the top, breathless, he waddles back a few feet then drops the boy again to deal with the door. He's lucky it's practical, like so few things in the motion picture business, and he's able to drag the boy inside and out of sight. The camera is out again.

'You try to do the right thing. I'm easy, I approach sex like cinema – because is there any difference?'

We'll ignore that.

'Boys, girls; arthouse, multiplex; young, old… But who wants to brutalise a young woman on screen these days? Huh? As if they haven't had enough of that over the years. A modern filmmaker has to ask themselves… Is that their story to tell? Their crime to commit? I asked myself that question…'

The camera points at the boy, eyes wide and terrified, bankable as gold coins.

'So let's call our romantic lead Mike…' A chuckle as charming as a producer's edit, a smile just as crooked. 'In honour of another great filmmaker.' He looms into the lens, sincere but so oleaginous that you would gladly swat him away with a cricket bat. 'And can I just say, the 1998 movie was an interesting experiment in form, whatever the thoughtless masses might have said.' He nods. Turns the camera back on 'Mike'.

'And I'll be killing Mike shortly.'

Mike has notes on this proposal. Mike has issues with the story. Mike has a good deal of feedback. Mike also has enough industrial tape gummed to his go-to-bed mouth to glue a moose, so, for once, we're spared the tedium.

The phone is revolved, a slow pan, a tour de promenade…

'As you can see, like so much in Hollywood, this place is hollow in the middle. The exterior façade, while reasonably faithful to the original movie, is as skin deep as the characters that hold a modern audience's heart.'

He steps back outside, strolling, comfortable, cocksure; unaware, one presumes, that the phone is uneven and therefore likely to be distorting perspective lines. Perhaps he's one of those modern film-makers who thinks this adds interest to the image.

'Out here, it's easy to believe one has stepped back in time to 1960. *North by Northwest* has committed crop-duster strafe runs on the box office and yet Paramount could hardly be less interested in the project Hitchcock is proposing next. Bloch's novel is deemed too violent, too foul for film, unsuitable for the eyes of America. How little they know the dark hearts of their audience. Because cinema is about to change, tastes are about to widen, and soon, millions of people will become complicit in one of the greatest acts of violence ever committed culturally. Did the knife enter Marion Crane on screen or just in your minds? In all your millions of murdering minds?'

Cut, and back inside he goes. A gaffer-tape worm is pushing its way through the dirt, trying to wriggle to freedom.

'Where do you think you can go?' the director asks. 'There's nothing left for you but fame.'

He starts to unpack a large haversack.

'The only thing you're running away from is mediocrity and STIs.'

He pulls out a ratty bundle of hair. A brassy gopher, lit and flared from tonguing the mains.

'State of this…' He combs it with his fingers. 'Fabulous to gutter while my goddamned back was turned.'

He does the best he can, which is no good at all, pulls the wig onto the boy's head, tufty prophylactic.

'Always pick blonde when you're feeling brutish.'

He drags the boy towards the wall then returns for the bag, scooping out a pair of chains. They, not to put too fine a point on it, would better suit the bedroom than the boatyard, but they'll be strong enough to keep poor Mike where he's needed. As for the walls, the studio, for once, had an eye to longevity, so our filmmaker isn't working with flimsy flats, lauan wood, splatter of plaster. The

wooden frame he's running the chains through – high-pitched metal song, like robotic crickets – will take the weight, however much that weight may kick up a fuss.

It takes a short time, but eventually we have a bruised young fellow strung up and moaning.

'Keep it up,' the bloody awful bugger says, 'it all helps. Psychogeography goes both ways.' He senses a damned monologue as the camera is back on him.

'Let me explain about magic,' he says, and we feel boredom sink into our bones, if, indeed we have any. Is this exposition? It is, isn't it? It's bloody exposition. 'Because that's all this is. Just ask Kenneth Anger. The mental space and the physical space have equal weight, what we perceive, what we feel, what we believe, shapes us as much as environment. As much as psychogeography, the effect that locations have on the people that inhabit them.

'This building represents something. It represents a film, yes, but that film grew into much more than it might have been. It became an event that marked culture. A line on the wall of the childhood home showing how high the human race has grown. Cinema was changed by it. Culture never recovered. You didn't even have to have seen it to have felt it. It lives on in YouTube clips, in references, in images. Iconography. A shower. A plughole. A hand over the mouth. Bottled scream, soon uncorked. A spray of water. A dissipation through plastic. A silhouette. A knife blade.

'The whole world knows those images. Morphic resonance. A baby is born knowing the harrowing hell of Herrmann strings.'

He hangs back his head and hollers, 'Mother!!!!'

Perhaps he was dropped on his head by his.

'The cultural weight *Psycho* holds is beyond measure. The magical weight it holds is likewise. A huge celluloid ball of energy and this building – however much it may just be a sketch of the original, a copy, a simulacrum – is a sigil that holds that energy.' A beat, the theatrical tart. 'Until, that is, I release it.'

My, how some people do like to justify their tomfoolery.

The bag again. A portable projector. A tripod. Let the rigging be rigged.

I'll cut this time, let the audience be saved more union work. The phone is fixed in place; whatever it sees now, it won't be able to look away. The projector is powered up, spraying yellow light onto poor Mike – will we ever find out his real name? Will any of the people who read about this in the days to come – salacious gossip over breakfast, commutes, defecation – remember it the minute it's gone? A credit rolled by, never to be recalled.

'There's a quality to the air,' the director says, proving he's slurped this LA slop through his lungs all his life, 'it's as thick as the text we're dissecting, as rich as Hitchcock's therapist.'

That, surely, would have been the audience? They're the ones who heard everything, whether they were paying attention or not. And they were not.

He tears open what's left of poor Mike's shirt, pointing the projector onto tanned skin. An appendix scar raises its eyebrow at all this, even as Perkins, that beautiful boy, looms across a lower abdomen. He's extolling the virtues of taxidermy, all those birds – whoever could tolerate those damned birds? – roosted in death, wings spread wide as Mike will soon be, filled with sawdust and wasted dreams.

'No, no,' tuts the director, who cares less for thematic undercurrents than he claims, 'forward, forward…'

Ever forward. And now we're peering through the hole in the wall. We're peering through the camera. We're peering through the mind of Norman, Robert, Joseph… Hmm… *Alfred*… as Janet Leigh slips out of silk and the grips of the censor and into the consciousness of the world.

'Bit more, bit more…'

Oh yes, we all, always, want a bit more.

And then Norman is trying to escape. Away from the shower. Away from the heat. Away from himself?

Psycho Geography

'Bit more...'

And the toilet flushes and the gown falls and plastic curtains hiss like cats as they're pulled closed.

'Yes!'

And the camera is rolling again, as our projector screen twitches and pulls against its chains.

A knife appears in our director's hand, anticipating another to come.

'It's heady in here,' he says. 'Oh God... I'm actually... I can feel something shifting... something ready to reveal itself...'

But that should never come too soon. Never explode the bomb. Keep it ticking. Keep them on the edge of their seat, keep them *held*.

'Magic is about realisation...' Lord save us, is he expositing again? There's a time and a place! Never now! Never here! 'It's about tapping into the potentials that surround us. The power points. The oil beneath the earth. It's about releasing it for yourself.'

The water rushes. Janet, mouth open, orgasmic, joyous, building up to her moment. Through the plastic, is that... is that someone coming?

'The shadow... it's nearly here!'

And, perhaps, were he to look around, he would see that he's quite correct, a shadow forms... So recognisable, might I say?

'The camera moves in... No music, no relief, just the rushing water and the pumping of blood in our ears... And the shadow gets closer...'

It does, dear boy, it does... Stepping into place and casting itself over you. Haven't you spotted it yet? That barest hint of a brow, that bruiser of a hooter, slumped shoulders, slalom run of a belly... It's all one can do not to hum 'Funeral March of a Marionette'.

'The curtain pulls back, the music kicks in...'

The knife goes up.

That poor boy, Mike, sees, just beyond the blinding light of the

projector. He's not looking at the knife that's moving towards his stomach, no, he's looking at me. He's looking at *me*.

'And... Oh God!'

Now he senses... Now he turns... Now he falls back, mirroring Marion, just like Janet, face in shock, arm held out...

'Are you seeing? Are you seeing him? How is that...? I didn't think... So huge... So...'

The knife turns in his hand. I didn't get where I was without people following my orders. I didn't get where I was without a little authority. It's yours, my boy, every cold inch of it is yours.

'No... not me... Not me... Please! I brought him for you... A beautiful blonde! Please!'

And...

CUT.

It's Raining Violets

Ana Teresa Pereira

1

She was a blonde, her dress had to be blue.

He remembered one of his first stories. A young taxi-dancer had a date with a stranger she was half in love with. He should have worn a flower in his buttonhole. She had a green dress; her best friend, a redhead, was also wearing green, a darker shade of green. The greenish-blue lights of the club could play tricks, and when a man approached her and asked what colour her dress was, she only noticed he didn't have a small white flower in his coat and said blue.

He hadn't been to a nightclub in a long time. The film with Barbara Stanwyck was more vivid than his memories of them. 'All you need is a ticket / Come on, big boy, ten cents a dance!' After buying a few tickets at the entrance, you gave one to a girl, and she tore it in two. In one of his stories, the girl ran away from a killer and dropped half-tickets along the darkened roads; her detective boyfriend followed them and arrived just in time to save her. He was not sure whether he had written the story or only imagined it. That's what happens when you start writing a short story in the evening, finish it at dawn, and don't bother to reread it.

His deadline at dawn. A quiet joy to see the sun or simply the

light coming through the window, as if he was awakening from a nightmare. He remembered a dog he had when he was a little boy; she slept on his feet, she occasionally had bad dreams and groaned; he moved his feet and talked to her, *I'm here*. Sometimes he wished there was a girl there in the morning to tell him, *I'm here, it was only a nightmare*.

He often went out at night, to buy whisky or cigarettes, or just for a walk. He liked to go to the movies, but the last one he had seen, the adaptation of one of his novels, had left a terrible impression.

It was not any book; he had been preparing for it all his life.

In the first version of the story, the girl was already 'Angel Face'. That's what her husband called her. He said she didn't have a thing inside her head, but the outside was honey. One day she found out he was leaving her for another woman and went to see her. When the other woman was murdered, 'Angel Face' had to prove her husband's innocence. In the second version, the girl was older, more experienced, she had been working in all kinds of nightclubs to afford a home for her little brother and prevent him from joining a gang. And he fell in love with a woman who was found dead… That one had been made into a B-movie. He saw it one night and it was okay.

When he began the novel, he knew it was the real thing. He could finally see *her* – her face when she was nineteen. And when he saw her, he fell in love again. It wasn't in his plans, but somewhere in the book he told the story of his first love. Jeannie was lovely, and everything fell silent when she entered a place. They had been happy, there were kisses and a bench near a chapel where they used to meet; until the night they went to a ball, she was wearing a black dress and a pearl necklace, and something terrible happened.

He was shattered when he wrote the last page of the book. It was cruel, but he couldn't help it. The girl was left alone in the dark,

It's Raining Violets

even though there was someone by her side who said it was only a dream: *'Angel Face', it was only a bad dream.*

When he sold the rights to the film adaptation, he was really scared. Tread softly, he wanted to ask them. But he couldn't do that, they were paying well, and he desperately needed the money.

Nobody sent him a ticket to the opening, but they usually didn't. He saw the poster on a nearby theatre, the actress was pretty enough, though she was not her. But how could she be? And he liked one of the actors.

One night, it started to rain when he was passing in front of the theatre. Like Wakefield, he took it as a sign. The first minutes left him indifferent, but then it was like falling into a nightmare. Not even the angel of the title was the same. The male protagonist was two of his characters mixed and he could live with that. But not with what they did to his girl. The fragile housewife who knew nothing of the world except what she had learnt from the movies, and her descent into hell, were nowhere to be seen. He couldn't believe it when he saw her, in an elegant black dress, start to sing. An honest wife who was not vulnerable to passions or degradation, who ended up as whole and untouched as she had been before. He was in the dark, there weren't many people in the cinema, and nobody could hear him say, 'Where are you, baby? What have they done to you?' And it was as if he had lost her a second time.

The following days, he didn't leave the hotel. He stayed in bed with a bottle of whisky and old issues of *Ellery Queen Mystery Magazine* – they used to send them to him, and he only glimpsed at the covers, he was afraid to find his own stories in them. But, despite everybody thinking he was eternally depressed, there was that quiet joy that came from nowhere, and one morning it wasn't the sun but some flakes of snow on the windowsill – he had fallen asleep with the window open – that made him remember everything was only a dream. He took a shower, put on some warm clothes

and went out to have a coffee and eat a piece of pie, at the café on the other side of the street.

The movie was terrible, but at least his bank account would be okay for a while. Not to be sleeping on a bench and having coffee every morning was already a good thing. He thought of the story he had begun days before. A man whose profession was to kill people with the blessing of the state, and had a normal life, in a nice house, with a garden full of carnations. And the call girl who sold her dresses, her coats and her jewels, to try to save the life of a man who didn't even believe she loved him. The girl who, with a modest dress, no make-up and her hair pushed back, pretended she was a flower seller who grew red carnations, the reddest the old executioner had ever seen. He had to find an end to the story; he would think of something.

There was another story, an important one, taking shape in his mind. Images are all we have, and he must get Jeannie's image back. No matter what he had lost in his life, he wouldn't give up love.

So, it was a night like any other night, the snow had melted and there were stars again, not stars that spied on him, but friendly ones…

He walked for a while, until he found a nightclub. The neon lights and a name that made him smile, he would remember it for a story, the music that arrived at the street and sounded friendly too.

He bought a few tickets at the entrance. The feeling that life was simple, all you need is a ticket. And a bit of chance.

The lights made everything unreal, the moving lights that turned blue into green and green into blue. He went to the bar and asked for a whisky.

The orchestra was surprisingly good, they were playing old songs, and that was comforting. There were only a few couples on the dance floor, gliding slowly, as if half-asleep.

There was a redheaded girl, there had to be one; she wasn't wearing green but black. Most dancers were wearing black. Then

he noticed a girl near a column, alone, her body moving slightly to the sound of the music. She couldn't have been there long, he thought, if she still listened to the music. She was slim, her hair was blonde and tied back, she had long earrings and a beauty mark, probably a fake one, near her left eye.

The music stopped. She didn't leave her place, near the column, but her body stood still. He kept staring at her, until she noticed him.

They smiled at each other. He finished his drink, stood up and waited for her.

The lights made the colour of her dress change.

She was a blonde. Her dress had to be blue.

2

The world didn't fall silent when she walked toward him. That only happened in his stories. And then a memory returned: there had been a girl who brought silence with her; a kind of silence for which there was no word, as if it began to snow.

She was very pretty. And very young. Twenty-two, twenty-three. Very slim, almost skinny. Her small breasts that the dress didn't hide properly, and her face, were her main attractions. The dress was blue. There wasn't much to it, two straps and a bit of cloth that barely covered her knees. Her sandals were black, and there wasn't much to them either, a few straps and very high heels.

He wondered if he could still feel desire, or if, like everything else, it was just a memory.

She had too much lipstick, and the beauty mark was fake. Her eyes were hazel, and she wasn't wearing a bra. Her legs were long and her ankles shapely. But he imagined her knees were scratched, there was something in her that made him think of a girl falling from a bike; it was a miracle she could walk and even dance with those shoes.

'Do you want to dance, or did you buy a ticket just to look at me?'

The ticket that was everything he needed! He gave it to her and saw her tear it in two. He put his half in a pocket, and they both waited for the orchestra to start again.

Her perfume was strong. Not unpleasant, maybe jasmine, but she had put too much on. Perhaps because she didn't want to feel the smell of the men, one after the other.

He thought again of the old story, from the time he wrote about love. A girl who dreamed of a man who would change her life; a small apartment where she would cook, listen to radio plays and wait for him in the evening.

She felt so good in his arms. Her skin was lightly tanned, as if she had lived near the sea or a lake. A small place, anyway. The sophistication was fake, copied from movie actresses, from girls' magazines.

'What's your name?'

She seemed to hesitate. Did she usually give a fake name?

'Lizzie.'

'Have you been here long?'

She grinned.

'Nearly an hour.'

'I mean…'

They both laughed.

'Do you come here often?'

'You know I don't.'

'You could have danced with other girls.'

'Impossible.'

It wasn't even a compliment, because they both knew it was true.

'What do you do… after dancing?' he asked.

She looked at her sandals.

'I get rid of my sandals.'

'And of the beauty mark.'

It's Raining Violets

'I like it.'

'Do you sleep with it?'

'No, of course not. A girl should clean her face before going to sleep.'

'That much I know. And put on some moisturiser cream.'

'Do you have a girlfriend?'

'I haven't had a girlfriend for a long time.'

'Why?'

'You wouldn't understand. One can just forget about those things. Having a girl, getting married, having children. That's something other people do. But for you, that's not real.'

The music had stopped, and they were standing in front of each other.

'But you must do something. After your job.'

'I don't have a job. I write stories.'

She leaned against the nearest column.

'Love stories?'

'Once. When I was young.'

'Maybe I have read some of them.'

'You were a small child then.'

'But we can buy old magazines. We can even exchange them for a few cents. I'm a sucker for dime-store novelettes.'

Another song. 'April Showers'. He gave her a ticket and she tore it in two. They did that smiling, as if it was a game.

'I love this song', she said.

'It's raining violets.'

'It's my favourite flower.'

'Not daffodils?

She smiles again.

'Daffodils too. But it's too early for daffodils.'

'I thought after a while you began to hate music.'

She missed a step.

'Where did you get that idea?'

'Oh... never mind. Perhaps you haven't worked here long enough.'
'I've always loved music... and I always will.'
'I used to have the radio on during the night, while I was working.'
'So... you were the one who got tired of music.'
'No. It's just another thing I kind of forgot.'

There were many people now, and when he looked around, he almost didn't recognise the place. All those couples in a simulacrum of dancing. The men were there just to grab a pretty girl by the waist. And the pretty blonde in his arms was one of them.

'Listen, Lizzie, I'll be around here tomorrow at twelve. Will you go for a walk with me? Maybe eat something?'

'You could walk me home tonight.'

'I have a deadline.'

'Don't you ever sleep?'

'Oh, I'll have finished by the morning.'

'We are both night workers, then.'

'I guess.'

He left her there, in the middle of the dance floor. He didn't look back but wondered if she went on dancing alone.

The night was cold; it would be even colder in two hours, when she left. He hoped she had a warm coat. The thought surprised him.

It had been a good night's work. He had found her. He hadn't even looked for her, it was as if he already knew where she was, a few blocks from his room.

It didn't make sense. Like many things in his stories. But if there was any logic in life, he had never noticed it.

The same with coincidences. That was one of the flaws people usually found in his work: too many coincidences. Only lack of attention could explain that. There were more coincidences in life than in any novel or short story he could write.

It's Raining Violets

3

It was one of those days in early spring that made him think he wanted to start again, a new novel, a new life. People often whistled in his stories, mainly killers; he didn't. But last night songs came to mind, and he whistled slowly, violet rains. He stopped by a flower seller and noticed the red carnations, but it was not a day for carnations. It was a day for violets, and he bought a small bunch: just a few flowers surrounded with green leaves that the woman seller splashed lightly with water.

She was looking at a shop window. Her hair was loose. Slightly waved and recently washed, or maybe it was just like that, soft and shiny. She wore a coat with some kind of fake fur around the neck; he thought he would buy her a new one, a check coat like the one Jeannie wore the winter they were together. She was a little flushed, as if she had run. She must wake up late, after her dancing hours. *I would like to take you away from that place*, he thought, *give you a small apartment, you're the kind of girl who should sleep with the same man every night*. If only...

'You're late.'

'You look lovely.'

'Thanks.'

'Why don't you get rid of that?' He pointed at the beauty mark.

'I did, last night. But I kind of miss it. Can't you pretend it's real?'

It suited her, but it was a little spot in the image.

No way.

She looked at the violets he had forgotten.

'Are those for me?'

'Are you going to give half of them back?'

'Only if you dance with me.'

'Here?'

'Anywhere.'

They walked for a while. Neither of them was hungry; he just bought orange muffins and two lemonades, and they sat on the grass by the river. There were many couples around, some of them were kissing. At a certain point, they kissed, they were both clumsy, and they laughed at that. In the afternoon they went to see a movie, Barbara Stanwyck in a light role, and he felt reconciled with the darkness and the black-and-white images.

He refused the invitation to have a last coffee when they arrived at her place. But, like in his memories and in his stories, he stood at a corner near a shop window and watched the building until he saw her coming out, with the same coat, her hair pushed up in an intricate fashion she must have seen on a movie star.

He didn't follow her. He headed to his hotel; he had to finish the damn carnations story and start a new one.

The apartment was small, rather shabby, but in a few days, she had changed it. She took away the ugly curtains and made new ones, she cleaned the cupboards and filled them with food, she put a kind of ornament on the shelves, paper with paintings of cherries and strawberries, not in a very good taste, but somehow moving. Like the printed sheets, and the pillows on the chairs, that made the ugly furniture almost acceptable. He was expecting the worst, regarding pictures – they got rid at once of those that were on the walls – but she bought some good prints of landscapes by Renoir.

He was also surprised to see that she could cook. She didn't have a wide range, but she was good at making simple dishes, and even though her cookies were disastrous, the coffee was good, and so was the cocoa.

He insisted on buying her new clothes. It was spring, and he remembered Jeannie's light dresses. Some of them had been made by her mother. He liked to imagine her on a stool and her mother kneeling, with pins in her mouth, adjusting the cloth around her

It's Raining Violets

body. And the magazines opened on the floor, the movie magazines that, like the dime love stories, were a kind of food.

Lizzie didn't have a mother to make her dresses, or maybe she did, he wasn't really interested in knowing what her life was in the small town she came from, a house with a garden, a boy next door with whom she went to the cinema, or dancing. To get a husband, you must be very beautiful or be a terrific dancer; he didn't remember where he had read that. She was both, but she had come to the big town because she wanted another life. Being an actress, they all dreamt of being actresses, but after two or three years the dreams changed, and they were tempted to go back home and marry the boy next door. Lizzie loved New York, though, she wanted a small apartment near the park, the movie theatres, and the fancy shops.

He could see she was disappointed when he took her to a big store. It wasn't that he couldn't afford something better, but Jeannie had worn cheap clothes. Fashions changed but he found a blue dress, backless, like the one she was wearing the first time he saw her, and a printed one, that Lizzie said looked like a tablecloth, but fit her blonde hair. He imagined himself much older, buying a tablecloth with that pattern and putting it on a table of his hotel room – another hotel, probably, but still a hotel. *God, will I be pathetic by then, but who cares?* A few dresses and they went to another store.

This one hadn't received the spring collection yet, and he found the check coat he wanted, almost like the one Jeannie wore that winter. It was more expensive than he expected, but it would be good to think he had left Lizzie with something warm and cute to wear the following winter.

Looking for the perfume was fun, almost poetic. He remembered a mixture of tangerine and wild flowers. She tried a few, floral and fruity, and finally there was one he believed was Jeannie's. Perfumes don't go out of fashion, do they?

She wasn't happy with the shoes. She liked high heels, even though she was almost as tall as he was. The low sandals made her feel attached to the ground.

'You will always be light,' he said.

'I feel heavy.'

'Well, you look younger.'

'I don't want to look younger.'

'Someday you will.'

Lizzie no longer wore the beauty mark and the pencil on her eyebrows. He had chosen another colour of lipstick, almost cherry.

'I don't understand,' she said once, when they were sitting on a bench by the river. 'Men, particularly older men, like to have pretty girlfriends.'

'You were never prettier.'

He was looking at her hair and suddenly she understood.

'No, not my hair.'

'It can't make much difference to you...'

She leaned her head on his shoulder.

'Please, baby, not my hair. I thought you liked it.'

'It will grow back.'

She drew away from him.

'I won't cut it. I thought it was only the colour.'

'The colour is fine. But I want it to be shorter, and even, with just a clean part running up one side to break the evenness.'

'I won't do it.'

But she went with him to a hairdresser the day after, and he gave his instructions; the nails shorter too, painted in white.

Only the black dress was missing. Jeannie's dress on the night of the ball. The dress the girl in his book was wearing near the end, and which changed her completely. Only a skinny girl in a bathing suit, but with that dress she looked like an angel.

It's Raining Violets

4

He could have gone to her hometown – hardly a town – and find out at the library which books she borrowed when she was in her teens. He could have found some little shop on a side street where they sold cookies in the shape of a flower or a heart. He could have said, 'Have a heart, baby!' But those were not his lines, they belonged to the screenwriter of a film based on one of his stories. A story where you never knew who the murderer was. In the film they had to present a murderer, and he was okay with it.

He wasn't writing much these days. She captured all his imagination. For the black dress, they had been to a good store. Something provocative, but with elements of fairy tale, shoulders naked and a tight waist, and then lots of tule, a long skirt that only left the ankles visible. They saw a few dresses, she liked most of them, but he wasn't satisfied; once he slipped and said, 'It's not this one.' They were alone in the showroom for a moment, and he noticed she didn't look amused but rather serious.

'This is all part of a plan, isn't it?'

'What do you mean?'

'You didn't want your girlfriend to be a taxi-dancer, and I quit my job. I didn't mind, I can go back to being a waitress or work in a store. But there is something else.'

'You are only mad because I made you cut your hair.'

'I've always wanted to know how I'd look with short hair. I just never had the courage to cut it.'

'You look like an angel in an old painting.'

She touched it almost with tenderness.

'Yes. I kind of like it.'

The manager had just entered with a model, a tall girl with short hair in a long black dress. He felt excited.

'Yes, that could be it.'

Her voice was different, almost defensive.

'I don't like it.'

But he could see in her eyes that she did. It was a lovely dress, the dress of the princess on the third night of the ball. Jeannie's dress the night he had lost her, the girl in his book's dress when she danced in the nightclub and the customers couldn't take their eyes from her.

'We'll take it.'

'I better try it. It may be too long.'

It was. But the manager assured them it would be ready the following day.

They went out. It was still daytime when they had entered the shop, but it was dark now. And cold. She seemed to tremble in her check coat. For a moment he stared at her face. Something was missing… Maybe that quiet joy he had found in her when she was at the nightclub, leaning against a column, moving alone at the sound of the music.

Was that what love meant to her? A kind of sorrow?

He thought of the girl who had sold her dresses, her jewels and her fur coats to pay a good lawyer and try to save the man she loved from being executed. This was worse.

They were passing a club, one where you didn't have to pay to get a partner.

'Do you want to go in?' he asked.

'I don't feel like drinking anything.'

'We could dance. It has been a while.'

'I don't want to dance with you.'

'But you still love music.'

'I always will.'

'The radio I bought you… it's never on.'

'It is sometimes… when you're not there.'

'What do you hear?'

'Radio plays. *Suspense*, mostly.'

He had sold a few stories to *Suspense*, but he never listened to them. Did she know about that?

It's Raining Violets

They were arriving at the apartment.
'Are you coming up?'
'No.'
'You have a deadline…'
'Yes.'
'This morning, I went to a bookshop. I bought one of your books.'
'I don't know if you will like it. They are violent.'
'More violent than life?'
'I don't know much about life.'
'Somehow I think you do.'

Lizzie turned her back, and the movement of her slim body in the check coat made him remember another girl. But it didn't hurt anymore.

She disappeared, without saying goodbye. In another life, he would have gone to a dark corner and waited, staring at her window. A window with brightly coloured curtains and a vase of flowers.

'What am I doing?' he asked himself.

He walked to the hotel. It looked shabbier than usual, perhaps because that night he knew he would never leave it.

When he arrived at the apartment, she wasn't there. He lay on the bed, where he had caressed her so many times, and in her Jeannie and the girls in his books, girls more fey than beautiful, with their scent of tangerines and a hundred flowers, that would kill for him. Jeannie hadn't killed anyone; she had stolen a pearl necklace to look beautiful the night they went to a ball. With a new perfume she couldn't afford and a black dress for which she had made a first payment. *What happened to that dress?* he wondered.

On the bedside table there were some magazines and a book. His last novel.

He closed his eyes and was soon asleep. When he woke up it was dark, and she hadn't come back yet. With a sudden fear, he opened the wardrobe; her clothes, at least the ones he had bought

for her, were still there. He noticed the big cardboard box, but it was empty. So, the dress had been delivered. And she was wearing it.

The room was so cold and empty he was shivering. He washed his face and smoked a cigarette. Then he went out.

The name of the club tonight didn't make him smile in irony. The music reached the sidewalk. He took the change he had in his pocket, and the boy at the entrance gave him a few tickets. The lights were so strong he could barely see anything at first. But he recognised the song, they had danced to that song.

Even though most girls were wearing black, it was easy to spot her. Her slim figure and the black dress with an ample skirt that was totally wrong for the place. The short hair, the very high heels. And a man's hand on her waist.

'Baby, it was you I wanted,' he whispered. 'Not in the beginning, but now, and forever, it's you I want.'

The music stopped and she turned to him. She had put a flower, a cloth flower, he guessed, in her hair, to change the even cut. Her face was pale, and the make-up had something clownish about it: the black mascara, the beauty mark, near her left eye, the red lipstick.

You're wearing too much lipstick, he thought.

Too much of everything. Not her fresh perfume but lots of the old one, it seemed the dance floor was full of white jasmine. She was coming toward him and for a moment he hoped everything would fall silent. But the orchestra started again, and he didn't know this song. He gave her the tickets and she put them in her cleavage.

'You are supposed to tear one of them,' he said.

'Your tickets aren't good here.'

Another man came by and gave her a ticket that she tore in two. He saw the man's hand on her waist. The lights were giving a bluish tone to her dress.

Like a Bun at Bewley's

David Thomson

These things can happen nowadays, ever since we decided that we no longer murder murderers. Wasn't it Hitch who wondered if we'd grow fond of them?

You can be walking on a Dublin street on some idle afternoon, sunny but fresh. You tell yourself how pleasant it is to be out. And how fortunate you are. Then you see a fellow swaying towards you, and you notice that bumptious air he has, as if barging his own shadow aside, even if he is an idiot and it might start to rain. No matter. He walks beneath an umbrella of verbiage, quite sheltered and dry, without his complacent smile being spoiled by damp.

'Oh, my word,' you say to yourself. 'That's Thingy. It really is.' You've recognised him from the pictures in the papers and that endlessly rerun TV footage of him, handcuffed to a policeman. Just seven strides. On his way, leaving court. We all saw that.

You recall the story: two strangers slaughtered for no apparent reason. I think 'slaughtered' is the proper word – a hammer and a shotgun – two erased faces. Wasn't that what the authorities called a modus operandi? Though you notice now, with his every step coming towards you, that he does look alert, or devious. Or is that just his way of being superior? Some people are a warning in how they walk.

Here's the question. Are you going to stop him and ask, 'Aren't you so-and-so? I thought I recognised you.'

And he might answer, quick as a flash, 'I think I know you, too.' And then you could be off in a kind of relationship. Small talk, but amiable. Like, will it rain? You could even say you'd like to write a book about him.

Then he might give you his beamish smile – soon enough you may want to scrape that fat look away – as if during all his years in prison he had dreamed how one day someone would make this request.

I believe that, put in that situation, I would walk straight on by, right past him, even if in the next hundred yards or so I had worked out much of the three hundred words I've just written. Wouldn't I see it as a story, half amusing, half sinister, but one I'd prefer to keep shut up in my head? Yes, I think that's me.

But then I turn a blind corner – on my way to Bewley's – and there he is again, bumptious beamish, with his closed-lips smile, telling me, 'Not so easily, old chum. You can't just walk away from this.'

You'd have every right to be affronted, to say nothing of alarmed.

'I must warn you,' you might say, 'I could call a policeman.'

'Aha,' he sighs, as if he's just farted.

'What would you call him? Arthur is a good name for a constable, don't you think? Or George. What about PC 49?'

He breaks out in chuckles at this – he will always be a man who leads the laughing at his own jokes. That will be a mark of his loneliness. Maybe that's what prison does for you.

You fight the terrible urge to join in, as if there's a charm in how he knew to pick on childhood constables from your youth. How has he come so prepared? Is the role written?

No, if I know you – and I feel I do – you are having no part in this clinging routine. You'll look away from beamish, without a sign of recognition or interest. Indeed, you'll make a note not to be

Like a Bun at Bewley's

walking on this street again, not at this time of day. For you can reckon he has an aimless life so that he walks a regular beat, waiting to glimpse a long-lost love, or to be recognised at last. You'll have to think of another route to Bewley's. I say 'have to' because you know there is a compulsion about getting to that cherished café. You can picture its lovely buns lined up, waiting for you.

Not that Thingy doesn't have a right to be going to Bewley's. Fair's fair. He's done his time, paid his dues. And while you have no wish to be his pliant accessory, you'll abide by that code, while knowing in your heart of hearts – the place where you experiment with stories – that you will have nothing whatsoever to do with it. Nothing to honour such a fearsome thing as murder.

Apart from doing the story.

Why am I here? Why are you there?

Well, you may be caught red-handed, but I have an alibi and I can explain it in a matter-of-fact way.

I opened my *Spectator* (the issue for 8 July) and there was this double-page spread. It had a picture of a man. He seemed self-possessed, if not a little cocky, though he was walking a street in Dublin manacled to the wrist of a policeman.

This was a photograph, unquestionably based in fact. It was from 1983, a picture of Malcolm Macarthur on his way from court to start his thirty-year sentence for murder – it was for the woman whose head he had hammered home. He had shot a man dead, too, but apparently the prosecution saw no need to pursue two crimes. Macarthur wore a white shirt and a bowtie; his jacket flared open in the breeze, not buttoned up because he was a little plump. He looked as if he was going to lunch. He could have passed as a poet or a door-to-door salesman.

The picture of Macarthur was accompanied by a book review. The book was *A Thread of Violence: A Story of Truth, Invention and Murder*, written by Mark O'Connell, who had once encountered

Macarthur on the street and then got into a lengthy talking relationship with him that had led to this book.

The review was written by Frances Wilson, and that speaks well of the *Spectator*. She has taught at Reading University, and at the University of London. As well as many reviews and articles, she has written six books, including *Burning Man: The Ascent of D H Lawrence* and *Guilty Thing: A Life of Thomas De Quincey*, which was especially well-reviewed. It also qualified Wilson for this assignment in that De Quincey was fascinated not just by murder, but by our inclination to regard it as an art or a performance, an excellence even, in a play lurking within our avowed dedication to law and order.

So it's no surprise that Wilson's review of O'Connell (and Macarthur) is so good and so filled with dismay and even a contained anger. She quotes O'Connell on what he believes he intended for his book: 'I wanted to witness the breaking down of his ego defenses, the revelation of some terrible emotional truth within.' That sounds right, if a little heavy-handed.

Wilson refers to De Quincey's commentaries on killings and to John Banville, whose novel *The Book of Evidence* was derived from the Macarthur case. As Wilson puts it, these other works grasp a point that seems out of O'Connell's reach: 'the whole business of turning murderers into colourful characters – particularly in the genre of true crime – while their featureless victims fade into obscurity'.

That is so well said. It's what I like to think I would have said if given the opportunity. And Wilson picks out the moments when O'Connell (whatever his first motivation) seems daunted by Macarthur's capacity to be both garrulous and boring, so far from a monster and so much closer to a comedian who has inadequate material but won't get off the stage. He's all adverbs and expletives and seldom makes sense. It may be that O'Connell had a true interest in the methods and the impulse of irrational crime. Perhaps

Like a Bun at Bewley's

he thought this would be a saleable book that attracted smart reviews – or even some Hitchcock wizardry if it ever reached the screen.

It occurs to me – as an actor, I have a professional interest – there might be a TV series with Macarthur on the rampage and then just Thingy on the street, happy to reminisce over a pot of tea and some scones at Bewley's Cafe?

What draws us to this empty-headed beamish boy. There is a feeling in the photograph with the review that Macarthur was still a lad in 1983, not quite grown up and never prepared to be.

Well, this line of thought came and went, or so I thought, in the manner of so many things that hold one's interest for an hour or so. I was 'resting', that's what I called it, not quite myself for a few weeks, waiting for the unpleasantness to pass off. After all, I had been acquitted on what was a minor charge. The indignant gossips of Dublin would have forgotten about it in a few months. Even in the *Spectator* there are too many provocative pieces to keep up with. I used to cut out such articles, until I found I was smothered in paper. I started to burn the cuttings and – one thing and another – there was a small fire that required a couple of machines. More fuss than fire. Never mind about that.

Then my agent told me, 'They are thinking of you to play the fella. They don't know what to name him yet – there are legal complications. Would you be up for it? Eight weeks, they are thinking.'

Why not? I asked. Call the character 'Himself'. They liked that and asked for an audition piece – not a test, they said, I had the part, but something to explore the role, to get into it.

The test was quite a nice situation, about a child and a cobra. I was to be sitting in a lovely garden on a hot summer afternoon. There was a toddler there, just beginning to walk, happy as can be, talking to himself. It's a nice sight to see. Then I had to notice a

few yards away, slithering from out of a brilliant clump of bougainvillea, a cobra.

Don't ask me how the cobra got there – it must be an Indian garden. That's why it's so hot. Of course, I could sit there and watch what happens, as if it was all a movie. Get out of here! I jump up and lay hands on that cobra. Oh, the dreadful feeling of its cold scales, its muscle inside, and its hatred. It could bite me in the hand or the arm. But I am too brave for old cobra. I have charge of it – two hands – so I take it to a brick wall and hammer its head against the wall, so many times, till the cobra is mere pulp.

They tell me I'm a hero. Director loved it, said she couldn't wait to be working with me.

So the screenwriter chap made a beeline for me straight away – I was impressed by that. 'A bit of small talk,' was what he wanted.

'Happy whenever you are,' I replied.

'I mean the character,' he said. 'As much small talk as possible. Passing the time of day, kind of thing. But wordy. I've noticed this for years in your work. It's something you do so well.'

'Really?'

'There you go,' he said.

'But you're writing the stuff?'

'So I am, or so the credit will say. But I think you have the rhythm and the air of – what's the word – persiflage?'

I daresay I beamed. That really is a nice word. 'I admit it,' I said, 'I can come up with words most people never think to use in films.'

'You can?'

'Recondite, emolument, liverish, happenstance, orotund, maliciously—'

'That's the ticket. Tell you what: I'll listen to you, make notes, and in a few days, we'll get some of those words in your lines.'

And this was no badinage. By Thursday, I was saying, 'There are

homicides more resonant than required.' The crew whistled as if I was a girl showing a bit of tit.

'You know,' I said to the writer next day, en passant, 'Tony told me once that he only got the hang of Lecter when he realised the man was a writer manqué. Loved to talk more than he ever wanted to eat anyone.'

'My word, yes,' the writer said. He got up from his chair on the set and it was then that I saw – it was printed on the canvas – the name was 'FRANCIS WILSON'.

It only took me a moment to hear the bell ringing. 'Do you have a sister, Frances?' I asked.

'Emily,' he answered.

'Because just a while ago I was reading this excellent essay by a Frances Wilson – talking about our chap. What a coincidence, I was thinking.'

'Never heard of her. This chair is left from another production. I'm Harry Cholmondely. My name's too long for a chair. There are a lot of Wilsons, you know.'

This is true: Bob Wilson kept goal for Arsenal for years; there was a Wilson who went with Scott to the Pole; there was the Harriette whose bed was open house. Wasn't there a prime minister? And don't forget that William who kept bumping into himself.

The shooting went well, I thought; there is nothing like a gang of boys and girls busily pretending. And I felt I was getting into the role. Some good soul in sound even mentioned the chance of another statuette. 'All that nasty stuff will be forgiven then,' she said, in a motherly way. I smiled and combed my hair.

They had begun by wanting my own hair, but Thingy had to have a full head of it, very dark, tightly curling. Like topiary.

So they made me a wig, and they seemed pleased about it. But it felt like a helmet as far as I was concerned, oppressive under the lights. Until one afternoon I had half an hour to spare (I was in

most of the scenes, you see) and I went down to make-up, found myself a good mirror, and simply experimented with it until I got the right jaunty slant.

It's remarkable how suddenly an item like that can fall into place. 'Oh yes,' I said aloud. 'Now I see you, my naughty boy.'

The fresh angle, tilted back like a drunk's top hat, did something extra. It was as if my head was unbalanced and might fall off. That's how I found a new way of walking, like a juggler balancing a pile of plates in a breeze. This was a strain or misaligned; it tired me by the end of the day. But the awkward way of walking suited his strut. I was suddenly a touch frightening; it was a thrilling feeling.

I went along to Bewley's after the day's work, still wearing my wig and costume, of course. I sat myself down to hot chocolate and an almond bun. I had to keep his tummy showing, you understand. Not that that was any hardship.

That afternoon at Bewley's, across the room, I noticed Hitch. He's unmistakable. Not that he said or did anything more than contemplate his almond bun. I realised how he and the bun were delightfully alike – round, poised, aglow with sweetness, waiting. I didn't say a word. I could tell this was just one of his cameos. The way he's there but without any function in the story. Like luck?

'Are those almond buns still memorable?'

The voice came from another nearby table, and its solitary occupant. He was an elderly fellow, slender but frail. It was in keeping with that condition that he was sipping a cup of hot water with slices of lemon. He wore a shabby summer suit, too big for him now. His wistful gaze for my bun made me feel guilty eating it.

'Do you not enjoy the buns yourself?' I asked him.

'Alas, no more,' he said. 'Their sweetness no longer agrees with me. You best take care, sir – if I may say so.'

Great God! It struck me. What had seized not just my attention but my entire being was his hair. It was the one department in which he was not depleted. He had a full head of curled hair, densely

Like a Bun at Bewley's

packed – it was like my wig – but his was bright white and it seemed larger than his head.

It was Thingy! Macarthur! Sitting there in Bewley's Oriental on Grafton Street. I noticed that dear old Hitch was not noticing us. A man and his bun – they make a sufficient world.

For all I knew, this elderly relic was still dangerous. Had he sought me out, and followed me on the street? Did he have a Derringer in that sagging pocket? And nothing else to do but fire it off? I felt certain he knew who I was, or who I was pretending to be. He knew my attempt and my limits and he contemplated these things with apparent patience.

'May I join you, sir?' I asked, and he said – can you measure the despondent charm? – 'Oh, I believe we are together already.'

I lifted up my cup and plate and moved them to his table. Gently he made a little room for me and seemed to sniff over the last crumbs of my almond bun. But he said not a word for a few moments.

'I imagine you know what I'm doing?' I asked.

'I believe I do. You're being me, but a younger me. You look quite credible – of course, I know your work. You can be startlingly unpleasant, yet well-spoken. It's an intriguing act.'

'Why, thank you, sir,' I said. 'That is a welcome compliment.'

'I saw some of your films in prison. You had a following there.'

'Really?' And so on.

I asked him about prison, and how it must have been harder for a man of his genteel refinement.

'Not so much,' he sighed. 'I felt at home there.'

'Really?'

'Why not? A warm room. Three meals a day – not up to Bewley's standard, but decent. You're taken care of, and that is harder to come by these days. So many ordinary worries just don't obtain there. You feel a kind of peacefulness creeping up on you. It's the being released that is difficult – at my age and reputation.'

'But the company inside?'

'Well, murderers get some respect... and while the staff are indifferent, I suppose that's the word, there is something calming in that.'

Thingy was subdued and a little sad. I found this heartening or freeing, for I did not have to alter my performance, even if some degree of pathos was now available in seeing this washed-out state for the character.

'May I presume?' I said. He did not react. 'Can I ask you about the murders?'

'How do you mean? You know, I am wondering if I might try a bun. If I can't manage it, you could surely eat it up.'

Hitch had gone away. Cameos don't linger. But we hold on to their atmosphere.

We got a waitress – it was Siobhan – and then a bun. He examined it for several minutes, then took one slow bite. I saw his grey teeth and the shiny bun.

'Are you haunted by the killings?' It was the least I could ask. I saw no reason to give a hint of approval or sympathy. Yet interest was merited, and reasonable. He seemed to appreciate this point.

'I don't want to be pushy,' I said, 'but how did it feel to do it?'

'You are asking out of your professional interest?'

'Exactly.'

'I wish I could help you more, but the truth is it's rather vague now.'

'You knew you were doing it?'

'I must have done.'

'And the why?'

'Because I could. Maybe?' He was aching to be useful. 'It came out of a great boredom, I think. An emptiness. That can be upsetting.'

'The hammer?'

He smiled. 'Oh, that was plain bad luck. There was one just

Like a Bun at Bewley's

waiting on the counter. Like a dog asking to be taken for a walk. What a dreadful mess. If there's one thing I could change, it would be the hammer. Have you any idea about cleaning up blood? The stickiness?'

'You spoke of boredom?'

'They say I was ill.'

'Did you feel ill?'

'I don't think so – but would I be the one to know?'

'I need to think about these things to play the part.'

'Of course, you do.' He hesitated; it was a dainty instant. 'May I ask, how are they going to do it? The thing?'

'Oh, some vivid shots of me hitting out, and then a model head – very well done, just a few seconds – with ghastly wounds. So much of it will be in the sound.'

'How interesting!'

'Do you know what they did?'

'Not at all.'

'A sack of boneless cuts of raw meat. The sack made of velvet. Then soaked in water. And beaten with a three-pound lead weight. Extraordinary sounds of impact. Afterwards the meat was distributed among the crew.'

'Good Lord,' said Thingy. There was a dreamy look in his eye, as if something was coming back. Or was it just the thought of a fragrant daube?

It's an exciting time now, waiting for the picture to be released, with early controversy over decency and so on. I must say, modesty aside, I feel my knowing Thingy has helped a lot. I had been putting too much energy into my performance – a certain gloating air, the writer said – and my being with Thingy brought me down, or made me truer to life and, I hope, more credible. You see, Thingy was emptied out, except for his frail voice and a certain geriatric formality. That was the secret in being him.

The most recent time I saw him, last Thursday, he came into Bewley's with a young woman who needed to photograph the two of us together. The movie people felt it would be a good angle. The woman was equipped with three cameras, packs of accessories, and two assistants. They looked like soldiers. She said she had taken me once before – at the time of *American Habits* – but I had no recollection. The cameras become like gnats in August.

'Is it right, that you have seen the rough cut of the film?' I asked her.

'Last night,' she whispered. 'It's brill in a disgusting way. Hitchcockian.'

'My dear,' said Thingy. 'You really should try the almond bun.'

'All right, nuncle,' she said. I hadn't realised they were related.

'Why disgusting?' I asked her as she held a light meter up to my face.

'I shouldn't have said that. But I couldn't sleep afterwards.'

'Yes, sleeping gets harder. Intermittent.' I was going to tell her about my difficult nights. But she was off on her own track. I can imagine that she has been taking pictures in some very ugly situations. I noticed she had a scar on her left cheek. It made her more attractive, I thought. Though attraction can be weird.

'Matter of fact,' she said, 'I've just signed to do a book – *Dead Heads*.'

'Really?'

'An album of the faces of killers and their victims.'

'Oh, I can see that,' I said, and I could: wanted pictures and unwanted.

Her face brightened. The scar shivered. 'Tell you what, nuncle, if you know anyone that would fit the scheme – there must be a club of them – I need a few more. I'll give you my contact information.'

I had to tell her, 'I'd happily oblige, but I don't possess a phone.'

Like a Bun at Bewley's

'No!' She slapped her hand on the table. Chuckling. The bun bounced. 'That's a treat! Really. Look at that bucking fun!'

Of course, she meant 'fucking bun'. Sometimes we misspeak when excited. I daresay the bun did no more than shuffle sideways.

'That Hitchcock,' she said, as if he was her expert lover. As if he'd done the whole shebang long ago.

The Birds on a Train
Lee Child

Sticky Johnston went to Hastings to kill a man. Overall not a new experience, although Hastings as a location was a first. He had never been there before. He had worked Eastbourne once, and Bexhill-on-Sea once, and Brighton, of course, a couple of times, but that was it for the seaside. Mostly he stayed inland, from the marshy levels around Pevensey up to the fringes of south-east London, where a whole different type of person took over.

He went by train, as always. There was CCTV, but way less than the roads had, with their facial algorithms and automatic number-plate recognition. He got on at sleepy Stonegate and wore a hoodie to hide his face and a bulky jacket to hide how thin he was. By then it was mid-morning, rush hour over, and the train was half empty. He sat half-opposite a man who was twisted around looking at two passengers two rows ahead. A woman and a girl. Probably mother and daughter. The kid was maybe eight. They were dressed identically in dark blue wool coats. Each had a fancy birdcage on her lap. Each birdcage had a live bird in it.

The man half-opposite turned back and said to Sticky, 'Budgerigars, I think.'

'Too green,' Sticky said back. 'Budgerigars are blue. I think those are the other kind.'

The Birds on a Train

'Of what?'

'Of birds people keep in cages. I think they're canaries.'

'But not in a coal mine.'

The man was shorter and wider than Sticky, not wearing a hoodie, but never looking up from under the enormous and well-rolled brim of a baseball cap. Sticky said, 'Where do you think they're going?'

'A day out at the seaside? Maybe they're rich and eccentric. Dukes or earls or something. They do stuff like that.'

'Who do?'

'Rich people. They take their birds for a day out.'

'Not by train, and not in a second-class coach. They would have a Rolls-Royce, with a chauffeur, maybe an old family retainer.'

'Then what are they?'

'Maybe it's a sad story,' Sticky said. 'Maybe their birds have a fatal disease. Maybe they're going to the vet.'

'In Hastings?'

'They have vets everywhere.'

'Exactly,' the man said. 'So why go to Hastings for one?'

Which seemed a reasonable question, in a train-gently-rocking kind of a way, so Sticky said, 'Maybe they're making a movie. You know, dressed like that.'

'Damn,' the man said. 'I thought I recognised her. The mother, I mean. I think she's on TV. Really good looking. I mean, like, smoking hot. But where are the cameras?'

And then suddenly, maybe because sexual attraction had been alluded to, the man got all caught up in some kind of primitive bonding thing, face to face with a partner at the heart of a mystery, the two of them against the world. He stuck out his hand and introduced himself. He said, 'I'm Padstow.'

Sticky didn't answer. Because Padstow was the name of the guy he was travelling south to kill. The name was all he had. No

photograph, no description. There was some background information, but not much.

Awkward.

Sticky shook the offered hand and said, 'I'm Steven.'

Padstow said, 'I'm pleased to meet you, Steven.'

Sticky asked him, 'Is Padstow a common name? I'm pretty sure I've heard it before.'

'No, it's not common,' Padstow said. 'I'm the only one I know, for instance. Should we go ask her?'

'Ask who?'

'The mother. If she's on TV. I think they secretly like to be recognised. They're very insecure.'

'Where does it come from?'

'Does what come from?'

'The name Padstow.'

'I have no idea,' Padstow said. 'Someone made it up, I expect, like most names.'

Sticky looked ahead. At the mother. He would have bet all of today's fee she was not on TV. She was just a normal person. Except for the tailoring. Velvet collar. And the birdcage. Not a utilitarian item from the pet shop. It was made of gilded wire, bent into exotic shapes. With a bird inside, definitely a canary. Same for the kid exactly, including the collar. Some kind of sect, maybe. Or a cult.

He said, 'What's your main hustle, Mr Padstow?'

'Why do you want to know?'

'We're getting along. Maybe there's a synergy between what we do.'

'What's your hustle?'

'Very unglamorous. I prefer to go second.'

'I run boats in and out of Hastings. Mostly fishing, sometimes small cargoes.'

Sticky nodded. Awkward. Definitely the right Padstow. A

smuggler-by-sea, said the background information. Very well paid, but skimming too much, even so. Greedy. Sticky had been told the guy would be down at the fishermen's huts after lunch. That was where he was supposed to find him. Allegedly the guy was planning a new route somewhere. He would be preoccupied by tense negotiations. Presumably the fish huts were easy to find. On the beach, obviously. Maybe a tourist attraction. Therefore safer to take care of business right there on the train. No one around, except two weirdos with canaries. Except, the weapon he had planned to use was waiting for him in a stolen Audi, strategically pre-positioned. In Hastings.

Padstow asked, 'So what's your hustle?'

Sticky said, 'I'm in the extermination business.'

'Like rats?'

Sticky nodded again.

'I do a lot of rats,' he said.

'Then you were right,' Padstow said. 'There's a synergy. I get rats on my boats. Not just me. All boats get rats. It's how they spread across the world.'

Sticky knew nothing about rodent control, but he nodded sagely. He asked, 'Want me to come and take a look?'

'Great,' Padstow said. 'I'll be on the beach after lunch. Where the fish huts are. I have a new route to plan. Synergy, man. Who knew?'

Then his phone rang, and Sticky looked away, as if offering privacy. He watched the mother and daughter. But he listened to Padstow's side of the conversation. It was clipped and cryptic, but to a practised ear it was clearly long-range planning for a crime Padstow wouldn't live to commit. Not if Sticky did his job. Which he intended to.

The canaries were staring at him. Straight at him. Four beady eyes, locked on.

Then his own phone rang. His sister. Who said, 'Something the

client just mentioned in passing. Padstow had a breakfast meeting in London, and then an Uber ride to Charing Cross. Which means he's travelling to Hastings by train. Like you are. It's even possible you're on the same train right now.'

'Lots of things are possible,' Sticky said.

'Still no photographs or video. All we have is the name. And the dynamic. One guy will come from the sea, and one from the shore. Padstow is the one from the shore.'

'Copy that,' Sticky said, and clicked off. Padstow was making one call after another. Sticky listened in, while pretending not to. Padstow was all business. For the time being, Sticky thought.

The canaries were still staring. Like they knew.

Padstow talked and the canaries stared all the way to Hastings. Padstow was up as soon as the train slowed, still on his phone, backing away, pointing at Sticky as he went, in a bonded kind of way. Sticky waited until the train creaked to a stop, and then waited some more, because he wanted to see the mother and daughter get out. He wanted a better look.

But they didn't move. They just sat there, upright, formal, birdcages on their laps. Which was weird. Hastings was the last stop. Only the English Channel ahead. For a moment Sticky wondered if he should go check they understood. Maybe they were foreign. Maybe they thought they were on the Eurostar to Paris. But in the end he didn't. He just stepped down to the platform and walked away.

There was no sign of Padstow ahead of him. Clearly he had hustled away in a hurry, probably still talking on the phone. But no problem. Sticky knew where the guy was going to be, and when. He came out of the station and stood for a moment. He sensed the sea was somewhere to his right. There were gulls in the air, making a racket. There was a breeze, carrying the scent of salt water and garbage.

Sticky followed his nose, through narrow streets, past old-fashioned

The Birds on a Train

shops selling buckets and spades and kites and sandcastle flags. He came out on the seafront road, which was lined on one side with faded old hotels, and on the other by a broad shingle beach. Limp waves were crunching in and out, slowly. Gulls swooped and called, dozens of them, with bodies the size of rugby balls.

There were no fishermen's huts on view. Probably east of where he was, Sticky thought, so he set out walking. He passed the end of the pier, and the streets changed to a different style. Old Town, it was called now, according to the name on a kebab shop he saw. He followed the sea wall, and a hundred yards later the coast curved and the fish smell in the air grew stronger and he saw boats pulled up on the shingle. At the top of the beach were a number of slender black sheds, modest in footprint but much taller than normal. For drying nets, Sticky assumed. Or mending them. The huts were made of tarred wood, and looked vaguely sinister. Gulls cawed and the eastern horizon turned grey with rain.

First order of business was to find the Audi. He guessed it would be two streets from the main drag, legally parked, facing west. His sister had organised it, and she knew how he liked things. He found it immediately. He blipped the fob she had given him, and the car flashed its lights and unlocked its doors. It had been stolen in Birmingham. Its plates were cloned from a same-model, same-year, same-colour Audi that lived innocently in Bristol.

Sticky opened the passenger door and leaned in. He opened the glove box and took out his Ruger .22 and its suppressor. Plus a knife. His sister always left one. Just in case, she would say. He put the gun in a long pocket she had sewn inside his coat. He put the knife in the same pocket as his house keys. He locked the car and walked away.

Next order of business was lunch. He was hungry. Fish and chips was the obvious choice, he decided, at the seaside. He surveyed one establishment after another and picked one based on its authentic

appearance. Probably been in business many years. He went in and ordered. Haddock and chips, large, salt and vinegar. They didn't come wrapped in newspaper, like they used to. Instead, they were laid out inside a cardboard clamshell box, which was packed into a heavy paper bag. Sticky carried it back to the beach. He had time to kill.

He got close enough to the fish huts to hear if somebody approached one, and he sat on the shingle on the far side of a breakwater wall that jutted out into the sea. The shingle had washed out a broad hole and his position was low enough that he was hidden from view. He reckoned he had thirty minutes minimum before anything happened. More likely an hour. Plenty of time for lunch. He pulled the cardboard clamshell out of the paper bag and flipped it open. He was heartened by what he saw. The fish looked great, and the chips looked great. He pried out a long, fat chip and bit off the first half. It tasted wicked and bad but also virtuous. It was a humble root vegetable, cooked in a manner already thousands of years old.

The gulls got the second half of the chip. The first to react swooped in and tore it from Sticky's fingers, after which the second wave came in a second later, aiming at the cornucopia that was the open clamshell, which was securely lodged in his lap, first ten, and then a hundred gulls, whirling in the darkened air, then diving, slamming into him like heavy punches, battering him, over and over, their beaks stabbing him everywhere as he twisted and turned.

Then helping hands pulling him clear, others beating the birds away. A paramedic suddenly appearing, a stretcher, an ambulance, people mopping his blood, then suddenly a policeman handcuffing his wrist to the stretcher. The paramedics had found the pocket his sister had sewn. And what was in it. They patched him up and declared him fit to be arrested. Which he was, for attempted murder, plus actual murder, once in Eastbourne, once in Bexhill-

on-Sea, and twice in Brighton. Not that the local force would get a look-in. It was the suppressor that did it. All kinds of people were on their way from London; in fact, enough three-letter agencies and acronyms to make a perfect anagram: *no one will ever see you again.*

The Karpman Drama Triangle

Denise Mina

David and Betsy sat close on the sofa, knees touching, hips distant, craning forward into the laptop screen. They looked grey and mismatched, grubby even if the surroundings were quite grand. The huge Georgian bookcase behind them reflecting the rest of the room in its glass-panelled doors and the large open fire flickering in front of them. Flames danced and leapt around the dull couple.

They looked as if they were in hell.

They each examined their own reflections critically.

Both were in their mid-forties but they looked a lot older today. Betsy was gaunt, David's eyes were puffy and the buttons on his shirt tight over his belly. He pulled his shirt loose and examined himself again. His hair seemed thin. He could see his scalp.

'Sit back,' said David, watching his own reflection as they did.

That did look better. The light was softer here and they looked less intense, less crazy than when they were leaning into the camera.

Betsy touched her hair, patting it flat at the top, and straightened her skirt over her lap. She rehearsed a smile that came off as a cadaverous twitch.

David cleared his throat. 'She's three minutes late.'

'I know.'

Their daughter Millie had scheduled the call, asked for it, and they had been getting ready since breakfast. David had been to

The Karpman Drama Triangle

Trumper's for a trim and a hot shave the day before and Betsy was wearing a nice Chanel suit in the house, which she never did. They had put all the dogs out on the patio and asked the staff to leave them in privacy so they wouldn't be interrupted.

It felt as if they were about to do an interview with a hostile journalist.

'Four minutes,' said Betsy, unhappily examining her neck on the screen. 'I should get my neck done.'

'No,' said David, imagining how much she would complain and need caring for afterwards. 'You're perfectly lovely as you are.'

She gave an uncertain smile again and he knew she was thinking about drink and how to get it. She didn't want to be here. Betsy didn't like emotional things.

'Five minutes late now...'

That was really quite late. They were paying thirty thousand a month for this clinic and never seemed to be able to get hold of anyone, and now this. Five minutes late was really quite late. A few minutes late could be explained away as a problem setting up or a bad connection or something, but as the seconds ticked by they each began to wonder if she would log into the call at all. They were only allowed fifteen minutes and then Millie would have to hang up and go to her one-to-one therapy session.

'Perhaps,' said David, 'she had to cancel and the email didn't come through yet?'

'Perhaps...'

They brightened at the possibility. In the screen reflection their brows flattened, eyebrows rose, they shed ten years each at the simple possibility that their daughter might not appear.

They had both been dreading this call.

It was a month since they had spoken to her or seen her face.

The clinic wanted her to settle in, and no contact for the first four weeks was just one of their many, many rules, like paying upfront and no parental interference. They were emailed updates

on her progress, her weight gain and how she was fitting in. She had done rather well and was now just severely underweight. She had gained a stone in a month. It really seemed to be working.

But they were to leave her alone, it was essential. Still, because they were paying the bills, which were many and steep, they were sent updates which they skim-read. Neither mentioned Millie when they didn't have to because her absence from the home had been quite wonderful.

They couldn't admit that to each other – Betsy could hardly admit it to herself – but they were fleetingly happily during those four weeks. They circled each other in the huge quiet house, nodding hello, sleeping in separate rooms, watching different programmes on different TVs, hardly talking at all. David read in the library and Betsy drank and slept. They had soup together one evening but made excuses the rest of the time and grazed, eating only when they were hungry and sometimes not at all. There was no need for mealtimes and concomitant arguments about Millie's eating and life and lying and stealing, no nightly penance for the mistake of having a child when they were so firmly themselves. With Millie gone there was no need for that nightly fraught performance.

Once or twice, David went for a full day without eating because he was reading and forgot. He had to get up in the middle of the night and ask the butler to bring him plain biscuits and hot milk.

It was so lovely. He hadn't felt this free since she was born, tongue-tied and whining for milk and rusks. Her eating had always been difficult, even before she started starving herself.

Betsy had taken Millie's absence as an opportunity to drink more without being screamed at and David didn't mind at all. His evenings were spent in quiet contemplation of Justinian's Institutes and maritime law, while Betsy sloped off to watch TV and doze in armchairs. Her liver was quite swollen, she looked a little pregnant and she couldn't eat in the mornings or stop trembling, but he didn't mind. Millie said her mother was iron deficient, that

The Karpman Drama Triangle

was why she was so lethargic and fell asleep at odd moments. She might even have been right, but David didn't mind what she did. She was a big girl. The house was hers, she had a lot of money and a couple of million income a year. She could do what she liked.

In their own private way, over the seventeen years of Millie's life, both David and Betsy had realised that they should have remained childless. She was a difficult, needy child, never happy, odd-looking, perpetually resentful. They would have been happier without Millie and all three of them knew it.

Of course, they couldn't say that. Millie could scream it at them but they couldn't agree with her openly. They had friends who were childless, not through choice, and David sometimes wanted to tell them that his experience of parenting had been utterly thankless and unrewarding. He couldn't say, look, it's pretty awful. You've dodged a bullet there. Millie doesn't like us and we sometimes wonder if we like her beyond the usual hormonal connection. Sometimes you love them and they don't love you back. Sometimes they wish you'd die.

This was very much Millie's position.

They knew that because she told them that she wanted them to die. She wanted to sell the house and all the crap they'd collected in it, all the paintings and books and bloody vases, and take off with all the money and travel. Get the fuck away from them. They offered her money to travel but she said no, it wasn't enough, so they offered her more, ten thousand a month, that's plenty, but still she said no. And that was when her eating went haywire. She started thin and lost tens of pounds. Every morning she would get up thinner and dressed to show off her stick-like arms and stringy legs. He knees looked like knots.

Well, said Betsy, it was just as well that she didn't take the money and go, or she might have starved herself to death in Bali or Australia. It was good that she didn't go.

Betsy trembled as she settled next to David on the sofa in the living room. Her eyes were damp, her fingers trembling.

Suddenly Millie's angry face appeared on screen, filling the frame. Betsy gave a terrified little jump.

'*Mum!*' Millie sat back and glared.

'Hello, Millie dear,' said Betsy, nodding a frightened smile.

'I can't hear you, you're on mute.'

Betsy didn't understand. 'On what?'

David sat forward. 'Oh, I forgot to turn the mic on, sorry Millie…' His face loomed into shot, blocking out the image, grotesquely foreshortened as he reached for the pad to change it. 'Hello?' David sat back. 'Can you hear me now?'

'That's it, I can hear you now.'

Betsy smiled uncertainly. 'Can you hear us now?'

'Yes, I can hear you now.'

'Hello dear,' said David, smiling as if someone was demanding he do so at gunpoint. 'How nice to see you again.'

'Lovely…' said Betsy vaguely.

Millie glared out at them. 'Have you got the fire on?'

'Oh, um, yes, I suppose, well, yes.' Betsy's speech was stilted, her breathing fast and shallow.

'Is it *cold* there?'

David had forgotten how spikey her delivery of a perfectly ordinary sentence could be. She often emphasised strange words in the middle of sentences as a way of wrong-footing the listener, to set them on edge. Or was it? Perhaps she was trying to make sure they were listening.

'Oh, gosh, yes,' said Betsy. 'It is a bit frosty. Is it cold there?'

'In *Kent*!?'

David could see himself and Betsy shrinking into themselves. They were beaten down by her and the history of their little trio, the screaming and the school refusal and the awful things she said to them. I hate myself. I want to die. I'll bludgeon you when you're

The Karpman Drama Triangle

sleeping if you leave that butter on the table. He knew that if they were ever going to reset, it had to start now.

'You look well, Millie. How are you enjoying it?'

'It's not a *summer* camp. I'm not having fun here—'

'Have you spoken about your hostility to the counsellor?'

Millie reeled back, surprised at him. '*Hostility?*'

'Towards us. The aggression.' He knew she had. The updates from her therapist specifically mentioned it. She was aware of it and she was sorry that she made them feel unsafe. Rather unnecessarily, the update went into why she was hostile: their meanness with money (they weren't mean with money, she was actually rather spoiled), how cold and distracted they were when she was young, the feeling she had that they were trying to thwart her dreams of travel.

'Yes,' said Millie. 'We have talked about it. A little. Have you heard of the Karpman Drama Triangle?'

'No,' said Betsy uncomfortably, 'I don't think I have…'

'Well it's, sort of, a way of understanding the way people interact. Like, it's a triangle of conflict, people in conflict, and when you're in it, sometimes a person can be the rescuer and sometimes the persecutor and sometimes the victim, but we all have different roles at different times but it's about conflict and how to break out of it and get away.'

'That's nice,' said Betsy. 'A bit of insight.'

'Yes,' said Millie, knowing she was being dismissed. 'It's interesting. A way to look at it. At conflict.'

'Hmm.' Betsy had a disgusted air about her and straightened her hem. 'Lovely.'

David felt that he should take over. 'Well, we're very grateful to you for doing this all, Millie, it can't be easy. I think you're very brave. Don't you think she's brave, Betsy?'

Betsy managed an affirming sigh. She didn't like talking about feelings. She liked to imply that they were vulgar and weak but actually she was terrified of them.

'Yeah,' said Millie, her voice lower now. 'It hasn't been easy talking about it, all I've been through. The *trauma*...' She was looking at her mother. At least David thought she was. It was hard to read the line-of-sight on the screen because she was looking at the image of them on the left-hand side of the screen and they were looking at the image of her on the right.

'Oh,' said Betsy. 'Oh, you look ever so well!'

'*Yes*.' Betsy flinched at Millie's voice. 'I am well. They have a garden here and we're allowed to walk around the *grounds—*'

David's gaze roamed the background as Millie talked about the hedgerows and the plants, the pathways and the therapist. She was in a plain room, nice. He could see the edge of a large bed with nice pillows and good linen. It looked as if a maid had made the bed. It was so tidy, the fluffy white duvet brushed flat and pillows puffed up to sit nicely to attention against the headboard. A teal-coloured coverlet ran along the foot and was tucked in tight at the side. It was a bed that invited a sleeper. Perhaps they had staff there, but that didn't sound like a rehab clinic. He thought they had to sweep up and wash things and make their own bed in most of them.

Next to the bed was a wall light and a table with books stacked on it. He wanted to read the spines, reading was his comfort, but they were turned away from the camera.

On the wall next to it was a painting, a dull bit of corporate art.

He was assuming that the desk had a phone on it next to her laptop, but then he remembered she wasn't in a hotel, it was a clinic. There would be no phone or minibar.

It was a nice room, though, and she seemed to have it to herself. He was glad to see that. It was costing enough. He had been troubled by the scandal surrounding those expensive wilderness programmes in the US, read about terrified parents bankrupting themselves to send their children off to die on hills or being beaten by other troubled teens. He understood the parents, though, the

The Karpman Drama Triangle

terrible panic they must have felt, a terror of what their child was turning into. There had been moments when he would have let men come into his home in the middle of the night and kidnap Millie. When she smashed the Ming vase in the hall and, later, when she shot the dog in the blue parlour and filmed it bleeding to death.

Mostly, he would have paid for that service so that he didn't have to deal with her for a while. He was very tired.

But Millie recognised that there was a problem and found her own clinic, applied for a place and let them know where to send the money; it was tremendously mature, he thought, and the room she was in looked nice and Millie herself looked, not so much well, as a little bit better. The screen was below her and up-lit her face, softening all the hard edges and the dark circles under her eyes. Her black hair was clean, lank because she was malnourished, hanging flat against the sides of her head with her ears poking out like a little monkey's. He used to hate her hair like that but found himself pleased to see it now. Glad.

Maybe he was missing her and just didn't realise it. He asked, 'Any word about you coming home?'

'*No!*' Millie looked up at the camera, frightened. 'No. Not yet. Not yet *at all*. They're filming this to see how I am with you. They want to monitor us, our interactions, see, you know, what's what.'

She looked at Betsy, he could tell despite the lack of coherent eyeline. Betsy was the problem. Betsy's drinking.

Betsy breathed out, a careful little rage-sigh, and he could smell the sour tang of white wine on her breath. Millie wanted to shame her mother into sobriety, but it didn't work like that.

She had been drinking and it was only nine thirty in the morning. Shit. David had stopped noticing because he wasn't even looking for it now. He didn't want to think about it. His eyes flicked up to the corner. Seven minutes left.

'Excuse me a moment.' Betsy stood up unsteadily and lumbered away, clambering over David's feet as she mumbled something about

the toilet. She left the room. No one thought she was going to the bathroom, not unless she had a half bottle of vodka in there.

'Dad.'

'I know.'

'*Dad.*'

'I know, I know, Millie, I know.'

They looked at the images of each other, eyelines never meeting, each alone.

'I *can't* come home if you won't do what we said.'

'I will do it.'

'You said you would and you didn't.'

'She wouldn't take them.'

'Of course she won't take them, she wants to keep drinking. *Of course* she won't.'

He sat forward to explain his failure but balked when he saw the buttons straining across his belly. He had let things go. He had let everything go.

'You're making it impossible for me to live.'

He rage-sighed, more angry at himself than her. 'Have you told the therapist about your mum?'

'Yes. I don't like her, the therapist.' Millie smiled. 'She's got great long gums and tiny little teeth dangling on the end of them. She looks like a horse.'

He laughed at that, delighted because they were talking about someone else's failings, not his own.

'I *swear*, her teeth have been getting smaller since I've been here.'

'Maybe she has been chewing on the door frame and ground them down.'

Millie giggled. 'Listening to me talk about my eating has broken her brain. She's like, "one apple a day and no more", and "*gnaw gnaw*".' She made a face and spoke in a weird American accent when she said this. It was lovely to see her joke about something, not something mean either, she wasn't saying this to the therapist's

face or being unkind or trying to get anything. She was joking with him. He felt that she had made real, extraordinary progress. But then her face fell serious again.

'You're not going to do *anything* to help Mum.'

'I *am*, Millie.'

'No,' she said softly, 'you're not. You will never do this. *Nothing* will ever change. She'll keeping pissing in my bed, on my *clothes*, crashed the car when I'm in it with no seat belt. She blacks out and doesn't remember and you just pretend that everything is fine but it's not fine and it's not safe and I'm not the one with the *problem*.'

'Millie, I will challenge her—'

'Do it now.'

'Let's be reasonable.' He had his hand up at her, his eyes rolled back in his head and shut, and he saw himself for a moment, sitting there, refusing to help.

'You *act* as if I'm the problem but I'm not the problem, Dad. I'm a symptom. There is no point in solving a symptom. Mum's drinking is the problem.'

She was very clear-sighted for a seventeen-year-old.

'When they watch this tape and see Mum staggering off, her eyes rolling around, how in denial you are and how unwilling to face the situation, they'll ask you to come in for *family* therapy and they'll challenge you. Do you see?'

David's mouth dried out and his skin felt cold and clammy. That was the very last thing he ever wanted to happen, ever.

'They'll *keep* her in here and she'll get sober and then she might want to know about your girlfriends and about the gambling debts and that six-year-old in Jamaica who has your eyes and a stipend for life. That'll be an interesting session, don't you think?'

His mouth was so dry that he tried to chew his tongue to produce saliva but pressed his teeth too hard and cut his tongue. His eyes watered.

'Are you *okay*?'

'Millie, what do you want me to do?'

'*You know.*'

He did know. Millie had left the bottle of medication with him when she left. Tell her it's an iron supplement, she'd said, and give her one a day. It was a mild form of Antabuse and, taken consistently, would give Betsy gentle nausea when she drank. In therapeutic terms it was a mild negative reinforcement. Millie got the lowest dose available for safety reasons. It wouldn't really have an effect for the first week or so, might not work at all, they didn't work for everyone. But gradually, if Betsy took one a day consistently, she would slowly but surely lose interest in drink and sober up. She could do it without having to go through all the fuss and unpleasantness of a detox, all the therapeutic interventions and truth telling and family therapy sessions. There would be no need for that. But she had to take it consistently. There was no way around that.

'Have you even spoken to her about it?'

David didn't answer and that was an answer.

'I see.'

He fished the small pill bottle out of his pocket. 'I have them with me. I've had them in my pocket since you left. I've thought about it.'

She glanced up at the camera on the top of the screen as if drawing God into the conversation. 'I'll talk to them. I don't know what else I can do but they won't let me come back if nothing has changed...'

David didn't want her to come back. That was the truth. But more than that, he didn't want Betsy to know about the stipend or ask where the money was going or why he didn't have a job. At least if her sobriety was gradual, things might tick along as they had before.

'Dad, it's such a mild dose, it won't even have an effect for the first week. She'll be used to taking them by then and you can tell

The Karpman Drama Triangle

her they're vitamins if that means she'll take them, but they want to see that you are willing to do more than send me away. I can't tell you how unhappy this is making me. I told them about my suicidal thoughts...'

She seemed to want to talk about that, but he didn't. She had never mentioned suicidal thoughts, just murderous ones.

He looked at the bottle in his hand. Seven small pills rattling about at the bottom of a brown smoked-glass bottle with a child-proof lock. They were very small pills. He could make Betsy take them, of course he could, she'd do anything for him as long as he didn't leave her. She would take them for him. He could get her to take one, and then another one every second or third day. That way he'd give the impression that they didn't work, not for her, but he'd be trying. Even once a week. Or just once in a while, when people were watching, when they were recording.

He glanced up at the camera. They'd see him trying at least. That would surely buy him some good grace.

Betsy arrived back at the door to the library, feet scuffing the oak floor as she shuffled drunkenly back into the room. She must have had a good fast drink while she was out of the room. She walked unsteadily around the back of the sofa, her torso smearing the screen behind him, and shuffled out of frame.

He could smell the high bouquet of vodka radiating from her as she sat down.

Four minutes left on the call.

He could just give her a pill while they were recording and then make excuses: her constitution was just so strong, you see, because of all the years of heavy drinking and sleeping pills that she took and so on. Maybe she'd had them before, he didn't monitor her medication, maybe they didn't work for her, they didn't work for everyone.

Betsy sighed with effort as she rolled her face towards the camera and smiled at Millie.

'Youvluck super, d'rling,' she said, her lips sliding around her teeth, her eyes half-shut, hands gesturing out of time. About a quarter bottle. They were so attuned to Betsy's drinking that each could measure her intake to the millilitre.

It wasn't always like this.

When Betsy was young she was daring and clever, she sallied through exams and parties and summers and jobs with style and aplomb and a sharp wit. Her vast inheritance meant that nothing bothered her terribly because nothing could go very wrong for her. She was secure, pretty, nice. David loved her before he knew she was terribly rich. She saw in his eyes a reflection of herself that she liked, and knew that marrying someone with nothing would give her the whip hand. She could have things just as she liked them, live where she wanted, drink when she felt like it. But all the days of what she wanted started to run together in grand, country seclusion. Horse days, party days, shopping days became just days sliding around, feeling nothing much, saying nothing much, doing nothing much.

Millie arrived in the middle of all this, unexpected, unbidden, and David took charge, found nannies and schools and tutors and then therapists while Betsy slept and drank and smiled in her wan, vacant way. To Millie she was less real than the dogs. At least they had personalities.

Three minutes. David was still holding the pill bottle. He took a deep breath and turned to Betsy.

'Betsy, darling, I don't know if you're aware of how incredibly pale you are just now?'

Betsy was startled to be spoken to. 'Hmm?'

'Very pale, darling. Millie has been telling the staff that she's worried about your iron levels.'

'Iron?'

'Do you know that iron deficiency is terribly common?' David shot Millie a half smile and she smiled back at how clever they

The Karpman Drama Triangle

were being. 'It has a lot of side effects. It can make you very sleepy and lethargic.'

Betsy startled and mumbled, 'Oh? *I'm* sleepy lethargic.'

'I know you are. Millie has noticed too, haven't you?'

Millie nodded, wary, half amazed that he was actually going to take some action. She was watching the pill bottle. 'Yes.'

'Well.' He held up the pill bottle. 'I have some iron tablets here and I think it would be a good idea for you take one a day, just for a week, see if it has any beneficial effects. Would you be willing to do that?'

'I don't like pills.'

Three minutes. He had to show willing. He pressed the lid and turned it, shook the bottle until one tumbled into his palm. He looked into the lens for approval. They'd see this, they'd know he was trying. 'It's very small.'

He held it up. Betsy shook her head loosely.

'Yes, that's right,' he said, using an old technique that had worked in the past: pretending she had agreed to do something when she hadn't.

It worked.

Betsy took the pill from his pinched fingers and put it in her mouth, crunching down on it, flinching as she chewed and swallowed the bitter little blue pill.

David looked to Millie to see if she was pleased with him.

Millie's mouth was open and her eyes were wide, drinking it in, as if she couldn't see enough of this. She was holding tight to the desk, so tight that when she let go her hand caught the edge of the keyboard and the screen image jolted sideways to a room service menu on the desk for the Madison Hotel, Manchester.

The laptop swung back suddenly to Millie and her careful framing of the room. She looked panicked.

'Millie?'

'*Yeah?*'

'Are you in a hotel?'

'Am I what?'

'Have you left the clinic and gone to a hotel?'

'No.'

He gave an incredulous huffing laugh. 'I know you are. Why didn't they notify us?'

'Who?'

'The clinic. Why didn't they notify us that you left and went to the Madison Hotel in Manchester?'

'We're running out of time,' said Millie, sitting back in her chair, watching her mother intently.

'Why are you looking at her like that?'

A small smile flickered across her lips. 'Like what, Dad?'

It was a guttural gurgle, very soft, very near. David turned and looked at Betsy. She was glistening, her face wet. A bead of sweat trickled from her temple down her cheek and fell from her jaw onto her skirt. The material swallowed it up.

'Betsy?' he said. 'Why are you—'

All the colour left Betsy's face like water on a hot plate. Her heart had stopped. He could see it. She was still sitting up, balanced like a spinning top come to a stop, but she was no more alive than a memory.

The moment of her life was over.

The meat that was once Betsy slid elegantly away, off the sofa, tumbling soundlessly to the ground, landing face down.

David looked at her unmoving body, thought to call out to her, but it caught in his throat and he knew it was past the time for that.

Millie grinned out at him, gleeful and calm.

'Millie?'

'She's gone? That was quick.'

'Millie, what did I give her?'

'I told you not to. I *begged*.'

The Karpman Drama Triangle

She was lying. It was a lie. She was lying.

'You told me to— Millie, you gave me the pills. It's recorded. What you said: it's recorded.'

'Is it?' She wasn't smiling anymore but her eyes were.

'Where are you really, Millie? I'll call the police. The Madison in Manchester. I know where you are!'

'Oh, I wouldn't call the police, Dad. You've just poisoned Mum… I think maybe I should call the police. That would be better. Why did you do that to her?'

He still didn't understand. 'What did I do to her?'

'Fed her a thousand-microgram pill of Fentanyl that you bought online using your own credit card. How *could* you?'

'A thousand micrograms of *what?*' He held up the bottle and looked at the six pills. 'What are these?'

'Maybe you should take one, Dad. They'll calm you down.'

Millie reached forward, her forefinger massive in the frame, as she tapped the button to *End the Meeting for All*.

The Mountain Eagle

Xan Brooks

Precious items go missing in the backwoods of Kentucky – sometimes by accident, other times by design. Outside of town the wagon trails twist and double back on themselves and the forest plays tricks because most trees look the same. Snowfall in the mountains is God's great eraser. It wipes the page shiny white and clean. You walk twenty yards, turn your head to look back, and already it's like you never walked there at all.

If you were to keep pressing north along these backwoods trails, always opting for the steepest route, you might eventually reach the cabin of John 'Fear-o-God' Fulton, way up in the hills, three miles from its neighbours. This in its day was a rough and plain habitation, with a downtrodden dirt floor and undressed walls of white pine, although it was not nearly so rough and plain as the creature who once called it home. Fear-o-God was a hillbilly, a mountain man, and he lived alone like an ogre out of a children's bedtime tale. 'If you don't say the pledge, Fear-o-God will come get you,' the schoolteacher, Beatrice Brent, told her class at story time. 'If you don't go to church, if you don't say your prayers. If you stray from the path, Fear-o-God will come get you.'

The previous year there had been sixteen students in class. But then Gladys Enloe eloped and James McEntee died of scarlet fever and Robert Coombs took a job sweeping up at the sawmill. That

The Mountain Eagle

left Miss Beatrice with thirteen, a nice round baker's dozen that ranged in age from eight-year-old Sissy Hughes to lanky Edward Pettigrew who was full-grown but a cripple and whose pa owned the store and served as justice of the peace. Old Man Pettigrew practically ran the whole town. If it was his view that Edward required further schooling, then it was Miss Beatrice's pleasure to teach him, and never mind the fact that he loomed over his classmates and couldn't join in at playtime. When he sat on his stool his knees were up by his armpits.

'How old are you, Miss Beatrice?' he asked at three o'clock when she was putting her books in her bag. Loud enough for the other children to hear. Loud enough to wake the dead in the graveyard. 'How old? When's your birthday? Why, I'll bet that you're not many years older than me.'

He had watched a film at the nickelodeon. It was the tale of a pretty schoolteacher and the earnest young scholar who pursued her. He said, 'You ought to go see it. I reckon you'll like it just fine.'

Or again, another afternoon, when she had knelt by the window to help Sissy lace her boots and the late sun in the glass had been almost too bright to bear and he suddenly shouted for her to remain perfectly still and to not move a muscle. She thought that he must have seen a wasp or spider on her collar and was trying to prevent her being stung. But no, Edward said, there was no spider or wasp – it was only that he liked how she looked on one knee by the window, with the sunlight in her hair and her head bowed just so. He said, 'You look all lit up like coloured glass. You look like a picture in a Bible story.'

'Edward, don't be foolish.' By the end of each day the children were tired and restless and wanting something to distract them. All it took was one improper comment to send the entire class into uproar.

'Don't move,' he said, lifting his voice to be heard over the swell of laughter. 'Stay right that way, like coloured glass. Oh, Miss

Beatrice, you moved, why d'you go and do that? Didn't I just say not to move, goddamnit?'

'Edward,' she pleaded. 'Edward. Children. Be quiet.'

The problem, of course, was that the boy was in love. That was the nature of boys, particularly those grown to manhood, just as it is the obligation of women not to toy with their affections. In the town, Beatrice Brent was regarded as an excellent teacher. But it might have helped if she were married, or if she were widowed, or just a few years past her prime. Old Mrs Perrot had likewise been judged to be an excellent teacher. And yet she hadn't risked ruffling feathers the way that Miss Beatrice Brent did.

It was the middle of March, a dangerous time – no longer winter and not quite spring. One day warm, the next bone-cold. The trees in the valley gleamed a raw newborn green. Up in the hills, one could still see heaps of snow. Mating season, the locals called it. For coyotes and skunks. Probably for human beings as well.

This, then, was the problem – Edward was in love. Old Man Pettigrew's pride and joy. The image of his mother, now deceased, right down to his long dark lashes and dimpled chin. Lame down his right side and historically slow on the uptake, but a red-blooded young buck – fancy that, what a twist. It only went to show that you shouldn't count people out. It only proved that crippled Edward was his father's son as well as being his mother's boy.

Old Man Pettigrew called in at the schoolhouse after class was let out. He was a heavyset fellow who went about life as though he was hell-bent on violence, even when embarked on the most harmless of errands. He said, 'Hand on heart, Miss Beatrice, I do sympathise with his plight. I do indeed, it's a drumbeat, what some might call an affliction. As a youngster, I'd have been just as saucer-eyed as he is. Set myself front of class with my tongue hanging out. But as a man I can see how these things can get out of hand.' That was why he had visited her at the schoolhouse: to speak to her as an adult and provide some friendly, wise advice.

The Mountain Eagle

'The boy is no great bother,' Beatrice Brent assured him. 'He's a sweet, sensitive student. He writes poetry, you know?'

'I don't care to see his poetry. Do you think that helps – his poetry?'

'Well.' The teacher had made herself busy, clapping dust from the erasers. 'Honestly, as I said, he's no bother at all. I am very fond of young Edward.'

'That's plain to see,' Old Man Pettigrew said. 'It's plain to see that you're very fond of him. Is that why you dress yourself up so nice each morning? Like you've mistaken the schoolhouse for the county fair?'

The boy was a cripple, which meant he had to be handled with care, as one would a cracked china bowl or a bird's nest full of eggs. All that winter he'd been breaking down, getting worse, because he lacked the wherewithal and fortitude to properly manage his affliction. First, this unhealthy obsession with the nickelodeon picture shows. Then hard on its heels, the affliction, his curse. All men are afflicted, of course, Pettigrew knew that himself at first hand. But the good men – the strong men – are able to control it.

He drew up his chair and adopted a gentler tone. 'There's no denying that you are a pretty girl. If I were your student, I dare say that I'd be a little in love with you, too. But what you need is a husband. A grown man, not a child. I don't believe that a child can provide what you need.'

'Mr Pettigrew. Please.' The woman crossed to the blackboard. Pettigrew rose and went with her. He said, 'Let us try to avoid any misunderstanding here, miss. My abiding concern is for my son and his schooling.'

How long, she wondered afterwards, had Edward been outside the open window? How much of their exchange had he heard? How much had he seen? It was only now that the cripple stood up and leant in. His fingers gripping the sill had turned white, but his voice remained calm and he announced himself with a smile.

He said, 'The picture show that I saw played out much like this. It's like the school window became a little nickelodeon screen.'

'Edward,' said his father. 'You are interrupting a private conversation.'

The young man cocked his head. He regarded his father with a dispassionate interest. It was as though Miss Bea, in that moment, did not exist for him at all. He said, 'The world is full of dirty animals. Wherever you look, more dirty animals. That's the lesson I've learned watching you and Ma, Pa – and maybe Ma most of all. You can send folk to church. You can teach them to walk on hind legs. But they're still dirty animals. Only ever got one thing on their minds.'

The town sat at the bottom of a steep mountain valley and hugged the east bank of the Rockcastle River. It had been a mining town once, before all the coal was stripped out, and a lumber town ever since, because there were trees enough to sustain it. And it was this same lumber – predominantly red oak and chestnut – which had been cut to build both Pettigrew's Local Store on Main Street and the Calvary Baptist Church down by the water's edge. People said the town's business centred around these two institutions, the store and the church, and that there was no great difference between them, they were like two peas in a pod. Standing at the counter with his apron freshly ironed, Pettigrew had a joke that the housewives enjoyed. 'You just give your orders to me, ladies, and I'll pass them on to the big man upstairs.' And while he said this to be funny, he was halfway serious, too. Pettigrew liked to make out that he and the Lord were in daily cahoots; that they were business partners in all but name. Orders, he said, are a little like prayers, and I'll see that the big man receives every one. Ring the cash till; that's another sweet sale. It almost sounds like a church bell tolling.

The townsfolk loved the Bible. They loved Old Man Pettigrew,

too. And the altercation at the schoolhouse was seen to be the final straw. Pettigrew, it was agreed, had made every effort to steer the teacher straight. He'd asked that she modify her attire and be sure not to lead Edward on, however flattered she might be by the attention he paid her, and her response to this was to raise a fuss, which only had the effect of further upsetting the boy. It had become clear as day that she could not continue in her post, nor indeed remain boarding at Mrs Henderson's Guesthouse. County schoolteachers were expected to lead by example – whereas Miss Brent's example, folk said, led all the way to the honky-tonk.

It was fixing to rain when Miss Beatrice Brent took her leave, and while the walk to the station was not very far, the road ran past the schoolhouse, the local store and the planing sheds, and she didn't care for the thought of everyone milling about to watch her go. This, then, was why she struck off on an alternative route, up behind the backs of houses and presently into the woods themselves. Up on the slope, the rain fell as snow and the going was hard; her suitcase scraped her legs. She cast about for a path that would reconnect with the road, but the route of the trails forced her wide and high and after a half-hour of walking she had no idea where she was. Miss Brent might have died, out there in the woods, were it not for the presence of John 'Fear-o-God' Fulton. He found her scared half to death and turned about on the trail. The man had been out shooting squirrels. He might just as easily have shot her by mistake.

At the schoolhouse, she confessed, she had made him a monster in her stories. 'If you don't say your prayers. If you don't say the pledge. If you stray from the path, Fear-o-God will come get you.'

'You strayed from the path today all right.'

'I did.' She was cold and shaken, close to tears.

'You strayed from the path, but I came and got you.'

The sides of his cabin were matted with snow and heavily camouflaged. You could walk quite close before you realised it was there.

This was just how Fear-o-God liked it. He had tried living with people once, long ago, and had come to the conclusion that they weren't to his taste. He much preferred the hermit life, out in the woods, heating snow-melt on the stove, with no one to bother him and nobody even knowing where he was, except for the animals that scurried by at ground level and the eyes in the sky – the mountain eagle up there.

'The mountain eagle? Up where?' Beatrice shielded her eyes with the flat of her hand.

'Up there. Over yonder.'

'I don't see it.'

'You don't see it, but it sees you.'

The eyes in the sky had been watching her the whole time, he said. They saw everything that occurred in this corner of Kentucky. They saw the good men in their little tar-paper shacks and the wicked men in their painted gingerbread homes. They saw the children born as bastards and mothers dead in childbirth. Oh yes, he said, they saw it all. The merry comings and goings of the townsfolk in broad daylight and the furtive, creeping movements of the same folk after dark. Tawny-yellow and unblinking. The eagle eyes in the sky.

Beatrice shivered. She suspected the shiver was not purely on account of the cold. 'I'm not sure I like the idea of something looking down on me, unblinking, especially when I can't look it back square in the face and say hello.'

'Yeah, but there ain't nothing you can do about it,' the hermit said flatly. ''Sides, most people behave better when they figure they're being watched.'

The cabin was rough but it was at least warm and dry. Fear-o-God kicked the snow from his boots and got the wood-stove alight. In his shirtsleeves and britches, the man appeared almost normal and not a monster at all. He had crudely cut his own hair and his moustache was lopsided. But Beatrice thought that, with a

little tender care, he might yet be patched up to the point where he could rejoin society, should he ever want such a thing.

'Rejoin society.' Fear-o-God snorted. 'No thank you, ma'am, no. It's society that ought to rejoin me.'

Back in town, Beatrice said, the shopkeeper made out that he was in regular communication with God. He said that God was always looking down and that he was always looking up, passing shopping orders like prayers, and maybe prayers too, who could say? 'The big man upstairs', that's what he chose to call him. He'd say, 'I'm passing your orders to the big man upstairs.'

She had hoped the hermit might laugh a little at that. Instead, unaccountably, her story seemed to rile him. He glowered at her. He kicked his boots. He said, 'There ain't no such thing as a big man upstairs. There's only the mountain eagle up yonder, see?'

Two days after Miss Bea's departure, Edward Pettigrew lost his mind. He had been losing his mind for several months, truth be told. Losing it in the schoolroom and inside the water closet and a quite considerable sum in his feather bed of a night, but on each occasion he had managed to relocate it again. This time, after supper, he realised it had gone for good. Items were forever getting lost in the backwoods of Kentucky. Well now, here it was, one more for the list. Cripple boy's unsound mind. Last seen at the schoolhouse, pining after Miss Bea.

He had once read a poem about a tragic princess who was spurned by the prince. The heartbroken princess decided to take her own life, and built a shrine to herself in the woods near the palace. Edward thought that's what he would do. He'd construct a shrine containing his most treasured possessions, after which he would stretch himself out in its centre, close his eyes, and expire. So, he packed his books and his jottings and a photograph of himself as a child posed on a coconut mat. Then he jimmied the window at the town's movie-house and added the canister of film to the items

in his sack. The projection machine, he conceded, was altogether too heavy to carry.

That should have been that. The boy had all that he needed. But the robbery of the nickelodeon had stirred his senses to such a pitch that he walked in a daze back to Pettigrew's Local Store. In the unlit interior of his father's business, he swept all the dry goods from the shelves and poured the flour and sugar up the central aisle. 'Like baking a cake,' he murmured to the darkness. 'A nice big cake for the dirty animals to eat.' He opened the jars of molasses and painted their contents on the windows and walls. He opened the register and tore the dollar bills into ribbons. Only then did Edward gather his hessian sack of belongings and start picking his way along the steepest route out of town.

Whatever you do, don't go into the woods. That's what the children were told; that was their first, crucial lesson. It's what old Mrs Perrot used to tell them, back when she was still teaching school, before she got too deaf to hear answers and too blind to count heads. Mrs Perrot, he thought now, had an abiding horror of the backwoods beyond town, probably because she remembered the place when it was full of bobcats, wolves and savages, when there were no trails or railroad or stacks of raw lumber leaking orange sap. 'Whatever you do, children, don't go to the woods.' Like they were planning to go haring off right that second, never to be seen again. Haring away to a pitiless fate, either eaten or scalped or married off to Chief Bear, when the truth was that these hills had been pretty much civilised. The wolves had been shot and the savages driven out and most bobcats could be tamed with a saucer of milk. Nowadays, Edward thought, all the world's dirty animals could be found in the town.

He was lame down one side and so his progress was slow. The further he walked, the more fresh snow he encountered. Edward had not pictured snow in his carefully composed deathbed scene. He had pictured a sylvan glade and shafts of sunlight and perhaps

The Mountain Eagle

a pair of young deer in the role of mourners. He'd not pictured drifts of snow and his pant-legs soaked and his precious books all waterlogged. The reality of the hills was a bitter disappointment to the boy. He had found that little in the world lived up to his imaginings.

Clambering north through the woods, weighed down by his treasure, Edward quickly redrafted the deathbed scene in his head. In place of a sylvan forest glade, he pictured a high mountain peak, penetrating the clouds. That way he could retain the shafts of sunlight, because he hated to lose the shafts of sunlight, although in every other respect it would make for a harsher and more dramatic tableaux; wild and windswept where the initial conception had been picturesque and tranquil. It was a change he could live with. It was a change he could die with.

Serve them all right, his ma and pa, dirty animals. But the sack was so heavy and his rotten leg had cramped up and he had walked in a fog, delirious and exhausted, right through until dawn when he saw, like a magic-eye trick, the rough cabin in the hills with the matted snow on its walls. He staggered on the trail, sunk to his knees and cried out – and it was at this exact same moment, nearly three miles south, that Old Man Pettigrew flicked the electric lights at the local store and surveyed the scene with a dark, darting gaze. The split bags and boxes, the mounds of spoiled food and the tattered bits of banknote thrown about like sad confetti. 'Oh,' he said. 'Well. Somebody somewhere will be paying a high price for this.'

Spring can be furious in this part of the country. It strips the leaves off the trees on the hillside and lifts the loose shingles from the roofs in the town. In January and February the land's in deep freeze, locked fast like hard candy. Now, in March, it's gone liquid and the melt runs through the mountain to flood the valley floor. Springtime means change. The people feel it in their bones – and

so it was with John 'Fear-o-God' Fulton, who awoke that morning to find his circumstances transformed. For years he had lived all alone in these hills, neither seeking nor desiring human company. Only him and the birds, the coyotes and the deer. Only him and his thoughts and the sound of his own breath. Now, all at once in his cabin, two fellow lost souls. It made him feel noble, a protector of the weak. It made him feel he had family for maybe the first time in his life.

'Now then,' said Miss Beatrice, examining the jars of preserves and the sides of cured meat. 'Now then, my boys, what shall we be eating this eve?'

Already Fear-o-God was growing accustomed to the woman's voice – its rise and fall, its lightness and warmth – to the point where he believed he would miss it when Miss Bea went away. The cripple boy, he could take or leave, although only a hard-hearted brute would have turned Edward back, not after he'd come all the way up the mountain, practically on one leg. Poor bird, he thought. Poor sparrow, with his dragging broken wing. The boy had been delirious, half-dead when they found him. For a moment he had taken Miss Bea for an angel.

Laid out by the wood-stove, Edward Pettigrew slept for eleven hours straight, but he awoke feeling restless, remembering what he'd done. He shook his head to clear it and checked the contents of his bag. How unlucky, he thought, to have somehow slipped death and found Miss Bea again, only to be tripped up by the crimes he'd committed the night before. Had it snowed, he might be safe. As it was, he'd have left prints all the way through the hills: a decisive left tread accompanied by a soft, trailing right. They'd pick up his scent, the dirty animals, and track him to the hermit's home.

Fear-o-God smoked his pipe. He scowled across at the boy. 'So your pa comes to fetch you. Let him do it, so what? It ain't my concern, what you've done. It's between you and him.'

'It is, though,' said Edward. 'He'll blame you for it all. He'll make out you took me and are holding me captive. He'll make out it was you that caused all the damage in town.'

'Why in heaven would he do that?'

He was addressing the cripple, but it was Miss Bea who replied. She said, 'Because he's ashamed to have the boy as his son. Because he'd be embarrassed to have people know it was his son who robbed the town.' She shrugged. As an afterthought, she said, 'And besides, it is always easier to lay the blame on outsiders. Visiting teachers. Lonely men on the mountain. Those who have power always like to kick those who do not.'

Tomorrow, in all likelihood, their enemies would run them down. Miss Bea had enough knowledge of Pettigrew to suspect that the man wouldn't make the trek in person. He was too lazy, too heavy; she supposed that the shopkeeper was a coward at heart. But he had two men who worked for him and weren't afraid of rough work. That's who he would send into the mountains, she thought. Ferner and Martini, the worst of the worst. They had been coal miners once and jailbirds after that. Ferner and Martini were the ones who would come to rescue the boy.

Fear-o-God was defiant. 'Let them come. I don't care.' He would gut the men like fish, he said. Or he would strangle them both with his bare hands, like this.

'We have this evening,' Beatrice said, watching him. 'We're fine until tomorrow. They're not going to make the trip in the dark.'

In the closed porch of the schoolhouse hung a framed needlepoint motto. 'Every day is God's gift to us. That's why they call it the present.' And while Beatrice had removed most of Mrs Perrot's old effects, she had chosen to leave the motto on its nail-head, because it sent a worthwhile message, one that she agreed with herself. Nobody can say what tomorrow holds, so enjoy the moment and be thankful. These past few days had been difficult. The days that followed might be more difficult still. But here she was, safe and

dry with a roof above her head and good, simple food to make her feel strong again. This is it, she thought. The present, a gift.

The little cabin contained only one chair, so Beatrice Brent sat on the bed while Edward perched on the low footstool, looking as oversized and ungainly as he had back in class. He rooted through his sack and removed the metal canister. This was the film he had stolen from the nickelodeon, the tale of a pretty schoolteacher who was courted and then wronged. They couldn't watch it without the projection machine. But if he unrolled the film and held it to the light, he might be able to show them individual frames and tell the story out loud as he ran the print through his fingers.

Beatrice gestured. 'Not too close to the lantern, though.'

Edward's right hand was not as dexterous as his left, but he managed to unroll a yard of the nitrate film. Now he bent almost double, head bowed, eyes narrowed. His posture was that of a watchmaker at work, or a monk at a desk inking holy letters.

He said, 'Here it is, I can see the mountain, sharp and black against the sky. It's awful small, though. We ought to get more light.'

They repositioned the lanterns and propped the stove door open so that the grate glowed fierce orange. This was as light as it was going to get, Fear-o-God said, unless they waited until daybreak and ran the reel of film through a sunbeam. His cabin was already lit up like a Christmas tree in Time Square.

'Times,' said Beatrice. 'Times, not Time.'

The hermit checked the coal in his pipe. He leaned across to nudge the boy. 'Or we could hold it up in front of her. Look at the way she holds the light. It's like her skin's all aglow, like she's lit from inside.'

'Yeah, well, she's beautiful,' said Edward, almost angrily. 'She's beautiful and she knows it, too.'

'Edward,' she said. 'Please. Continue with your story.'

Fear-o-God drew compulsively on his pipe. He said, 'She glows

The Mountain Eagle

too bright for the backwoods, it's true. That's why she'll be leaving us soon, probably.' The prospect seemed to sadden him. 'There ain't too much that we can offer her here.'

If it were to snow overnight, they might yet be spared. They could latch the shutters and hole up inside while the forest floor filled with snow. She imagined Pettigrew's henchmen – Ferner and Martini – caught by the tail of the blizzard and losing the track, pressing hopelessly on through that blank white country. Things had a habit of getting lost in the woods. People and livestock and precious items from town. They were swept off the path and buried five feet deep, and much of the time that was that. Much of the time, well, good riddance.

'Our story begins in the mountains,' said Edward. 'There's a pretty young schoolteacher and the strange boy who loves her. And there's a villain as well – a wicked fellow from town. Every good story needs a villain, you see?'

Was it snowing outside? Beatrice believed that it might be, and fancied that she could hear it because she couldn't hear it; because the world beyond had stilled and hushed. Fear-o-God explained that a heavy fall in the mountains was nature's way of cleaning up after itself. He'd dwelt for long enough in these parts to know the history of the landscape, to the point where he could point out the charred foundations of burnt-out homes, the overgrown, abandoned mines, even the scratched, faded outlines of the ancient Chickasaw camps. Every visitor came to plant a flag or leave a mark, but they were really only passing through.

'Here's the villain. I've found him, look. He's walking up to the schoolhouse now. I need more light, it's hard to see. But here's the young teacher, with her dress and her hat. She opens the door to let the rich fellow inside.'

Beatrice felt she could risk lying back on the bed. The warmth of the cabin was making her drowsy. She said, 'This story you're telling – does it end happily?'

'You'll have to wait and find out, Miss Brent. I'm not about to spoil the ending, see?'

Outside it was snowing. It might snow through the night. The tracks all covered, the trails wiped clean, the woods turned into crystal canyons. Nature's way of cleaning up. Nature's means of forgetting its past. It meant they were safe, said the hermit. It meant the schoolteacher's prayers had been answered. He said, 'I passed them on to the big man upstairs.'

Beatrice shut her eyes. She was seconds from sleep and very nearly at peace. In a murmur she said that there was no such thing, it wasn't real, and the hermit chuckled and relit his pipe. He said, 'Yeah, that's true, I was kidding. No man in the sky, only the mountain eagle up there.'

Hitchcock Blondes Have More Fun

Lily Samson

It was written in the stars, my collaboration with Alfred Hitchcock. We met when we were both young and unknown, yet to be appreciated by the public.

It all began late on a Tuesday afternoon when I was walking on the Victoria Embankment, carrying a fresh ham and some vegetables for supper. I was eighteen years old. It was 1926: history books will tell you that we were all bobbing our hair and living lives of champagne decadence. My brown hair lay flat and touched my shoulders, and I had no knowledge of how to dance the Charleston, just the drudgery of cooking three meals a day for Harry and keeping his house clean. My wedding ring was forever catching the light and making me squint. These days, I'm not sure where the ring is – when they arrested me, I had to abandon my possessions. I hear collectors and opportunists have broken into my house, so it's probably up for sale on eBay.

But I'm getting ahead of myself. I was walking by the Thames, troubled by the February fog and the sense of a commotion on a nearby street. A man with brown hair approached me. He was very well-spoken: 'I'm involved in filming *The Lodger* – it's going to be in cinemas next year – and some extras have failed to turn up. It's rather a *desperate* situation, you see. Could you possibly help us out? The payment will be three pounds for the day.'

LILY SAMSON

Destiny, you see. I followed the man on to the next street, where I encountered a lively film set. There was a small, plump man sitting in a chair who looked tired. Later, I found out he was the director. He'd even saved money by playing the part of an extra himself. Two minutes into the film, we see Hitchcock sitting at a desk in a newspaper office, his back to the camera. Towards the end, he also plays an extra in a crowd scene who are baying for the lodger's blood; I ended up a few feet behind him. There was a moment when our eyes connected and we both felt the exhilaration of the moment, grinned at each other. As though we sensed that we were making history.

The Lodger, which concerns the hunt for a Jack the Ripper-style serial killer, was a breakout success for Hitchcock. I went to see it at the cinema sixteen times.

Filming on *Number Seventeen* began in 1932. On the day I was due on set, my husband kicked up a fuss.

'What did you say his name was again?' Harry asked. 'Pitchcock?'

'Hitchcock.'

It was a banter between us, this forgetting of his name and my correcting it, conducted with an undercurrent of malice. I had been an extra in Hitchcock's previous two films. In *Blackmail*, eleven minutes in, you can spot Hitchcock sitting on the London Underground, trying to read a paper, when a naughty boy in the next seat tugs down his hat. I played the boy's mother, which gave me three seconds of screentime. In *Murder!*, sixty minutes in, Hitchcock walks past the scene of the crime; as do I, a few seconds after him.

Today I was wearing a new dress that my mother had gifted me for my birthday. I'd trimmed my hair with scissors in the bathroom. Hitchcock liked smart dress and good manners on set. All the men wore a tie.

'I'll be back by five at the latest,' I lied to my husband, knowing it wouldn't be before mid-evening.

'What about my lunch?' he asked.

This was another argument between us that was becoming a script. I'd returned from my filming on *Blackmail* and *Murder!* all aglow, to find my husband complaining that he was starving, hadn't been able to work the stove, even though I'd left written instructions. His cold mood hadn't been able to touch me as I whisked up eggs for him; still bathed in the euphoria of the shoot, I'd felt invincible. Then, a day or two later, came the sadness as life slid from extraordinary to mundane, and the hunger set in again, for the next shoot, which would probably be 365 days away, or more.

'I've chopped up all the potatoes for you, and there's chicken in the fridge...'

'Say you're sick,' he insisted.

'What! I can't – they're depending on me, they need me.'

'*Need* you?' he scoffed. 'Your part will be all of two seconds. Blink and they'd miss you. They can get any old fool to take that part.'

'No, you don't understand, Hitchcock choses his extras with *care*... And this is just the beginning. I'm going to get bigger and bigger parts, and then one day I'll be a *star*.'

His eyes widened, his smile became a smirk. I felt raw, sharing those dreams I nursed at night when I lay awake, sick of his presence beside me.

'Rebecca,' he said, his tone gentle. 'You're never going to be June Tripp. Mr Pitchfork is never going to cast you in a lead role.'

I forced a laugh, but I sounded like Jack the Ripper.

'They're exploiting you. Now, I'm going to go telephone them and say you're sick.'

As he turned, I was very close to picking up the fork lying in the sink and driving it between his blades.

Hitchcock's part as an extra in *Number Seventeen* is disputed by some, but I recognised him clearly. As for my cameo – I often

imagine how I might have been on that bus playing a passenger beside him. It wasn't one of his best pictures, anyhow; I kept reminding myself of that, on days when I was doing the washing up and the pain felt overwhelming.

Two years on, Hitchcock made *The Man Who Knew Too Much*. I missed a part in that too, thanks to my husband's dietary needs. When I watched it in the cinema with Harry, the excited bustle made me angry. Hitchcock was becoming a familiar name: diluted, shared by the dirty masses. Back home after the film, I saw a new line appearing on my face, dour around my mouth, and rubbed butter into my skin. In four years' time I'd be *thirty*.

That night, I suffered a nightmare. I dreamt of future Hitchcocks, of white blank spaces on the screen that signalled roles I'd been thwarted in playing. I dreamt of a woman in a shower, white tiles stark behind her, a knife plunging towards her, and woke up screaming.

In 1935, I watched Hitchcock walk down the street as a red bus passed him.

'*Cut*,' the assistant director yelled.

The whole crew burst into applause. As I clapped, tears stung my eyes. It was so good to be back on set. I had a role for a day, as part of a crowd scene.

Hitchcock turned and nodded at me. Relief was sweet and cool inside me. Five years, one month and fourteen days had passed since my last shoot and I was afraid he might have forgotten me, but in that nod, I saw acknowledgement, redemption: my part might be small, but I was essential. After that day, I began watching films differently. Instead of noticing the stars, I'd focus on faces in a crowd, those on the fringes: shop workers, passengers, diners. And I'd think about how ridiculous the films would be without them, how empty; how we framed the stars; how vital our roles were.

Hitchcock Blondes Have More Fun

My husband kept asking me what *The 39 Steps* actually were. I hadn't been able to glean it myself on set – it was a protected secret – so I improvised and said they led to a secret door. When we finally went to see it in the cinema, it was embarrassing; when the truth was revealed, Harry frowned and said: 'I suppose you and Litchcock thought it was funny to lie to me.'

In 1937, filming started on *Young and Innocent*. When I turned up, they took one look at my swollen belly and said, 'Sorry, Rebecca, it's not going to work.'

A few weeks later, my boy came out into the toilet in a splatter of red. *What a waste*, I thought, *I could've done the shoot if the timing had just been a little earlier*. My husband wept for days. When we went to see *Young and Innocent*, I could barely focus on the plot, waiting and waiting for the moment when Hitchcock appears, and my heart was wild when I finally spotted him, waiting outside the courtroom, taking a photograph. The following year, in *The Lady Vanishes*, Hitchcock can be spotted, fleetingly, outside Victoria Station, ninety-three minutes in.

Then he deserted his homeland for Hollywood. War was declared, making any hope of my travelling to America a hopeless dream. I was cleaning the kitchen when I heard and I broke down sobbing.

People flocked to the cinema during the war, craving escape. I never once sat alone; my elbows were always brushing a stranger's. In *Rebecca*, whilst George Sanders is talking to a policeman, Hitchcock walks behind them. Harry wrote to me from France saying that he was missing me and had lost a finger on his left hand. *Foreign Correspondent* was released later that year. Hitchcock and Joel McCrea walk past each other, Hitchcock relaxed and reading a newspaper, McCrea looking fraught. Six months went by, and I didn't hear from Harry at all. In *Mr & Mrs Smith*, Hitchcock strolls past a hotel as the camera pulls back, the shot widening out until

he's a tiny figure. I thought about that hotel one night during the Blitz, when I was curled up in an air-raid shelter in my neighbour's house; as the sky shook above us, I fought the horror of picturing that hotel smashed to smithereens by arguing that it had been immortalised in his film. Harry wrote again, finally: he was in a hospital in France, badly injured. In *Suspicion*, Hitchcock posts a letter. In *Saboteur*, one hour in, Hitchcock can be seen outside a drug store called 'Cut Rate Drugs'. In *Spellbound*, he emerges from a crowded lift ostentatiously exhaling a mouthful of smoke. One night, when I had put up my blackout blinds and I was lying awake in terror, I pictured Hitchcock inhaling a deep lungful of silky smoke and exhaling it all over me like a soothing caress.

I might never have had the chance to collaborate with Hitchcock again, had it not been for the death of Harry. The grief shattered me for weeks, rendered me hardly able to get out of bed, but I was cheered by the news that he had inherited a large sum from his mother, stored it in a secret savings account. There would be no more make do and mend for me. When my neighbour asked after the FOR SALE sign outside my house, I explained to her that I was going to America.

'All alone?' she asked, looking a little shocked.

'Yes – I'll be in Hollywood. I need a fresh start and I want to return to acting.'

'Acting? You've acted? But I thought you were just an extra...'

'I've had small parts, yes, but Hitchcock's asked for me.'

Her eyes flickered with admiration and a little envy.

'Could I please speak to Mr Hitchcock?' I asked, the telephone cord bound around my wrist, indents burning into my skin.

'May I ask who's calling?'

'Rebecca Frith. You might be familiar with my work in *The Lodger*, and *Blackmail*, and numerous other Hitchcock films.'

A pause, her voice becoming distant as she dealt with another enquiry.

'Can I take a message, Mrs Frith?' she came back to me.

'I already left a message yesterday.'

'Mr Hitchcock is a very busy man, as I'm sure you'll appreciate—'

I slammed the phone down. A new project, *Notorious*, was rumoured to be starting soon. I wanted to be cast opposite Cary Grant. I walked around my living room in circles of eight. The only furniture in my new little bungalow in Eagle Rock, LA, was a bed, a wardrobe and a table. I hadn't even unpacked properly. I had flown over with a number of Melton Mowbray pork pies in my suitcase, knowing they were a Hitchcock favourite which he had to have imported. Unfortunately, they'd crumbled on the journey and their juices had seeped out. I'd washed my clothes several times but there was still a sour pork aura lingering about them.

The dress I'd been wearing on the day destiny chose me for *The Lodger* was a little tight around my hips, and had needed patching up in places, but I put it on for good luck. Then I sat down and studied the map, copying out a route to the Universal Studios lot into a notebook. Before I left, I slipped my wedding ring on. It was easier to pretend that I was still married, my husband away on business; it kept forward American men at bay.

When I arrived at Universal an hour later, I had been expecting to have to skulk around, waiting for Hitchcock to enter or exit. To my surprise, there was already a crowd of people outside the gates. I asked one young woman, who had ginger hair and freckles, if they were part of a shoot.

'They all want to be spotted, honey!' She laughed. 'Just like you and me.'

I swallowed, shocked. She asked me if I wanted to get a coffee downtown.

We sat in booths in a technicolour diner as a thin black liquid was poured into our cups.

'I'm an established actress,' I told Ginger, expecting her to look impressed. 'I had parts in *The Lodger*, and *Blackmail*, and—'

'I've been an extra in sixteen films,' she agreed. 'I've signed up with Central Casting too. None of us want to end up like Bess Flowers.'

'Who's Bess?'

'She's the Queen of Extras.' Ginger smiled as I sipped the coffee, my lips sour with its bitterness. Then she tipped her head to one side, looking curious. 'Was he cruel to you, Mr Hitchcock?'

'Gosh, no,' I replied. I was still practising sharpening my British accent. 'He's the only director who says, "Action" and then adds, "please."'

But Ginger seemed to be thinking of something else: 'I heard he was so cruel to Joan Fontaine on *Rebecca*. He put her down all the time so she'd feel downtrodden, which was perfect for her role. Then she got an Oscar nomination.'

Suddenly I found myself analysing every polite 'hello' Hitchcock had ever given me: not a sign of quiet respect, but indifference. I drank more coffee, hating the taste, the curdle of it inside me, drinking it all down.

Before my interview with Central Casting (which was all thanks to Ginger's introduction), I pictured each moment like an image on a storyboard. The mouth bubble coming out of the woman's mouth asked HOW OLD ARE YOU? and my reply would be THIRTY. When the moment came, she raised an eyebrow. My heartbeat began to flurry, but she carried on going through the questions, nodding and smiling, and I wanted to go down on my knees and kiss her feet for her kindness.

In *The Paradine Case*, Hitchcock carries a cello onto a train. In *Rope*, his silhouette is a flashing red neon sign seen through a window. In *Under Capricorn*, he stands in a town square in historical dress, sporting a top hat. In *Stage Fright*, he walks past a distressed Jane

Wyman on the street and gives her a quizzical look. In *Strangers on a Train*, he wrestles a cello onto the train. In *I Confess*, he appears in the opening sequence a few minutes into the film, the sky wide and bright behind him. I did not succeed in getting roles in any of these films. I was offered roles as an extra in numerous other films, which I turned down.

I feared that Martha at Central Casting might give up on me, and then one day, the phone rang.

My casting in *Dial M for Murder* came as a thrill a first, and then a shock. I was to play an extra on the street, described as an 'older lady'. (Had they found out about my real age? Or was it just Hollywood's designation that any woman over the age of thirty was geriatric, whilst men could age at their own pace?)

Hitchcock's cameo was an appearance in a reunion photo. As for the leading lady, she was barely twenty-three and called Grace Kelly. I found her acting superficial to the point of frivolous. I was convinced we'd seen the last of her. You can imagine my shock when she came back for *Rear Window*, where both Hitchcock and I had roles as extras in the mosaic of apartment windows that Jimmy Stewart gazes out over. And then – a third role! – in *To Catch a Thief*, which I failed to snag a role for at all. There are still some Grace Kelly autographs floating about today which I signed on her behalf: notebooks, scraps of paper, flesh even. I often think about how beautifully I crafted that name, the long curls of my *G*s and the flourish of my *y*.

'She's a problem,' I overheard Alma saying, after Hitchcock had called an emphatic, '*Cut!*' 'It's the hair.'

We were on set at the Paramount Pictures lot; it was hot under the lights. As cast and crew scattered in relief, I found myself patting my chignon. It hadn't been easy, working out how to curl my hair into that taut shiny twist. My first attempt at going blonde had

been a failure, for Ginger had helped me with a home dye. I'd ended up looking like a skunk and salvaged the damage with a trip to an expensive salon. I'd given Maggie, the hairdresser, a photo of Grace Kelly and specified that my hair should be the same shade. 'All the women come in these days with photos of her,' she remarked, drawing on her cigarette. 'Clearly, Hitchcock blondes have more fun!' Her laughter chilled me.

Now, as Daniel McCauley, the assistant director, approached me, I knew that my commitment had paid off.

'It's an issue, you see,' he told me. 'You look like Kim Novak, from behind, and so anyone watching would think it's her… which confuses the story…'

This was it. The moment I'd been waiting for. My name on a press release; Kim quietly dismissed. I felt so overwhelmed, everything blurred: the chatter around me became white noise, Hitchcock's empty chair in the corner of my vision. When I came to, I realised that his words were all wrong. He was saying *sorry*. Telling me that I'd have a day's pay despite being dismissed—

'Look, I can dye it back!' I cried.

'I'm sorry,' he shook his head. 'We have to film it today.'

I regret that I reacted the way that I did. Jimmy Stewart came over and soothed me; he was unexpectedly kind.

Later on, I had a call from Martha at Central Casting, her voice sharp: 'I heard you caused a commotion on set…'

When *Vertigo* was released, the critics panned it. They said it was far-fetched, unconvincing. I relished their every word, cut them out and pinned them onto my kitchen wall. For months, I had sworn not to see it; my savings were also running low and cinema tickets were becoming a luxury. But the pull mounted, became unbearable, and I skipped lunch to finance my ticket, sitting in the cinema feeling sick and dizzy.

Hitchcock appears ten minutes in, at Elster's shipyard. He walks from left to right carrying a bugle case.

Hitchcock Blondes Have More Fun

Two hours later, I left the theatre in a daze; it was a masterpiece. I walked for many hours, all the way over to Bel Air. I had to wait until dark so that I could climb over the fence of the golf course next door, and then into the back garden of Hitchcock's home. The roses were in bloom, their perfume soft on the night breeze. I drifted across the lawn. His swimming pool was a sight to behold: why is it, I wondered, that destiny takes care of a rare few and ignores others?

I could see a figure through the kitchen window. He must have got up in the night for a midnight snack. A jar in his hand crashed to the floor. His mouth was an O. I am sure I saw him mouth *Grace* before he called the cops.

16 June 1960: I was six minutes – just six minutes – late for the three o'clock showing of *Psycho* when I arrived at the DeMille movie theatre, bypassing a queue that had already started to form for the next performance at five. I tried to argue with the guy selling tickets behind the counter.

'See?' He pointed to a large cardboard cut-out of Hitchcock sitting in the foyer. 'It's the director's own rule that there can be no late admissions.'

'But I'm his muse,' I cried.

He blinked, looked me up and down. I was dressed in a white chiffon circle skirt with a black top, pearls around my neck. My platinum hair was coiled into a chignon beneath a white pillbox hat, a white veil covering my face.

'Don't you recognise me?'

'No...'

'I'm Grace Kelly.' I mimicked her accent perfectly.

He looked taken aback. His eyes narrowed. For a moment he wasn't sure, and then a smile tweaked his lips. 'Ha ha – you nearly had me. Please join the five o'clock queue.'

And so I walked in a slow, dignified manner to join the end of

the queue, ignoring the whispers, the raised eyebrows, the nudges. Grace Kelly never broke a sweat about anything (although a bead did slide down my spine as I stood in line). When I finally entered the theatre and sat down in seat C5, I lifted my veil. I felt a little angry that I had no idea when Hitchcock's cameo would occur. The film was black-and-white, which the newspapers claimed was due to the tight budget, Hitchcock having to finance it himself. His cameo came too soon, only six minutes in – standing outside Janet Leigh's office wearing a cowboy hat – and I feared I might be bored. But when the shower scene hit us, I found myself screaming, my hands flying to my face, the white silk of my gloves against my skin. *You've gone too far*, I warned him, *this is disgusting, all horror and cheap shocks*. I resolved to walk out, but the man next to me was having hysterics, his girlfriend soothing him, so I had to stay until the end. By then, I was mesmerised. As the credits went up, there was a long silence, followed by clapping and cheers. I went into the toilet and sat in a cubicle for a long while, wondering how my cameo might have worked. When I came out into the foyer, I drew a moustache on the cardboard Hitchcock, until the usherette came up and told me off, shooing me away.

Given the restraining order against me, I had to return to being a brunette to befriend Hitchcock's daughter. I couldn't bear to dye away my perfect blonde hue, so I opted for a wig, shoplifting it from a store in downtown LA.

It took some months of planning. She had three children, and they seemed the best way in. I would follow them for an hour each day, no more, chatting to Patricia at a playground, a café, until casual chitchat blossomed into a potential friendship.

Patricia and I had lunch at Chasen's together. I tried not to worry too much about the fact that I didn't have enough money to pay my share of the bill. I'd have to pretend I'd lost my purse.

One of the waiters there recognised me despite the wig. I was officially banned after a few 'incidents' earlier this year when I'd attempted to cajole Hitchcock into lunching with me. The staff conferred, but didn't protest; Patricia looked confused and whispered, 'Maybe they think we're serial killers!'

Finally they let us in, drew us to a table at the back.

Patricia ordered the chicken and I asked for the same.

'So, how's filming on *The Birds* going?' I asked eagerly, hoping, praying she had been on set.

'Oh, I'd really rather not talk about my father,' she sighed. 'I'm so sick of being His Daughter.'

'Sure,' I said, my appetite wilting, wondering how I was going to get through this lunch. Then I saw the pain on her face. I'd read somewhere that when she was a child, Hitchcock would come home late from a film set and paint her sleeping face with clown paint, so she'd have a surprise when she woke up.

'You know,' I went on, 'I'm surprised you didn't get a part, actually. I mean, Tippi Hedren – versus you!'

'My daddy doesn't believe in nepotism.'

'You were so good in *Psycho*.'

'You noticed me? Nobody else does. Everyone notices my father's cameos, but me, I'm always the dowdy friend.'

'It's crazy,' I insisted. 'A waste of your talents. I'm really quite furious.'

'But, you know, I'm very happy being a wife,' she asserted quickly. 'Being the mother of three sticky-fingered children takes up most of my energy.'

'Uh-huh.'

'Do you have kids?'

'I had a son, Patrick. He died when he was three. He fell over.'

'Oh God, I'm so, so sorry...'

'Does your father have a cameo in *The Birds*?'

Patricia sighed, but her tone was softer now I'd become a tragedy.

LILY SAMSON

'I think he might have, but he's getting very distracted by Tippi, and something's happened between them. I mean, yesterday they were filming a sequence where she's attacked. She was wearing this coat with birds tied to it by elastic and she got injured – her eyebrow was bleeding, they had to stop. And the look on Daddy's face...'

My heart broke then. He could only be that cruel if he was in love with her.

It was fortunate that our lunch arrived, because I couldn't speak for jealousy. It was as though I'd swallowed the emotion like a ball and it sat halfway to my stomach, so that every breath was a gasp of pain. I chewed and chewed on my chicken but it wouldn't go down – I had to spit it out, see it hit the floor.

Patricia jumped.

I reached out and seized her hand, pressing it tightly. 'I need to be in that film. I need a cameo. I'm out in the cold, you see, and it's a desperate situation.'

She agreed to help but her smile was too thin, and as a waiter came to scoop up the chicken, she apologised on my behalf.

The films that follow *The Birds* also include cameos by Hitchcock, despite his lament to Truffaut that they had grown 'troublesome'. In *Marnie*, he distracted the audience by emerging from a hotel room five minutes in. In *Topaz*, he is in a wheelchair, pushed by a nurse through LaGuardia International Airport, New York.

Ginger introduced me to an Englishwoman called Carole Murphy. She'd been an extra on *The Spy Who Came in from the Cold* and was signed up to appear in *Torn Curtain*: the new Hitchcock.

I took her out for a coffee and then demanded: 'Tell me everything.'

'It's going to be about an art forger – no—' She frowned, laughed. 'I'm getting muddled up. That's *How to Steal a Million*. No, the Hitchcock is a spy thriller. I *think*.'

'You're in a Hitchcock and you don't even remember the plot?' I asked her.

'Well, I'm in a *lot* of pictures.'

I gazed at her: dull brown hair, nondescript face, bottle glasses. The perfect extra.

'Let me have the role,' I begged her. 'I'll give you money. Contacts.'

'Oh, I don't think so.' Something flashed in her eyes: an opportunity for minor victory, humiliation. 'I've been handpicked.'

'But if I dyed my hair back brown, we'd look the same…'

'I'm fifteen years younger than you,' she pointed out.

A hot silence between us. Then she reached out, her hand quivering over mine.

'I'll do it,' she whispered, 'if you come home with me…'

At her apartment, I saw a copy of *The Price of Salt* lying on her kitchen table, which confirmed her intentions. I offered to cook for her and she smiled, lounging on her couch with a script on her knees, making notes in the margins. As I cooked, she told me that the omelette smelt delicious. If this had been a movie, I'd have had some arsenic to hand that I could crumble in, but I had no idea where one might procure some. My hands were shaking and I felt the danger of temptation. My despair was a black hole. I did not want to want this, but my desire defined me; I was caged by it. We can't control what drives us, those forces of childhood pain, wrong turns, bad choices, that coalesce and cause you, one late Thursday afternoon, to dish up an omelette on two plates, and then take the frying pan and slam it into the face of an innocent woman so that she falls to the floor.

Blood ran from her head as though it was a broken red yolk.

I went over to the couch, picked up the script she'd been reading, only to find it was some piece of crap for a second-rate director. Horror crawled over me as I went through her papers – *what if she'd been lying about the Hitchcock role and I'd killed her for nothing?*

And then I found the paperwork for *Torn Curtain*, a contract – no script, though. Destiny, as though the universe was responding to my act of daring: the telephone rang. It was Martha from Central Casting, making sure I was ready to turn up to the set at nine o'clock tomorrow morning. *You bitch*, I thought furiously, hearing the cheerful sing in her voice, *you bitch. You fire me and then give work to someone like Carole.* I mimicked Carole's voice perfectly as I told her I'd be there.

In *Torn Curtain*, Hitchcock has a cameo eight minutes into the film. He sits in the lobby of the Hotel D'Angleterre holding a small child on his lap, looking tender and paternal.

I turned up promptly at nine o'clock. I was wearing Carole's bottle glasses and I could barely see through them. Nobody questioned me; it was almost disappointing.

I had slept in her bed last night. I hadn't moved her body from the kitchen. I hadn't really known where to put it, and I'd feared that I'd smear blood across her carpets, which felt disrespectful, however foolish that sounds. I hadn't noticed the scribble on her calendar indicating that her cleaner was coming this morning. I had wanted to invest my energy in preparing for the role. In that respect, I was a much more committed actress than a murderer.

I was delivering my sole line when the sirens began to scream and I felt my heart clench, knowing that I would never make it into the final cut.

My arrest and subsequent imprisonment in Holloway – for I was extradited back to the UK – meant that I was unable to watch *Frenzy* upon its release in 1972. Sometimes this was a consolation. I would sit for hours in my cell, gazing out at the sky, ignoring the girl in the bunk below me who had a habit of whistling incessantly. And I'd imagine how Hitchcock's cameo might play out, if he was on a bus or a train or carrying a flute or walking a small dog.

Sometimes the frustration was unbearable. Then I would write letters to various people – Patricia Hitchcock, Ginger, Central Casting – asking them to tell me the plot and how he appeared. They did not reply. I became suspicious that the warden was hiding my letters. I feigned a spiritual crisis and begged to see the chaplain, asking him to intervene. I requested that I see the film, but he failed to arrange it for me.

Then, one day, a few years on, I was choosing books from the library when I passed the common room where the TV blared. And I realised it was the start of *Frenzy*. I ran up to the TV set, turned up the volume, sat as close as I could (my vision was becoming poor, a cataract poisoning one of my eyes). I yelled at everyone in the room to shut up. When they threatened violence, I threatened worse.

His cameo was only three minutes into the film. Hitchcock wears a bowler hat, blends into a crowd, as Sir George pontificates on the Thames.

I did not like the film. The elegance, the restraint of his classics had gone; the consciousness behind the camera was too sadistic, took too much pleasure in the rape and murder of Babs. His fault, for betraying me and locking me away. Until my sentence was over, he would carry on going downhill without me to guide him.

But something about the sight of his celluloid self had felt religious, I tried to explain to the chaplain later that week. As though the anger left my heart, as though forgiveness flowed. It had served as the absolution I had craved.

In 1986, one month after my release, I entered the Notting Hill Gate cinema for the afternoon performance of *Family Plot*. They were reshowing the film a decade after its initial release. Hitchcock's reputation was growing beyond his death; *Sight and Sound* had listed the much-maligned *Vertigo* as runner-up in its list of the Greatest Films of All Time.

LILY SAMSON

As I paid for my seat, I was afraid that the ticket seller might spot the glint of metal in my handbag. I was a little disappointed when she passed over my ticket with a smile. *Destiny*, I thought. I shuffled into the cinema and sat on seat C5, tweaking my hearing aid. There were around thirteen others scattered around the theatre. I balanced my popcorn on my lap, which served as a cover whilst I slid the gun out of my handbag. My lifetime of cameos flashed before me: those luminous days that I would always be proud of, immortal on celluloid.

I had to wait forty agonising minutes for Hitchcock's cameo: a silhouette behind the door of the Registrar of Births and Deaths. Then I pressed the gun to my temple and pulled the trigger. I saw my blood spurt across the popcorn before it all went dark, just as it does in that magical moment when the lights hush and a film is about to start playing.

Coat Check

Keith Lansdale and Joe R Lansdale

Everything was black and white, until I let in the grey. Decent job. Decent house. That was more than some people had. Though, there were people that had it better. Like Chester.

Chester had been where I was, once. Getting by, hoping for a miracle. And then he found it. He'd landed a job that paid enough he could have picked up the cheque on my life a few times. We'd been friends forever, stretched through grade school and right into adulthood. Those friends that you always say you're going to reach out to more, but never get around to it. One of the reasons I'd agreed to meet for dinner that night.

Some steak place. I can hardly even remember what it was called. Buckhorn, or Butcher's, or Benny's? I felt pretty sure it had started with a B. I'd never heard of the place, as it was something local a couple towns over where Chester lived. Where he lived in his big house and lived his big life.

If you'd asked me at the time if I was jealous, I would have gladly claimed how proud I was of my good friend. How he'd made it out of the sticks and made something of himself. Something I'd not been able to do. But I can tell you now, it burned my gut so much it felt like it was going to punch a hole clean through.

The place was dimly lit, a real date-night joint, and Chester waved

his finger at me as he saw me walk in, unable to speak, being mid-sip of his beer when he'd spotted me.

I draped my coat over the back of the chair. He shook his head disapprovingly and sort of snapped his fingers at a waiter passing by as he stood up to get his attention.

'Have the hostess come check this coat for us,' Chester said, and turned away from him before he even responded. He embraced me. Chester had always been a hugger. I was not, but I made the exception for my oldest friend.

The hugs turned into pats on my back, and we took our seats. He offered me some bread in a basket. He had already worked his way through half the loaf.

'I'll probably just stick to the meal,' I said. 'Trying to watch the ol' waistline.' I playfully patted my stomach as it jiggled in response.

'Oh, you look great,' Chester said. 'But if you change your mind, let me know, because I am going to leave no prisoners over here.'

The hostess appeared behind me already holding my coat and handed me a check number. Number 39. I sat it on the corner of the table.

He was quiet for a moment and just took me in. 'Andy, it's so good to see you,' he said. 'It's been a minute.'

'It has been a minute,' I said. 'I kept meaning to pick up the phone.'

'You still working at that...' he paused. 'What was it?'

'Night-watchman,' I said. 'Mostly just keep an eye on a couple city properties so the kids don't get in there and mess with it.'

'I remember when we would have been those kids,' he said with a laugh.

He was right. We'd been what the fancier people in town would have referred to as 'misguided juvenile delinquents'.

But kids will be kids, which is precisely why my job exists. I

Coat Check

swing a mean flashlight as I walk what I playfully call my beat. A little stretch with a museum, the gift shop, and the Bates Cemetery. Officially we'd tell people that we don't want anyone in there after hours because they might get hurt, but grave robbery was a threat, though it had never happened at the Bates Cemetery. But there had been a rash of it over the last few years, kids stealing bodies as some kind of sick joke, sometimes putting them, or their bones, in public places. Sometimes they took something of value from the body.

But in our cemetery, we ran a tight ship. In truth, it was more about keeping those kids out, keep them from leaving bottles laying around and sowing their wild oats, as I'd refer to it in polite company.

'And you,' I said. 'Still working down at the docks?'

'Let's not talk about that,' he said. 'We didn't come all this way to talk about work. You seeing anyone?'

I shook my head. 'There was a woman for a bit,' I said. 'But you know how it goes. It all starts in a frenzy and ends calling each other psycho.'

'Well, I hope you won't mind me bragging a bit,' he said and pulled out his wallet. I noticed he had enough bills inside that it didn't even close well. But he drew my attention to the picture of a long-haired beauty.

'We've been together two years this month,' he said. 'Things are all starting to come together for your old pal Chester.'

'I'm proud of ya,' I said. 'I really am.' The hole in my gut burned.

'You know what I've been thinking about?' he said, then answered before I could even respond. 'That time we almost died.'

'Which time?' I said with a chuckle.

'You remember,' he said, 'that time we were coming back from Louisiana, and we passed that slow truck and you hit…'

'That loose gravel,' I said, laughing. 'We didn't flip it, we just sort of fishtailed a couple times and hit the ditch.'

'We almost flipped,' he said. 'It was on its side for a minute.'

'Then, boom!' I said. 'Fell back on all four wheels.'

It was nice to catch up. Nice to laugh with someone who remembers all the stories too boring to tell, but exciting because we lived them.

The rest of the meal wasn't much to remember. Chester dropped a couple of those large bills on the table at the end and told me this one was on him. I appreciated it, as I had concerns about what the rest of my week looked like after seeing the prices.

I exchanged my coat check number at the check desk, and Chester and I stood out front of the restaurant, both enjoying our conversation enough that neither of us was in a hurry to get back. Despite the feelings I had about my situation stacked against his, I really did enjoy his company.

Through the restaurant's window, a man was looking at me like he knew me or Chester. He stood up and went away from his table, even though his plate on the table was full, most likely just delivered. Then I lost him in the crowd.

'Any chance you'd want to come back and tie one on?' I asked.

Chester looked to be considering it.

'You know what,' he said. 'The lady is out late, I got nowhere to be tomorrow. Let's do it.'

We took our own cars, and I led the way back to my place. His brand-new car, fresh off the lot, following behind mine, which had a good chance of dropping a bumper if I hit the wrong pothole.

As we drove, I noticed a car had whipped in behind us as we left the restaurant. I had the impression it was following us, but then it was marooned by a red light, and I decided it had been my imagination.

One thing I do like about my house is the privacy. It's nestled on a spot well beyond a neighbourhood, positioned in some trees. The house itself isn't anything to crow about, but then again, it's a few healthy steps above a shack held up with a stick.

Coat Check

I flipped on some lights and went to the living-room bar next to the fireplace and asked what Chester would like. I fixed him and myself a drink.

As I prepared to sit down – Chester had already staked out my favourite chair – I took off my coat and flipped it over the back of the couch. When I did, I noted in the bright, living-room light that the coat was dark blue, not black. My coat is black.

I set my drink on the arm of the couch, interrupted Chester mid-story, and said, 'That's not my coat.'

'What?'

'Not my coat. They must have looked at the claim check wrong, gave me the wrong coat. I didn't even notice.'

'Call the restaurant and see if they still have your coat, and you can set up an exchange.'

'Good idea.'

But at that moment, car lights flared through the window glass, and there was the sound of someone laying down on their horn.

After a long blare of that mechanical voice, it stopped.

I rushed to the door, followed closely by Chester. The car was pulled up in my drive, behind my junker. Chester had parked at the kerb. A muscular man slipped gracefully out of the driver's side, and without slowing down, made his way across the lawn to the porch steps.

'You stole my coat,' he said, hulking over both myself and Chester.

'Accident,' I said. 'Just now realised it. I was going to call the restaurant.'

'Where is it? Where's my coat?'

He pushed past us, into the house, said, 'Where's my goddamn coat?'

Then he saw it on the back of the couch. He was wearing my coat, and he peeled it off like he was ridding himself of a poisonous cloak and dropped it on the floor. I noted that hooked into the back of his belt was a small gun tucked into a holster.

'Hey, man,' I said. 'I didn't invite you in.'

'Like I care,' he said, picked up his coat, and poked his hand into the coat's inside pocket. He pulled out a yellow slip of paper and held it up. He looked at it, took a deep breath, pushed it back where he found it, and turned to examine us.

'You tried to steal my coat,' he said. 'You tried to steal my future.'

'Don't be ridiculous,' Chester said. 'They gave you both the wrong coats.'

'But you kept mine,' the big man said.

'I didn't know I had yours until a moment ago. Hell, you were wearing mine.'

'They aren't even the same colour,' he said.

'Restaurant light was dim,' I said. 'They both looked black in that light.'

'Bullshit.'

'Really,' Chester said. 'Be reasonable. We go out to eat, and our plan all along is to swap coats with you?'

'Maybe not your plan, but someone's.'

'What the hell, man?' I said.

Logic was out the window. Whatever was in his pocket was making it tough for him to see reason.

'I ought to give you both a good thrashing,' the big man said.

'That won't be necessary,' Chester said. 'You have your coat. Now you can go.'

'I can't abide a thief,' he said. 'I ought to shoot holes in the both of you.'

'For Christ's sake,' Chester said. 'It's obviously an accident.'

But the big man was having none of it. He was obviously upset beyond reason; one nut shy of a peanut patty. He reached back for his pistol, but as happy fate would have it, he got his fingers tangled in his coat, giving me enough time to rush him and take his legs out from under him, driving him backwards toward the fireplace.

Coat Check

When his head hit the brick hearth it made a sound like an elephant standing on a watermelon. It was the kind of sound that made you sick to your stomach.

I climbed off him and took the gun from his limp hand before I tossed it on the bar.

'Wait a minute,' I said. 'He's not moving. Hell, he's not breathing. Jesus, call the cops.'

'I don't know,' Chester said.

'What do you mean, you don't know?'

'I'm just saying,' Chester said. 'I don't know.'

I started towards my phone and Chester caught up to me and grabbed my arm.

'Can we talk about this a second?' he said.

'Talk about what?' I said. 'It was an accident. It was self-defence. The cops can tell that.'

'Can they?' he said.

I thought a moment.

'Plus, down at the dock, you know, cops have been sniffing around already. Some tough guys trying to muscle in. Some of my guys muscled back. I didn't have anything to do with it, but now I'm caught up in it, and with this...'

'You think this is one of those guys?'

'No. But what I think, all that's happening with the dock business, it could flash back on me. Maybe you, too.'

'Me?'

'You're the one killed him,' Chester said.

I was standing, looking down at the dead man. I noticed for the first time that he was also wearing two-tone, black-and-blue shoes. They were Italian style, long toes, fine leather.

To hell with the shoes. To hell with the coat. To hell with the dead man.

'Maybe we just get rid of the body,' I said. 'Just move past it.'

'Yeah,' Chester said. 'That sounds right. But how?'

'I got an idea,' I said. 'I got two ideas. One for him, one for his car.'

It was handy having access to a cemetery. Only the dead could have seen us punch in the gate code and drive inside. I tooled down the little blacktop road that split the cemetery and parked in the back near a grove of oak trees that bordered the cemetery's back fence.

Me and Chester got out of the car, and I opened the trunk. The big man was in there. We had wrapped him in large black trash bags. One slipped over his head, the other over those fancy shoes. He was mostly covered.

I had tossed in a couple of shovels from the garage. There was a freshly covered grave with old lady McEntroy in it; a socialite who had died from being too damn old to live. The dirt on her grave was easy to dig, so we dug.

We got to the coffin surprisingly quick. Mrs McEntroy looked as dead as before. She was still wearing her expensive necklace, as if she might have some plans for the evening, and on her wrist was her fine expensive watch, as if time was of an essence even in the grave. She was so small, the big man fit right on top of her. I tossed his pistol in the coffin with him and closed the lid. We closed up the coffin and re-mounded the dirt. I worked it so that it looked pretty much the same.

'That was smart,' Chester said. 'Smart.'

We went back to my house. I gave Chester a pair of gloves to hide his fingerprints, and then he followed me in the dead man's car down my road onto a small path that cut into the woods. We drove until the road ran out. We left the car there. Eventually, the car would be found, but there wouldn't be a body. Maybe they'd think he'd gone off in the woods and topped himself. It could be like that. Cops liked easy answers. And if they didn't like that answer, they still didn't have the body.

Coat Check

When we got back to the house, Chester said, 'Thanks, man. This'll keep the heat off of me.'

'If there was ever any heat on you. We got no idea what that guy was about.'

'Either way, we don't have to deal with the cops,' he said.

'Hard to imagine a guy like that being missed.'

'You done me a solid, man. The dock business, it's got me up against the wall. Lawyers taking my dough. I'm not doing as good as I act. Living above my means, you know.'

'Go home,' I said.

I looked at my coat on the floor. I couldn't believe it. A man was dead because of that damn coat.

We probably didn't need alibis since we weren't suspects in any crime, but Chester and I made sure our stories matched. We ate, we came here, we talked about old times, he went home. No mention of the coat. No mention of the gun. No mention of Mrs McEntroy's new roommate. It was the truth without the complications.

After Chester left, I finally went to bed, but I might as well have been sleeping on a bed of nails. I tossed and turned. Who the hell was that guy? And what was he so worked up about? What was in his coat pocket?

Damn. I was so caught up getting rid of him, I had forgotten about the paper he was so happy to see.

The more I thought about it, the more I thought whatever that paper was, it was important enough to set him off. He had called it his future. It probably meant money. It's always money. And I needed money, and then I got to thinking maybe whatever was in his coat might be something I could profit from. It was that kind of late-night idea that won't go away.

About three in the morning, I got out of bed and got dressed. I had become obsessed with the idea that there was something in that coat pocket I could profit from. A winning lottery ticket. A locker number that might have something in it of great worth. You

wouldn't go that whacky over a laundry ticket or some such. It had to be something truly important.

I drove to the cemetery, and got through the gate and out to the grave only to be greeted by Mrs McEntroy and her new friend open to the world. I had buried these two only hours before, and now the grave and the coffin were wide open.

The man was missing the coat. And those fancy shoes. He was in stocking feet and one of the socks had a hole in it and his big toe was sticking through. McEntroy's watch and necklace had also vanished.

I picked the gun out of the coffin and covered the grave.

It wasn't long before morning, but now I was preoccupied with that missing stuff. It was simple. There was only one other person who knew what was in the coffin, and Chester had mentioned he was living beyond his means. He had to be thinking like I was thinking. What was in the coat pocket, and did it mean money?

He had watched me put in the gate code, so it would have been easy for him to memorise it. All he needed then was a shovel.

More I thought about it, more certain I was that was the case.

Why should he profit from what was in that coat? Hell, I was the one that killed the bastard. I was taking all the risks.

I parked out front of Chester's place and checked to see that the gun was loaded. It was. I jumped out of my car and started up his drive.

The sun started to cut through the darkness as I approached the front door.

I knocked against it and waited. I knocked again. I realised I was still holding the gun and tucked it into my belt as the door opened and was replaced by Chester.

'Andy?'

'Let me in.'

He started to move then hesitated.

Coat Check

'What's going on?' he said.

I pushed into him and went into the living room and started to search.

'Where is it?' I said.

I started to push things around, looking to find where he had tucked the coat away.

'Where is what?' he said.

'Don't give me that shit,' I said. 'The coat. Where is the coat? Where's my future?'

'Your coat?' he said. 'Your future?'

'You know what coat,' I said. 'I'm wearing my coat. The guy's coat. The dead guy.'

'We buried it.'

'Yeah,' I said. 'We did, and then you dug it up.'

'What?'

'You were thinking what I was thinking,' I said. 'That the thing in his pocket, his future, was probably worth something.'

'That's crazy.'

'Answer me,' I said. 'Where is it?'

I threw pillows from his couch, looking to see if it was tucked behind them.

Chester took a few steps towards a closet near the front door.

'Is it in there?' I said, and sprung to cut him off.

He darted and grabbed at the knob as I got there. I pulled the gun, pressing it against his chest.

'It's in there,' I said. 'Right?'

Chester shook his head no.

'Then why were you going for the door?'

I pushed Chester away using the barrel of the gun and opened the closet door. There were coats inside, but nothing that looked like the coat we had seen.

There was also an umbrella and a bag of golf clubs.

'Is it in here?' I said, still looking at everything.

'No,' Chester said his hands up defensively.

'Just trying to hit me with a golf club?' I said, waving the gun at the clubs and umbrella.

Chester took this as his moment and leaped towards me.

He was quick, but I was quicker, turning the gun and firing.

He grabbed at me, but his eyes had turned glassy, and his grip started to twist loose.

He opened his mouth to speak, but nothing came out. He fell into a pile at my feet.

What I had done didn't fully hit me right then. All I could think of was, where is that damn coat?

We were well into the morning by the time I had finished turning Chester's place upside down. If it was there, I hadn't found it.

I sat on the edge of the couch and looked at Chester's body. A pool of his blood had finally stopped creeping toward the front door and was starting to harden.

Then it hit me. His car.

I sprang out the door and ran headfirst into a woman I'd seen before in the picture Chester had shown me.

We both stopped, taking each other in. She dropped some bags and let out a scream that was my starter pistol, and I took off toward my car.

It didn't take the cops long to find me. I told them about the man and his coat, but he no longer had a coat. All they deduced is that I had killed him and tried to dispose of the body, Chester had witnessed it all, and I was afraid he'd talk. It didn't matter if the man in the grave's death was an accident. I had also killed Chester, and that wasn't an accident.

I sat in my cell, awaiting trial. It was all about procedure at this point. Bureaucratic process. Chester dead. Me covered in blood. In possession of the gun used. The house torn up from top to bottom. They'd decided we'd gotten drunk and gotten into an argument.

Coat Check

As for the man in the grave, he was identified as a swindler and a forger. As for the ticket, it was long gone and I still didn't know what it meant. Maybe it was a laundry tag.

First day of my trial, couple deputies came into my cell and shackled my legs and hands, and carted me over to the courthouse. They sat me down next to the guy who they had appointed as my lawyer. At this point, it was just waiting for all the due process to happen.

My lawyer leaned over to me.

'Try to look like you're sorry about what you did,' he said. 'Maybe we can win over a juror or two.'

I looked into the juror box to see if anyone looked sympathetic to my situation. No one really stood out.

But one guy caught my eye. A young guy. Eighteen, maybe. Sort of rough and smug looking.

He had crossed one of his legs, and I noticed his shoe. Two-tone, black and blue, Italian style, long toes, and fine leather.

It was only then I noticed he was wearing the dead man's coat.

Killing Hitch

Peter Lovesey

ALFRED HITCHCOCK PRESENTS… KILLING HITCH…
1/04/2025
 Cue music and intro sequence, cartoon sketch and silhouette.

1 INT. STUDIO EVENING

 HITCHCOCK (to camera)
Good evening, ladies and gentlemen. Have you ever given thought to the initials your parents imposed on you when you were too small to have any choice in the matter? Probably not. My suspicion is that they didn't give much thought either. But if you were called Roger Albert Tate, you might come to regret it later in life. Or Mary-Ann Dixon. Or even Susan Iris Nash. Do you see where I'm going with this? I met a man the other day called David Eric Angus Dean and his friends called him Lazarus.
 Fortunately I don't have a problem like that. I'm rather proud of my initials.

Turns to a white board and, using a black marker, writes *AH* in one-foot-high letters that he encloses in a head-and-shoulders outline slightly larger than life, speaking as he writes.

Killing Hitch

> HITCHCOCK (cont'd)
> My parents called me Alfred James, but as you know, I don't use the James. I'm happy to be Alfred Hitchcock. The little word 'ah' encapsulates my personality to perfection.

Turns to face camera with his head now encircled. As he speaks, an unseen knife-thrower punctuates some of Hitchcock's sentences with the thud of the knives hitting the outline behind him. He speaks on obliviously.

> HITCHCOCK (cont'd)
> My tender side – which is not often seen – is expressed by the elongated 'Aah' I emit when looking into a pram. I can never understand why the baby always screams. (*Thud.*) Then there is my full-throated 'Ah!' when I get a surprise. I *adore* surprises, as you know from this television series. (*Thud.*) Before each show I like to exercise my voice muscles using a simple vocal exercise: 'Aaaaaaah.' (*Thud.*) Yet another 'Ah' is the softly spoken one that I voice at intervals when someone like yourself starts telling me a story you think will be ideal for television. It usually means I'm bored out of my skull but too polite to tell you to shut up. 'Ah.' (*Thud.*) Finally, there is the bloodcurdling 'Aargh' when I get my comeuppance. (*Thud.*) Which brings me to tonight's entertainment.

Turns fully to look at the board and the hilt of a dagger is seen sticking out of his back.

> HITCHCOCK (over his shoulder to camera)
> Ah. How did that happen?

Run titles for 'Killing Hitch'.

PETER LOVESEY

2 EXT. WILSHIRE BOULEVARD EVENING

Establishing shot of Wilshire Boulevard. A limousine pulls into drive of Beverly Hills Hotel. Doorman opens rear door and portly male figure in Homburg and black suit steps out. We follow from rear as he crosses lobby and enters restaurant.

3 INT. RESTAURANT EVENING

His hat is taken and he is escorted past rubbernecking diners to table where blonde awaits. She stands and they shake hands formally. When seated, he turns to camera.

HITCHCOCK

You're right. It's me again. Uniquely, this episode is almost entirely about me. But if you think you deserve a pat on the back for recognising me, think again. I don't like to brag, but thanks to my television series and the cameo appearances I make in my films, I am the most highly visible director in the world. When I walk into a restaurant, everyone knows Hitch has arrived – the waiters, the bartenders, the musicians, the other diners, even the skivvies washing up in the kitchen.

Being so recognisable has some curious consequences. Gentlemen bearing a passing resemblance to me regularly win first prize in fancy dress competitions. Every portly fellow of a certain age seems to believe he can pass himself off as me. I get offers to be my stunt double, regardless that I don't do stunts. I do use a double from time to time for long shots when I am unable to be on set to film my walk-on appearances, but if that tempts you to apply for the job, forget it. I don't need another double. Besides, I pay peanuts.

Killing Hitch

If you're troubling your head wondering who my companion is, don't fret. You're unlikely to have heard of her. I wish she were Grace, but Grace is being a princess in Monaco. My fault entirely. I made a film on the French Riviera called *To Catch a Thief* and made it too well. Caught the thief and lost my star performer.

I'm currently looking for an actress for my next movie. This young lady is on my shortlist. I'll say no more than that.

Turns to her and speaks unheard for a moment before turning to camera.

You can buzz off now. This is a private meal.

4 INT. BEVERLY HILLS SUITE EVENING

Hitchcock alone, dressed in bathrobe, seated on bed with pillow behind him, watching a Grace Kelly movie.

Knock on the door.

HITCHCOCK (shouts)
Come in. It isn't locked.

A waiter closely resembling Hitchcock (the part is played by the same actor) but dressed in hotel livery and with a wig, glasses and moustache pushes in a trolley with supper including an uncorked bottle of wine and silver cloche plate covers.

Hitchcock gives him a long look and a frown before facing camera with eyebrows arching.

HITCHCOCK (to waiter)
This is awfully late in coming. It's more than an hour since I placed the order.

PETER LOVESEY

WAITER (in Cockney accent)

We was run off our feet downstairs, sir. I'm proper sorry it's late. Gutted, in fact.

HITCHCOCK

Are you Australian?

WAITER

British, sir. London, born and bred. Can I pour you a glass of wine, Mr 'Itchcock?

HITCHCOCK

How long has it been uncorked?

WAITER

The sommelier 'imself pulled the cork twenty minutes ago, sir.

HITCHCOCK

Very well. Put it on the bedside cabinet.

Waiter pours wine and deposits it as instructed, lifts tray and stands by, uncertain where to place it.

HITCHCOCK

On my lap, man. On my lap.

Waiter turns towards bed and hesitates again.
 Close-up of Hitchcock's bulging belly. He has no lap.
 Hitchcock pats the bed beside him.
 Waiter, embarrassed, frowns.

HITCHCOCK

The tray, man, not you.

Killing Hitch

Waiter puts tray down.

WAITER
Want me to lift the cover for you, sir?

HITCHCOCK
No. (to camera) He's trying for a tip. (to waiter) What's under it?

WAITER
The steak you ordered, sir, medium rare and double thick.

HITCHCOCK
What's under the other cover?

WAITER
The ice cream, sir.

HITCHCOCK (to camera)
Here's a typical Hitchcock moment. None of us knows what is actually under that silver cover. It could easily be a live tarantula. Do you want to cover your eyes? Is your heart racing? I'm tempted to keep you in suspense by prolonging the dialogue with the waiter, or cutting to another scene, but I'll spare you this time. (to waiter) Show me.

Short pause.
Waiter removes cover and reveals a bowl of ice cream.

HITCHCOCK (to camera)
So we can all relax. Those of you who know my methods as a director may have guessed it wouldn't be anything unpleasant. That would have been shock, rather than

PETER LOVESEY

suspense. Shock is a crude device, a cliché of melodrama. In my shows, I avoid clichés like the plague, which is a cliché in itself. (to waiter) How long have you been working here?

WAITER
Six weeks, sir.

HITCHCOCK
And nobody told you how I like my food served?

WAITER
It was 'ow the kitchen give it to me, sir.

HITCHCOCK
They were playing a game with you. Every restaurant I visit knows about my steak and ice cream diet. I eat the steak first and then, twenty minutes later, the ice cream is served. Twenty minutes. Do you hear me?

WAITER
Yes, sir.

HITCHCOCK
Followed five minutes later by the second steak and, after a further twenty minutes, my second portion of ice cream. Does that sound excessive to you?

WAITER
It's not for me to say, sir.

HITCHCOCK
I asked for your opinion.

WAITER

If you want the honest truth, it's more than I could manage.

HITCHCOCK

What's the matter with you? You're every bit as large as me. I am reliably informed that Mr Orson Welles can put away two servings of steak, a baked potato, an entire pineapple and three bowls of pistachio ice cream, all washed down with a bottle of scotch. This ice cream is starting to melt.

WAITER

Want me to take it away, sir?

HITCHCOCK

Certainly not. I'll have it as my appetiser. You can bring me a second portion after I've eaten the steak… in how long?

WAITER

Twenty minutes, Mr 'Itchcock.

HITCHCOCK

And after you've served me with my second steak, I will need a third bowl of ice cream.

WAITER

Very good, sir.

HITCHCOCK

It had better be.

Waiter exits with trolley and closes door.

Hitchcock lifts a spoonful of ice cream to his mouth, hesitates and returns it to the bowl.

> HITCHCOCK (to camera)
> You're thinking I treated him harshly. I didn't trust him. Did you notice the superficial resemblance to me? Take away the wig – it was obviously a rug, wasn't it? – and the Hitler moustache and you have yet another Hitch lookalike. Extremely odd. Is he really a waiter? He was dressed for the part and played it moderately well, but I caught him out over the matter of the ice cream. What if he's an impostor? The order was late in coming. What if he's an out-of-work actor trying to impress me, waylaid the real waiter, locked him in a storeroom and stole his uniform? I, of all people, am aware how costume gives conviction to a performance.

Looks down at tray and shakes his head.

> Here's a dilemma, ladies and gentlemen. I'm hungry. The ice cream looks delicious. I can smell the steak, but should I eat any of it? If he's an impostor, what's his game? Does he wish me harm? Could he have doctored the food in some way? Is the wine a Mickey Finn?

Pause.

> If so, what's his motive? I have little here that anyone would want to steal.

Close-up as he rotates his wedding ring on his finger.

Killing Hitch

I am known as the master of suspense and the king of surprise. When you watch a Hitchcock movie you expect to be bamboozled. People say I must have a devious mind to think up the plots. Am I reading too much into this little episode? What do you think? For all I know, he could be planning to murder me. Somewhat overblown as a theory, I agree, but it has to be considered, and I would look awfully stupid if I dismissed it. But why? I return to the question I posed before: what's his motive? I'm an entertainer, for heaven's sake, bringing pleasure to millions. Why would anyone want me dead? Me? I can't see it.

Lifts the spoonful of ice cream to his mouth again. Draws it away and looks at it. Sniffs it, all done slowly, building suspense with music adding to the effect. Finally he puts it in his mouth, swallows it, gives a suspicious look, frowns, waits a beat, then grins at camera.

Perfectly... Aargh.

His body convulses. Eyes bulging, his head sinks lifelessly onto his shoulder.
Freeze frame of his deathly grimace. Music reaches a crescendo and stops. After several beats Hitchcock comes to life and grins.

HITCHCOCK (cont'd)

Testing you out. You didn't think the crime would be so obvious in one of my shows? Of course the ice cream is all right. The taste is good, but I wouldn't describe it as ice cream to die for. The steak will be safe to eat and I can drink the wine in confidence. Rest assured you can leave me to enjoy my supper.

Cut to:

PETER LOVESEY

5 INT. HOTEL CORRIDOR EVENING

Back view of waiter pushing his trolley at a fast rate.

 The blonde seen earlier is moving towards him. He gestures hurriedly for her to pass on, then turns and gives a wolf whistle. He moves on fast, with a quick glance at a door labelled Housekeeping. Turns a corner, leaving view of empty corridor.

END OF PART ONE

PART TWO: Next day

1 EXT. WILSHIRE BOULEVARD MORNING

Two police patrol cars race towards hotel with flashing lights and sirens. They draw up beside two other parked police vehicles. Officers in uniform and plain clothes dash through hotel entrance.

2 INT. HOTEL LOBBY MORNING

The area is busy, and the majority appear to be young women, wannabe starlets. Police enter from POV of the hotel manager who is waiting prominently, deeply concerned. He stops one of the officers.

 MANAGER
Who is your senior officer? I'm the hotel manager.

 OFFICER (points to a plainclothes detective)
Lieutenant Wright, sir.

Long shot of manager hurrying across to Lt Wright and conferring. They move across the lobby to manager's office.

3 INT. MANAGER'S OFFICE MORNING

Manager, nervous of being overheard, closes door and they remain standing. Lt Wright is painstaking and unshockable.

> MANAGER
> I don't know how much you know, but we have a situation here.

> WRIGHT
> A report of a violent death. That's why we are here, sir.

> MANAGER
> Yes, but do you know who the victim is?

> WRIGHT
> That's part of our remit, sir. First we need to look at the scene and seal it. I hope you and your staff haven't corrupted it in any way, aside from the person who discovered the incident. Who was that?

> MANAGER
> Someone from housekeeping. This isn't the point.

> WRIGHT
> Pardon me, sir, but from here on we decide what the point is.

> MANAGER
> For Christ's sake, man, Alfred Hitchcock has been murdered in my hotel. Hitchcock, the film director – do you get that? – one of the most famous men in the world,

and the press are going to be all over us as soon as the news gets out. I want this handled right.

WRIGHT

You're way ahead of me, sir. I haven't even viewed the scene.

MANAGER

There's no doubt about it. I know him well. I want you to keep the lid on it until I'm over the shock and can decide how to deal with it.

WRIGHT

That won't be easy, sir. Everyone enjoys spreading bad news. It's a human failing. You must have dealt with unexpected deaths in the past.

MANAGER

Never like this. The whole world is going to hear about it.

WRIGHT

You had nothing to do with it personally, I hope?

MANAGER

I wasn't even on duty at the time. I took a phone call at home from my head of housekeeping, Miss Chinchilla.

WRIGHT

Miss who? Looks like the cat is out of the bag already. Where did the incident happen?

Cut to:

4 INT. HOTEL CORRIDOR MORNING

Lt Wright and Manager approach door to suite. The corridor is crossed with DO NOT ENTER tape. Two police officers are on duty. Wright shows his pass. Manager prepares to follow him in, but Wright puts an arm across.

WRIGHT

Not you, sir. (to police officer) We'll need a statement from this gentleman. And take his prints.

Shocked reaction from manager. Wright enters suite.

5 INT. BEVERLY HILLS SUITE MORNING

Wright's POV of murder scene. Hitchcock's body, still in bathrobe, lies on bed, propped against pillows, with a tray beside him. A half-eaten steak has slipped from a plate. A bullet hole is in the centre of his forehead. A doctor in a forensic suit has been examining him and draws back to speak.

DOCTOR

Over to you, Lieutenant.

WRIGHT

Not much doubt about this one, doc. Was it self-inflicted? No. There's no weapon.

WRIGHT

Didn't even get to finish his supper.

DOCTOR

Someone must have served it to him.

WRIGHT
You're doing my job, doc.

DOCTOR
Better call room service, hadn't you?

Cut to:

6 INT. KITCHEN MORNING

Lt Wright is with a man dressed in white and wearing a chef's hat.

WRIGHT
In a nutshell—

CHEF
No nuts were involved, Lieutenant. We can't risk allergies.

WRIGHT
In a nutshell, you allowed a waiter you didn't recognise to collect a trolley of food and take it up to Mr Hitchcock's suite.

CHEF
Not me personally.

WRIGHT
One of your staff, then.

CHEF
It was peak time for us. You wouldn't believe the mayhem in here trying to cope with restaurant orders as well as room service. This man was dressed like a waiter. He acted like a waiter. There wasn't time—

Killing Hitch

> **WRIGHT**
> Can you describe him?

> **CHEF**
> My sous-chef can and so can several of my team. We already discussed this. He was paunchy, about my height, wearing glasses. I don't know what else to say.

> **WRIGHT**
> Save your breath. I don't need any more from you. He's the prime suspect in a murder case. I need to speak to the people who actually saw him and spoke with him.

Cut to:

7 INT. KITCHEN MORNING

A motley gathering of about twenty worried-looking kitchen staff and waiters are lined up as if for a group photo in front of Wright and some of his officers.

> **WRIGHT** (to himself)
> This will take all frigging day.

8 INT. LOBBY RECEPTION DESK AFTERNOON

Wright has his arms folded, irritated by the manager. They are standing behind a receptionist seated in front of a computer screen.

> **WRIGHT**
> I'll ask you one more time. Will you put the guest list on screen?

PETER LOVESEY

MANAGER

We have a duty of confidentiality to our guests.

WRIGHT

Do it. Or I'll do you – for obstruction.

The manager sighs heavily and nods. The receptionist taps a key.

WRIGHT

Now make a search for Mr Hitchcock. (to manager) I take it he registered under his own name. You knew he was one of your guests?

MANAGER

Lieutenant, I swear I had nothing to do with this dreadful business.

WRIGHT

That isn't what I asked.

MANAGER

You can see it in front of you. 'Hitchcock, Alfred,' in the Beverly Hills Suite.

WRIGHT

Nice when you can afford it. I won't ask the cost. Did you collect a reservation fee?

MANAGER

Of course not. That would be an insult. I don't know where you're heading with this, Lieutenant, but if you persist in treating me as a suspect, I want my lawyer present.

WRIGHT
Who else knew he was staying here?

MANAGER
The world and his wife. He isn't exactly hard to spot. All the guests and diners, all my staff and most of Hollywood for that matter.

WRIGHT
Some of your kitchen staff mentioned he was dining with a blonde lady.

MANAGER
An hors-d'oeuvre, that's all.

WRIGHT
Was she?

MANAGER (deep breath to contain himself)
I was referring to what they ate. He dined alone in his suite, as you saw.

WRIGHT (faint smile)
After the hors-d'oeuvre?

MANAGER
She's often in the hotel lobby trying to be noticed. An actress. Wants to get into movies, like every other young woman you meet in this town. (has an inspiration) Could *she* be a suspect?

WRIGHT
I can't see how or why. She's not going to kill Mr Hitchcock just when she's got lucky. One more thing. The medical examiner needs to conduct an autopsy.

MANAGER (horrified)
In the Beverly Hills Suite?

WRIGHT
That would be difficult. Downtown in his department. I'm informing you we need to move the body.

MANAGER
Christopher Columbus!

WRIGHT
No. Alfred Hitchcock. He'll be in a body bag.

MANAGER
Can't this be done at night?

WRIGHT
That's the plan. About three in the morning when most of your guests are asleep. We'll use the service elevator. Better warn housekeeping.

Cut to:

9 INT. HOTEL CORRIDOR NIGHT

Long view of empty corridor with lights dimmed. Music reflects the tension. A door opens left and manager looks out in both directions. Steps fully out, checks again and gestures with both

hands for those inside to join him. Two assistants push out a gurney with body bag containing portly corpse. Manager leads them to the corner at the end. Distant thunder can be heard above the music. He steps forward to check the next corridor. We get his POV before a flash of lightning causes a sudden break in the power supply. A second flash shows the familiar profile of Hitchcock. Normal lighting is restored and he has vanished. Close-up of manager's disbelieving face.

END OF PART TWO

PART THREE: Next day

1 INT. HOTEL LOBBY MORNING

Lt Wright enters and cameras flash. The press are there in force. Uniformed police have to force a passage for him. He enters manager's office.

2 INT. MANAGER'S OFFICE MORNING

Anxious manager is waiting inside as Wright enters.

> **MANAGER**
> He was there, I promise you, alive, in the flesh. We all saw him. Then he was gone. He must have stepped inside the elevator as we turned the corner.

Urgent knocking on the door.

> They're a menace. They won't be stopped.

> **WRIGHT**
> Let's do this somewhere else. I know where to go.

PETER LOVESEY

3 INT. HOTEL CORRIDOR MORNING

Long view of Wright and manager, escorted by uniformed officers, pursued by the press, approaching the police cordon outside Beverly Hills Suite. The pair cross the police tape and enter. Police bar the way to the press.

4 INT. BEVERLY HILLS SUITE MORNING

Lt Wright and manager enter.

> WRIGHT
>
> The crime scene people finished here last night. We've got this to ourselves.

> MANAGER
>
> Not entirely, I think.

HITCHCOCK rises from an armchair.

> WRIGHT
>
> I don't believe this.

> HITCHCOCK
>
> Good morning, gentlemen. Did I startle you? I can't resist a good surprise. Yes, it really is me this time.

> WRIGHT
>
> You're supposed to be dead.

> MANAGER
>
> Who the hell did we deliver to the morgue? They'll be on the autopsy table right now.

Killing Hitch

HITCHCOCK

My latest lookalike. He was smart, very smart, but not smart enough to save himself. I didn't discover his name. Do you want the full story?

WRIGHT

Your version of it, sir. Do you want your lawyer present?

HITCHCOCK

Good Lord, no.

WRIGHT

You won't mind if I tape-record you?

Produces a recorder from his pocket and switches it on.

HITCHCOCK

If it saves me repeating it all in court. (to manager) Some days ago, one of your restaurant staff alerted me to what was going on, a clear case of identity theft. This wolf in sheep's clothing was picking up women – all blondes with ambitions of getting into films – and convincing them that he was the real Alfred Hitchcock looking to cast the female lead for his next movie. They fell for it. He had my mannerisms to a tee. He looked like me, dressed like me and spoke like me. I am on television twice a week for anyone to study, and he must have watched for hundreds of hours to do it so brilliantly. I observed him in action from a distance, heavily disguised. He had the nerve of old Nick, bringing the stupid girls here, and putting everything on my account. As far as he knew, I was at home in Bel Air or on location – as I would have been if your whistle-blower hadn't put me wise to what was going on.

PETER LOVESEY

WRIGHT

So you devised a plan?

HITCHCOCK

One I was comfortable with. I like dressing up and I'm the world's best practical joker. With the assistance of my waiter-friend, I disguised myself and delivered his supper here, to this suite. My own usual supper, in fact.

WRIGHT

That was you? I thought he was the real Mr Hitchcock and you were the fake.

HITCHCOCK (smiles)

If you'd seen my amateurish performance, you would have been in no doubt. I couldn't do much about my looks except wear a wig and a false moustache. And I employed a Cockney accent. Not the best, I admit. I'm an Eastender, born and bred, but I ironed out my diphthongs to rise in my profession and now I've almost lost my Cockney twang. I was speaking a sort of Hitchcockney. The impostor was suspicious of me, but not enough to blow my cover altogether. You see, he was faking as well, extremely well, and enjoying it, a fatal error. That's about it. I knew for certain what he was up to and I had already decided to turn him in.

WRIGHT

You mean turn him off, don't you?

HITCHCOCK

Not at all. I didn't kill him.

Killing Hitch

WRIGHT

Oh, come on. Who did, then? Nobody else was with him all evening.

HITCHCOCK

His lady companion.

WRIGHT

The blonde? She wasn't there. She left after their meeting in the restaurant.

HITCHCOCK

She returned. When I came out of his suite with the trolley, she passed me in the corridor, on her way to murder him.

WRIGHT

How can you be sure?

HITCHCOCK

I saw the look in her eyes. I knew what to expect when I went back with his next course.

MANAGER

You found him dead?

HITCHCOCK

Yes, but I didn't report it. I would have come under suspicion myself – as I did this morning when you still believed I was pretending to be a waiter.

WRIGHT

Which you were. Why did she do it?

PETER LOVESEY

HITCHCOCK

A fit of anger. She was desperate to get into the movie business. They all are. When he invited her into the restaurant for a libation and a modest repast, she thought she'd made the breakthrough and her life had changed forever. In reality, all he offered was a quick shag. That's what he has been doing in my name – inviting women he met in the lobby to his room for sex. This one wasn't playing. She was angry and betrayed. She took a gun to his room and shot him dead. Can you blame her?

MANAGER

She can't be allowed to get away with it.

HITCHCOCK

She may, if she's got any sense and gets rid of the gun and is never seen here again.

MANAGER

That would be outrageous. (to Wright) You'd better pull her in and charge her with murder.

WRIGHT

It's not so simple as that. I don't know who she is. The only description I have is the colour of her hair. What Mr Hitchcock has told us is all circumstantial. We'll do our best to find her. Of course we will, but with so little information I can't even put her on the wanted list. I hate to say it, but this was the perfect murder.

Fade on close-up of manager's disbelieving face.

Killing Hitch

5 INT. STUDIO EVENING

Hitchcock stands admiring a poster of a seductive blonde. He turns.

> HITCHCOCK (to camera)
> Ladies and gentlemen, I have to tell you that the blonde in the story you have just watched is still at large. The lieutenant questioned all the young blonde ladies in the hotel lobby and got nowhere. Not one of them would admit to knowing her name or where she came from. My guess is that she left Hollywood for good and changed her hair colour.
>
> I don't know where the rumour originated, but people say that I am fixated by fair-haired women. Miss Janet Leigh, Miss Kim Novak, Miss Tippi Hedren and, of course, Her Royal Highness Princess Grace. I am said to be an example of the adage that gentlemen prefer blondes. The play you have just watched will only add to the myth. The truth of the matter, ladies and gentlemen, is that more than thirty years ago I married a lady who has been my constant companion ever since. We have stayed faithful to each other. I wouldn't dare to do otherwise. Would you like to know the colour of my wife Alma's hair? She's a redhead. Goodnight.

Fade Out.
Run closing music and credits.

<center>The End.</center>

The Mark

Anne Billson

On the whole, he preferred not to have to kill them, but sometimes it was necessary. What he liked was the thrill of the hunt, the courtship, the moulding of the personality to the shape of his will. And, of course, the money. He was in it for the money, not the kill. At least, that was what he told himself. If he was being honest, he would have to admit that the killing part, which had begun as pragmatism, had evolved into such an integral part of the process that the last few times some silly goose had backed down and let him get away with it, he had experienced something close to frustration that he would never feel the fluttering of her pulse against his thumbs.

It wasn't as though he was a maniac with a compulsion to kill every woman he met, like some freaks he had read about. He had no intention of killing Barbara, for instance. She wasn't exactly destitute and obviously there had been enough in the kitty to get her as far as Venice, but from the first he had noticed a certain guardedness to her spending habits. She clearly didn't have access to the sort of fortune that would make her worth the risk.

But she was useful in other ways. Her father had been a senator, and she liked to brag about her connections: the privileged clans who invited her to house parties in Palm Beach or the Hamptons; the matriarch who had adopted her as a surrogate daughter; the

bejewelled widows with unfortunate taste in men. She broke off mid-anecdote, something about how one dowager had turned the tables on an exceptionally avaricious Argentinian, and said, 'I know so many women who would kill to meet a man like you.'

The line couldn't have been more of a lure if she'd baited it with glittering mealworms. He knew better than to seem thirsty, but over the coming days extracted more information out of her, bit by bit. There was still enough in the Zurich account to keep him in the style to which he was accustomed, but his resources were dwindling and needed to be topped up. Not only had Monte Carlo been a costly debacle, it had also piqued the interest of certain parties it would be better for his health to avoid. Without that money to ease his flight into Italy, he would have been dead in the water.

'What kind of man am I?' he teased.

'Oh, you know. They're such lonely souls, these women, and the only gents they attract are spiffy moochers whose dim-witted schmooze bores them to tears. But you, Alvin, are a man of the world. You know how to butter up a gal without being insincere, when to ply her with red roses and bijoux, how to talk to waiters and choose the wine, gentlemanly skills like that. Your presence at her side would stave off the pitying glances. Best of all, you have your own dough, so she would know you weren't after hers.'

He summoned his most heartfelt sigh. 'I still don't know if I'm ready to move on.'

Barbara, eyes shining with sympathy, reached out to pat his hand, the one without the bandage. She had already been given a bowdlerised account of his first wife's tragic fate. He hadn't told her about the other wives, and only partly because not all of those alliances had been legal.

'I'm sorry,' she said. 'I shouldn't have reminded you.'

He sighed again. 'I thought Europe would help me forget. But the memories follow me everywhere.'

She paused for a decent interlude before resuming. 'All the more

reason to make new memories. Most women of a certain age have also lost someone dear to them, so you would have that in common. You could support each other in your bereavement.'

He allowed himself a wry smile. 'You may be right, my dear. But you overestimate my sociability. I have absolutely no idea how to meet people.'

She raised an eyebrow. 'You met me easily enough.'

'True. But it's not every day one runs into unescorted damsels in Harry's Bar.'

She giggled. 'They would have thrown me out if you hadn't come to the rescue.'

'Least I could do for a fellow American.'

She looked pensive. Then said, 'I have an idea.'

It sounded just the ticket, but there was a drawback. It would mean going back to where he was a wanted man. Not that he wasn't wanted nearly everywhere these days. The Côte d'Azur and Amalfi Coast were already off limits, at least for a time. All it would take for his luck to run out would be bumping into the wrong agent at one of the ports, or for two separate departments to put their heads together and compare autopsies. According to what he'd gleaned from an old issue of *The Chronicle* he'd found in Bar Americano, the city's law enforcement was too busy raiding poetry readings and queer bars to waste time on old cases like his, but it would still be a risk. He would have to steer clear of familiar haunts. No Ernie's, not this time.

The city had already been changing when he'd skipped out on it, but the place he came back to had shifted even further away from the romantic origins that had once so beguiled him. Bookshops, galleries and cafés had sprung up on formerly colourless streets. Unshaven men in black polo-necks perched on stoops, smoking roll-ups or poring over hand-printed pamphlets. The women, especially, had changed. They strode around in clam diggers and flat heels, hair in disarray, unafraid to speak their minds, utterly devoid

The Mark

of the feminine mysteriousness he had always gotten such a kick out of dismantling.

But he was surprised to find how much he had missed the rumble of the trolley cars, the ghostly outline of the bridge across the bay, savouring the sunset over a dry martini at the Mark, dining in restaurants where the waiters grovelled instead of sneering at his attempts to order in French or Italian.

Anyway, if the city had changed, so had he. These days he was tanned and fit. He'd kept a close watch on his alcohol intake, stuck to a fish and vegetable diet (even if he did sometimes yearn for Dungeness crab or Joe's Special), and was religious about exercise: one hundred push-ups every morning and, whenever he could, snorkelling off Ischia or Mykonos, perfecting his seat in Andalusia, working on his backhand in Nice, skiing in Gstaad. His figure was more wiry than athletic, but he looked nothing like the boring businessman he had once been. More like – what? – an international playboy? A latter-day conquistador? Perhaps even a secret agent, like James Bond in *Dr No*? He chuckled at the thought. All he knew was that women were drawn to his cosmopolitan charm, to his impeccable taste and the elegant way he helped them spend their money. But for how much longer? He was pushing sixty now, and the clock was ticking. He needed one last payoff, substantial enough to see him through his dotage, before he lost his teeth and they began to suspect he was on the lookout for a nursemaid rather than a wife.

Barbara paused at the top of the steps. 'Here we are.'

There was a yellow banner tacked above the door with 'VOLT' emblazoned across it in thick black letters. Underneath, in smaller print, were the words 'JO WOOD: SET-PIECES' and 'Abandon your hang-ups, all ye who enter here.'

'What does that mean?' Steger wondered out loud, but his voice was drowned out by a mournful blast of the foghorn across the bay.

He tried not to let his discomfort show. When Barbara had mentioned an exclusive private viewing, he'd been expecting a classy downtown venue, not some dank basement in an alleyway reeking of fish. But there would be more women than men, she'd said. Mostly wealthy widows and divorcees, all of a certain age.

A cornucopia of rich pickings.

She skipped down the steps like a mountain goat in kitten heels. The treads were worn and slippery, so he followed more cautiously, keeping a grip on the knotted cord fixed to the damp wall in lieu of a banister, wincing as his bandaged hand scraped against the ragged stone.

At the bottom was a wooden door that looked as though it had been hauled up from the wreck of an old sailing ship; all it lacked was a coating of barnacles. Barbara pushed it open and Steger followed her inside. As the door swung shut behind them, the foghorn and fish smell were instantly blotted out, replaced by a murmur of voices and a mauve cloud of cigarette smoke perfumed with Dior and Chanel. On a dais in the far corner, skinny white musicians were extracting discreet elevator music from an upright piano, vibraphone and a set of bongos.

Barbara slipped away to deposit her coat, leaving him to gaze in wonder at the prospect before him. It was just as she had promised: no more than a sprinkling of men in an ocean of women past their prime. All of them, to judge by their jewellery, as rich as Peggy Guggenheim. His fear of the female population succumbing to the trend of pedal pushers and unkempt hair were unfounded, because this was old-school glamour writ large: hair primped and twisted into tight coils or orderly curls atop a sea of pink, white, red, black, canary yellow, gold or silver gowns, exquisitely tailored to enhance their wearers' bosoms and hips. His ears picked up a whisper of chiffon and silk as the superannuated sirens drifted hither and thither, smoking cigarettes, sipping cocktails, swapping womanly thoughts, jewels glimmering at their throats.

The Mark

He drank deeply of the vision, enchanted, until Barbara returned and broke the spell. She was surely one of the youngest women present, but her sleeveless grey taffeta looked frowsy next to the other gowns. 'I'm parched,' she said. 'Let's get something to drink.' She began to drag him through the nearest thicket of sweet-smelling womanliness, but they didn't get far before she was waylaid.

'Babs! You're back! How was Europe?'

Steger scrutinised the speaker. No grey hair, though of course she could have dyed it. Handsome rather than pretty, but there was an openness to her face, and a determination that was pleasing to the eye, even if make-up couldn't conceal the frown lines giving her an air of permanent anxiety, as though something terrible had once happened and she now spent her life worrying it could happen again. But the green silk was cut to flatter, her manner was polished, and the diamonds around her neck were so dazzling that Steger found himself almost salivating.

'It was peachy!' said Barbara. 'You'd love it, Charlie. You should go.'

'Honey, I already went! Six months lollygagging around Paree after Jack and I went our separate ways.' Her eyes drifted past Barbara and landed on Steger. 'And who do we have here? Someone you picked up on your travels?'

He forced a smile. 'You make me sound like a disease.'

'This is Charlotte. She's frightfully clever, runs her own business and everything. And this...' Barbara lowered her voice. 'This is Mr Alvin Steger, an obscenely wealthy art collector from Europe.'

'Oh, really?' Charlotte seemed to find this amusing. 'See anything here you like, Mr Steger?'

He gazed into her eyes. 'It's as though the gods have laid on a feast especially for me. But please, call me Alvin.'

'Your first time in the city, Alvin?'

He felt slightly peeved that she didn't appear to be succumbing

to his charm. He would need to work on that. 'No, I used to live here.' He bit his tongue. What a fool he was. He should have pretended this was his first visit. He hoped no one remembered the lurid headlines: *Lightning Strikes Twice! Ex-Tec's Squeeze Perishes in Belfry Plunge!* His own involvement had usually been relegated to a line or two in the last paragraph. But now Charlotte would ask troublesome questions about the past, and he would have to invent ever more elaborate falsehoods to mask the truth.

Luckily, Barbara reiterated her need for a drink and pulled him away before things got awkward. He glanced back and saw Charlotte gazing after them with a peculiar expression on her face. If he hadn't known better, he would have described it as revulsion, as though she had just bitten into an apple full of maggots, but as soon as she saw him looking back at her she smiled, and the odd impression vanished, and he wondered if he had imagined it.

They jostled their way through the scented throng and finally emerged into a clearing in front of the bar, where a woman in lavender tulle and a ruby necklace was rattling a crystal cocktail shaker. She would have been beautiful once, Steger observed, but now there was a harsh, almost cynical cast to her features. He marvelled, not for the first time, at how men such as himself were spared the tragic changes wrought by time on the once flawless faces of the fairer sex.

'Howdy, Barbara.'

'Hi, Janet.'

'What'll it be, chum?'

'The usual.'

'Dry martini for the gentleman, coming right up.'

'Not so fast, ladies,' said Steger, annoyed by their presumption. Ordering drinks was a man's job. 'I'll have a whiskey sour.'

Janet paused mid-rattle. She and Barbara stared at him in mild consternation, as though he had put in an order for puréed frog.

'But you always drink martini,' said Barbara.

The Mark

'Been a while since I last met a decent bourbon,' he said by way of explanation.

Janet recovered her poise. 'Whiskey sour coming right up.' She prised the lid off the shaker and began to empty its contents down the sink.

'No need to waste that,' said Steger. 'Barbara drinks martinis too, don't you, Barbara?'

'Hmm. More in the mood for bubbly tonight.'

Steger was taken aback. In Italy he had gotten used to Barbara following his lead, drink-wise. Perhaps being back on native soil had brought out her inner Eleanor Roosevelt.

Janet, mouth set in a grim line, sawed a lemon in half and began, very slowly, to squeeze the juice out of it. Why was she so unhappy? He decided she needed cajoling.

'Cheer up! It might never happen.'

She raised her eyes to meet his, and he was shocked to see the seething resentment in them.

'Too late, buster. Ever eaten a chicken leg off your boyfriend's coffin lid?'

He was wondering how best to respond to this nonsensical remark when Barbara grasped him firmly by the arm and spun him away from the bar.

'What's she talking about?' he asked.

'Don't worry about Janet. I mean, she earns a lot of bread writing for magazines, but I really don't think she's your type.'

Steger didn't think she was his type either, and not only because he didn't hold with career women; but just then his eyes fell on the painting on the wall in front of them, and he forgot all about Janet. He'd been expecting abstract expressionist junk, but this was a neo-classical pastiche, which if anything annoyed him even more. The naked man was sprawled on the bathroom floor. He was wrapped in a shower curtain, but you could tell he was dead because blood was leaking from multiple stab wounds in his torso and

pooling on the floor beneath his body. His skin was waxy yellow, eyes bulging sightlessly, mouth open in a slack-jawed scream. Next to him on the tiles lay a bloodstained knife.

Steger felt resentment rising inside him. What did the artist know about murder? She had deliberately made it look ugly. There was an art to killing. You couldn't just stab a person like that. You got blood all over your clothes, for a start. His mind went back to the bespoke Paul Stuart he had been forced to consign to the incinerator. Never again, not like that. Besides, the sight of blood made him feel queasy. It was better not to be reminded of what lay beneath the skin.

'Such poor taste,' he muttered.

'That's the point,' said Barbara. 'Hey, your whiskey sour is ready!'

He turned just in time to see Janet setting a low-ball tumbler on the bar. The bleakness had drained from her face; she smiled like a proud mother as he picked it up and took a sip, leaving the bottom of his moustache coated with a fine skim of froth.

'How is it?'

'Just what the doctor ordered.' He took another sip, and felt warmth spreading through his system.

Janet's smile grew wider. 'It's our doctor's special recipe.'

Barbara clinked her coupe against his tumbler and said, 'To absent friends!'

What the devil did she mean by that? But he had no time to mull over it, because a woman in black deftly inserted herself between them and pecked Barbara on both cheeks, continental style.

'You've been brilliant,' she said.

'I had the best teacher,' said Barbara. 'I'm still not sure why you didn't send her instead. You know she went to acting school?'

'And never lets us forget it! But she's the one with the little black book, so we needed her back here.'

Steger watched their mouths moving, but couldn't make sense of the words. He had a feeling they were saying something important, but the meaning kept slipping out of his reach.

The Mark

'Jo, this is Alvin Stegers, from Europe. He was just admiring your work. Alvin, meet the artist, Jo Wood.'

Jo Wood shook his hand warmly. But the warmth didn't extend to her eyes, nor did her smile. He considered himself gifted at reading women's intentions, but hers were opaque. Perhaps his woman-reading skills were deserting him. He should have seen through that bitch in Monte Carlo, for example. The last thing he'd expected had been for her to fight back, but obviously she wasn't as much of a lady as she pretended to be.

Not that Jo Wood was his type, any more than Janet had been. She didn't seem part of this moneyed crowd. She wasn't even wearing jewellery.

She looked directly into his eyes and said, 'You have no idea how much I've been looking forward to meeting you, Mr Stegers.'

'Likewise,' he lied.

'That looks nasty.' Her gaze flicked downwards, and he realised he had been fiddling with the bandages on his hand. A yellow stain was seeping through the cotton.

'Slammed a door on it. Nothing serious.'

Maybe if he had gone to a doctor earlier, the infection would have cleared up by now, but he'd been too busy fleeing the country to stop off for medical treatment. Perhaps in a few years' time, when the fuss had died down, he would go back to Monaco and make that stuck-up popsy pay for what she had done.

Jo Wood was saying something else, again with the smile that didn't reach her eyes.

'You should get it seen to.'

Patronising bitch. Did she think he was stupid? He smiled back, irritated by her strident self-confidence and stubborn refusal to dress up for her own show. If she made an effort, she could be attractive. But the sweater and jeans did her no favours, and the spectacles didn't help. The severe black frames made her look like some sort of... *beatnik*. Some sort of beatnik *librarian*, dressed entirely in black.

He'd run into more than a few artists on his travels – you couldn't go a hundred yards in the south of France without running into a peripatetic American socialite with an easel – and even the more talented ones were almost always penniless, sponging off wealthy relatives or companions. All female artists had one thing in common, though – they were pretentious. And if there was one thing he couldn't stand, it was a pretentious woman.

Anyone could see Jo Wood was pretentious. Her customers, now, they were another matter. He surveyed the perfectly coiffed heads. So much bounty here he hardly knew where to start.

An older woman swathed in pale blue chiffon seized Jo by the arm and began to drag her away. Steger heard her murmur, 'The boat's here.'

'Don't forget to look at my paintings!' Jo called over her shoulder to Steger. 'I think you'll like them.'

Her parting remark made him bristle. How would she know what he liked? He ordered a second whiskey sour.

Barbara, now on a second glass of champagne, said, 'I guess we should look at the art.'

'I'd rather meet the collectors,' said Steger. The cigarette smoke was making it harder to breathe. He longed to loosen his necktie, but, unlike the new breed of man on the street, prided himself on maintaining a civilised demeanour, especially in mixed company.

'Hot in here, isn't it?'

Barbara gave him an enquiring look. 'No, it's not. It's quite chilly, in fact.'

'Should have kept your coat on,' he said, looking pointedly at her bare arms.

Barbara made a face.

They mingled. Barbara presented him to Eve, who he gathered was a partner with Charlotte in some sort of agency. Talent or real estate? He didn't quite catch what kind. And Daphne, and Ruth,

The Mark

and a woman Barbara said was her older sister Anne, though they didn't look anything alike, and a head shrinker with a Swedish accent, whose name he promptly forgot. He began to feel dizzy with all the introductions, and progressively ill at ease, though the women professed to be pleased to meet him. But they didn't seem as impressed as he thought they should be. Surely he couldn't be losing his touch?

The atmosphere was changing, though he couldn't work out how. Perhaps it was the music, which had been shimmering just beneath the surface of his consciousness. But the notes of the vibraphone, instead of dying away, were growing more resonant, echoing around his skull until his head began to pulsate with a faintly metallic timbre.

'Are you okay?' asked Barbara. 'Can I get you a glass of water?'

'I'm fine. I would just like to... look at the paintings.'

It was hard to corral his scattered thoughts, and even harder to turn them into speech. Looking at the paintings, he reasoned, would absolve him from having to make small talk. But the paintings didn't make him feel any better. In fact, they made him feel a whole lot worse. It didn't help that they all seemed to be about violent death. On one canvas a man sprawled supine on a stage. It might have been a nice painting if only he hadn't been sliced in half, with his entrails spilling out. In another picture, a boy was impaled on some railings. Other paintings showed men consumed by fire, or lying broken on the ground, brains leaking out of their smashed heads.

'How did she do that?' he blurted, waving his free hand at the picture of a man falling backwards down a staircase.

Barbara patted him on the shoulder. 'She's very talented.'

'But that effect there, where the colours look as though they're moving.' He shifted from one foot to the other. 'Flowing into each other, like fresh water meeting salt in an estuary.' He took a step towards the canvas, and sniffed. 'Smells like the caramels my grandmother used to give me.'

'You dope. All it smells of is oil paint.'

He sniffed again. She was right. Oil paint and nothing more. Two drinks didn't normally go straight to his head like this. Perhaps it was the travelling. Perhaps the different time zones had scrambled that circadian rhythm he'd been reading about on the train. All he needed was a good night's sleep.

'Maybe I've had too much to drink.'

'Or maybe you haven't had enough.' Barbara wrestled the empty glass from his grip. 'I'll ask Janet to top you up.'

He couldn't find the words to refuse. His heart was beating faster, as though he were on the verge of a momentous discovery. Perhaps another drink would help, rather than hinder.

And there it was, right in front of him! How come he hadn't seen it before?

'They're not paintings at all. They're doors. Doors with signs on them.'

He thought he was talking to Barbara, but Barbara was no longer there. She had been replaced by the woman called Eve. Earlier on, Eve had seemed impossibly glamorous, but up close he could see the grains of powder clogging the wrinkles around her eyes, and her scarlet lipstick bleeding into the fine lines radiating from her lips. Her diamonds seemed lacklustre and weightless, like theatrical jewellery.

'Doors?' She eyed him curiously. 'Is that what you're seeing?'

He looked back at the nearest door, read the words etched into the brass plate there, and flinched. 'Is this a joke? Because if so it's in execrable taste.'

'Is what a joke?' Only now did he see that Eve had been replaced by Jo Wood, the artist, in her black sweater and spectacles.

He read the words out loud. 'Strangulation Day!' Even as he spoke, he realised he had misread the sign. 'What I meant to say was *San Francisco Bay*.'

'The mind is a strange and terrible thing,' said Jo.

The Mark

He suddenly felt scared of her, and the fear made him aggressive. 'Why are you wearing black? Did someone die?'

She leant closer and stood on tiptoe to whisper in his ear.

'A lot of people died, Mr Steger. And one of them was a very dear friend of mine. He drank himself to death because of you.'

'Oh dear. I am sorry.'

'No, you're not,' she said.

There was no longer any point in pretending. 'You're right, I'm not.' He reached out to grasp the doorknob beneath the sign, turned it and the door opened. On the other side it was dark, but he could see something sparkling in the distance. Diamonds, perhaps?

'Where does this lead?'

She shrugged. 'You tell me. It's your head, not mine.'

He stepped through the doorway into the darkness.

He was back in the Hotel de Paris. The Mediterranean sparkled in the moonlight. He turned away from the window and saw Margot standing there, so lovely in her white gown that he had a fleeting moment of regret. But too late, because it was all arranged. He'd had an exact copy of the dress made, and Françoise was already wearing it downstairs, at the dinner table. At close quarters she looked exactly what she was: a fille de joie disguised as a lady. But from across the restaurant, she was a dead ringer for Margot, and that, combined with Steger having arranged for their usual waiter to go down with food poisoning and be replaced by a myopic ex-convict suffering from anterograde amnesia, would be more than enough to provide him with a watertight alibi. Everyone would have seen them eating dinner together. No one would notice if he were to pop out for a few minutes, take the service lift, lure Margot out onto the balcony, fasten the rope around her neck and push her over the balustrade before returning to the restaurant, at which point he and Françoise would have a very public argument, and she would make her excuses and leave, just as the fireworks began.

'I see you,' Margot said.

'Of course you do.'

'No, I really do see you. Do you honestly think you're the first man who tried to get his hands on my money? Or that I wouldn't have told anyone about you? My friends know who you are, Mr Alvin Steger. They know *exactly* who you are. And they'll be coming for you.'

He stopped listening to her crazed babble. 'I'd been hoping this wouldn't be necessary,' he said, pulling off his necktie, wondering as he did so what he was planning to do with it, because in the past he'd always used his hands. Hands were more personal, more intimate. He took a step towards her, then another, and raised his arms to loop the tie over her head. He wanted to watch the life draining out of her eyes as he cut off the oxygen supply to her brain.

To his surprise, instead of trying to escape, she stepped forward so she was pressing right up against him. The overpowering aroma of Fleurissimo made him lightheaded.

Out of nowhere, she produced a pair of silver dressmaking scissors and plunged the fine, pointed blades into the back of his hand.

He yelped, more from shock than pain, and wrenched his hand free, tearing something inside it as he did so. Dropping the necktie, he staggered back towards the window, finding it hard to keep his balance because the room was moving up and down, like a fairground ride. She kept coming towards him, scissors raised, blades dripping blood. The tight waves of her blonde hair came loose, and now he saw to his horror she wasn't blonde at all – she was wearing some sort of wig, and her face was no longer Margot's face, but shrunken and leathery, with gaping sockets where the eyes should have been and brown lips peeled back from the teeth in a death's-head grimace.

He couldn't help himself. He let out a shriek.

'There, there,' she said. 'It will all be over soon.'

'Let's hope not,' said another voice.

The Mark

With his uninjured hand he groped behind him, searching for something, anything he could use as a weapon, but all his fingers found was net curtaining. Better than nothing, he reasoned, and rolled himself up in the flimsy fabric. Perhaps she wouldn't see him there.

But she didn't need to see him, and in any case, she no longer had eyes. She just knew he was there. The scissors sliced easily through the drapes and plunged into his abdomen, again and again, slashing the flesh to scarlet tatters. It didn't hurt, but the sight of so much blood spilling out of him and ruining another bespoke Paul Stuart filled him with the keenest anguish, so he closed his eyes.

It was the violent shivering that woke him up. The smell of urine would have made him feel sick, if he hadn't been feeling sick already. He looked down at his torso, dreading what he would see, but there was no blood. His clothes were intact, unshredded.

His hand, though, that was a mess, the bandage discoloured by dirt and pus.

His head was throbbing. Next to the mattress was a glass of water. He sat up and gulped it down, trying to work out where he was. The hotel? The bedroom at Avenue Montaigne? The Queen Mary? The options presented themselves to him in rapid succession, like playing cards, and he rejected them one by one. He had never been here before.

Watery daylight cast stripes across the concrete floor and over a cracked toilet bowl. The room was small, about five by eight. The walls were a collage of peeling green paint, rust stains and obscene graffiti only partly obscured by a gilt-framed portrait he was having trouble getting into focus, because his eyes weren't working properly. He could hear wind whistling through pipes, and the breaking of surf somewhere outside. He picked his way over rubble towards the exit, only to find his progress blocked by iron bars. He pushed and

pulled, but they wouldn't budge. His eyesight was still rippling around the edges, so he couldn't altogether trust it, but through the bars he could see other bars, and other bars beyond those.

Some kind of cell, then. He yelled for a while, and then yelled some more, until his throat was hoarse, but there was no response, just the sound of the wind and the waves. Wherever this was, he was on his own.

He retreated to the mattress. His vision was less blurry now, so he tried to take an inventory of the objects around him. One mattress. One blanket. Two pitchers of water. Two bottles of bourbon. A box of dry crackers. Two packets of Lucky Strike. One box of matches. One roll of toilet paper. A length of rope. A knife. A revolver with a single bullet in the chamber. A picture on the wall…

The painting finally swam into focus. He'd seen it before: the portrait of a woman in mauve silk, hair tightly coiffed, holding a pink nosegay. Carlotta Valdes! But she had changed. Now she was wearing spectacles. A ghostly hand reached into his thorax and clamped itself around his heart, and squeezed, as he realised with mounting horror the woman in the portrait wasn't Carlotta Valdes as he had first supposed. It was Jo Wood. She gazed out at him, a half-smile on her lips.

Fragments of the previous evening drifted back as he vomited. If it *had* been the previous evening; there was no telling how much time had passed since the whiskey sours. He couldn't tell which memories were real and which imaginary, but it no longer mattered, because either way he would make those bitches pay.

His mouth twisted into a sneer. They'd made a big mistake. They hadn't known who they were dealing with. He would save the bullet for whoever came to feed him, or let him out. And then he would track down the others and use the rope or the knife, or buy more bullets for the gun. The thought of what he would do to them warmed his blood, and at long last he stopped shivering.

The Mark

He opened the first bottle of bourbon and took a swig and leant back against the wall to light a Lucky Strike, feeling strangely optimistic. He surveyed his supplies again. If he was careful, he could make them last a month, maybe longer.

He was not to know that it would be nearly six months before five Lakota Sioux and a mob of reporters and press photographers landed on the island.

Hitchcock Presents

Kim Newman

The first one, I don't get...

My son Tom Skypes me from my home computer. He's settled in at my address while I'm in Leipzig for Krimifest, scaring off burglars and taking in the post. Also, his girlfriend – Sesame – has thrown him out of their place. She looked in his cache and found many more logins to online games and adult sites than to the server where he was working remotely for a firm which actually terminated his contract three months ago.

My son Tom. You have to love him... or, in Sesame's case, not. Even I know to clear the computer cache. Which I did before handing him the keys to the house. Now he's been reminded what a cache is, he won't be able to resist poking around.

'Early birthday or late Christmas,' says Tom, holding up an oblong parcel.

I gave him instructions to open everything which might be time sensitive. I still get a lot of physical media through the post. Comes with the field. Not everything is online. Even iffy Russian sites don't host that many British films noirs made between 1922 and 1952. Which is what I know a lot about.

Should Tom open the parcel?

It's unsolicited – not from any online retailer I use. Or any

online retailer at all, to go by the unmonogrammed brown-paper wrapping. My name and address are on a printed label but that's it.

'There's a card,' says Tom.

He holds it up. Also printed. *1972.*

'Is that when you were born?' he asks.

'No. I'm 1974.'

I can't see why Tom shouldn't see what's inside.

With eagerness, he shreds the brown paper. I remember him always tearing through careful wrapping every Christmas and birthday. He'd offer to open everyone else's presents too, just for the surprise. He still attacks parcels the same way. There's a scalpel on the desk he could use, but he prefers fingers.

Inside the paper is a long slim shallow box, matt black with a gold logo. Reiss. I've never heard of them.

Tom opens the box and unfolds tissue paper to find what's inside.

It's a necktie. Geometric print in oatmeal, according to a tag.

I haven't worn a tie since I left school in 1992. Even for the formal ceremony at the close of Krimifest, I'll only go so far as to match a Robert Donat T-shirt to a suede jacket. I doubt if I could tie a tie if I had to. My fingers have forgotten the moves.

'It's not your style, Maurice,' says Tom.

'Nor yours.'

We share that much.

'Sess uses ties for belts.'

'Give it to her then.'

No response. Sore point.

'It must be a promotional thing,' says Tom. 'I got sent scented candles shaped like whales a while back. No idea how I got on that list.'

I have to get to a screening of *Pink String and Sealing Wax* (1945), so the mystery is set aside.

The next one, I should have tumbled …

Tom Skypes again.

He shares the screen with a bigger, noisier parcel – also wrapped in brown paper, also with a printed card.

1963.

'Is there something alive inside?' I ask.

'Let's see…'

Tom demolishes more paper.

'Oh,' he says.

It's an old-fashioned birdcage, like two supermarket wire shopping baskets stuck together. Inside are two plastic budgies which chirrup when their trapezes swing. One is bright red, one bright yellow.

Tom shakes the cage and makes the birds squawk together.

'This is pound shop at best,' he says.

1972. 1963.

That suggests a series. Counting down. To what?

1960.

So it's not going to be an even countdown or the Fibonacci series or anything.

Another long flat box. Another unfamiliar brand name. Nihon. More tissue paper. Honestly, the waste in packaging makes you spit.

Inside is a new kitchen knife.

Tom picks up the knife and looks at the shiny, sharp edge.

'Hang on,' he says. 'There's another date card. Under the blade.'

Or 1928?

I almost see it then, especially when Tom holds up the knife like

a movie murderer and goes *kill-kill-kill* like the *Friday the 13th* theme.

If he'd gone *eeek-eeek-eeek* I'd have seen it.

At Krimifest, I'm introducing a series of British films noirs. It's tied in with my new book, *Green Penguin Cinema*.

I've prepared pieces on *They Drive By Night* (1938), *East of Piccadilly* (1941), *They Made Me a Fugitive* (1947) and *It Always Rains on Sunday* (1947).

These films are my focus at the moment.

But there are other strands of the festival. A retrospective of German Edgar Wallace adaptations. This replaces a strand which was planned but didn't come together.

Alfred Hitchcock rarities.

It was to be the re-premiere of a previously undiscovered silent Hitch made between *The Mountain Eagle* (1926) and *The Lodger* (1927). *Murha veitsillä* (1926) – literally, *Murder with Knives* – turned out to be a) previously discovered, b) actually called *A Bit of an Argy-Bargy on Sunday*, and c) directed by Maurice Elvey. The archivists who turned up a truncated print in an Finnish vault made rash assumptions based on a script credit for Anita Ross, who wrote Hitchcock's uncompleted first feature *Number 13* – not to be confused with the later, completed *Number Seventeen* (1932) – and the presence of Miles Mander, who is in Hitchcock's first finished film *The Pleasure Garden* (1925), as a mad murderer… along with two or three set-ups similar to those in *The Lodger*, which it now seems likely young Hitch copied from the established Elvey.

The British Film Institute hold elements for *A Bit of an Argy-Bargy on Sunday*, and I made the comparisons myself. There are substantial differences between the two versions, and *Murha veitsillä* includes three scenes not present in the BFI print. These may well not have been directed by Elvey but could have been shot by any of a number of second unit men who weren't Alfred Hitchcock.

The Finns, in a huff, pulled their precious film from Krimifest. All week, attendees had bemoaned the loss of a chance to see *Murha veitsillä*, no matter who directed it.

The alteration to the programme came too late to cancel an exhibition of Hitchcock posters in the lobby of the festival cinema.

Every day, between screenings and seminars, I saw that big green one-sheet of Tippi Hedren beset by pigeons and Hitchcock gloomily claiming 'it could be the most terrifying motion picture I have ever made!' *If you can't quote critics, quote yourself*, he seems to be thinking.

The tagline is...

'The Birds is coming!'

Very clever.

Of course, it's not a grammatical error. *The Birds* is singular, a film, not plural, some birds. It's *The Birds* (1963).

Click.

The necktie. *Frenzy* (1972).

A film about a murderer who throttles women with his tie. Possibly geometric print in oatmeal. Probably not.

The birds. *The Birds* (1963). The birds who attack Tippi Hedren – and humanity in general, pecking out eyes, slashing-squawking at schoolchildren.

The knife. *Psycho* (1960). *Eeek-eeek-eeek* Bernard Herrmann strings. Janet Leigh in the shower.

...but also *Blackmail* (1928)... the mumble-mumble-mumble-*KNIFE* on the soundtrack.

So, the mystery deliveries were Hitch-themed.

Instruments of mayhem.

The next card is *1954*.

The box is too small for a window.

'Maybe a camera,' suggests Tom. He doesn't just watch slasher films from the 1980s. 'Or just a lens?'

Not much of a view out the back of the flat. Certainly no Miss Torso – and likely no grave under the wheelie bins.

The paper comes off.

It's a pair of scissors. Also from Nihon, sharp implement manufacturer to the trade… who probably don't want an endorsement from a series of movie murderers.

'I don't get it,' says Tom. 'What have scissors to do with *Rear Window*?'

I get it. Hitchcock didn't only make one film in 1954.

'That's the murder weapon – well, self-defence weapon – from *Dial M for Murder*. Grace Kelly stabs the cashiered officer with them.'

'Not seen it,' says Tom.

1948. I guess it before the paper is off.

A coil of rope.

Rope (1948).

Instrument of murder. Also of judicial execution.

I accept the Golden Automatic for best rediscovery of the year on behalf of the team who've restored *East of Piccadilly* for its new presentation. If those Finnish claims hadn't proved to be hot hair, they'd probably be the ones explaining to customs officers that the gun-shaped item in their carry-on luggage is an award presented by a major cultural institution and not a blinged-up hijacker's tool.

I've not been sent a gun yet – not a favourite Hitch weapon, of course. Maybe the extra-size prop pistol Leo G Carroll commits suicide with in a flash of scarlet at the end of *Spellbound* (1945). Or the revolver the spy chief uses to gun down Mr Memory as he blurts out the secret in *The 39 Steps* (1935).

At the dinner after the presentation, I mention the themed mystery parcels.

'So, Alfred Hitchcock Presents,' says Vangie Cicero, who's from

California and has written a book about Ida Lupino. 'Not *Alfred Hitchcock Pres-ENTS* but Alfred Hitchcock PRESents.'

I'd not thought of it that way.

Jeremy Bellamy from Hull chips in with what might come next... the shrunken head from *Under Capricorn* (1949) or the wine bottle filled with radium filings from *Notorious* (1946).

Those aren't murder weapons – though the bottle could be if you tipped radium in someone's champagne. The other Hitchcock presents are instruments of death – unless the plastic budgies reference the token harmless lovebirds Tippi gives Rod Taylor rather than the killer avians in the rest of the picture.

'It'd be a job to wrap up a lifeboat,' says Jeremy – who knows a lot about Jules Dassin – 'or deliver the poisoned glass of milk... or the Statue of Liberty.'

'*Lifeboat*, 1944... *Suspicion*, 1941... *Sabotage*, 1942,' says Vangie, getting the references.

Yes, at this table, we really do refer to films like that, with dates...

At this table, we all know the references. And are eager to pounce on tiny errors.

'...*teur* not *tage*,' says Jeremy, smugly. '*Saboteur* is American, 1942... *Sabotage* is British, 1936.'

'Based on *The Secret Agent* by Joseph Conrad,' I put in.

'Not to be confused with *Secret Agent*, 1936, based on *Ashenden* by Somerset Maugham,' adds Jeremy.

'Silly me,' says Vangie. 'I've not seen *Sabotage*. Is it the one with the bomb under the table? Hitch's illustration of the difference between surprise and suspense. If the audience doesn't know there's a bomb in the room, you get a boring scene of people then a shock as it goes off. If the audience *does* know, there's a ticking countdown to doom. Every trivial remark or development – the guy who wants to go home but is persuaded to stay and play cards – adds to the tension...'

'That's him talking with Truffaut, not the film *Sabotage* – which has the bomb in a can of film, carried by a boy on a bus,' says

Jeremy. 'Hitch said it was a mistake to have the bomb go off and kill the boy, since the audience were annoyed with him and impatient with the rest of the film...'

'...though the innocent killed in the explosion is the key incident of Conrad's novel, and based on something which actually happened,' I say. 'Take it out and there's no story.'

This leads to a discussion of Hitchcock's treatment of source material.

We get on to Daphne du Maurier, Winston Graham and Arthur La Bern – author of the novels filmed by Hitch as *Frenzy* and Robert Hamer as *It Always Rains on Sunday*, and a subject I'm especially keen on getting into.

At the end of the meal, Jeremy slips in a warning.

'The moral is – be very wary if a card marked 1936 is stuck to a parcel the size of a London bus, eh, Maurice.'

So, *1936*.

Tom holds up a parcel which isn't the size of a bus.

I didn't expect it to go this far.

Inside the brown paper is a film can. Metal, not plastic – old, too, with a crusting of labels pasted over labels. The sort of can I am familiar with. Tucked away at the back of shelves or fallen down behind filing cabinets in archives and attics around the world, promising a surprise discovery of something considered lost... usually delivering a badly decomposed reel of something achingly commonplace and safely preserved in multiple locations.

'What's this...' says Tom, looking at a faded, pasted-on label. 'Is this in Old Norse or something?'

I guess Finnish.

I try to tell Tom not to open the film can.

It doesn't contain a reel of undiscovered silent Hitchcock or highly flammable but not explosive Maurice Elvey trims.

But it's Christmas morning again and my son can't wait to see what's inside.

The Nest

Jeff Noon

Helen Milvane lay asleep in her bed, deep asleep. Yet her face trembled, and her mouth puckered as though something alive was lodged within, alongside her tongue. Then her lips parted. The creature did, in fact, look a little like a human tongue, in shape and size. But it was darker, not pink, more a sludgy grey. It was wet. It slipped out from between the lips, onto the pillow.

Helen stirred a little, but she did not wake.

The creature reached the edge of the bed where it fell to the carpet, soundlessly, softly. Then it crawled away. It was grub-like. Sometimes it elongated its body, and then it looked more like a leech. It had tiny feelers on its head, but otherwise the flesh was smooth. It slithered along until it reached the skirting board. Everywhere it went it left behind a silvery trail of slime. This mucus had a sticky quality, which enabled it to climb, very like a slug. With some effort the creature reached its target, a small patch of light on the wall. And here it bathed, its body glowing slightly, taking on a bluish hue. A quarter of an hour passed.

Then it set off on the return journey, this time travelling via the wall, which made it easier for it to crawl back onto the pillow. The feelers drew back into the body. It nudged at the woman's lips, which opened, and it slid inside. Helen slept on for another five

The Nest

hours, when she awoke showing no obvious effects of the creature's presence.

The next night, the creature again emerged from the sleeping woman's mouth. It had reverted to its natural colouring, dark grey. If it had eyes, they were miniscule, nothing more than slits in the flesh. It had one purpose only. This time it was drawn towards a patch of moonlight that lay across the carpet. The slug lay there in perfect peace, drinking up the warmth.

Because of its very particular blindness, and its comfort, the creature did not notice the figure sitting in the corner of the darkened bedroom. Edward Milvane kept his body still, taking shallow breaths. He had left a narrow gap between the bedroom curtains on purpose, to allow the moonlight entrance. Thus, he had set a trap. He watched the creature where it lay on the floor. Then he turned to look at the sleeping form of his mother, worrying, as he always did, that she might wake up. But Helen was lost to the world. Over the past ten years he had gotten her addicted to soporifics. Dr Milvane was an expert on such things. He needed his time alone with the creatures, and he needed them to remain a secret, even from the woman whose body housed them.

The slug stirred a little, its feeding time at an end. Milvane walked over to his prey, bending down to get a better look. With a quick darting movement, he plucked it from the carpet. He was wearing surgical gloves, so as not to contaminate the flesh; that was very important. On padded feet he walked out of the bedroom, heading down the stairs. In readiness, he had already unlocked the door in the hallway corridor that led down into the basement. Every step of the way the creature squirmed to escape, but Milvane had done this many times before. His fingers tightened. There was an old aquarium tank in the basement, once upon a time housing tropical fish, but now empty. He dropped the slug into the tank and placed the lid in position. A small, shaded lamp illuminated the tank's

interior. This would keep the creature alive, but passive. Milvane sat down at his workbench. His breath came heavily, and there was a ragged pulse in his chest. He was worn out. A glance at the clock he kept on a shelf told him it was ten past three. He needed to sleep. At least it was Saturday tomorrow, so no need to go into work. He could begin the operation then. In preparation, he laid out his tools on the work bench, the scalpel, the scissors, the callipers and the photographic slides. He took one last look at the occupant of the glass tank, then he went back upstairs, making sure to lock the basement door after him. Within five minutes of climbing into bed he was asleep.

It was 1963, the spring of that year. Edward Milvane was thirty-seven years old. He had few close friends, and even his colleagues at the Institute of Psychiatric Studies paid him little mind. He had been married once, for two years of bliss and a year of misery. He suspected he would never venture that way again. The time had slipped away, as he concentrated on his career. And anyway, he had never offered much appeal to women. You would think, given his profession, that he would be able to sort out his own life. But he failed in this.

His mother was preparing breakfast. A plate screeched as a breadknife slid across its surface. Milvane winced. He was sure she did this deliberately.

'What's wrong, Edward? Did you not sleep very well?'

'Not really. I was thinking too much, about work.'

She served him a plateful of liver and bacon, with a runny egg on the side. Grease swilled around the dish. He felt queasy looking at it.

'This is slop,' he told her.

'Eat up. Don't let it get cold.' She spoke flatly. 'It's all you're worth.'

'I should be eating caviar.'

The Nest

'Unfertilised fish eggs? Yes, that's about your level. Inert. All your potential wasted.'

Every day was the same, the same squabbling between them, a constant battle. Sometimes Edward won, sometimes his mother won.

He pushed the plate aside before the meal was halfway finished. 'Mother, are you meeting your stupid, stuck-up friends today?'

'Of course. Why, are you trying to get rid of me?'

He laughed gently. 'I have some work to do, a paper to write up.'

'I don't know why you bother. After all—'

'I need to earn respect in my field.'

'Respect? When you can't even look in a mirror without closing your eyes.'

The barb struck home. He rallied in the only way he knew: 'My patients need me, and nothing else matters.'

But it was true, Milvane's academic ambitions had stalled. He had written half a dozen papers all on the same subject, all of them rejected by his peers as being too fantastical, even too grotesque: 'A firm rejection of all the known tenets of scientific study.' But could the human mind really be studied by scientific means? There will be always things we cannot know. We are too close to the subject matter. We are the subject matter!

A mischievous impulse came over him. 'Sometimes, Mother, under the right circumstances, in highly sensitive individuals, when the soul is dark enough, something might be tempted out of that dark, when prompted, when stimulated by the right cocktail of drugs and a discreet use of hypnosis, something might peel itself away from the conscious mind and set off into the world, a nudging blind slug of a thing, for instance, slithering in its own trail of mucus. Climbing the walls, crawling across the floor, seeking to bathe itself in moonlight.'

He stopped speaking. Helen was putting the finishing touches to her face.

'Did you hear any of that?'

'Of course I did. Something about a slug crawling across the carpet.' She grinned. 'I presume you are referring to the subliminal self?' Helen had devoured the latest bestseller, *Your Other Self is Your True Self*. Milvane despised these 'self-help potboilers', but he was happy to engage with the jargon, if necessary.

'Exactly, Mother. Imagine if I could bring a patient's subliminal self to life, separate from the body, from the psyche that produced it.'

'And then what?'

'Why, treat it as a separate entity, of course! Yes, why not? It might be possible. It would revolutionise psychiatric care.'

She smiled and bent down to kiss him on the forehead. In such a way, a truce was called. Once she had left the house, Milvane went down into the basement. He lifted the lid off the glass tank and reached in for the slug. Please God, let there be something this time! It had been a while since his last gathering – three years, near enough – with only a few glimpses in between. At the bench, he placed the creature in the clamps and tightened them until the flesh bulged slightly. The feelers protruded their pitiful quarter inch and quivered. Milvane had long ago gotten used to operating on a live specimen. Needs must. He started from the tail end, because this kept it alive for the longest time, taking the finest possible slices he could manage. The flesh had to let the light through for the process to work. He held some of the first slices up to his work lamp, hoping to spot some darker patches on the tissue. Nothing as yet. He worked on, reaching the middle section of the slug's body. This was always the most profitable area, and his hands took extra care with the blade, as his eyes narrowed to their task.

The creature was by now dead.

Each chosen slice was placed in a tray filled with the specimen's own bodily fluids, to keep the flesh moist, and to preserve the contents for as long as possible. The unwanted portions of the slug

he cast aside into a waste-paper bin. By tomorrow these will have faded away, leaving behind a grey dust, nothing more. Helen Milvane was their creator and their nurturer, and away from her body the slugs quickly lost their hold on reality. Direct sunlight was the worst: it killed off their inner contents, and really that was all Edward Milvane was interested in, this was his proper study. Fifteen of the slices showed potential, and he placed each of these onto a blank photographic slide. They clung to the plastic quite easily, even melting into it a little way. Then he went upstairs and made himself a snack. His mother had not yet come home from her social engagement. After he had cleaned away his plate and cup, he went back to work. The slides were dry. Good. He placed them into the carousel of his projector and turned out the lights in the basement. It was pitch black. He switched on the machine and the beam of light fanned out to hit the viewing screen.

Milvane hesitated, savouring the moment. Then he clicked the button on the remote controller and the first of the slides moved into place. There was nothing to see at first, only the pale greyish blue of the creature's flesh. But within this expanse there were a few marks, scattered flecks of a darker colour. The second slide was a disappointment, being more or less blank. Milvane fretted. Thankfully, the next few slides showed promise, with more of the dark grey marks on show, some of them almost black in tone. Were they making a pattern? He got up from his chair and took a step towards the screen, careful to avoid the pathway of light. He clicked the remote. His eyes widened. Yes, a pattern was emerging. But of what? It was irregular in nature, and he struggled to make out anything clearly. He clicked on, and on, skipping through all fifteen of the slides, watching as this wild unknown shape fluttered from one area of the screen to another. It was fascinating. He started again from the beginning, forcing himself to concentrate. It wasn't perfect, but there was definitely something there, he knew it. The creature was speaking to him from beyond its death, showing him

a set of images. And, of course, his mother was also speaking to him, but from some hidden part of her mind, one that she was most probably not aware of; the true subconscious, or below that even, from the id, the deepest, darkest and oldest part of the human brain.

He took a rest after his third viewing. The initial excitement had passed. What exactly had he witnessed? A flickering pattern, nothing more, nothing that he could show to his colleagues at the institute. They would laugh at him, or at the least gently mock him, as they liked to do. He had actually showed them some of the better slides a couple of summers back, and photographs of the slug-like creatures. They had dismissed the whole thing as a sham, a typical attempt on Milvane's part to bolster his failing career. If only he could wait every night in his mother's bedroom, to capture whatever might emerge. Surely, then he would be able to piece together the puzzle, and prove to the world that he, and he alone, had penetrated the heart of the human mystery. Oh, what glory would ensue! But such a long-term stakeout was not possible. He felt bad enough already, creeping into his mother's bedroom whenever he saw the telltale signs that something might be ready to emerge from her mouth, to feed on the patches of light.

He cursed to himself, something he rarely did. The lack of sleep was catching up with him, that was all. The dark ragged shape on the screen flickered in the light for a moment longer before he clicked off the projector. He sat there in the dark of the basement for ten minutes or more, his mind raging.

In the morning, when he and his mother went to church, he could hardly keep his eyes open during the service. He could not remember the tune of the first hymn, although he had sung it many times before. His voice wavered off-key. It started to rain on the drive home. Helen chatted away about her latest charitable project. He said 'Yes' and 'No', appropriately. Milvane was glad to

The Nest

get back to the house on Primrose Avenue, glad to retreat to his underground lair.

'You're not working today, are you?' she asked.

'I have to, if I'm to catch up.'

He locked the basement door. She had once accused him of watching 'filthy movies' down there. If only she knew! He had replied that he did not possess a movie projector, but a slide projector, quite a different thing, and the images he looked at were only to do with his professional work. Which was true, absolutely true. But of course, it was his own mother he was studying. It was a terrible practice, debased, and even perverted. But he could not stop. Sometimes he wondered if his mother might be the only such nurturer in the world. The thought both excited him and worried him. Certainly, the known literature had never hinted at such a phenomenon. Was he the sole witness? What a responsibility that was.

After yesterday's disappointment he needed reassurance. He went to the cupboard where he kept his collection of slides, going back to the very first experiments, some ten years ago. In all that time, dissecting so many specimens, hundreds of them, he had only been truly rewarded on four occasions. He took these four boxes out now. The first came only a few months after his very first viewing of the creature, and was labelled *4 August 1954*. The title card read *View from a Window*. Twenty-two slides. He fed them into the carousel and took his seat for a pleasant viewing session. One by one the slides passed through the mechanism.

It was like looking through a faulty telescope. A large circle formed on the screen, its edges blurred and dark. The circle within contained an image, in fact a series of images, one on each slide, all showing the same location. He saw windows, many of them, lining the rear of a large apartment block. He saw a central courtyard. He saw the sky at dusk, a vivid orange. He saw people at the windows, and on their balconies, living their lives. He saw a young

lady in the middle of a dance routine, right there in her apartment, on full view, her body caught in one moment of poise and athleticism as he held the particular slide in its position. Then he clicked on. There was no sound; the slugs did not have that capability. They were a purely visual medium, showing objects, people, events, stories really, but told in a series of stills. Milvane had the impression that someone was watching these various scenes, looking through a window of their own, and that he was looking through this voyeur's eyes, sharing the vision. But the face of the watcher was never shown.

He took up the second box of slides, this one dated *9 May 1958*. Nearly four years he had waited. Four years! He had more or less given up, thinking that first set of images as an aberration. So the nineteen images he had gathered in '58 were an unexpected pleasure. He watched them now, clicking slowly, taking his time with each one. They all featured the same woman, a blonde, her hair fashioned into a tight knot on the back of her head. She was seen in different places: an art gallery; the bank of a river with a bridge arching across; a cemetery; the steps of a church tower. Milvane thought this woman very beautiful. From her expression he imagined her a soul in torment, caught in a spell of obsession. Accordingly he called this set of images *Under the Spell*. The bridge over the river interested him greatly, for it was without doubt the Golden Gate Bridge. So, unlike the first images, which showed an anonymous apartment block, this second set had a definite location in the real world: San Francisco. Now, as far as he knew, his mother had never once left England. He theorised that her repressed thoughts and fantasises were being ejected from the psyche into these creatures, that they formed a necessary safeguard, or a cleansing mechanism. The creatures came out of the body, fed on light, their natural fuel, and then went back inside to gather more of the images.

Quickly he took up the third box, with its twenty-five slides. These were very special indeed, altogether of a different nature, and

The Nest

they caused his early theories to be rejected. He had not been sure previously just what he was looking at. The images did not have the feel of reality, but more of staged or a filmed aspect. And that was now made plain by the contents of box number three, dated *1 July 1959*. In their fragmentary fashion the slides showed the title sequence of a movie. First of all, a green surface, with dark blue lines dissecting it at angles, forming a slanted grid, an abstract design. With the third slide these patterns dissolved into the facade of a building, a large modern office block. Over this the titles and credits appeared. The movie was called *North by Northwest*. It starred Cary Grant. It was filmed in Technicolor and VistaVision, or as Milvane more rightly called it, Milvanoscope. The final slide actually named the movie's director: Alfred Hitchcock. No action, this time, no characters. And yet, how much this gave him! So many clues. He knew of Cary Grant, of course, in fact he had seen many of his films; he was a very popular actor. But Milvane had never heard of a film called *North by Northwest*. He had found no mention of it in any of the books or magazines he had looked into, it was not listed in Grant's filmography. And the director, Mr Hitchcock? The *Encyclopaedia of Cinema* at the library did not have a listing for that name. Only one possibility remained: that Helen Milvane had invented this film director, somewhere deep in the recesses of her mind. But why? One morning he had quizzed her on the subject.

'Mother, do you dream?'

'Of course I dream. What kind of question is that?'

'Did you ever dream of a large office block, in the city? Or a woman with blonde hair, done up into a knot?'

'Please, Edward. Do not turn me into one of your patients. I shall quite dislike it.'

'Have you ever met with Alfred Hitchcock?'

'Who?'

'Mr Alfred Hitchcock. I thought you might know him.'

'No, I do not.'

Was there a flicker in her eyes, a quick darting inward look? Was she lying?

'Truly, Mother, you've never heard of him?'

'Edward, you really are a pain.'

And that was that. They moved on to other matters.

The fourth box of slides came from 1960, gathered on 16 June of that year. He was not given a title this time, so he made up his own: *Surprise Attack*. Over the years, he felt, the images were becoming clearer, and more profound, with people's faces sharply delineated. Actor's faces. For he now knew that he was watching a series of movies made inside his mother's head, with the slugs acting as a kind of organic recording device. *Surprise Attack* consisted of twenty slides, each one brutal in its intent. A shadowy figure, an old woman most probably, knife in hand, was attacking a younger woman, a naked woman, in a shower stall. The broken shower curtain, the plughole, dark blood flowing down the drain, the flesh on view, her eye, the eye of a dead woman, that single giant eye staring out at Milvane as it filled the screen. Every time he viewed this sequence he felt sick inside, and scared, and yet troubled with desire. He hated himself for these feelings, that his mother should think of such things, and that he should steal them from her, and that he should sit here, excited and fearful at the same time, and riddled with guilt. He crumpled up in his chair, his hands grinding against each other, his thin chest bent forward, his head almost touching his knees, and he wept, he wept.

All he could do now was wait, wait for those flickers of blue light in his mother's eyes, the slight tremble of her hands, the stutter of her speech: all signs of a new emergence. He had to be vigilant, he had to be ready, on patrol every night in his mother's bedroom. He could not afford to miss this opportunity. Nearly three years had passed since *Surprise Attack*. On occasion he found single images, snapshots: men climbing on the carved faces of

The Nest

the presidents at Mount Rushmore; a crop-duster plane spraying a field; a peephole in a wall, a staring eye pressed up against it, watching, as Milvane in turn watched, and peeped, and collected, and made his studies. He kept these single images in a box labelled *Miscellaneous*. One day he viewed a fragment of another credit sequence and saw the name Alfred Hitchcock mentioned again. *Let us propose*, he wrote in his notes, *that Mr Hitchcock is a representation of my mother's animus, to use Jung's term, the masculine component of the female psyche.* He also entertained more egotistical thoughts, that Alfred Hitchcock simply *had* to exist, his work had to be seen. He might well be a great artist! And it was his duty, Edward Milvane's duty, to bring that work into the light. It would be like having to invent Shakespeare, or Beethoven, if those men did not exist. Otherwise, we might as well all crawl in the mud.

On the evening of 28 March, he saw the necessary signs in his mother. They passed the time in a relaxed manner, listening to a drama on the radio. Impatience grew in Milvane, but he kept it hidden. Finally it was time for bed, and he put out the usual sleeping powders, adding a little extra this time. He went to his own room and watched an hour creep by on the clock face. Then he walked across the landing. All was quiet, his mother breathed easily in her sleep. He turned on the torch he had brought with him, aiming it carefully to make a circle of light on the carpet. He did not have long to wait. The slug came out of its nesting place, dropped down to the floor and slithered along towards the glow of the torch. Its silvery trail glistened. Milvane let it feed. Then he pounced. In his haste he had forgotten to put on gloves, and the soft pulpy flesh oozed between his fingers. It did not matter. He was already anticipating the viewing session, where he would learn the secret offered up by those strange flickering shapes previously seen. But something made him hesitate. He looked to the bed.

His mother's eyes were open.

'How dare you.' Her voice was a harsh sound in the softness of the night. 'You would steal from me?'

Milvane could not move. He could not speak, nor make any response. The only thing he was truly aware of was the slug he held in his hand, how cold and slippery it was, and how it pulsed with life, with potential. All those images, he must see them! But Helen had already freed herself from the sheets. She came towards him not quickly, but in a kind of daze. There was no escaping it. She made a grab for the slug. Milvane was still in shock. Her eyes were wild. He had to obey his mother, there was no other option, and he fell to his knees before her, as he did before the priest every Sunday to receive the host. She stood over him in the gloom. The creature was in her hands and she played with it like a woman caressing a much-loved pet.

Then she fed it to him.

They spoke of everyday things at the breakfast table, making no mention of the night's events. At work he was cordial to the other doctors, and he treated the patients with his usual compassion. He felt nothing at all of the creature within, no stirrings of any kind, and yet on the way home he stopped on impulse at a corner shop and bought a selection of chocolate bars, which he ate sitting in the car, all five of them, one after another. Then he felt better. After dinner his mother talked freely, without any of the usual insults.

'I was young, a young woman, when I first met Hitch.'

'Hitch?'

'That's how he liked to be known. A nickname.' A smile came to her lips. 'I was eighteen at the time, he was a couple of years older. He was my... Oh, how can I put this...'

'You were intimate with him? Mother?'

'Yes. But not in the way you think.'

He wanted to ask: *What other way is there?* But he let her carry on.

The Nest

'I was a secretary, working for a film company in London. Hitch was working there as well, writing, set-painting, doing anything he could, really. He wanted so much to be a director.'

Milvane felt a little faint. 'Did he make any films?'

'One or two amateur affairs. He put all his hope into a script called *The Lodger*. It came out in 1927. He called it, "A Story of the London Fog". It was going to be his first success.'

'I've never heard of it.'

'No, sadly, it failed at the box office. And well, that was that.'

'What happened between you?'

She took a moment. He truly thought she would say no more. But then she sighed deeply, and began, 'Our love was a ritual, the kind that witches perform in the dark. There was magic in it.' He had never seen his mother this way before, so serious, so lost in herself. 'He gave everything to the ceremony, in order that his career might take off. And myself, a willing participant.' She paused. 'I should have had a child by him. Instead of which...'

'Yes?'

She shook herself awake. 'Nothing, nothing more. He married a lovely young woman called Alma. She worked at the film studio as well. And after that, well, I never knew. I never heard from him again. I think he left the film industry.'

Milvane was startled. He didn't know what to say.

Helen went on, 'Hitch had such incredible ideas. He was a visionary, and I always thought he would be a famous director. But sometimes these things are not meant to be.'

'It *was* meant to be, Mother. It was!'

He was certain now of his task.

Dreams crept through the night, into his skull. He woke suddenly. The thing was halfway out of his mouth, and he retched and his throat closed up. He had to fight the urge to swallow. The taste was bitter. He could not breathe. In his panic he reached for the

slug and pulled it loose. It seemed to take an age before it emerged fully, slipping out onto the sheets. He took in huge gasping breaths and the vomit curdled in his stomach. A small light clicked on. His mother was standing near the window, where she waited, as he had waited for so many years.

In the basement he began work straight away. The first entry of the blade into the creature's flesh made him wince, as though he had cut himself, and indeed his hand did slip at one point, and he nicked his finger. But after that he settled into a rhythm. Occasionally he looked to his mother, for encouragement, but she gave him none. The scalpel went about its business. Slice by slice, these were the thinnest and most delicate examples he had ever managed. And he could see as he held each one up to the lamp that they were rich and dark with imagery. Already he was theorising: that his own contribution was to add focus, depth of field, or even overabundance of desire. Thirty-nine slices! Never before had he experienced such bounty. He started the process of transferring them one by one onto photographic slides. His mother fell asleep in the chair, and he let her be. His mind had one task only, and less than an hour later he had the projector set up, the carousel ready to revolve. It was a quarter past four in the morning. His mother woke up as the mechanism hummed and whirred into action, and the light was cast upon the screen.

Slashes of black, grey, brown, flickerings, flutterings: all these different shapes taking flight at last as so many birds – sparrows, crows, starlings, seagulls. Yellow beaks, jet-black eyes, hooked talons. Hovering, swooping, pecking, clawing, gouging. Attacking humans, children even. It was a vision from a nightmare. He was surprised to see spots of splattered blood. Not from the film, but from his own hand, where he had cut himself. Contamination. Fluids of his own body mixed with the vision on the screen. The ritual was complete.

Helen looked on, her eyes glazed. The light bathed her face. She

The Nest

was as spellbound as he was, and Milvane smiled to see this. They had a lot of work to do, and now, in collaboration, they would accomplish so much more. Together they would nurture the images, seeking out new stories, adding to the ones they already had, one frame at a time. It would take a while, years probably. Suddenly his mother screamed. It was not born of pain, nor of despair; rather it was the scream of the birds, of the children. Milvane revelled in it, his own personal soundtrack.

The carousel clicked on its journey, beginning again each time, the cycle repeating. He would label this box *The Birds*. It was simple. From the nest of the skull they had arisen, these winged creatures, to infect the world with their terrible beauty.

The Migratory Pattern of Birds

M W Craven

'I'm never eating potato-based products again,' Detective Sergeant Washington Poe said, looking at his just-opened packet of XL Cheese crisps. He stared at the lorry bed he'd just climbed out of. The pathologist and the crime-scene guys had moved in now and they wouldn't be rushed. 'One bad potato is bad enough; a lorry load of rotten ones is rank. Truly foul.'

'It must have been bad, Poe,' Tilly Bradshaw said. 'You eat more junk food than a Disney racoon. And you'll eat crisps anywhere. I mean *anywhere*.'

'I hardly think that's true, Tilly.'

'Last month you got caught eating crisps during a post-mortem.'

'Only because I'd missed my breakfast—'

'You weren't even in the viewing area,' Bradshaw cut in. 'The pathologist was pointing out some lesions on the dead man's head. One of your crisps went into the victim's mouth.'

'I apologised profusely for—'

'When Detective Chief Inspector Flynn heard about that, she called you a useless spunktrumpet. I didn't know what that meant so I looked it up on the internet.'

'And what did you find?'

Bradshaw frowned. 'Not many trumpets.'

Despite himself, Poe laughed. He threw the packet of XL into

The Migratory Pattern of Birds

the passenger footwell of his car. 'Well, the back of that potato truck has done what you and the boss couldn't,' he said. 'I'm off crisps for good.'

'We only want you to eat less junk food so your bloodwork improves. Your last test showed there was more saturated fat in your blood than a polar bear's.'

'I should eat fewer seals, got it.'

Bradshaw was a civilian analyst in the National Crime Agency, but she hadn't been deskbound for years now. Wherever Poe went, she went. They were friends (even if she did badger him mercilessly about his diet), she had a once-in-a-generation mind and was the most significant crime-fighting asset the NCA had ever had, but most importantly, he trusted her completely. So, when Poe was called to another victim of the necktie strangler, she went with him. He didn't need to ask, and she didn't need to be invited. 'Is it definitely him?' she said.

'No question. She's been strangled with a tie, and it's the same knot.'

Bradshaw nodded. The killer always using ties was in the public domain. It wasn't something that could be kept from the press. But the knot – a lariat loop – had been held back to weed out the cranks and the weirdos. 'Is Richard Blaney involved?'

'The lorry driver? If he is, it's only as a patsy. We'll take him in to make sure, but I think the killer saw his unattended lorry as an opportunity. It was headed straight to the landfill, and if that had happened, it's doubtful she'd ever have been found.'

'Who called it in?'

'Anonymous tip.'

'I'll get into that when I have a signal, Poe.'

Poe grunted his approval. The caller might think he'd made an anonymous call, but nothing was secret to Bradshaw. It was scary how open the world was to her.

'What's up, Poe?' she asked.

'I'm wondering just how many women this man has murdered.'

The necktie strangler had never attempted to conceal his victims. The most recent body being hidden in the back of a landfill-bound potato lorry could mean he had changed his *modus operandi*, that he knew this victim personally, or he mixed it up – some he hid, others he left where they'd died. If it was the latter, there could be additional bodies out there.

Movement from the back of the lorry caused them to turn round. The Home Office pathologist climbed down. 'I've got everything I need, Sergeant Poe,' he said. 'We can move the body now.'

Poe didn't ask for his early thoughts. Pathology was science, not guesswork. Attending the scene was about gathering evidence that might otherwise be lost when the body was moved. Only idiots asked for a pathologist's early thoughts and only idiotic pathologists gave them. Anyway, Poe didn't need the pathologist to tell him that the woman had been strangled to death with a necktie. It was as obvious as a yellow hat.

The pathologist directed the crime scene techs as they manoeuvred the body, still half-hidden in a sack of soft and spongy potatoes, off the lorry bed and onto a gurney. They pushed it under one of the crime scene lights for a final examination. Poe suited up and joined them. Bradshaw stayed where she was. The victim was a woman in her late twenties, early thirties. Apart from the tie around her neck, she was naked. She had long brown hair and a thin white face. Even teeth, an uneven nose. Blue eyes, haemorrhaged, tongue gaping.

Poe bent down and took a photograph of the tie's knot. He would get the official photographs later, but he would send this to DCI Flynn so she could officially add the victim to the investigation. He checked the photo was clear. It was.

Then he frowned. That was odd, he thought. He asked the pathologist if he could touch the tie. The pathologist confirmed he could. Poe put on a fresh pair of gloves and held out the tie so

he could see the pattern properly. He took another photograph and zoomed in, so the pattern was magnified. He frowned again. It didn't make sense.

'What do you know about black grouse, Tilly?' he asked.

Ennismore Hall, Sussex. Ancestral home of the Rusk family. Three weeks later.

Poe was mildly disappointed. He had been expecting more. Something grand. But when he'd turned the corner of the long driveway, he saw that Ennismore Hall was less *Downton*, and more *Wuthering Heights*. It had been built in 1964 but looked older. Bradshaw said it had eight bedrooms and six reception rooms. The original owner, George Rusk, who to Poe's surprise had made his money from iron rather than finger-biscuits for teething babies, had wanted a large family and built his home accordingly. It was a square, symmetrical building. It had no wings, no turrets and no moat. Just a central door and an equal number of windows on either side. It looked like it had been designed by someone with limited imagination. It was smaller than Highwood, the house he now shared with his wife, Lady Estelle Doyle, the daughter of the late Marquess of Northumberland.

Estelle saw his reaction. 'The Rusks have a lot of land, Poe,' she said. 'Even more than we do.'

Poe grunted something non-committal. They hadn't been married long, and he was still coming to terms with going from not having a pot to piss in to being one of the richest men in the north of England. It offended his working-class principles. He'd raised the subject of Estelle getting a prenup, but she gave him one of her looks and he immediately dropped the subject.

She said, 'And you still want me acting the inbred idiot.'

Poe scowled. They'd been through this at least ten times. His wife was an eminent forensic pathologist, one of the best in the

country. Far better than the guy attached to the necktie-strangler case, and he was no slouch. Doyle lectured all over the world. Pathology students wrote papers on her findings. To reduce her to acting like an extra in *The Crown* was demeaning. In Poe's world, forensic pathology trumped being 443rd in line to the throne. He remembered the last day of their honeymoon in Cornwall, when, for a joke, he had planned out how to simultaneously murder the 442 ahead of his new wife. Let her get her hands on the Crown Jewels. She read his notes and said, 'Don't ever show this to anyone, Poe.'

'I think Poe's best chance is for them to think they have the upper hand in the negotiations, Estelle,' Bradshaw said from the back seat. 'When they're absolutely focussed on getting what they want, they won't be thinking about… the other thing.'

'And you still won't tell me what that is?' Estelle said.

'Sorry,' Poe replied. 'We had a hell of a job as it was, convincing the boss to let you come with us. But rest assured, this is as big as cases come.'

'One of the Rusks is the necktie strangler, then,' she said.

Poe didn't answer. Neither did Bradshaw.

'How stupid do you think I am, Poe? You and Tilly were just about to leave the police to become private investigators, but instead of spending your last few days stealing paperclips, you're both working harder than ever. I've barely seen you these last six weeks and when I do, you're exhausted. Tilly too. But suddenly you want me to invent a spurious reason to visit one of my father's old shooting cronies.'

After an awkward pause, Bradshaw said, 'Poe would never steal from work! His heart is pure and his morals are strong.'

Poe, who had never bought a pen in his life, said nothing. That was the trouble with surrounding yourself with people who are cleverer than you, Poe thought. They could work things out for themselves.

The Migratory Pattern of Birds

'Fine,' he said eventually. 'But if the boss asks, you figured it out for yourself.'

'I *did* figure it out for myself.'

'You know what I mean.'

Estelle ran her finger across her lips. Zipped them shut. 'Lady Penelope it is, then.'

The front door of the house opened at the exact moment Poe turned off his engine. A man stepped out. He had a ruddy face, a walrus moustache and an award-winning belly. Poe wondered how long he'd been standing behind the door.

'I'll lead,' Estelle said from the side of her mouth.

'Welcome to Ennismore, Lady Doyle,' Group Captain Felix Rusk said as he approached them. He had a strange smile. It was genuine, but it only worked on half of his face. Turned his smile into a happy smirk.

'Daaaaarling,' she replied with a voice that could cut glass. She offered both her cheeks to the group captain, who obligingly kissed them. 'It's simply been toooo long.'

Rusk went to kiss Bradshaw, who said, 'Don't you dare, buster.'

He blinked in surprise. Poe sniggered but hid it behind a cough. He offered Poe his hand. 'You must be Washington Poe,' he said. 'My name is Group Captain Felix Rusk.'

'Pleased to meet you, Group,' Poe said.

'No, no. Group Captain is an honorific.'

'Oh, I didn't realise you were still in the Royal Air Force,' Poe said. 'Please accept my apologies.'

'Retired, dear boy. Retired.'

'Golly,' Poe said. 'I served with the Black Watch before I joined the police. I should start using my rank as an honorific as well.'

'Perhaps you should,' Rusk said. 'What rank did you reach? Major? Lieutenant Colonel? Colonel?'

Poe snapped to attention and flipped a goofy salute. 'Private Poe, reporting for duty, sah!'

'Er... no, you're not supposed to use—'

'Poe's just being silly, Felix,' Estelle cut in, throwing Poe a confused look.

Poe winked back. Let her know he knew what he was doing.

'The family are all here?' she asked Rusk. 'This concerns them, too.'

'Yes, yes,' Rusk replied. 'Your requests were very clear. Hetty has come down from London and Rusty lives here most of the time anyway. We're all terribly curious as to why the late Marquess of Northumberland's daughter might want an audience. We were rather hoping you might be thinking of selling some of your late father's grouse moors.' When Estelle didn't respond, he said, 'Anyway, we shouldn't stand outside, not when Birdie has been slaving away all week putting her high tea together. I hope you've brought your appetites. The game pie is bigger than my head.'

'Now you're talking,' Poe said slapping Rusk on the back. 'Lead the way, Group.' He turned back to Estelle and whispered, 'Birdie?'

'His wife, Beatrice,' Estelle whispered back.

Poe nodded. He had detailed biographies of every member of the Rusk family, but they didn't stretch to nicknames. There hadn't been time. Rusk had mentioned Hetty, which Poe assumed was his daughter, Henrietta. Bradshaw's biography stated she was an artist. Not well known, a little bit talented. Used to be a heroin addict, probably still was. Rusty must be his son, Charles. He was the only one left.

'Let's have a sherry before we eat, what?' Rusk said as he led them into his home.

'Got any beer?' Poe asked.

The dining room at Ennismore Hall was a grand affair. A mahogany table, groaning with food. High-backed seats, plump cushions. Silver cutlery. Silver salt and pepper shakers. Silver place-card holders, the names written in thick black ink. The napkins were adorned with the Rusk family crest.

The Migratory Pattern of Birds

'We're going French tonight, I see,' Estelle said.

Poe looked at the food Birdie had laid out. It looked British to him. A massive pie dominated the table. A ceramic bird broke through the crust. The piece of baker's equipment that helped vent the steam was stained with the oils and gravies of a thousand pies. Poe approved. The rest of the food seemed equally British. Cuts of meat, a platter of cheddar and Stilton cheeses. A poached salmon. Cakes and tarts and a big old trifle.

'French?' Poe said.

'The seating arrangements, Poe,' Estelle explained. 'It means the group captain and his wife will be seated in the middle of the table. If we were using the English style, they would sit at each head of the table.'

Poe smiled to himself. His wife may walk and talk like a goth, she may have more tattoos than David Beckham, and she may cut up dead bodies for a living, but if you cut her in two, her blood would be blue, not red. She had grown up with bullshit like this. The fact she'd shucked her aristocratic upbringing like a bad oyster made him love her even more. He took his seat, winked at Estelle again, then blew his nose on his napkin. They'd discussed dining etiquette on the journey to Ennismore Hall, and Poe had asked what he could do to come across as boorish without it being obvious. 'Just be yourself, Poe,' Estelle had replied.

Poe was sure that at larger events, the Rusks would have caterers or staff to serve them, but for just the seven of them Birdie had assumed the role. After they were all seated she left the dining room, returning with a tray of quail, happily spitting in their own fat. She had roasted them with grapes, which Poe thought was just about the weirdest concoction he'd ever seen. Quail wasn't gamey enough to need fruit, and even if it was, grapes weren't the berries to bet on. Oranges, maybe. Lemon, if the birds were on the turn.

Oh well, he thought. Time to misbehave again. He ignored his knife and fork and picked it up by a leg. He started gnawing on it

like it was corn on the cob. 'Not a lot of meat on it,' Poe said with his mouth full. He threw the bone back on his plate then added, 'Can we have some of that pie now?'

Estelle smirked but hid it with the back of her hand.

'Holy mackerel, this is an unhealthy meal,' Bradshaw said in disgust. 'Even the grapes are cooked in animal fat. Has no one here heard of bowel cancer?'

Rusty, Group Captain Rusk's son, muttered, 'Council estate,' under his breath, loud enough for everyone to hear. It drew a sharp look from Rusk and a delighted smile from his daughter, Hetty.

Rusk's son was an interesting man, Poe thought. Rusty. Despite living on a shooting estate, he was paler than a flour worm. Like he hated the sun. He was tall, a full head taller than his father, but somehow managed to look smaller. He had ginger hair, and ears like a cartoon mouse. Poe wouldn't have been surprised to see him being chased by a cat holding a mallet. Despite looking as though he never ventured outside, he was togged out in the full country squire get-up – tweed suit and waistcoat, plus fours and brown brogues.

Hetty, however, was a different kettle of fish. She looked every inch the artist, and unlike Rusty, who looked like he was born on a high-tea table, she seemed even more out of place than Poe did. She hadn't bothered to dress up and still had paint in her hair. To the casual observer, she would appear to be just another scatty member of the Bohemian set. No life skills, no way of supporting herself without being propped up by her rich parents. But Poe wasn't a casual observer, he was a *keen* observer. And he'd noticed Hetty noticing him. She wasn't falling for his act. Not one bit. She caught his eye and lifted a single, paint-flecked eyebrow. She raised her glass but didn't sip from it. She knows, Poe thought.

But how much?

Birdie and Rusk were exactly who they appeared to be. Posh idiots. Probably came from a line of posh idiots. Bloodlines with

fewer branches than a coconut tree. Had grown used to a world that bent to their whims and peccadilloes, and didn't like that it could now think for itself. Didn't like the government's inheritance tax or that their gamekeepers were no longer allowed to shoot peregrine falcons. Their son had referred to Poe and Bradshaw as 'council estate', and short of being accused of cheating at Bridge, that was probably the worst thing they could imagine. Hell, they probably didn't believe in Bradshaw's bowel cancer warning. Bowel cancer had nothing to do with dietary fibre; it was a poor person's disease.

'Yes, let's have some of that game pie, Birdie,' Rusk said, eyeing it greedily. It seemed he hadn't much cared for the quail á la grape either.

Birdie got to her feet and cut into the pie. A smell like no other wafted through the dining room. It made Poe salivate and Bradshaw gag. As Rusk bit into his pie, and Bradshaw grabbed another roll, Estelle said, 'Shall we talk business, Felix?'

Rusk put down his knife and fork, wiped the corner of his mouth with his napkin, and said, 'Business before port? How very modern.'

'I'm a modern woman,' Estelle replied.

'Then let's talk business. *Is* this about your late father's grouse moor?'

'It is,' Estelle confirmed. 'A substantial part of it, anyway.'

Rusk nodded thoughtfully. 'We're a Sussex shooting family,' he said. 'The Doyles are a Northumberland family. Why offer it to us?'

'I'm not.'

'Excuse me?'

'I'm not offering it to you, Felix. I'm merely broaching the subject. I'm broaching it with *all* my father's shooting cronies.'

'This is a negotiation, then?' Rusk said.

'Not exactly,' Estelle said. 'I'm merely satisfying myself that my father's legacy will be honoured. That means the moors are managed ethically.'

'And how can we assure you that the Rusks are the right fit, Lady Doyle?'

'I'll be deferring to my husband in this matter,' Estelle said. 'He has... unique qualities.'

'Oh... and what are they?'

'He knows when someone is lying.'

She picked up her wine glass by its hair-thin stem and leaned back in her seat. Her role in this was over.

'Him?' Rusty said. 'What does he know about grouse moors? He probably grew up in a trailer park.'

'Rusty!' his mother snapped.

Poe laughed to himself. It was like Rusty had posh person Tourette's. He faced him. 'I've lived in Cumbria all my life. For almost ten years I've lived on Shap Fell, a place so inhospitable the foxes travel in pairs and the badgers use knuckledusters. In other words, while you've been playing at nature, I've been *living* it.'

Which was a bit of a stretch. When he *had* lived on Shap Fell, he'd mainly been out and about catching bad guys. And he now lived at Highwood, Estelle's ancestral home. He had a butler. Gardeners. An estate manager. Other members of staff he was yet to meet. The Rusks didn't need to know that yet. The important thing was that they continued to look down their noses at him.

Poe picked up his wine glass then put it down again. He still preferred cask ale, but he'd grown to enjoy wine. But he was still in character, and right now, shunning the vine was the right play. 'Lady Doyle's lands are managed for black grouse,' he said. 'Tell me what you know about the bird.'

For fifteen tedious minutes, Rusk did exactly that. He talked about their displays during lekking season. The red wattle on their eyes, the white stripe on their wings. Their diets and their predators. A hundred other things Poe didn't care about. He soon drifted off. 'Do they migrate,' he asked after Rusk had finished.

The Migratory Pattern of Birds

'No,' Rusk replied. 'They're mainly sedentary.'

'They wouldn't ever fly in a V formation, then?'

'Of course not. Even if they did migrate – which they don't – they're solitary birds. They come together during lekking season but otherwise they keep themselves to themselves.'

'I wonder if you can help me understand something then, Group Captain,' Poe said. Respectful for the first time that afternoon. 'I understand you're a grabologist.'

'I am.'

'What the fu… dge is a grabologist, Poe?' Estelle said.

'A grabologist is an expert collector of neckties, Estelle,' Poe replied. 'And I have a necktie question.'

'I'm not sure what this has to do with black grouse, but fire away, sir!' Rusk said.

'I saw black grouse on a tie recently,' Poe explained. 'Nine of them.'

'And?'

'They were flying in a V formation.'

'Nonsense. You must be mistaken.'

'I can assure you I'm not,' Poe said. 'I thought it was peculiar, though. In fact, I thought it so peculiar, I was driven to take a photograph. Would you like to see it?'

'I would, sir,' Rusk said. 'Lay people occasionally mistake the black grouse for the Canada goose.'

'I'm sure that must be it,' Poe said. 'But if you could take a look?'

'Of course.'

'Tilly?'

'Yes, Poe?'

'Can you show the group captain the clearest photograph?'

Bradshaw delved into her omnipresent computer bag. Pulled out a sleek laptop, polished steel and black glass. It wasn't a make Poe recognised, but then again, Bradshaw never bought her hardware off the shelf. She opened it, placed it on the table and angled the

screen so Rusk could see a photograph of the tie. It was already on the right one. Poe hadn't asked an accidental question.

The black grouse's sedentary nature was why they were at Ennismore.

Rusk glanced at it. Then he frowned and reached for an ornate pair of reading glasses. He slipped them on and leaned forward. He studied the image for almost a minute, his moustache quivering.

'But that's one of the missing Steadmans,' he said, his mouth opening like a chick waiting for grubs.

'A what?'

'A Steadman, man! A Steadman.' He looked at Poe, exasperated. Sighed then said, 'Ambrose C Steadman & Sons has been making neckties by royal appointment since 1843.'

'They're good ties, then?' Poe said. 'But you said this is a "missing" Steadman. What do you mean by that?'

'I mean that, in the grabologist world, the missing Steadmans are the Holy Grail.'

'Explain.'

'The Steadman classic range, the one that country folk such as myself and Lady Doyle's late father might buy and wear, takes its inspiration from the flora and fauna of the British countryside.'

'And the black grouse.'

Rusk sighed. 'The black grouse tie was issued in 1904. But there was a mistake. As you pointed out, the black grouse doesn't migrate, nor does it fly in formation. It's sedentary and it's largely solitary. The designer made a mistake, one which was quickly rectified. The ties were recalled and destroyed before the Steadman reputation took a hit.'

'Some obviously survived.'

'Twelve,' Rusk confirmed. 'All from a new account. A tailor in Calcutta supplying the British Raj wasn't informed of the recall order. By the time Steadman realised their mistake, the tailor had fulfilled twelve orders. Over the years they became highly collectible.

The Migratory Pattern of Birds

Some were never found, but we know of seven in private collections. They're incredibly valuable.'

'How valuable?'

'To a grabologist, perhaps three hundred thousand sterling.'

'For a tie?' Poe said. 'Are you stark raving mad?'

'I have one, sir. Are you suggesting *I'm* stark raving mad?'

Poe lowered his gaze. 'Sorry.' He looked up. 'I'd love to see it.'

'The missing Steadman?'

'If it's not too much trouble.'

'No trouble at all, young man.'

This should be fun, Poe thought. An alert sounded on Bradshaw's laptop. She glanced down, read for a few seconds, then looked up and caught Poe's eye. She nodded. He breathed out in relief.

It was almost over.

'Damn and blast it,' Rusk yelled, storming back into the dining room. 'The bloody thing's missing! It's been stolen.'

'Perhaps you misplaced it?' Poe said.

'Balderdash! I haven't misplaced it. I never touch the damn thing. It stays in its case.' Rusk pointed at Poe. 'You, sir! Lady Doyle says you're a policeman?'

Poe didn't answer. The dining room settled into an uncomfortable silence. The only sound Poe could hear was Rusk's laboured breathing.

'You're not here by accident, are you, *Sergeant* Poe?' Hetty said.

Poe smiled to himself. Rusk's daughter was the only one with a working brain. If the rest of her family's brains were gelignite, they wouldn't have enough to blow their noses. But Hetty... she was clever. She watched. More than that, she *saw*.

'No,' Poe admitted. 'I'm not here by accident.'

Rusk's eyes narrowed. 'Do you have more photographs of that tie?'

'I do.'

'Do you have one of the keeper loop?'

247

'The thing on the back of the wide bit that the thin bit slots in when it's being worn?' Poe said.

'Yes, yes,' Rusk said, irritated. 'That bit.'

'Tilly, do we...?'

Bradshaw examined the photographs Poe had taken and the more professional ones taken by the crime scene investigators. She selected a closeup of the keeper loop. It was an inch wide and a quarter of an inch thick. It was burgundy, the same colour as the tie.

Rusk leaned in until his nose was nearly touching the screen.

'I can zoom in, if you want?' Bradshaw said.

'If you could, young lady.'

Bradshaw did. Filled the whole screen with the tie's keeper loop.

Rusk exclaimed in excitement then sat back satisfied. 'That's mine,' he said.

'How can you be sure?' Poe said.

'Because my tie – and my insurance records will support this – has a mark on the keeper loop. The previous owner, damned fool that he was, sent one of the world's rarest ties to the dry cleaners. The bloody dry cleaners! And *those* damned fools glued a label to the loop to track it through the system. It left an unsightly mark. It's been photographed and documented. I can prove beyond doubt that that tie belongs to me.'

'Then we have a problem,' Poe said.

'Yes, yes,' Rusk said impatiently. 'The damn thief will have to go to court, and until then it'll no doubt be kept as evidence. But at least it's under lock and key.' He paused a beat. 'It *is* under lock and key, Sergeant Poe?'

'It's in an evidence locker, yes. But that's not the problem.'

'Then what *is*?'

'The problem, Group Captain Rusk, is that three weeks ago this tie was used as a murder weapon.'

'A murder weapon?' Rusk said, stunned. 'I don't understand. How can a tie be used as a murder weapon? It's made of cloth.' Realisation

The Migratory Pattern of Birds

washed over his face like the tide. He reddened. 'You mean it was used to strangle someone?'

'It was,' Poe replied.

'Just what the hell are you accusing my father of!?' Rusty yelled.

'Be quiet, Charles!' Rusk snapped.

'But the impertinence of the man!' Rusty replied.

'You're a very stupid boy,' Rusk replied. 'You always have been, and always will be. It's our fault, I suppose. In the past, the Rusks and the Revilles were a bit too keen on marrying their cousins.'

'That's correct,' Bradshaw said. 'Restricted breeding pools are thirteen times more likely than the general population to produce offspring with birth defects and genetic disorders. As well as Charles's low intelligence, it also explains why he has webbed fingers.'

'I do *not* have webbed fingers!' Rusty snapped.

'You fucking do, mate,' Poe said. 'I thought I was having dinner with the Mugwump.'

Hetty burst out laughing. She raised her glass in Poe's direction. 'He has webbed feet too,' she said. 'We used to bathe together when we were young. It was like being in the tub with a soapy frog.'

Rusty was about to kick off, but his father stopped him with a practised, inheritance-cancelling glare.

'That's enough, Hetty,' he said. 'And you're a very stupid boy, Charles, because Lady Doyle won't be married to just any policeman. He won't be a common thief taker. He'll be the kind of man who hunts down the very worst of humanity. The best kind of man to hunt that damn scoundrel murdering women. The necktie strangler.' He paused. 'Your sister's right, Sergeant Poe isn't here about Lady Doyle's grouse moors. He's here to catch a killer.' He took a deep breath. 'Do you think I killed this woman, Sergeant Poe? Used my own tie?'

'Someone in this room killed her, sir,' Poe said. 'But I don't think it was you.'

'Eeny, meeny, miny, moe,' Hetty said delightedly.

'Anyone could have stolen that tie, Sergeant Poe,' Rusk said. 'I don't keep my collection under museum-quality lock and key.'

'That's true.'

'Yet, here you are anyway. You have more than a tie, don't you?'

'I do, sir,' Poe said. 'Were you aware that the most recent victim was found in the back of a lorry. It was taking spoiled potatoes to a landfill.'

'I watch the news, Sergeant Poe,' Rusk said.

'You might *not* be aware that we stopped the lorry after an anonymous tip. Someone called the hotline and said the cargo should be searched.'

'You think the killer tipped you off about his own murder?'

'It was the lorry driver who called the hotline,' Poe said. 'Tilly doesn't believe in anonymous tips. She certainly can't be fooled by one made on a mobile phone. We traced it back to him within the hour.'

'But... why?'

'Why indeed. It turns out the driver had got himself involved in drug trafficking when he was younger. Served time for it. So when he was paid a thousand pounds to leave his lorry unattended in a remote truck stop for an hour, he decided to do the right thing. He did as he was asked, then he called it in.

'Which got us thinking – how many more victims are there? We thought the necktie strangler was leaving their victims where they had killed them, but what if they'd hidden some too? Used a landfill and bribed lorry drivers to leave their load unattended? Organic waste is processed differently to non-organic waste. For one thing, it must be buried immediately. Otherwise, there'd be a massive rodent problem. As a deposition site for murder victims, it's pretty much flawless. And by getting an unwitting lorry driver to dump the victim along with the rotting produce, the killer can be hundreds of miles away. Clever.'

'And *were* there more victims?' Birdie asked.

'There were,' Poe confirmed. 'We interviewed all the drivers with contracts to take corroded fruit and veg to organic waste landfills. A surprising number of them had been paid to leave their lorries unattended. So far, the cadaver dogs have found seven bodies. All in the same landfill. *Your* landfill, Group Captain.'

Rusk said nothing.

'Your land, anyway. You hired out one hundred acres of brownfield land to Company X and they subcontracted it to Company Y. Company Y owns a legitimate waste disposal business.'

'Less One Hundred Acre Wood, more One Hundred Acre Shithole, then?' Hetty said. 'The kind of place where Winnie-the-Pooh goes looking for honey but gets stuck with a dirty hypodermic needle instead.'

Poe ignored her. He said, 'We didn't understand why some victims had been left where they were killed, while others were ingeniously hidden. We didn't understand the *pattern*.'

'Ah,' Estelle sighed. '*This* is why Tilly is here.'

Poe smiled at his wife. 'Estelle is right, of course. You see, to you and me, a pattern might look like a bag of dropped marbles, but to a maths genius like Tilly, a bag of dropped marbles follows a predictable model of behaviour. She can map what will happen. So, when I have something that appears chaotic, I show it to Tilly.'

'But the newspapers say the victims *have* been random,' Birdie said. She looked worried. 'If I remember, the only thing they have in common is that they're women, they have brown hair, and they're in their twenties. Their ethnicities look like a United Nations conference, and their socioeconomic circumstances range from quite well-off to owning a "will work for food" sign.'

'You're right, of course, Mrs Rusk,' Poe said. 'The victims we knew about didn't seem to follow any pattern. They *did* appear to have been selected at random. But the women we found in the landfill, well, they were different. They did have something in common.'

'Which is?' Rusk said.

'I asked you earlier if the black grouse migrated.'

'You did. It doesn't.'

'But other birds do. The woodcock, for example. They leave Russia and Finland and fly thousands of miles to winter in the UK.'

'What's your point, man!?'

'My point is that birds aren't the only species that migrate,' Poe said. 'Seasonal workers do; men and women who follow our crop cycles. They come here on a seasonal work visa to pick our strawberries and raspberries. Our plums and our lettuce. Even daffodils have to be picked by hand. Many come as an organised group. They're here solely to earn money. Get enough together to have something for themselves and their families.' Poe paused half a beat. Picked up his glass and sipped at his wine. He found it too sharp for his taste and he put it back down. 'But others come on their own. They travel to the UK to experience the country. To brush up on our language. Often, they're young women. They're here as part of a wider travelling adventure. They travel the world, following the harvesting cycle. Raspberries in Scotland, cabbages in Germany, avocados in California, bananas in Guatemala. Countless more. And if some of these young girls were to go missing, it might not be noticed for a long time. It might be difficult to pinpoint where they went missing. Which country. Which *continent*, even.' Poe paused again. 'There's a fruit business near Ennismore Hall, isn't there, Group Captain?'

Rusk nodded. 'Barry Foster has a few dozen acres dedicated to crops. As the pheasant flies, he's our nearest neighbour. He supplies the supermarkets. The kids used to pick strawberries for him. Rusty ate so many one year he had loose stools for a month.'

Hetty sniggered again. 'He wore a nappy until he was eight,' she said.

Birdie gave her daughter a sharp look. 'The victims were Barry's fruit pickers?' she said.

The Migratory Pattern of Birds

'We believe so,' Poe said. 'Some we've identified via DNA or dental records or fingerprints and know they worked there. Others, we examined their stomach contents and matched it with the crops currently being harvested at Barry Foster's. And we knew the tie was yours. There are only so many black grouse Steadmans in circulation. After discreet enquiries, we ascertained the others were all where they were supposed to be. Yours was the tie we believed was used. After that, it was a simple case of looking into disappearances at your neighbouring fruit farm.'

'The music's about to stop,' Hetty said, looking at her brother. 'I wonder who's going to be left without a chair.'

'Be quiet, girl!' Birdie said. She faced Poe. 'You think it was one of us. This... vile excuse of a human. You think a Rusk is capable of murder?'

'Oh, I *know* it was one of you, Birdie.' He checked his watch then checked with Bradshaw. She nodded her approval. 'We initially focussed our enquiries on your husband, of course. The group captain seemed an obvious suspect. But you'll notice he only ever uses a fork or a spoon. Never a knife. And that's because twenty years ago, despite being a relatively young man, he had a stroke. His left arm is next to useless. He can move it, and he's got good at disguising it, but if he doesn't have enough strength to hold a knife, he doesn't have enough strength to strangle a young, strong crop-picker.'

Poe turned to Birdie. 'We're equal opportunity suspicious bastards, though,' he continued. 'The press ran with the killer being a man and we let them. Didn't make any difference to the investigation. But we know full well that this country has a knack of producing evil woman. Three of them are serving whole life sentences as we speak.'

'You can't think it was my wife!?' Rusk exploded.

'Actually... no,' Poe replied calmy. 'We know it wasn't Mrs Rusk. She's strong enough, certainly, but she recently had a pacemaker fitted.'

'I don't under—'

'We used the GPS function to track where she'd been. She hasn't been anywhere near the murder sites.'

'Uh-oh, little brother,' Hetty said. 'I think the music's just stopped.' She looked at Poe mischievously. 'I wonder who it is the sergeant suspects.'

Rusty glared at his sister.

'I don't *suspect* anyone,' Poe said. 'I know who the killer is.' He paused for effect. 'I knew a few days ago.'

'Then why the devil did we sit through this blasted charade?' Rusk exploded.

'Because of the search warrants,' Poe said. 'We needed time to make sure we had all your properties listed. Sorting that took time. And I made you sit through this "blasted charade" so you were all safely out of the way while warrants were executed. Tilly has received confirmation. They've just finished.'

'Balderdash!' Rusk snapped. 'An operation that size would leak. One of us would have had a message.' He picked up his phone. Poe noticed the other family members did the same. Rusk showed Poe his screen. It was message-free. 'You see, nothing.'

'Tilly?' Poe said.

'Yes, Poe?'

'You can unblock their phones now.'

Bradshaw pressed a few buttons, performed a few tasks. After ten seconds the dining room at Ennismore Hall was filled with the sound of incoming texts and WhatsApp alerts.

'Whoops,' Poe said.

'This is outrageous!' Rusk yelled. 'How dare you! Your career is over! Miss Bradshaw's career is over!'

'This *is* our last case,' Poe confirmed. 'We officially leave the National Crime Agency next week. Should have been a month or so ago but we stayed on as a favour to the boss. Poe and Bradshaw Investigations – no cat too lost – will be taking cases from next

The Migratory Pattern of Birds

week. But egregious breaches of civil liberties aside, I think you're missing the point, Group Captain Rusk. One of your children is a serial killer. Are you not even the tiniest bit curious?'

'I don't believe they are,' he said. 'And if you have evidence to the contrary, my lawyers will dismantle it like the house of cards it surely is.'

'Spoken like a man who doesn't believe his own words,' Poe said. 'I think you know who the killer is. And I think you know because the genesis of their madness comes from something *you* did.'

'Me?'

'Many years ago, we think.'

'Enough of the parlour tricks, Sergeant Poe,' Birdie said. 'Tell us what you've found. The sooner you do, the sooner we can get on with our lives. The sooner we can *all* get on with our lives.'

'Okay,' Poe said. 'We found what we had hoped to find. We also found what we were *supposed* to find.'

'What does that mean?'

'It means we found physical evidence that Rusty killed those women. He has a flat in London, and hidden behind the kitchen pipes was an earring that belonged to one of the victims – Karolina Petrauskas, a Lithuanian student. It has his sperm DNA and her blood on it.' Poe paused half a beat. 'That was what we were *supposed* to find.'

Hetty frowned. Not as much as Rusty, but Poe wasn't watching him.

'I don't understand,' Birdie said. 'Someone must have planted it.'

'Someone did,' Poe said. 'Your daughter.'

'Preposterous!' Rusk shouted. 'This is—'

'How did you know?' Hetty said, quietly and softly enough to shut her father up mid-faux outrage.

'You really want to know?' Poe said.

'I do.'

'You did everything right when it came to setting up your brother.

You didn't go over the top. Just the one piece of evidence. Cast-iron, incontrovertible proof that your brother Rusty had had contact with one of the early victims and that he'd kept a trophy. I assume you wiped the earring on the crotch of a pair of his boxers. Neat trick. Would have worked if it wasn't for one tiny detail.'

'Oh?'

'Rusty couldn't have murdered Karolina,' Poe said. He picked up his wine, grimaced, then chugged it. 'You see, lesser pathologists might try to give you a time of death. They'll take the temperature of the liver. They'll check for insect activity. A few other "parlour tricks", if you'll allow me to borrow your phrase, Birdie. Estelle?'

'Not withstanding the fact that all room temperatures fluctuate, measuring how much a liver has cooled is notoriously unreliable. They use something called Henssge's nomogram; a mathematical equation developed nearly forty years ago. Even if the original maths wasn't suspect, the fact it's been squeezed and stretched to fit different textbooks makes it virtually worthless.'

'And insect activity?'

'To reliably measure insect activity, you need to be one hundred per cent certain the insects were there to begin with. Insects are good when you're measuring the TOD over a matter of days and weeks. You can't use it to pinpoint a death to within hours.'

'She's good, isn't she?' Poe said proudly. 'So, Estelle: *is* there a reliable method of determining the time of someone's death?'

Estelle nodded. 'You find out when they were last seen alive and you find out when the dead body was discovered. That's the only reliable window. Anyone who tells you different is a fucking moron.'

'And we have Karolina on CCTV alive and well at eleven o'clock in the evening, and we know she was found dead at seven the following morning. We therefore have an eight-hour window. Unfortunately for you, Hetty, your darling brother has a cast-iron alibi for that whole time period.'

'Alibis can be manufactured, Sergeant Poe,' Hetty said. She didn't

The Migratory Pattern of Birds

seem concerned. 'They can be bought and paid for, and my brother has a lot of disposable income.'

Poe nodded. 'He doesn't have enough to buy the FBI, though,' he said. 'Because he was in their custody at the time. You see, what you don't know about your brother is that he's been the target of a transnational investigation for three years now. A weapons smuggling ring. First came to light when some Glock 17s were found in a catch of halibut off the coast of Kent. The trail led to young Rusty here, and he's been helping the NCA and the FBI with their enquiries ever since. But, although he's going down for the guns, his arrest *does* clear him of Karolina's murder. To use your analogy, Hetty: the music *has* stopped, and you're the only one without a chair. But you're smart. You wouldn't keep anything in the family's property portfolio. Your flat in Camden, your cottage in the Lakes. A couple of other places we know you have keys to. Luckily, Tilly is an expert at finding what doesn't want to be found. It didn't take her long to find Dryden Chambers, the basement room you rent through so many blinds it made my head hurt.'

Hetty's mask of calm indifference slipped.

'And in it we found a trunk,' Poe continued. 'And inside that trunk we found the souvenirs you took from the victims. We also found your diaries. Your *murder* diaries.'

Hetty smiled. She blew out a big breath. 'Do you know something?' she said. 'I'm kind of relieved.' She turned to Rusty. 'I wouldn't have let you hang, little brother. I just wanted to sow enough doubt that while the police were talking to you I could slip out of the country and into the new identity I've been developing. It was a bit of sleight of hand.'

'Bitch,' Rusty said.

She shrugged. 'It appears you had your own thing going on anyway.'

'Double bitch.'

Hetty turned to Poe. 'You said you knew why?'

'I'll never truly understand what compels someone like you to kill, but I understand why you think you had to do it.'

'I saw my father masturbating.'

'That's what it says in your diary,' Poe said.

'He was naked except for the tie around his neck. He was choking himself.'

Poe didn't respond.

'I was nine years old,' Hetty said. 'The shock of me catching him caused his stroke, if you'll forgive the pun. I'm no psychiatrist, but I think that might have screwed me up a little.'

'What happens now?' Rusk said.

Poe put his fingers to his mouth and whistled. The room filled with police offices. Some in uniform, others in plain clothes. Detective Chief Inspector Flynn, Poe and Bradshaw's old boss, brought up the rear. She arrested Rusty and Hetty and some colleagues led them out of the dining room and into the waiting vans.

Poe looked at Birdie. 'The pie was nice,' he said, 'but the quail à la grape needs some work.'

And with that, he and Bradshaw left Ennismore Hall. They also left the National Crime Agency and their old lives.

They became private investigators.

They met a fifteen-year-old American girl called Esmerée Blue.

And shit got real.

Cameo

Donna Moore

'From the farthest to the nearest! From the farthest to the nearest, damn it! Get the wide shot first and *then* bring it in. How many times do I have to tell you?'

Margot glanced up from her crossword and glared at her husband. Look at him, the pompous old fool. *From the farthest to the nearest.* If she'd heard it once, she'd heard it a million times; and it had been *her* idea in the first place. He wouldn't be what he was without her, and what was the thanks she got? As she turned her head away from him in disgust, her eyes caught those of the young leading actor. What was his name… Larry? Barry? Harry. That was it. Harry Christian. A new one, and doubtless just as in awe of TR as the rest.

The young man grinned at her. 'Genius, isn't he, Mrs A? An absolute genius.'

Yes, she was right; another fawning Aysgarth acolyte. 'That's right Harry; indeed he is – an absolute… genius.' She didn't bother telling him that she wasn't Mrs A. She might be married to T R Aysgarth, but she was Margot Carrington. *The* Margot Carrington. The brightest star and the hottest property back in the day when they *really* knew how to make films and there was none of this one-film-a-year nonsense that the so-called stars made today. No. Margot Carrington made seven, eight, sometimes ten films a year – and

every single one of them a box office hit. But this young whippersnapper wouldn't know that. To him she wasn't even an ageing has-been, simply the director's wife, who the great TR humoured by giving her a teeny tiny role in every one of his films. She sighed and the young actor looked at her solicitously.

'All this sitting around must tire you out at your...' He drifted off into an embarrassed silence. Even with the ignorance of youth, he must have realised that his unfinished sentence was less than tactful. At her age, indeed. She was only fifty-eight, but she hadn't got top billing for twenty years, and even then only in *Behind Her Mother's Shadow* as the monstrous mother of some young starlet. Larry/Barry/Harry was still looking at her with those doe eyes, the sort of look one normally reserved for sick puppies, children in wheelchairs and... yes... *old* people. 'Are you all right, Mrs A?'

'Yes, Larry. Quite all right.' She gave him one of the glares she'd used in *Behind Her Mother's Shadow* and he shrank back a little.

'It's um... Harry, Mrs A.'

'Yes, yes, thank you, Barry. Here,' she fished in the colourful straw bag at her feet and pulled out a canvas bag containing a greaseproof-paper-wrapped package and a flask of tea, 'make sure the genius gets his lunchtime sandwich, would you. And remember he eats it on the *dot* of one o'clock, so don't dilly-dally.' The young man eagerly carried the bag away, clutching on to it as if he were one of the three wise men, delivering a gift to the baby Jesus, which, in all likelihood, as far as he was concerned he doubtless was. Margot felt slightly guilty; he was an inoffensive young man, but someone else had to be the one to deliver the sandwiches, so that suspicion didn't fall on her. She watched as Barry/Harry/Larry held out the package to TR, almost bowing in the process. TR nodded and waved him off, gesturing in the direction of his trailer, and the young actor scurried off with his precious cargo, presumably following TR's bidding to deliver the sandwiches there, as she had expected. TR looked over at her, no doubt sensing her gaze, and

Cameo

she gave him her best loving smile and kissed her hand flamboyantly towards him. The assembled cast and crew would appreciate her constant devotion. No, no one would ever suspect *her*.

She returned to the crossword she had been doing. Six down: a yellowish silicate mineral, the gemstone of good fortune and love – five letters. Easy. She filled in the answer: TOPAZ. Seven across: a 1936 novel by Daphne du Maurier.

'Margot... darling.' Margot's knuckles went white as she tightened her fingers around the pen, but that was the only outward sign of the fury she felt.

'Araminta, sweetheart. I should have known by the smell.' The leading lady blinked in confusion a few times. '*Brut*, isn't it?'

Araminta Madigan's eyes narrowed and then she laughed, an affected screeching that sounded as though someone was scraping a parrot's claws across a blackboard. 'Oh, darling, how you love to tease. It's *Madame Rochas*, as you well know. It *is* TR's favourite, after all.'

'Of course it is, sweetie.' Margot matched the younger woman's syrup-laced-with-lye tones. 'At least, it is since his nasal polyps. I wasn't expecting to see you on set today.' If she had, Margot would have stayed in her trailer for longer.

'TR wanted to shoot a few more of the love scenes today.' The parrot's claws came out again and Margot instinctively drew up her shoulders as though to protect her ears. 'You know what he's like with those love scenes, darling.'

Margot did, oh indeed she did. Back in the days when *she* was TR's favourite platinum blonde and his chosen leading lady in both studio and bed. She was neither of those any longer, but she'd been the only one to marry him, hadn't she? All because she was the only one who knew TR's Little Secret. She'd felt amazing on the day of her marriage, invincible, on top of the world; a world which had turned out in its thousands to watch the wedding of Hollywood royalty. It had all been filmed, of course. TR had made sure of that.

There were so many witnesses to the signing of that marriage contract and only two to the signing of the *other* contract, her special contract: the one in which she promised not to reveal his secret and, in return, there would be a role for her in every single one of his films and he would pay her stupendous salary – index-linked in line with inflation, of course – till death do us part, forever and ever, amen.

She should have thought about that contract a little more; specified that the role should be a *starring* role, rather than simply assuming it would be. Because she'd assumed that her acting prowess would guarantee that starring role, TR's insistence on writing into the contract that she had to be on set for the entirety of every film hadn't struck her as odd. However, after their marriage she'd never had a starring role again, even though he admitted that he was cutting off his nose to spite his face. She'd never shared his bed again, either. Instead, she had to watch on set every day as he sucked up to the myriad of platinum blondes who replaced her, stealing her role *and* her husband. To add insult to injury, he'd also had it written into the contract that she had to make him a packed lunch for two, every day of filming: cheddar cheese and Branston pickle sandwiches and a flask of proper British tea, with milk and plenty of sugar, just like she'd made him in London when they first met. At first she'd thought it sweet and funny and romantic that he wanted to share his lunch with her every day, but she'd soon realised that he was eating the sandwiches in his trailer with Miss Blonde of the Month. He was a cheapskate as well as a philistine, and having her do that menial task was just one of his little ways of getting back at her. After nearly forty years, she gagged every day at the smell of Branston pickle as she opened the jar.

She must stop thinking about it; it would do her no good. Araminta Madigan was still watching her, standing in that studied way she had; lips, tits and arse all thrust out. What had the silly

tart been saying? Oh yes. 'Well, I'm sure you're no stranger to faking love scenes, Araminta.' She'd have to be, if she was sleeping with TR. If? Of course she was. He'd slept with all his leading ladies. Margot smiled to herself. Usually, his affairs only lasted until the end of the film or whenever the next beautiful blonde came along. They always did. Margot never worried about that because she, on the other hand, was here to stay, thanks to TR's Big Secret.

The smile was soon wiped off her face, however, by Araminta's next words. 'And what's your role in this one again, Margot, darling?'

Margot waved a hand, airily. 'Oh, I haven't looked at the script yet, sweetie. I'll do that at some point. TR said he won't need me until tomorrow.' There was no point in her looking at the script; she knew she wouldn't have any words, she never did. She would walk on and die horribly and that would be the end of her appearance. It wouldn't tax her magnificent acting skills, a loss to the filmgoing public. Such a shame that the world was being denied her talents because of TR's pettiness. Oh well, not for much longer; she would soon be in great demand once again. She looked down at her watch. It was nearly lunchtime, and TR would open his sandwiches soon. And then…

She raised her head again, to see Araminta sashaying off. Thank God for small mercies. Margot turned back to her crossword and finished writing in the answer to seven across: JAMAICA INN, of course, any fool knew that. Thirteen down, a boat used to rescue people in distress at sea. Who compiled these damn things? This was far too easy.

'Here you are, darling.' Margot looked up. Araminta was back, this time holding out a copy of the script. She tapped on it with a long red fingernail. 'I've opened it to your page.'

'My page?'

'Yes, page four.' The scarlet talon tapped once again. 'Here.' She turned the script around and read slowly and carefully. 'Elderly victim is pushed off a balcony several storeys up.' She held the script

out once again. 'The character doesn't have a name, but I believe that's you.'

'Again?' Margot snatched the script from the younger woman's hand and turned to the character list. There she was: *Elderly Victim – Margot Carrington*. She flicked feverishly through the first few pages until she found her part: appearing on page three, bumped off on page four. No lines, of course, as she already knew. 'He's getting boring,' she said, handing the script back to Araminta, who was looking puzzled. 'My husband, I mean.' The 'husband' was said in a pointed manner. 'That's the eighth... no, *ninth* time I've fallen from a great height. I was hoping for something more inventive this time.'

In the past thirty-eight years she'd not only fallen from a great height nine times, but she'd been strangled, stabbed, drowned and shot on multiple occasions. She'd also been run over by a train, died in a train crash, and, of course, been pushed out of a train – he had a thing about trains. Added to that, she'd been poisoned five times (milk, whisky, champagne, mushrooms and an umbrella tip coated in polonium); beaten to death with a poker twice, once with a frozen leg of lamb and once with a table lamp; flattened by stampeding horses, bitten to death by a venomous snake, a rabid dog and a vampire (although, strictly speaking she hadn't died in that one); crushed by a merry-go-round; pecked to death by birds; had her throat slit by a sabre; was starved to death in a cellar; and squeezed to death by a sumo wrestler. And each time the camera had lingered lovingly on her repulsive, tortured face in that voyeuristic way TR loved.

Araminta was still looking at her, rather smugly, Margot thought. Well, that look would be wiped from her face soon enough. After all, she was the lucky woman who was currently sharing TR's sandwiches, and had been for the last four months. God, four months of cheese and pickle sandwiches; you'd think she'd get fed up. You'd think they'd *all* get fed up, but they never did. They probably thought

it was a small price to pay for the fame and fortune that being TR's leading lady granted them. As she handed the script back, Araminta had the audacity to grasp her hand and hold on to it. 'I think it's wonderful,' said Araminta, breathlessly, 'that TR insists on giving you a cameo in every single one of his films like this. Not many actresses past their prime have that luxury. It's so kind of him.'

Margot pulled her hand away and gripped her pen a little tighter; the temptation to stab the woman through the eye was enormous. She wasn't sure if Araminta was terminally stupid, or whether her words were carefully designed to reach their target. Given what she knew of the woman, she was tempted to think it was the former, but the sly look on Araminta's face could also suggest the latter. Still, not to worry, not long to go now. She looked at her watch again. Twenty to one. In exactly twenty minutes, to be precise. The joy she felt at this thought meant that the smile that appeared on her face was genuine. 'It is, isn't it, sweetie. He's always been such a kind and generous man, not only with his time and his money, but,' she gave a conspiratorial giggle, 'even with his sandwiches. I'm certain that he loves sharing those with you *every* day.' A pained look crossed Araminta's face. 'Oh dear, not a fan of cheese and pickle, sweetie?' She giggled again and pointedly turned back to her crossword. She felt, rather than saw, Araminta stalking off across the set. Good.

Eleven across: a dizzy spell where the world feels as though it's spinning, seven letters. VERTIGO, must be. She glanced up from the paper. Neither TR nor Araminta were anywhere to be seen. They must have scuttled off to TR's trailer. She looked down at her watch. It was only ten to one, but maybe sex was on the agenda before lunch. Araminta was lucky; it would only take five minutes, maybe even less these days.

TR wouldn't deviate from his one o'clock on-the-dot lunch. It had been mandated by his doctor: breakfast at eight, lunch at one, and dinner at six. TR's bowels demanded a gap of five hours – *exactly*

five hours – between meals. It had been the bane of Margot's existence. Their social life was practically non-existent. Nobody in this town – or any other town, if it came to that – ate dinner at six o'clock. It was as though she'd spent the whole of her marriage with a toddler. In this instance, however, she was grateful for it, since it meant that the timed device inside the flask would serve its purpose perfectly at one minute past one precisely. She'd practised her reaction to the explosion by listening to Tchaikovsky's '1812 Overture' turned up as loud as it could be, making sure that she didn't wince in anticipation of the climactic volley of cannon fire. It would never do, for example, to put her hands over her ears *before* the explosion. She gave a self-satisfied sigh. That had happened with an extra in one of TR's films and TR hadn't even noticed. Margot had, though, as she lay on set with fake blood seeping from her body. But she hadn't said anything at the time; indeed not. Instead, she'd waited until one of the first newspaper reviews had picked up on it. She'd circled the reference to the continuity error in the review in red pen and used the page to wrap his sandwiches that day.

Such a shame, though, that it had to be done this way. TR had always expounded the merits of suspense over surprise in his films. 'There is no terror in the bang,' he always said, 'only in the anticipation of it.' It was a pity that he wouldn't be able to enjoy the anticipation of this moment. She shivered; not with terror, though, but with pleasure. *Her* anticipation was one of sheer, unadulterated glee, and had been all morning since she'd set the device's timer, wrapped it in one of TR's enormous handkerchiefs so it wouldn't rattle, and popped the whole thing inside the flask. It was amazing how small and yet how powerful these things could be.

Two minutes to one. Margot imagined TR – or possibly Araminta – unwrapping the greaseproof paper on the package of sandwiches. Yes, she hoped it would be Araminta who would be assailed by the foul smell of the Branston pickle. The sandwiches would be placed

neatly on the plates TR had had shipped in from Morocco. The flask wouldn't be touched until approximately five past one, when TR would have eaten exactly one half of his sandwich. Margot concentrated on the crossword puzzle, trying to contain her excitement. The last clue, four down: one's direction of travel if one is heading from New York to Alaska: five, two, and nine letters. Geography wasn't her strong point and she frowned slightly; surely she wasn't going to be beaten by this final clue.

'Mrs A?'

Margot tapped her pen against her teeth, not looking up. South? North? Something something. 'Mmmmmm, what is it?'

'Mr Aysgarth sent me over with these. Said that Araminta's persuaded him to go to the canteen and that he can get sandwiches there if he likes. He told me you can have these, he won't be needing them today.'

Margot looked up to see Barry/Larry/Harry standing in front of her, a canvas bag dangling from his fingers. She didn't need to see the outline of the package of sandwiches and flask of tea to know what it was. Her gleeful anticipation turned to terror. TR had been right about suspense. She glanced at her watch as the second hand reached the top. One minute past one. Her final cameo.

Empire Builder

James Grady

'*It's gotta be him!*' hisses the weasel man sitting with two companions in the dining car of this depot-stopped Seattle-to-Chicago passenger train.

His skull jerks at a man sitting behind him six empty tables away.

That loner stares out his train window at this small town on that last afternoon of April 2025. A Wednesday. The border day.

The bigshot facing weasel man says: 'Leonard, fools *believe*. Victors *know*.'

Leonard sits between that table's window and a brown hair-bun woman. High cheekbones. Zero make-up. A dark long skirt, buttoned-up suit.

Her blue eyes fill with black letters outside on the white-walled depot:

Shelby Montana.

She snaps open a make-up compact.

Turns that mirror until it catches the reflection of the *him* behind her.

Short dark hair. Steel eyes. Maroon shirt. Black jeans. Lean. Rebel vibe. Wistful smile as he stares out the window like he knows what's *really* out there.

Two silver laptop computers and a cell phone lie on his dining-car table.

Empire Builder

'Philip,' says that woman. 'We're not even sure there *is* a "*him*".'

Suspicion narrows bigshot Philip's eyes.

'I tell you it's him!' hisses Leonard. 'I walked past twice. My detector clicked two wireless signals. One of his computers isn't connected. Hackable.'

Philip stares at the ivory-skinned woman connected to him by a gold ring.

'Eva,' he orders. 'Go as far as you must to make us *really* know.'

'Leonard,' says Philip. 'Get her what she needs. Prepare contingencies.'

Eva launches from the table toward the exit to the passengers' quarters.

Leonard follows her.

Bumps into the conductor with the jangling keys: 'Sorry.'

Steam hisses under the waiting train. The windows show a pickup cruising past the Oil City Bar. The loner scans the nearly empty dining room.

Philip drops his gaze to *obviously* scroll his cell phone's news feed.

Wildfires blacken the white HOLLYWOOD sign. Russia's dictator outlaws non-approved poets. New York's *In* crowd cancels an author who mocks their virtues. *Concerned citizens* forbid classic movies in public libraries. Congress argues over spending tax dollars to help the caravans of Kansas climate refugees.

The train whistles *WHOO-EEEEE!*

Lurches and clanks eastward up out of that valley town's V.

Enter 'The Blonde'.

Swaying into this chugging-faster train car. The tucked waist hitches her dark skirt high over shaved legs. Her white blouse trembles. Her notorious natural blonde hair is as platinum as any dyed movie star.

Her lush lips are ruby lightning.

Her ringless hands carry a party purse.

She ignores Philip.

Walks straight to the *Millennial-like-her* man sitting alone.

Her husky voice: 'May I join you?'

'What more could I ask?'

A cloud of musk perfume settles her across the table from him.

He reaches to close his open laptop.

'Don't let me stop you working,' she says.

He's spellbound. Sees words on his screen. Her blonde hair. Her ruby lips pouting '*Shh!*' Her intense blue eyes staring at him as her discreet right hand flaps up and down in front of her white blouse to plead *Close it!*

'Better things to do.' He shuts the laptop. Says: 'Well, here we are. Strangers on a train.'

'For now.' Her red lips smile: 'What do you do with your machines?'

'Fight to stay in charge of them.'

'Freedom is just a word.'

'It is what you make it. What do you make with yours?'

Her shrug trembles her white blouse.

Red lips say: 'The best with what I've got.'

Ask: 'Your machines. What— *Who* do you work them for?'

'For you.'

Her blue eyes blink.

'For souls I'll never know.' His gaze takes in the companions-deserted man who's the only other person in this dining car.

'I'm a prose-slinger,' he claims. 'Fiction. Or so they say.'

'Can I see?' say ruby lips as her hand, held low, waves *No!*

'Maybe later. It's a long train ride.'

'Are we going all the way?' Her crimson smile clarifies: 'To Chicago.'

'So says my ticket.'

'I'm Eva.'

'Cary.'

Empire Builder

She purrs: 'What do you carry?'

'What I must. What I should. What I choose. What I can. What I hope.'

The train *clackety-clacks* over Montana's sundown prairie.

Past a chain-link-fenced underground ICBM Armageddon war silo.

'I've been riding the wrong trains,' she mumbles.

Blinks. Shakes herself back to where she is: 'Why two laptops?'

'My writing one isn't cyber connected. No distractions. Or intrusions.'

'That's how you focus. Keep your work safe. Rule your time.'

'None of us rule time.' He shrugs. 'You never know *when*. Or *if*. But the official name of this train is the *Empire Builder*. So, what will our *reign* look like?'

'Ask me after dinner,' she says. 'Which is your sleeper cabin?'

Her hand secretly forbids that answer.

'Ask me after dinner.'

Philip with a white earpiece stands. Leaves the dining car.

White-jacketed food servers arrive. Passengers fill tables. No Philip. No Leonard. The floor-scanning, frowning conductor shuffles past the flirting couple.

Her hidden hand signals rein in their banter.

'Sitting here,' he says. 'With you. How'd I get so lucky?'

'Sometimes we land on the right train.'

'Luck is a fickle lady.'

'Sounds like a song from our grandparents' days.'

'Daze with a z?' Cary smiles. 'Dad's a Springsteen guy.'

'So post-Joni and Dylan. Is this Bruce's "runaway American dream"?'

Cary shrugs: 'Runaway… Yes. Dream… We'll see when we wake up.'

'Makes you wonder what Taylor Swift would sing.'

The train rumbles.

She stares across their consumed plates. 'Do you want dessert?'

'I'm more of an off-menu type. How about you?'

Ruby lips curve into a smile.

Cary and his electronics follow her moon hips swaying along the train's red carpet to the corridor of private lairs. He taps a glass-panelled door.

'Here.'

The maid service's turned down the lower bunk's white sheets.

He closes the door's torn curtain.

She catches his face between her soft hands.

Burning fire kissing them *both* 'n' she breaks – or is it brakes? – that electricity to press smeared red lips to his ear.

Whispers no cell phone mic could hear between audible affections:

'I'm a spy. For us.'

Wet warmth reddens Cary's cheek.

'Targeting Philip. And Leonard... Russian agents... Their spy ring controls new political group Make America Right Again... MARA's thousands don't know... Moscow calls them *polezni durak* – useful fools.'

Eva loudly sighs: 'Work my buttons.'

The white blouse falls away.

Her ivory chemise barely hides and holds her heavy swollen tips' flesh.

Kissing with convincing moans as she whispers:

'Philip met me through my uncle, who's right about being wronged but wrong about who's right... Philip said he'd kill my uncle if I didn't...'

Cary kisses her forehead.

'I play Philip's prim wife so he can move 'n' mould MARA's duped religious 'n' conservative leaders... Politics needs a package to sell... No sex, he's... Leonard is a fanatic slave... FBI wouldn't help me unless... Being Philip's cover is my cover... Act like convert accomplice. Steal data of ops 'n' traitor in FBI's name who told

Empire Builder

Philip a counterspy might grab their secrets at Oregon rally 'n' escape on this train.'

Eva steps back: 'Let's lose the skirt.'

Unzips and drops it.

Stands by the bed in only her black panties and white chemise.

Pushes the black panties down. Foot-flicks them into the air—

—caught by Cary as the train whistles into North Dakota's night.

She leans over... Reaches....

Pulls a plastic-bagged flash drive from her vagina.

Her husky voice: 'Come here.'

They wrap themselves together.

Eva whispers: ''S the one place they'd never look... Never even look at. Are afraid of.'

She breaks free. Gingerly unsnaps the purse lying on his sink.

He sees the transmitting cell phone.

From the purse, she pulls out two other flash drives.

'Your turn,' she orders.

Loud *clunks* kick off his shoes.

He turns toward the purse in front of a sink's mirror.

Watches himself *loudly* pull his zipper down. Unbuckle his black jeans. *Clunk* them to the floor.

Eva's naked bent-over hips fill his eyes as she inserts the flash drives from her purse into his laptops on the cabin's table.

Pulls him close.

'Now they'll analyse you're not a secret agent. Leave you alone.'

The flash drive in his writing computer blinks green. So does the other.

She pulls the *before* (purse) flash drive from his writing computer.

Inserts the *after* (vagina) flash drive.

Hits DOWNLOAD.

Hurries back into his arms for their whispers.

'Walk it to the FBI in Chicago. Can't use the 'net-connected laptop or Philip 'n' maybe the inside Bureau traitor'll know.'

His heart *and* his co-conspirator's mind whisper: 'What about you?'

She stands back to see, *really see* him.

Lifts the straps of her ivory chemise. Drops it down her curved hips.

Fills his eyes. His hands.

Cries: *'Take me!'*

The *Empire Builder* WHOO-EEEEE whistles through that starry night.

Black-business-suited Leonard slips into a hallway of cabins.

The cell phone in his black-gloved hand shows midnight.

Leonard's mouth chomps on his fingertips. Jerks the black leather glove off his hand. Bare fingers swipe his cell phone screen:

Arriving Fargo – 47:09 min

Leonard fumbles his black glove back on.

Puts his cell phone where he always keeps it: his shirt's heart pocket. Easy to grab. Block a bullet.

He eyes a cabin door with its curtain across its centred glass panel.

Leonard pulls out a black box with bulbs from one suit jacket pocket. His black-gloved left hand posts on the train wall to steady his ride. His right hand silently sweeps the detector box over the cabin door's closed-curtained glass.

One green bulb lights up.

Then a second bulb greens.

An orange bulb glows.

Satisfaction brightens Leonard's face.

He slides the detector back into his suit pocket.

Spots the gash in the torn curtain.

Leers. Squats. Peers through the torn curtain.

Groks that the cabin bathroom's broken door swings open and shut with the train's *clackety-clack*. Punctuates the cabin's interior with flashes of blue light.

Empire Builder

An intertwined naked couple listlessly doze on the cramped lower bunk.

Leonard's eye stares into the cabin through the torn curtain.

The spying eye spots *expected* two laptop computers and a cell phone on the cabin's window-mounted table.

The corner of a cell phone in the open black purse.

Blue light swings off/swings back on.

Through the torn curtain, Leonard's eye blinks.

There! On the table. Not *one.* Not *two.* *Three* flash drives!

Horror fills the torn curtain's prying eye.

Leonard stands on the rocking train's red-carpeted hallway.

Looks both ways.

Pulls a pistol out of his shoulder holster.

Fits it with a silencer.

Reaches under his suit coat—

—pulls out the conductor's pickpocketed silver loop of cyber keys.

His left hand uses a cyber key to *click* the door open.

His right hand holds the silencer-equipped pistol.

Leonard opens the door and slides in, closing it behind with a *click!*

That bathroom door swings off and on blue light.

The silenced pistol aims toward the fitfully dozing naked couple.

The blue light swings the cabin into darkness.

Blue light swings back to lighten this rumbling room.

Eva's blue eyes float open.

Leonard blinks.

Blue light winks to darkness.

Blueness swings back on—

—as tumbling out of the lower bunk springs naked Eva, swinging a pillow like a softball pitch in a lunging arc—

—that swoops up under Leonard's gun arm as his pistol *Phhts!*

A bullet hole dots the train-car ceiling.

275

Naked Eva kicks her bare foot into Leonard's crotch.

Leonard gasps.

'*Oh yes!*' screams/sighs Eva for the purse's cell phone.

Blasting awake, Cary grabs/twists/jerks gasping Leonard's gun arm.

Eva scoops her black panties off the floor.

Blueness swings off.

Blueness swings on.

Eva stuffs her black panties into Leonard's gasping mouth to clog any screams above her own faked sexual moans.

'*Yes, like that!*' lies Cary as he blocks Leonard's swing—

—elbows the killer's throat.

Eva rips Leonard's cell phone from his shirt pocket—

—the phone drops, crushed by Leonard's staggering shoe.

Cary twists the gun from Leonard's hand.

The gun falls soundlessly onto the floor-dropped pillow.

The gagging assassin pushes off Eva and Cary.

Flings open the door.

Staggers into the train hallway.

Naked Cary tackles Leonard as he jerks out the black panties.

Eva slams the cabin door softer than her sexual cries.

On the narrow corridor floor, Leonard gasps.

Kicks free.

Scrambles away toward the far end of the train car.

Naked Cary chases him.

They rumble-stumble down the narrow train stairs to their car's first floor, with its door to the baggage car and the outer wall's sliding EXIT door.

Leonard slams Cary against the train car's locked EXIT.

The conductor's steel loop of cyber keys is shoved into Leonard's pants waistband. A retractable chain holds the keys to the loop.

Leonard bats away/absorbs/dodges Cary's strikes.

Lances a cyber key into the wall lockbox.

Empire Builder

Red lights blink on the EXIT.
Leonard knocks Cary against that sideways-sliding steel door.
The key snaps back to its loop.
Leonard slams the open-door lever to OPEN.
The steel door slides out/folds back along the train car's outside wall.
The prairie stench and roar of the outside world swirl around the fighters.
Leonard punches Cary out into the rumbling rushing night.
Cary grabs the edge of the slid-sideways door—
—slams into the outside steel wall of the train—
—and onto steel rungs.
The train's forward rush. The pushing wind.
Naked Cary fights his way up the rungs to the top of the train.
Crazed Leonard gapes at that sight as he holds on to the open doorway.
Jerks a fire axe off the emergency display.
Shoves the axe handle through the front of his belt.
Grabs those same rungs.
Pulls himself out into the night. Climbs toward the stars.
Two men grabbing handholds on top of a passenger train racing through the North Dakota night.
Cary grabs the crossbar at the end of this train car. He's face down.
The wind and rush yank Cary out flat like—
—like he's a naked flying Superman of his father's days *pushing* the train!
'I'm a victor!' yells Leonard. 'I'm gonna know you're dead!'
His black suit flaps.
His shoes grip the rooftop steel.
He pulls the axe from his pants.
The locomotive's cyclops headlight spotlights a coyote loping on the tracks.

The engineer taps the brakes.

Inertia whips and slips the black-suited man on the rushing train's roof. Throws him face down—

—buries the cutting edge of the axe's blade deep into his chest.

Leonard's axe-in-his-chest body slides past hanging-on Cary.

Cary grabs the steel loop of cyber keys.

The axed body tumbles off the night-rushing train.

Cary slips the steel loop of keys onto his arm.

Needs both hands to hold his naked self flying stretched out atop the train.

Vertigo contorts his face.

His hands start to slip...

Steel brakes squeal. The train slows down. Inertia slides shut the open car door below. Wind against Cary eases. He strains his neck. Looks up. Forward.

The lights of Fargo.

The train stops at that after-midnight depot.

A chilly night for a naked man sneaking along the top of a train.

There! On the ground below! At the end of last car/observation car!

The conductor folds downstairs. Climbs down. Looks toward the front of the train, where his assistant opens a car for any passengers. Zero appear. The troubled-face conductor shuffles forward to stare at the lit depot.

Steam hisses under the parked train.

A night-shadowed man clumsily/quietly climbs off the train's roof.

His naked body squishes over the train's rear window.

He scrambles inside the train behind the conductor.

Naked Cary on the train's second level. Limping. Gasping. His left arm looped by the key ring. Quietly shuffling toward the private cabins and—

The cabin door ahead of Cary whips open!

Empire Builder

Out steps...

A woman who fought for and got much of what she deserved, *except*... Frumpy sweatsuit. *Can't sleeps* sag her face. Slouches out of her cabin—

—confronts a naked man!

'*What?!*' she mumbles coming out of – or is it into? – a dream state.

Cary holds up his *Shhh!* finger. His face pleads with her as he hurries on.

She whispers: '*Come back!*'

Naked Cary scurries through the red-carpeted halls to his car.

His glass-panelled door covered by the torn curtain.

He raises his fist to knock—

—stops.

The train rumbles forward through the night.

Cary grimaces '*Shit!*' as his *Make no noise!* fists hangs above the door.

The torn curtain's gap fills with a blue eye.

The blue eye sees only the door-latch-level view of a naked man.

The cabin door opens.

White blouse and dark-skirt-dressed Eva rises up/backs away from the opening door. She's *like in the movies* combat-shooter zeroing the silenced pistol at *the who* she's let in to the swinging blue light cabin.

Cary fills the doorway.

Eva's pale face drops from combat glare to relief.

She lowers the pistol.

Phhht!

A hole pops in the cabin's floor.

She frantically waves for Cary to say nothing with her left hand while her right hand *now* pulls her finger off the trigger.

Battered Cary's face flashes joyous relief/frowns as he hears rushing water while Eva wraps herself around his nakedness.

279

Throws herself away from him. Waves for him to close the door.

The blue light sways on and off.

Catches Eva darting into the bathroom.

Sounds of a shower stopping.

Eva darts back into view.

Her face pleads as she proclaims: '*Wow*, you must have used all the hot water on the train! With that damn broken door swinging open and closed, the sound of you showering kept me up and moving around.'

She points to her wrist where a watch would be.

Points past the naked man to the closed door.

Cary grabs his clothes as she babbles: 'Come back to bed!'

WHEE-OOO!

Two clothed souls sneak through the corridor out and beyond Cary's cabin.

Cary has a computer bag looped across his chest.

Holds the silenced pistol in one hand.

Holds Eva's hand in his other.

'Had to get out of there,' she says as they sneak to the end of the car and its stairs down to the first level and the door that threw Cary out into the night.

Leonard rigged the computer for Philip. Compresses transmitting cell phone into summary sounds. Lets him sleep. Wake up. Review summary sounds in like eight minutes instead of eight hours. When he hears… When he can't find Leonard…

'He's a better shot than me,' says Eva.

They tumble off the stairs where Cary and Leonard fought.

Cary stares at the clamps for the missing fire axe.

'Why didn't you let me take my cell phone?' he says. 'Or laptop, that's—'

'Psycho,' she says. 'That's Leonard. Cyber assassin. Hacked your linked-in laptop. Turned it off. Locked it down. And your phone.'

'Guess that's why Mother hasn't called,' mutters Cary.

Empire Builder

Glances to his left:

A corridor of closed doors stretches back through the train.

Glances to his right:

Black letters on a closed and locked steel door: BAGGAGE CAR.

Cary pulls the loop of cyber keys out of his jacket pocket.

The baggage-car door slides open.

Cary and Eva scurry inside.

That door slides shut, *Click!*

Dim security bulbs light and shadow the car that hides them. They see boxes. Crates. Stacks of suitcases. Snail mail bags. Crew lockers on one wall.

'Call this a victory for the twentieth century,' says Cary. 'Here we are. On the run. Trapped. And no cell phone. Can't call the panic line like in that great old spy movie. We should turn ourselves in. Train attendants have cell phones and—'

'What if the person who answers the panic line is the traitor who works with Philip, and is ID'd in the flash drive I downloaded from Philip's computer?'

Cary sighs. 'Dating apps never get you who you want.'

His spread-wide hands stretch out a rope.

He shoves crates. Makes a couch for Eva to sit on beside him.

Cary pats his computer bag: 'Least we got this download.'

Eva says: 'And I got my upload.' Her blue eyes don't blink. 'One of us might not make it.'

They settle shoulder-to-shoulder.

'Tell me about growing up,' asks Cary.

'Don't you have anything you want to say to me?'

'I want to hear your everythings.'

Eva nuzzles closer.

Says: 'I always wanted to—'

Clackety-clack, clackety clack...

Scheduled stops when Cary and Eva hide inside an empty

closet-like cardboard box for dirty rags, as local and train attendants load and unload luggage and rail-shipped cargo.

They hear outside daylight cries and swoops of the birds.

Now they're out of the box. Stand in the rumbling train's baggage car.

'It's May Day,' says Eva.

'*If only,*' mutters Cary. Checks his watch. 'We hit Chicago in thirty-one—'

He rushes to the wall lockers.

Uses the cyber key...

...opens a locker.

Turns back to Eva holding a train attendant's blue uniform.

Says: 'You or me?'

Eva stomps her right foot on the steel floor.

Her midnight-black shoe snaps off its high heel.

She bends that now flat-soled seducer into a shoe for running.

'*Your attention please! Welcome to Chicago's Union Station!*'

Passengers stream off the *Empire Builder*.

Scurry beside the steam-hissing train on a platform to the huge station.

Frenzy passes where the troubled conductor stands.

Moms. Dads. Kids. Business travellers. Tourists. A woman who watched a dream vanish. A quick-walking pair of workers.

That visor-capped worker man in a too-small train attendant's blue uniform strides past the conductor. Carries a computer bag. Slips the missing keys into the conductor's reflexively reaching hand.

Relief brightens the conductor's face.

The blue-uniformed stranger walks on.

The... *person* beside him wearing far-too-big tan coveralls and a flaps-down, head-covering cap strides beside him.

'Is my hair showing?' whispers coveralls Eva.

'No,' whispers Cary.

'Wish I had that damn wig Philip made me wear so I'd be boringly prim and forgettable, not a threatening woman.'

Distant *clanging* comes through the crowd from inside the station.

They're fifty steps from the glass doors into the station.

They're thirty steps from the revolving glass door.

Eva sees that spinning glass door—

—spots reflections of Philip hustling closer in those whirling panes of glass.

'Run!' she cries out to Cary.

He charges forward.

Pushes her ahead of him through the station's regular glass door.

Catches the reflection of the crowd-knifing man from the dining car.

In, they're in the station, running through the bustling crowd toward...

Eva points to distant doors filled with sunlight.

They charge toward that glow.

Eva's cap falls off. Her white, blonde hair flies free.

Ever louder *Clang! Clang! Clang!*

Whump of the glass doors throws them outside.

A street. A few pedestrians. The road leading away from the station.

The road rising up at an angle in front of their racing-toward-it eyes.

Warning *clangs* sound as Chicago's Jackson Street drawbridge cranks open and up so boats below can sail to the river's north by northwest bend.

The paved street/bridge is angling up to eleven degrees.

The gap between each side opens to the sky above the river.

'Come on!' cries Eva. 'We can make it across before he can!'

Cary runs beside her.

Skedaddling through barriers, flashing lights, clanging alarms.

Philip runs out of the station behind them.

Draws his unsilenced pistol.

Fires at the fleeing couple as he races across the street to the bridge.

Bullets zing near the fleeing couple. Ricochet off the rising road/bridge.

Three zinging bullets slam Cary's computer bag.

Leonard's pistol flips out – its silencer barrel is bullet-bent.

The bridge rises to twenty-one degrees.

Cary and Eva race toward its opening gap.

Cary throws off the computer bag. It spills out gunshot parts as it slides down the rising bridge toward Philip.

Who races onto the thirty-one-degrees rising bridge.

Freezes. Shooter's stance. Fires three rounds at the fleeing couple almost to the opening gap between the sides of the forty-seven-degrees rising bridge.

A bullet rips through Eva's tan coveralls' flopping pants legs.

She cries out—

—trips/loses her balance/spins turning falling through the open gap of the fifty-three-degrees rising bridge.

Cary leaps—

—catches her hand as she falls!

He front-flops onto the rising bridge's pavement.

Eva dangles from his grip.

Swings by one arm above the crushing fall to a drowning river.

Bullets zing over Cary's flat holding-on body.

Four uniformed Chicago cops at the station-side foot of the rising bridge blast at the *immediate threat* shooter.

Forty-one shots blast through the Chicago morning.

Six hit Philip and drop him dead to roll down the now locked-open bridge.

Ricochets everywhere.

One bullet blasts a hole through a *so-hip* water bottle held by a lawyer commuting to her office through Union Station.

Empire Builder

Cary's leaned half over the edge of the bridge gap.

One hand grips the bridge.

One hand hangs on to the terrified blonde woman dangling over the edge.

'*I've got you!*' cries Cary. '*I've got you! I've—*'

'—got you,' grins Cary as he guides Eva's rise off the rumpled lower bunk of their sunny-day train cabin.

Her ruby lips grin as she slides standing against him. Her arms circle his neck. She wears a blue blouse and hips-curved black slacks.

'Who's got who?' she says as she flows into their deep kiss.

The train rumbles beneath their feet.

They pull apart but stay in each other's arms.

Cary smiles at her: 'Yes, well, the answer to that question is coming up.'

'I bet *something's* coming up,' says Eva.

'Too bad I smeared your lipstick.'

She pecks his cheek.

'Half the reason I wear lipstick is to smear it with you.'

'What's the other half?'

'I gotta be me.'

They kiss again.

'And now you are,' says Cary. 'Just you. No more spy life. So now you should fix your lipstick.'

Her look goes quizzical.

'You got to be *you* in the pictures.'

'What pictures?'

'Up ahead. In Shelby. The town where we met. Where I bought the tickets that you trusted me on without asking where or why. The town's Justice of the Peace insisted that I hire a local photographer.'

Eva fights crying and laughing at the same time.

'The good news is besides hired witnesses, neither your uncle nor my parents will be there.'

A tear trickles down Eva's cheek.

'Maybe we'll help them find common ground.'

'That's up to them.'

'From now on,' he says to her wide wet blue eyes, 'it's—'

'—just us,' say her ruby lips.

WHOO-EEE! goes the train as it dives down into that valley's V.

Private Browser

A K Benedict

Balancing her laptop high on one palm like a waiter with a silver cloche, Mara grinned into the camera and one-finger-typed into the chat box: *I'll show you mine if you show me yours.*

On the screen, Bobby nodded, cheeks peony-pink. *You go first*, he wrote back.

Mara swivelled, angling the camera to show the bookshelves spanning the length of her living room. As she slowly stroked the spines of her green Penguins, she could almost feel them shiver and thrill under their covers. *This is my crime section*, she wrote, *from Golden Age British and Antipodean to US noir, right up to contemporary thrillers and true crime.*

No reply.

Bobby was looking towards his knees.

What's wrong? she typed, settling into her sofa. She only allowed texting during online sessions. The written word was more reliable, and less exposing.

Head still down, Bobby glanced up, then away as he wrote his reply. *I've only got one bookshelf left, in the bedroom, and not many books. Poppy took the rest.*

Of course she had. Mara stabbed her fingernails into the palm of her hand in annoyance – she should've anticipated this. In their £5-a-minute sessions every Friday night (£2.80 of which went to

Mara after streaming site and agency fees), Bobby had told her, gradually, haltingly, about the relationship with his ex-wife and its decline due to his gambling. He'd either had to sell his possessions, or lost them in the divorce.

I'm sorry, Bobby, Mara now wrote. *I should've realised.*

I just don't want you to think badly of me. Fat tears fell as his big, sad eyes gazed directly into the camera. It felt more intimate than his orgasm.

I could never, she replied. And it was true. Mara only lied playing poker, her other paid occupation. Her honesty had cost her a place in the secret services when they approached her at Oxford, and many clients in her first weeks as a webcam model. Two years of being a 'camgirl' later and she'd accrued a loyal and lucrative client base who relished being told the truth, and, at times, what to do. To some she was a brutally honest online dominatrix, to others a confidante, dispensing valuable advice in Agent Provocateur. Bobby, had described her once as a 'counsellor with benefits'. She'd advised him to see a proper therapist instead. It'd be far cheaper. He'd just shaken his head.

At times she was more of a body doubling coach, encouraging him to face his fears and debtors, sitting on the other end of the video, as he'd opened threatening post and emails. She'd seen him go pale, but he'd never told her what they said. *Maybe if we meet up, one day*, he'd replied when she asked. *I don't want to write anything down that could be used against me. They could see it.*

And, for once, it worked both ways. She'd found herself confiding in him, crashing through her usual boundaries. She'd told him about her childhood: her brothers – one dead, one lost to the criminal world; throwing herself into schoolwork to escape their small town; and Walnut, her escapee hamster, who made a nest in her dad's stash of *Mayfair*s.

Shall we have dinner? he typed. The image was blurry as he walked over to the kitchenette.

Private Browser

Mara went through to her kitchen and propped up the laptop on the table, already laid for their weekly candlelit supper. Popping on battered, orange oven gloves, aware of how they clashed with her black silk kimono sleeves, she took out a tray of charred salmon, followed by one of hairy carrots and burnt potatoes. Glasses steamed up; she served the veg and fish onto a pile of rocket.

Bobby was pixelating as he plated up his own salmon. Each week, he DMed the recipe and ingredients a few days in advance so they could sit down to the same meal. Both also had a large glass of Viognier.

When they were both sat, facing each other across separate tables in different parts of London, Mara typed, *Yours looks exactly as it did in the recipe.* She tipped her plate so he could see. *Mine looks mid-cremation.*

Bobby laughed. She loved it when his smile was so wide it showed his back teeth. It rarely happened. *You tried, at least. And it gets me cooking again. I don't normally bother just for me.* Bobby used to be a chef. He'd told her once, his eyes basted with tears, about his time as a sous-chef in a Michelin kitchen, and running the pass at a gastro pub. Now, he never left the house.

She raised her glass to toast Bobby.

He lifted his in response and took a sip. *To health, wealth, and happiness,* he typed. Behind him, his cat, Brecht, was playing with a golf ball, thwacking it with his paw so it bounced off the closed door.

Tell me about your week, Mara wrote, as she always did to start their dinners. It was one of her favourite moments of client time. And, if she was really honest, of her whole week.

Bobby grinned in recognition of the ritual, but his smile dipped. *Could've been better.*

In what way?

I can't really say much, he typed, teeth worrying at his lower lips. *But I think I'm going to have to move.*

Is Poppy making you leave your flat? Mara was glad the written word didn't carry the incredulity her voice would otherwise convey. Bobby was now renting his flat, in the building he once owned, from his ex-wife. She lived downstairs, with her new partner.

It's more complicated than that.

Tell me. Maybe I can help.

Bobby shook his head. *I want to keep it separate from you as I can.*

Clients often lived their lives like trains. Compartmentalised carriages: one for their marriage; one for work; another for friends; the last, sometimes sleeper, car for extra-curricular sex. Any carriage could be jettisoned, left on a platform when not in use. She considered herself the smoking carriage. And she respected these distinctions, she did it herself. She'd never seen Bobby this worried, though.

You can tell me, you know, she wrote. *I'm like a confessional, only the rosary beads are used for different purposes.*

He didn't return her twinkle. The shadows under his eyes seemed deeper. *Really, I can't. I don't want you hurt. You're too close to it all as it is. I've tried to spell it out before, but it's too dangerous.*

As she was typing her reply, something caught her attention. The door behind him was very slowly opening. Brecht was on the sofa to the left so it couldn't be him.

Is someone else there? she wrote.

What do you mean? he asked. For a moment she thought the connection had failed, but it was only Bobby that had frozen in place, eyes wide.

A shadow stood in the doorway.

Someone's behind you, she wrote, heart rate soaring. The pastiche of panto heightened the horror.

Bobby turned at last, chair falling as he stood. Fumbling in the drawer to his right, he yanked it open and took out a gun. It was a black blur in his shaking hand.

Private Browser

A tall man in a black balaclava strode across the room, his own gun trained on Bobby's head.

'Don't,' Mara stood and called out, but neither could hear.

Get out! she typed, but Bobby wasn't looking at the screen.

An orange flash, and Bobby lurched to one side, falling onto the floor. His head was a mess of red.

Puke rose to her throat as she backed away from the table. Her glass smashed on the tiles.

The gunman, though, was approaching the screen. He saw her. Looked into the camera. His eyes were green, and empty.

Then the screen went dark.

'His eyes are still there when I shut mine,' Mara told Tally on FaceTime as she dragged her overnight bag from under the bed. 'They're an algae green you can't unsee.'

'But you didn't see his actual face?' Tally, originally Mara's mentor at the webcam agency, now her best mate, was sucking on her vape like it was an inhaler.

'The balaclava covered the rest.'

'That's good. For you, I mean. If he hadn't been wearing it, you'd be able to identify him, which would make you a threat.'

'I'm a witness to murder. I reckon I'm a threat.'

Tally nodded, vapour rising around her. 'Fair point. Did you call 999?'

'Yeah, immediately, but I didn't know where to send them. Would the streaming site have his address?'

'I suppose they'd have his credit card details, but you'd need a warrant to get it, and it's US-based, so I've no idea what jurisdiction the Met would have.'

'I know Bobby's dead, he was shot at short range, by someone so calm they must be a professional, but if there's even the slightest chance that he survived, and I didn't get help…' The thought of him suffering made bile rise again, burning her throat.

'How are you feeling?'

'Numb, I suppose. I saw it happen, in front of me, but can't take it in. It's not real.' *I don't want it to be real*, she thought.

'You must be in shock. You shouldn't be by yourself. Don't go to a hotel; stay at mine instead. I'll feed you, make sure you're okay.'

It was so tempting. Mara would love to lie on Tally's sofa right now, eating junk and drinking wine, talking about anything other than death.

The eyes of Bobby's killer shot into her head.

Mara rolled up her clothes, distracting herself from the foxed feeling of being prey. 'I can't. I'm a witness. The murderer saw me and will have taken Bobby's laptop, with all his account information. Pretty likely he'll come after me, and when I'm found, I don't want you to get hurt.'

'They can't get your details via Bobby. All calls go via the streaming site, not your phone. And if he comes to us, we're not going to give your details. Just for GDPR reasons,' Tally joked, although her tone was far from comic. 'Not because I want to keep you alive or anything. Obvs.'

'Obvs.' Mara zipped up the bag and looped it over her shoulder.

'Will you at least let me know you're safe?' Tally's forehead was ribboned with worry.

'I'm going straight to the police station from here. I'll *probably* be safe for a bit at least.'

'Sure, because the police are always so good with sex workers.' Sarcasm spiked her voice.

'I play poker with a DI at Brentwood. He knows what I do, respects me, and will help, if he can.'

Tally's micro-bladed brows arched in disbelief.

'But, yes, I'll keep in touch.'

'Promise me you won't try and work out who did this by yourself?' Tally asked.

Private Browser

Mara laughed and shook her head but didn't reply. She didn't want to lie.

Mara was used to the off-duty version of Robin Mardle. Sitting opposite her at their poker table in a grubby back room in Wood Green, he always wore the same 'lucky' shiny purple-and-blue-striped shirt and a moth-munched brown cardigan. He was clever, shy and good at bluffing, but she'd never seen him win, or smile.

Now, in the station, he was striding across the open-plan department in a decent suit, large-toothed grin stretching his face. 'Mara! So good to see you. You're lucky to catch me, I was about to go home when I got your message. Although,' he dropped his voice, 'they said you didn't want to disclose the crime you were reporting. Apparently, it's a "delicate matter".'

'If murder can ever be delicate,' Mara replied as he scooted her through into his small office.

He said nothing, just got out his notepad. 'Why don't you take me through what happened.'

Half an hour later, when she'd finished retelling the story, Robin was tapping the desk with the chewed end of his pen. 'What else do you know about the victim?'

What could she say? That Bobby used to love going to the theatre, so he arranged for them to watchparty plays online on some of their Fridays. That he looked much younger than his thirty-five years when transported into Shakespeare, Churchill and Beckett. That she'd never get to see him smile again. That his sharp, sad intelligence would no longer be spilled over their late-night text exchanges but instead removed with his blood from his carpet.

'I know that he lived in Wood Green, somewhere near the station. I've seen buses frequently go past his window so he must be on a well-used route. He's agoraphobic, and hasn't left the house in a long time. He used to be a chef but is now online tech support,

your classic "have you turned it on at the wall?" and "can you turn it off and on again?" role.'

'What brought on his agoraphobia?'

'It was always there,' she said, thinking back to their conversations. 'But when his marriage broke down, it got much worse. He lives upstairs, in a house now owned by his wife, whose name is Poppy.'

'That gives us something to go on, at least. Anything else?' asked Robin.

'He was in significant debt, and was being pursued – for repayments, I presumed, but could be something else.' She paused, thinking of Bobby's guileless smile. A backlog of tears started to fall.

Robin frowned. 'You seem fond of him – *close* to him, even – but he was your client. How does that work?'

Mara bit back her first response. He'd never understand. 'I've told you what I can. I'll have forgotten loads,' she said, 'but I'll give you my password and you can go through our messages. It's all there.'

'Okay,' he said. 'You're shivering, and it's late. Let's get you into a safe house. It may be an overreaction, but I'd rather that than you be in danger. Even if you always beat me at poker.' His wink was more of a blink as he went to pick up the phone.

'I'd rather go to a hotel or B&B,' Mara said. She'd heard enough industry rumours to know safe houses could be oxymoronic. 'Somewhere I can get room service, and not raided. One of the out-of-the-centre, private ones.'

Robin hesitated. 'I don't think that's wise.'

'Then *you* go to a safe house. After you've found Bobby.'

The hotel was known in sex worker circles for its discretion and French toast, and Mara now had need of both. Her room, paid for in cash, looked out over one of London's Magnificent Seven cemeteries. Night had settled over the dead. Lit by flanking streetlights, graves knee-deep in weeds marched grey-faced into the distance.

Private Browser

Mara closed the curtains and settled on the bony sofa. Blanket wrapped round her, peanut M&Ms on her lap, she sent both Tally and then Robin a message on a burner phone: *I'm safe, in my hotel.*

With the telly on low to keep her company, Mara went back through her messages with Bobby using a secure VPN. There must be something in there that could help Robin. Each transcript of their Friday nights uncorked memories. The time they watched *Psycho* together and exchanged horror stories about their mothers; the night he talked her through making a chocolate fondant; the strip Scrabble session last week in which 'mutualmasturbation' was not only allowed but encouraged, and given the highest word score...

Something niggled in her memory. Bobby saying, *I tried to spell it out.*

Zooming in on the photo of the Scrabble board that she'd shared on their chat, Mara noticed that the 'm' of masturbation was also part of 'Blackmail'. She remembered that he had added 'mail' to the 'black' she'd laid down. And he'd said something odd. What was it? Something about the words belonging together, and how you had to *see the whole board to make the next move.*

He'd then stopped the game and put all his clothes back on. Refusing to say why, he cut short their session and didn't mention it in the week since or in their final session.

Mara should have, though. Guilt squeezed her heart. What if she could have stopped his death?

Her burner phone buzzed. Message from Robin: *We've located the address for your client, but there's no sign of a struggle or gunshots. No blood. No Bobby.*

They must have sent someone in to clear up, she texted.

Could be, Robin replied. *But could you assure me that we have the right address.*

Several images pinged through. All were of the flat she'd glimpsed

295

during hours of calls with Bobby: handwritten notebooks of his recipes were stacked on the sideboard; the clock on the wall ticked seven minutes fast, a habit he'd developed in his chef days to counter lateness; and Brecht the cat stalked the room, tail curled into a question mark.

It's definitely his place. Sadness surged. Bobby's absence in the pictures made his abstract death concrete. *What is going to happen to the cat?*

No idea.

Mara thought of poor Brecht wandering the flat, miaowing for his gentle friend. *I'll take him, if no one comes forward.*

'*Typing*' dots hovered, then stopped. Started again. Stopped.

Then he rang. 'I didn't want to write this down,' Robin said when she answered, 'but we have to consider that what you saw is either a hoax or a set-up.'

'What do you mean? That Bobby isn't dead?' Hope surged.

'It's a possibility.'

The scene of Bobby's death replayed in her head. It looked real to her. But then she had to fake things all the time. 'What would be the reason?'

'You tell me. You know more of his situation.'

Mara's brain raced through options as if staring at tiles on a Scrabble rack. 'His ex-wife could have life insurance on him, and they'll split it if he disappears. Or he's trying to convince debtors or blackmailers that he's been murdered to stop them coming after him?'

'You think he was being blackmailed?'

'I remembered a conversation we had last month, over Scrabble. It was one of the words, and maybe I'm imagining it, but in hindsight his reaction was significant.'

'A hunch isn't enough. Imagine presenting that as evidence to the CPS – "the alleged victim spelled out the word 'blackmail' in naked Scrabble".'

Mara looked back over the Scrabble board image, this time seeing the whole board.

'Could you look into his bank accounts for regular payments or suspect withdrawals, or whatever else you do in blackmail cases?'

'If his ex-wife makes an insurance claim we can look into fraud, but until there's an advance in the case, I can't—'

'You're stopping investigating?'

'Without a body, or *any* evidence of a crime, there's nothing to go on. It's only been a few hours – he's not even a Missing Person yet. His ex-wife is more concerned that he hasn't paid her rent in three months.'

'But I *saw* him die, doesn't that mean anything?'

'My instinct tells me he's already on a plane to somewhere he can disappear. And that he has used you, set you up as a witness to his fake death.'

'I hope so,' Mara replied. 'As that means he's safe.' Her instinct, though, was that Bobby was dead, and she was the only one who was going to find his killer.

'That's because you're a good sort,' Robin said. 'It's why I looked into it. But back off now, right?'

'I'll spell it out to you, Detective Robin. No. I can't leave this alone.'

Her next caller was booked in for midnight. She didn't have long to prepare. At least it was a group call, with other models present, so the pressure was reduced. Tally had asked in a text if Mara was really up for it, whether she could perform, and, although not entirely satisfied with Mara's answer that it'd be a good distraction, allowed the session to go ahead.

Dressed now in red silk pyjamas, Mara dimmed the lights and set up her laptop on the desk, facing the window. Trying to blink away the images in her head, she took a picture to test what she'd look like on camera. Her ring light gave her skin a glow and reduced

the stubborn tear streaks. Behind her, the door and the light from the corridor beyond were visible, but there wasn't much she could do about that.

The link appeared on screen. Mara switched on her widest smile as, one by one, models from the agency appeared.

The caller was typing into the chat. *I want you all to do what I say, when I say it.*

Whatever you say, Mara replied. *It's your call.*

Some of the models simply nodded, others replied in kind.

Footsteps walked along the corridor, spiking Mara's pulse. They stopped outside her door. A beep from a room key. Her heart slammed against her ribs.

Your door is opening, the caller wrote. *Someone's coming in. Turn around. Now.*

Mara stood up, holding the laptop on one hand like a waiter so that all the cam girls could see the intruder.

The green-eyed killer's hand shook, as did his gun.

'What are you going to do now, Detective Robin?' she asked him. 'They're all watching you, through their windows. Eight cam girls and Tally, my caller and mentor. And this is being recorded, in case you think that their word, like mine, can't be trusted.'

'How did you know?' Robin's voice was low and broken.

'I never forget a fellow player's hand of cards, or their eyes. I recognised you immediately, through the screen. I doubted myself, though, so came to you first. And you never were good at bluffing. Plus, Bobby left me clues. The words "blackmail", "detective", and "Robin" were on the board. As he said, he spelled it out.'

'You have no evidence I killed him.'

'I'm sure your boss, DCI Windsor – who is through there, listening in the adjoining room, by the way – will find how you blackmailed Bobby. And breaking in here, with a stolen key I presume, with a gun, perhaps the same one, won't look good for you. Neither will tracking my burner by keeping me on the phone.'

Private Browser

Robin turned, bolting through the door. From the corridor came scuffles and blows as Windsor's team brought him down. His protests disappeared down the hall.

Collapsing onto the bed, Mara swivelled the camera round so she could see her friends. 'Thank you,' she said. The tears returned. For her, and for Bobby.

I'm coming over to get you, Tally wrote, then stood, vapour billowing around her like a cloak. *See you in thirty minutes.* The link closed and Mara suddenly felt very alone.

'If I may have a word?' DCI Windsor said, gently knocking on the open door. 'We'll need a statement from you. When you're ready, one of my DCs is set up next door.'

Mara wiped her eyes. 'Of course.'

'Good job, by the way. Working it out. Not sure I could have.' He gave a little bow, then retreated, muttering into his phone.

Mara opened the curtains, looking out over the crematorium. If Bobby's body was found, maybe he could be buried there, safe among London's dead. She'd pay for his gravestone, with an inscription spelled out in Scrabble tiles.

Russian Hill

Jerome Charyn

1.

Had a bodyguard by the time I was seven. A retired detective from San Francisco's Mission Station, Rusty Royce was more of a dad to me than my own dad. I was raised in a mansion in San Mateo, a mansion that soon became a fortress. Eric Ferguson – my dad – was obsessed by the San Mateo Massacre; the son and two youngest daughters of a prominent local merchant were kidnapped on their way to school and bludgeoned to death. The kidnappers didn't even bother to leave a ransom note. It seemed strange, almost random. The entire county was terrified. Parents kept their children out of school. The sheriff and his deputies went from door to door, searching for clues. The deputies discovered nothing, nothing at all.

Like the local merchant, Dad was a man of great wealth. He'd made a killing in the stock market while he was still at college, and he parlayed that small fortune into a bigger one by opening the first round-the-clock convenience stores in the Bay Area. He was a millionaire by the time he was twenty-five. And he didn't want a child of his to suffer the fate of the slaughtered girls and slaughtered boy.

Ergo, the bodyguard. Rusty was with me on a permanent basis.

He lived at the mansion, ate at the mansion, and slept at the mansion, in the room next to mine. He'd never married and didn't have a family of his own. Dad was cruel to him, on account of all the attention I got from a mere bodyguard, but Rusty was devoted to me and tolerated Dad's barbs.

I didn't.

'Dad, you don't have to insult the man. It'll encourage him to quit.'

Dad had the wicked smile of someone who considered himself the king of San Francisco Bay, with Rusty as one of his vassals.

'Little John,' he said, 'Detective Royce can quit whenever he wants. Bodyguards are a dime a dozen. Where else could a retired cop get a job with such benefits? Free toothpaste and a toilet of his own.'

I happened to be ten at the time we had this talk. 'Dad, would it cost you extra to be kind to Rusty?'

'Yes, it would, Little John,' Dad quipped and left the dinner table.

I was always Little John, even after I left for college. But Rusty never called me that. I was 'Scottie' to him on account of Dad's Scottish ancestors.

Mom ran off with the manager of one of Dad's convenience stores about a year after the San Mateo Massacre. She left a note under my pillow, like the tooth fairy might have done:

Love you, Little John. I cannot bear to be with your father.
I'll get in touch. I promise.

She never did. Perhaps Dad prevented her. Perhaps he destroyed all her letters to me and had her phone calls blocked. It remained a mystery, a hurtful one. Dad wouldn't agree to a divorce. He brought his girlfriends to the mansion – fashion models, movie starlets. None of them lasted more than a weekend. I watched them with a detective's eye. They swam in Dad's indoor pool. I remember painted toenails and ample portions of bare flesh. They danced across the tiles with a rhythm that amazed me. They rarely ate with

us. Dad abandoned me to my bodyguard during these weekends, while I ached with delirious desire.

I learned the skills of a detective from Rusty. If Mom stayed invisible, we decided to make her visible again. I found an old driver's license of hers that Dad had left in the basement with Mom's other stuff. Rusty called his friends from the Investigative Bureau at Mission Station, and pretty soon we had an address for the missing Mrs Eric Ferguson: 900 Lombard Street, a little white apartment house with a red door, on San Francisco's Russian Hill. Lombard had become a tourist attraction, Rusty told me. The area above the white house was so full of steep twists and turns that it was called 'the crookedest street in the world'.

The street wasn't crooked at all. It curved around a series of little houses and gardens because the hill was so steep that the road couldn't have been built without such massive curves. From the little white house at the bottom of the hill, the street looked like a macadam serpent that had lost its head and tail. But we had a bit of luck at 900 Lombard. The landlord had evicted Mom. She'd been rowdy and hadn't paid the rent, my bodyguard learned from another renter in the building. But that renter did have her current address: a convalescent home near Fisherman's Wharf.

The home was another miniature white house. It was maintained by nurses who were also nuns. Mom wasn't in the charity ward. She had a room of her own. Dad paid all the bills but he never visited Mom. It was obvious, even to a boy of twelve. The rogue manager who had run away with Mom had abandoned her and she fell into an alcoholic haze. That's why she'd lost her apartment in the little white house on Lombard Street. Mom wasn't catatonic. She recognised me and my bodyguard.

'Little John,' she whispered. She was wearing a white robe the nuns had given her. She reminded me of a bird with broken wings – that's how frail Mom was. She began to cry.

'I missed you so much.' Her shoulders swayed and wandered with

Russian Hill

a rhythm that was more and more erratic. The sister in charge said we should leave. I was putting Mom under emotional duress.

'You mustn't return here, young man.'

We drove back to my father's fortress. Rusty was in a bind. Dad would fire him if he drove me to that little white house near Fisherman's Wharf, or if I went there by myself. Even at twelve, I made a choice. I didn't have the means to free Mom. I couldn't run away with her. Where would we go? I held to Rusty as tight as I could. I'd become a detective, living with one. Dad must have paid off that ex-manager of his to drop Mom – paid him plenty – and she couldn't survive on her own.

'Rusty,' I said, 'why don't we run away?'

He shrugged. 'Where would we go? Your dad would accuse me of kidnapping you. Scottie, you're better off where you are. Just wait your old man out. You'll inherit what he has and you'll be free of him.'

It was a loveless plan. But I listened to Rusty. I couldn't afford to lose him. Mom died soon after our visit. Dad had her disposed of without a funeral. I learned all this from Rusty, but I had to keep silent, or Dad would have gotten rid of Rusty, too. But my bodyguard did abandon me. He died of a heart attack while I was a freshman at Stanford. Dad had given him a handsome settlement, though Rusty never got to enjoy it. Perhaps he missed me as much as I missed him.

I got through Stanford Law School and passed the California bar on my first shot. I went right to Mission Station and met with San Francisco's chief of police, a distant friend of Dad's. He was delighted.

'We can use a dazzling young lawyer in our legal department.'

'Sir,' I said in a very low voice, 'I want to be a cop.'

He laughed. 'Don't be silly, John. All that time and money you spent, years of hard work, and you want to carry a whistle and a nightstick?'

'Yes.'

The chief was disheartened. 'What will your father say?'

I didn't give a damn. I passed the physical and went through a background check that seemed more like an inquisition. But I didn't train very long. I was plucked out of the academy after eight weeks and put into a special investigative unit at Mission Station, which was also a firehouse at the time. And we could hear the roar of the fire engines past midnight.

I wasn't treated like a novice. I had my .38 special and a pair of handcuffs and went on raids with the officers and detectives of the Investigative Division. But something out of the past rubbed at my brain. That cloak of randomness around the San Mateo Massacre. I told my captain about it. He got in touch with the cold case squad at the San Mateo sheriff's office. And I was temporarily assigned to San Mateo. The cold case squad consisted of a deputy near retirement with files that hadn't been looked at in years. I went out on my own.

The local merchant who had lost a son and two daughters lived in a mansion that was half a hill away from Dad's. His name was Robert Wilson. He owned a pharmaceutical company, Lion Drugs. I asked Dad about him. He wasn't that happy to see me now that I was a cop. Dad had grown feeble. He used a cane. There were no more weekend rendezvous with models and starlets. Dad needed a nurse.

'Wilson,' I muttered. 'Dad, what can you tell me about Robert Wilson?'

Dad mocked me. 'Sherlock Holmes on the march. Hasn't that man suffered enough?'

'But did you have any business with him?'

'Wilson's in pharmaceuticals. We didn't sell any of his stuff at our stores. But he did borrow money from me – several times. He never welched. I always got my money back.'

'Dad,' I said, 'please try to remember. Did he need cash at the time of the kidnappings?'

Dad stumbled for a moment. 'I can't recall.' Then his mind fell back into place. 'No, it was before the kidnappings. He seemed troubled – almost unhinged.'

'Did you tell that to the police?'

'Of course not,' Dad said. 'No one ever asked.'

Using the tricks I had learned at law school, I had the San Mateo sheriff get a court order to subpoena Wilson's bank records, both his personal accounts and the accounts at Lion Drugs. Nothing seemed out of the ordinary except payments to 'Maxwell Industries', which had no discernible address or telephone number. The payments weren't enormous. A couple of grand each time. But there were a good number of these payments. They stopped six months before the massacre, and then started all over again.

No one in San Mateo could tell me about Maxwell Industries, and I didn't want to question Wilson himself. I was an interloper, a detective-in-training from a rival town. I had to do my own investigating. None of the current detectives in my unit at Mission Station had ever heard of Maxwell. So I went to a retired cop, an old friend of Rusty's. His name was Oscar Butterworth. He lived in Chinatown, on a street of flophouses. He was suffering from emphysema. He had to suck on the tit of an oxygen tent. I gave him twenty bucks and brought him a bottle of Four Roses. He drank a sip of bourbon with each suck of the tit.

'Maxwell,' he said with a bitter laugh. 'A dummy corporation, a drop used by several loan sharks. One in particular. Leopold Morgan, known as the Lip.'

I asked Oscar if he'd ever heard about the San Mateo Massacre.

'Of course,' he said. 'That businessman, Wilson or whatever, didn't pay his bills. He tried to stiff Leopold. And so the Lip called on his usual bill collectors. And Wilson never stiffed him again.'

I started to shiver with anger and an odd anticipation. 'And you didn't tell your superiors?'

'I was retired,' Butterworth said. 'The Lip could have slit my throat.'

I didn't go back to the San Mateo sheriff's office. I returned to Mission Station. I met with the chief of police. Leopold was a known item. But no one had ever linked him to the San Mateo Massacre. His pawnshop on Mission Street was raided every six months. And so the chief decided to raid him again.

I was with the war party. Leopold was senile, I could tell. His eyes had lost whatever blaze they'd ever had. I wore the silver star I was entitled to as a detective-in-training. 'What do you know about the San Mateo massacre?' I asked the old man.

'Everything,' he said, cackling at us. He didn't pretend. Wilson owed him money. And so he went to his heavy hitters. They weren't supposed to harm the three kids. But malice was in their blood. They went too far. Leopold scribbled their names. We brought him back to Mission Station. The hitters were arrested.

I thought Wilson would be charged with obstruction of justice. But the San Mateo prosecutors decided not to charge him at all. They wouldn't be able to build a case against him, they said. He didn't finger Leopold, even after the massacre, because he was frightened of what might happen to his other children. A good lawyer could have convinced one or two jurors at least, and San Mateo would have a series of hung juries. A case like that could go on forever.

My photo was in *The Chronicle*. A kid fresh out of the Academy had solved the San Mateo Massacre. I wasn't a kid. And I'd had a lucky spell. But Dad's attitude changed once I was in the papers. He liked having a son who was San Francisco's Sherlock Holmes.

Wilson decided he wanted to meet with me – without his celebrity lawyers. We met beside Dad's indoor pool. I could feel the deep sadness on his face.

'Scottie,' he said, 'I'm not a monster. I dealt with Leopold for

Russian Hill

years. I borrowed when I had to borrow. He came to Nannie's confirmation.'

Nannie was his youngest daughter.

'Mr Wilson, you shouldn't have lied to the police.'

'I had to lie,' he said. 'Do you really think they could have protected my children? Leopold's men moved like ghosts.'

'Well, the ghosts are in jail right now. And so is Leopold. He'll cop an insanity plea. But he'll never see a streetcar again or Golden Gate Bridge.'

Wilson became a pariah. Lion Drugs went bankrupt. He put his mansion up for sale and disappeared. His wife had left him. His three surviving children had moved from San Mateo years ago.

I wasn't a trainee very long. I became a detective among other detectives. Dad died suddenly, and I inherited his entire estate. I put the mansion up for sale and bought the little white house on Lombard, and moved into Mom's old apartment, with the red front door. I had all the apartments remodelled. I didn't enjoy being a landlord. I charged my tenants only what they could afford. I let them coast for months if they couldn't pay the rent.

I'd solved the San Mateo Massacre as a trainee. I was the star detective at Mission Station. I was photographed with visiting dignitaries. I got marriage proposals in the mail. My cohorts introduced me to their sisters and to the widows of fallen cops. I didn't feel comfortable around them. They were a little too eager to plunge into matrimony.

I did have a friend from my college years, Midge Wood, a fashion designer who lived on Telegraph Hill. I didn't feel a strong attraction to Midge, though I believed her when she said we had once been engaged. We were comrades who never kissed. Perhaps Dad's weekend starlets had ruined me. But that's where my erotic dreams went.

And then I had my own misfortune. I was chasing a bank robber on the roofs of Taylor Street with another officer right behind me.

I slipped, and had to hold on to a ladder at the edge of a rooftop. The officer, Sergeant Crisp, tried to help me. But the rooftop was very steep, and he tumbled to his death. I clung to the ladder until a fire truck with an enormous net arrived just in the nick of time.

'Jump,' the fire chief screamed into a megaphone.

I couldn't. I realised right then that I suffered from a morbid fear of heights – acrophobia, it was called. And it was often accompanied by a dizzy spell – vertigo. But my friend the fire chief reasoned with me.

'Scottie,' he shouted, 'that damn ladder can't hold you very long. Jump, will you! We've set up a net. I promise you. It will be like living in a circus.'

I managed to glance at the fire truck as the dizzy spell grew worse. But the chief was right. The ladder gave. And I fell – right into the net. I managed to wrench my back. I was laid up for a month. I had to wear a damn corset. That's when I decided to quit Mission Station and the Investigative Unit. You couldn't have a damn detective with a dizzy spell. Could have claimed disability, but I didn't. So I retired without a cent from San Francisco. I had my own 'pension' from Dad.

Suddenly I was a guy with nothing to do. That's when one of my classmates at college, Gavin Elster, called. We'd lost touch because I'd been so busy as the cold-case wizard with a silver star. Gavin had been a loner, like me. He married an heiress from Nob Hill and inherited her family's shipbuilding firm. He needed a favour from his old college friend. I wandered down to the piers and visited Gavin's shipyard in the Tenderloin district.

Gavin hadn't changed much. He'd always been secretive, even at college. I'd walked through the shipyard. It was filled with cranes. Gavin's office had a panoramic view of the yard, almost like a movie set. It made me suspicious. He wanted me to tail his wife.

'Jesus,' I said. 'Gavin, I'm a retired detective, not a private dick.'

He turned very sombre. 'Scottie, it's not sordid, nothing like that.

Russian Hill

There isn't a Romeo running loose. Madeleine and I are very much in love. But she's been acting strangely, like a woman possessed – as if a dead body has taken command of her soul.'

I was getting curious. 'What dead body?'

'Carlotta Valdez, a cabaret singer who lived a century ago. A very rich man fell in love with her. They had a child, a baby girl. He dumped Carlotta and kept the child. He left San Francisco with the girl and let Carlotta live alone in their mansion. She grew mad with grief. Her fine clothes turned to rags. She'd stop a stranger and ask, "Where's my child?" She threw herself into the bay, a suicide at twenty-six. My Madeleine is twenty-six, and Carlotta is her great-grandmother.'

'Well,' I said, 'that explains it. She feels a kind of kinship with Carlotta.'

Gavin grew very stern. 'She doesn't know a thing about Carlotta. Madeleine's mother assured me of that.'

'So it's a kinship of ghosts,' I said.

'I'm not sure. Madeleine wanders, wanders very far.'

'How do you know that?' I asked him.

'I checked her speedometer. She'd travelled over a hundred miles on a single afternoon.'

I got curious all of a sudden. I still had my old silver star. He suggested I catch a glimpse of her. They were going to the opera that night and dining at Ernie's, San Francisco's lone five-star restaurant. Gavin suggested I could have a look at her from the bar. It felt sordid. But I agreed. Perhaps I was desperate and lonely enough in my retirement.

Ernie's was on Montgomery Street, right near San Francisco's former Barbary Coast, a haven for pirates and prostitutes. The restaurant itself may have started as a bordello. It had scarlet wallpaper and scarlet drapes. I sat at the bar on a red stool. Gavin was at a corner table with his wife. All I could see of Madeleine was her remarkable blonde hair, tied in a chignon; I noticed all the

swirls in that knot of hair, as if her very own coif was a puzzle. It was a curious start for an ex-policeman.

I didn't prey on them. I let them have their meal, while I enjoyed a flute of Veuve Clicquot. Dad had been a great connoisseur of champagne. So was I. Madeleine rose first from the table. She wore a green dress that seemed to clash with her blonde hair. But I shivered at her stunning profile and the ripeness of her body. I was a child again. Madeleine Elster could have been one of Dad's starlets who spent the weekend with him and then disappeared from my life. But she had much more elegance than Dad's weekend 'dates'. And when she passed in front of me, I was frightened. I had that same sense of dizziness, of delirious desire. I should have realised that I had suffered from vertigo long before I chased a robber across the roofs and nearly tumbled to my death.

I was caught in Madeleine's web, willing to wander wherever she wandered. Gavin must have understood. He returned my gaze. Madeleine didn't. I could barely sleep that night.

I was about to go on the hunt, trying to unravel the reincarnation of Carlotta Valdez in Madeleine Elster.

Gavin and his wife lived at the Brocklebank, a posh apartment complex on Nob Hill, with its fine masonry, its lanterns and triangular roofline that triggered a dizzy spell. Gavin had given me all the information I needed. I waited like a wolf for Madeleine to get into her green Rolls-Royce, as I sat in my DeSoto. I followed her from hill to hill. She stopped near the Presidio, walked across Old Fort Point, and jumped into San Francisco Bay, like a woman walking in her sleep. I tossed off my fedora and fished her out of the bay. She was still in the midst of some enchantment as I carried her to her car. I could have driven Madeleine back to the Brocklebank. But it would have been too conspicuous, Scottie Ferguson with a wet, blonde mermaid.

So I brought her to Russian Hill. I carried her unnoticed through my red front door. I undressed the mermaid, rattled by her beauty

Russian Hill

as I squinted under the brim of my grey hat. Barely conscious, she remained limp as a rag doll as I dried her with a towel and put one of my choice white flannel robes beside her on my bed.

The phone rang. It was Elster. I told him that she had fallen into the bay. 'Has that happened before?'

'Never,' he said. 'Scottie, I'm worried. My wife's wandering is no longer a game. She would have drowned if you hadn't followed her.'

I could hear a stirring from the bedroom. I hung up on Elster as Madeleine walked out of the bedroom in my flannel robe, her unknotted blonde hair down to her shoulders. I was the one who trembled, not Madeleine, who began to interrogate me in a soft voice. 'What am I doing here?'

I told her how I'd rescued her from the bay. At first she didn't believe me. 'Where are my clothes?'

'In the kitchen,' I said. 'I left them there to dry.' I told her my name.

She seemed both petulant and apologetic. 'Are you a travelling lifeguard, Mr John Scottie Ferguson?'

She fetched her clothes from the kitchen. Gavin Elster rang again. As I picked up the phone, Madeleine flew out the front door.

I had a troubled sleep. I was the drowning party. It was the mermaid who rescued me. The next morning, I discovered her outside my window, leaving a note in my mailbox. I ran out in my slippers and the robe Madeleine had worn, drenched in her aroma. I captured her before she could escape in her green Rolls.

'I wanted to thank you,' she said about the note she'd left. 'Are you often so kind to strangers?'

I answered her with a question of my own.

'Where are you going, Madeleine?'

'You were my one destination. Now I'm free to wander.'

'Madeleine,' I asked like a schoolboy, 'may I wander with you?'

She didn't answer. I went back inside, got dressed, and went out

again, convinced she would be gone. But the green Rolls was still there. I got into the car, and we drove off. I had a cop's suspicion that I was about to begin the one great adventure of my life.

2.

We went to museums, had lunch at tiny bistros near North Beach. I met several old friends, retired and current cops and stoolies I had kept. But no one seemed to recognise Madeleine and her blondeness wasn't much of a disguise. It seemed odd to me. San Francisco was more like a village than a metropolis. I was constantly bumping into people I knew, whether it was at the Palace of Fine Arts or the Presidio. But Madeleine Elster didn't have either friends or acquaintances, except for Scottie Ferguson.

Gavin seemed to disappear as I wandered deeper into Madeleine's life. She never spoke of Carlotta Valdez, the courtesan and cabaret dancer who committed suicide, but she kept speaking of her own haunted past life. One afternoon, I touched her hand. We kissed, made love behind the red door on Russian Hill. I'd betrayed Gavin's trust, but it didn't feel like a betrayal. I stopped cashing the checks he sent through the mail. A month past forty, and it was the first time I'd ever dealt with my own desires. I was a novice all over again.

We'd ended our wanderings. But the more we stayed on Russian Hill, the more Madeleine seemed distressed. 'I remember a cantina. It was near a church with a bell tower. I danced with many men. Scottie, am I going out of my mind?'

'No,' I said. 'That bell tower exists. It's ninety miles away. At the Mission San Juan Bautista. What a history it has! A soldiers' barracks, a nunnery, and even a bordello – if I remember right.'

We drove the ninety miles to San Juan Bautista. We wandered through the stables. We sat in the little cantina. Madeleine seemed alarmed. Coming to the mission where Carlotta Valdez had once

danced brought her very little relief. She was more and more agitated. She got up like a ghost and ran toward the bell tower.

'Carlotta,' I asked, 'what's wrong?' Numbskull that I was, I'd confused Madeleine with her own dead double at such an awkward time. I caught up with Madeleine, embraced her with all the tenderness I could summon. I'd never been in love until now.

'Madeleine, we'll go away together. We can live wherever you want, coast for the rest of our lives. I have the money.'

She tossed my own tenderness back at me. 'It's too late,' she said.

She entered the bell tower, raced up the stairs. I ran after her. I couldn't reach the top. I had a dizzy spell. My vertigo had caught up with me. I heard a scream. And then I saw the whirl of her body from one of the tower windows. She'd fallen to her death…

I was like a mummy at the coroner's inquest. The chief examiner said I had been paid to protect her, but fell victim to my own disability. 'Mrs Elster was in a state of turmoil,' the examiner said. 'She was unwell. She had visions of a past life. And when Mr Ferguson brought her to a place where the woman who possessed her – Carlotta Valdez – had once danced, he couldn't protect her from her own self-destructive tendencies. He was obviously the wrong man for the job, disabled as he was, afraid of heights. He couldn't climb the tower.'

I was acquitted of any crime. But everyone at the inquest must have realised that I'd had a hand in Madeleine's death. I might as well have pushed her off the tower ledge.

Gavin was there. I couldn't even look him in the eye. 'Scottie,' he said. 'It's not your fault. You did the very best you could.'

He sold his interest in the shipyard, walked away with Madeleine's fortune, and sailed to Europe. I fell silent, caught in a depression I couldn't conquer. I had myself committed to the same convalescent home where Mom had stayed until the end of her life. The charity ward was gone. There were only private rooms. I had one that overlooked the harbour.

JEROME CHARYN

My old schoolmate Midge visited almost every day. She brought flowers and read to me. Always books of turmoil and strife, as if she meant to jog my mind into normality. She chose Dickens. There was *Barnaby Rudge*, about a hangman who joins a revolt, and *Great Expectations*, about a convict who returns from Australia to greet the grown-up orphan who had saved his life. It was Dickens who inspired my own ability to plot. The power of speech returned out of my own curiosity. My Madeleine could have come right out of a Dickens whirlwind. There was plenty of strife. One afternoon I took my fedora, signed myself out of the facility, and returned to Russian Hill.

I couldn't find Elster. Elster was gone. But I went to the library. I searched until I found a photo of Gavin's nuptials. The bride looked nothing at all like the Madeleine I had met. The bride had plucked eyebrows and a very long nose. I thought about it day after day as I sat on the same bed where I had undressed Madeleine after I rescued her from the bay. I was the unfortunate witness to a murder that was meant to look like a suicide. The fall from the tower had smashed Mrs Elster's bones, had made her unrecognisable. My Madeleine wasn't dead at all. Gavin had brought the real Mrs Elster up to the tower, had probably broken her neck, and flung the corpse from the tower like a bird made of lead. It was my Madeleine I had heard scream. Perhaps she had revolted at the last minute. But both she and Gavin knew I couldn't climb the stairs. It had to have been planned like a murderous ballet. Gavin had taught my Madeleine to assume the role of Mrs Elster. Was she his sweetheart, or an actress from a local playhouse in desperate need of cash? He'd gone up to the tower with the dead Mrs Elster, sneaked her past all the nuns, waiting for me to climb as far as I could. Gavin wasn't Dickens, but he had Dickens's ingenuity. He'd heard about my fear of heights. I was the perfect patsy, a retired detective as his prime witness.

But Gavin wasn't the one with a silver star and a cop's intuition.

Russian Hill

What if he'd left the fake Madeleine behind? He didn't need her now. I had an itch that said she was in these hills somewhere. I would hunt for Madeleine, track her down. I'd solved the San Mateo Massacre. I'd solve this.

I searched for months, like a true tracker. I didn't spot Madeleine or her green Rolls. I became more and more of a recluse. Midge brought me groceries from time to time or I might have starved. And then, about two years after the coroner's inquest, I could hear a faint knock on my door. It wasn't the first time a tourist had come searching for San Francisco's 'crooked street'.

It wasn't a tourist. It was my Madeleine, without her blonde hair. She wore rouge that was blood red. Her eyes were painted. She didn't have Madeleine's aristocratic mien.

'Aren't you gonna invite me in?'

I prepared coffee and biscuits for the both of us. She didn't say a word. Madeleine's ghost seemed very solemn, full of remorse. I caressed her hand to help ease her torment.

'I'm Judy Barton from Salina, Kansas,' she confessed. 'I tricked you. I played you dirty. Gavin hired me. I was his girlfriend, sort of. And then he ditched me, left me with a bankbook and a stack of hundred-dollar bills in a rubber band. That was my inheritance, my reward. We'll, ain't you gonna arrest me? You caught me flat.'

'I didn't catch you,' I said. 'You caught me.'

'It's the same thing. I could have gone back to Kansas. I was rich enough now. But I stayed. I was hoping you'd find me.'

'I tried,' I said. 'I kept looking for your green Rolls.'

'Oh, Gavin wouldn't have left me with an expensive toy like that. He sold it to a rich widow, a neighbour of his. You can't imagine how many times I stood on Russian Hill, looking at your red door. But I didn't have the courage to take that extra step. I loved being Madeleine, because it meant having you. Well, I've gone this far. Arrest me.'

Madeleine moved in.

At least, I saw her as Madeleine, even with the rouge and the auburn hair, and her background from Salina, Kansas, rather than Nob Hill. I buried my silver star and let Gavin get away with murder. I was living with his accomplice on Russian Hill. I stopped calling her Madeleine after a while. She was Judy by the time we ventured out from behind the red door and had our maiden dinner at Ernie's. It's simple. I was covering my tracks.

Chest

Ragnar Jónasson

'Where the hell is Harry?' I asked.

My friend David had arrived on time, but Harry was late, as usual.

We had made plans to watch *Rope*, a suggestion from Harry, a great fan of Hitchcock's work. I think he was inspired by the fact that I owned a big wooden chest similar to the one used in the movie. Of course, we'd all seen the film before.

Alongside my day job running a nearby coffee shop, I have been the director of a local film festival for a few years, focusing on Golden Age cinema.

David was working for Harry, who had a small production company and had brought a few high-profile television series to the screen in recent years.

I had spent the day with David, we'd had a long lunch and then started to make arrangements for the movie night, buying ingredients for cocktails, as well as some snacks, of course. I hadn't met Harry for weeks, and I did feel we were drifting apart – but maybe there were other reasons for that.

David and I used to be flatmates, living in my current basement flat in Maida Vale, a place that I now got to call my own. It wasn't fancy, but it was a decent apartment for a decent price in London. David used to drop by every now and then, usually unannounced,

as he still had his keys. Somehow I hadn't asked for them back, and the fact that he had access to the apartment had made me nervous in recent weeks, as my latest relationship was not one I was too proud of. I had zero interest in David walking in on me and this girl.

'Have a drink, we'll wait for Harry,' David said.

'Of course we'll wait, but I have to go to work tomorrow, so we need to start watching the film at some point before midnight,' I said.

'Relax, old man. He'll be here, and we'll have fun.'

'Okay. Do you want a drink also?' I asked David.

'Not right now, but you go ahead. You're looking very uptight, my friend.'

'I am not. I'm just working hard.'

'And is your girlfriend keeping you up at night, perhaps?'

I was genuinely surprised at the question.

'My girlfriend?'

'Come on, there is someone and you don't want to talk about her. I know you.'

'Maybe there is, but it doesn't really matter. It won't last.'

'Is she younger than you?'

'A bit younger, yes, but please, let it go, Dave.'

'Young and innocent.'

'Stop it.'

'Pretty?'

'Of course she's pretty.' I managed to smile, then I asked: 'Did you speak to Harry today? Did he know we were starting at nine?'

'That's the trouble with Harry, he's never been on time, not once in his whole life.'

'It's already half past, Dave.'

'Should we start at ten? What does the owner of the cinema say?' He grinned.

I shrugged. 'Let's start at ten. We'll be done by midnight, then.'

Chest

'How pretty?'

'Sorry?'

'Your new girlfriend.'

'She's not my girlfriend. Just someone I'm seeing, okay.'

I left the living room and mixed a strong gin and tonic. I didn't like David's interrogation or his tone.

When I returned, he was standing by the large chest.

I repeated my earlier question: 'Did you speak to Harry, then?'

'Not today, actually. I saw him over the weekend and told him to come to your place at nine tonight. Drinks, popcorn and his favourite movie.'

'So he's forgotten. I'll call him.'

'No, we'll wait. Relax, I see you have your drink.'

I nodded, took a large sip and then put the glass down on the chest.

'Maybe he's in there,' David said, looking at the chest.

I stared at him.

'Harry, I mean,' David clarified.

'Yes, maybe he is,' I replied, playing my part in this weird joke. 'Maybe he arrived early, and had a nap in the chest.'

'Well, he doesn't really have a key, does he?'

I shook my head. 'He doesn't, so that's that. He's just late.'

'Unless you killed him, of course.'

And now David was dead serious, the look on his face sending shivers down my spine.

'What kind of a joke is this, Dave? I'm not in the mood for this.'

'You're really on edge. I guess it's the new girl.'

'Can you please stop. She is none of your business.'

'What's her name, if I may ask?'

'You may not!' I replied angrily. 'Are you drunk?'

'As sober as I can be. I'm having a drink later. When this is all over.'

'When the movie is over? We haven't even started.'

'Should we start? I don't think Harry's coming.'

'What do you mean?' I asked.

'I think he's somewhere else. Maybe in the chest.'

'Of course he isn't! There's no one in there.'

'It's big enough for a body.'

'There is no one in there!'

'Should we check?'

And for some reason I hesitated. My glass was still there, and I just stood still, looking at my friend.

'I think we should call it a night,' I said at last.

'Yes, I'll be leaving soon. I left my keys on the small table by the door. I don't think I should have keys, not now, when you've got this mysterious girlfriend.' And then David added, after a brief pause: 'What's her name?'

'None of your business!' I yelled.

He smiled. 'Is her name, by any chance, Marnie?'

For a second it felt as if my heart stopped, then I managed to compose myself. 'Marnie is Harry's girlfriend. You know that as well as I do.'

'I do, actually. I was just wondering if you'd been sleeping with her?'

I took a step back.

'Of course not. Are you crazy?' My voice was shaking. 'Harry would go absolutely... Harry would...'

'He has a temper, yes. What happened? Did you kill him by accident?'

'I didn't kill anyone! What is going on here?'

'Nothing is going on. You're behaving very strangely. Drinking, preparing to watch *Rope* all by yourself, with your very own dead body in your very own antique chest.'

'There is no dead body in there!' I pushed David to the side, and forcefully opened the chest, with my drink flying to the floor in the process.

Chest

And now I couldn't breathe.

'Surprised?' David asked, and his smile was the most menacing one I had ever seen.

Lying in the chest was Marnie, the girl I had been sleeping with for the past three months; Harry's girlfriend.

I bent down and checked if she was okay, but she most certainly wasn't. I tried to shake her, bring her back to life one way or another, although I was certain she was dead. Her face was blue, her eyes wide open, and her gaze truly disturbing.

'It's… it's Marnie.'

'She's dead. Did you kill her?'

'Of course not. I… I… I loved her.'

'I would say she died fairly recently. Maybe earlier tonight? What have you done?'

'I haven't done anything! Dave, you were with me today, the whole day. I'll call the police now and you'll tell them, you'll tell them you were with me. I couldn't have done this.'

'Actually, I won't tell them any such thing. I won't lie to the police. I have to leave now, but if they ask, I will of course tell them that I was with Harry today. The whole day.'

'With Harry?'

'Yes.'

David walked away, but then he stopped, turned around, and looked at me.

'I'm sorry. I am sorry, Alfred.'

The Falcon Hotel

Nadine Matheson

My husband's hand is around the throat of another woman. The light in the car park is dimmed but I know my husband. His height, his build. The shape of his hand and his profile. I know every part of him and that it's his hand around her throat; but then he leans in. It's tender. Loving. All the things that he hasn't been with me as he kisses her lips. Light, butterfly kisses and then he moves his mouth to her ear.

I've known that he was capable of betrayal, but I've never seen him in the act before.

'Michael,' I shout, but my voice is drowned out by a revving car engine and a loud squeal of rubber against tarmac as the driver navigates the tight angles of the ramp to the next level. The woman that I'd become obsessed with places her hand on top of Michael's hand, and he turns his body round. I can only see the back of him, but I can see her. Young, blonde, with full scarlet lips, but whatever moment of pleasure she's just experienced is clearly gone. Her eyes are wide with surprise and her mouth has formed a small 'o' as Michael pushes forward, and they are both hidden by a concrete column. I step out from behind our car, but my view is obscured by a black Sprinter van which has chosen that moment to come to a stop at my feet and attempt to poorly navigate into a car park space. By the time I make it around the van and onto

The Falcon Hotel

the pathway, where I'm supposed to walk safely, Michael and the woman are gone.

He's insisted more than once that the attention this woman gives him is not reciprocated. The texts late at night. The phone calls that interrupt our few evenings out together. The fact that she has a key to his office at the back of our garden. He insists that it's just work. He's told me, more than once, that I'm reading too much into things. That I've misinterpreted what it means when she's touched his arms or shifted her chair an inch closer to him.

There have been times when he's been correct. I have been wrong. Last summer, I saw him with his arm around his intern. It was intimate. As though it wasn't the first time that her head had been buried in his chest. I made the accusation, but I was wrong. The intern had suffered a bereavement and had chosen to fight her way through the day instead of allowing her grief to consume her at home. She broke down in Michael's arms. I was wrong then. I accept that, but not now.

Michael swirls the whisky around the melting ball of ice in his glass as he looks at me. I see his eyes flicker and his pupils dilate. He's trying to read me. Eventually he gives up and takes a sip of whisky.

'Come on, Gia. Tell me this hasn't been fun?' Michael says as he places a hand on my thigh. He tries to mask his annoyance by forcing a smile onto his face.

How can it be fun when I know that he is lying? He'd told me this morning that he was staying in his room to make a phone call, and that he'd booked a spa treatment for me. I thought he was being romantic. Finally taking care of me and not controlling me. I was halfway to the spa when I'd realised that I'd left my book in the car, but I'd left the car key in our room. I returned to room 303

but Michael wasn't there. I went to the car park, and Michael was there, with her.

'It would have been more fun if I was travelling with you,' I say, as I shift aside the almonds in the bowl of mixed nuts, searching for the cashews. Unsuccessful, I push the bowl away and pick up my glass of wine.

'I did invite you, but you said no.'

I'm confused. I don't remember the invitation. He told me that it was a work trip, but he didn't discuss the trip with me. It's not the first time Michael has told me that we've discussed things when we haven't. Or maybe I just don't remember.

He sounds jovial but I can hear the flicker of resentment in his voice as he continues to talk. I turn away and watch my reflection in the gilded mirror. My reflection is obscured and distorted by the numerous liquor bottles and reflecting lights. I look tired and annoyed. I try really hard to please him with my appearance, but it never seems enough. I can't seem to capture the woman who I used to be. The woman who excited him. I can't help but blame myself; after all, he's told me often enough that it's my fault and I made him feel unwanted. I do want to be with him, but I don't enjoy who I am, or who I've become with him. I don't want to look like the woman who doesn't trust her husband. I made that mistake before and was accused of being pathetic and insecure. I am neither of those things, but I know what I want, and I know what I saw in the car park. I feel an emotion stir in me. It's resistance. I want to be the old Gia, not the Gia who sits in the background like a good little wife. I can no longer watch as my husband basks in the spotlight and disingenuous adulation, but the moment of fight is brief.

'I only said no to the trip,' I say, turning to face him. I need him to look at me and to really see me. 'I didn't say no to being here with you.'

'Are you trying to make me feel bad?'

The Falcon Hotel

There it is. The hostility in his voice. He's no longer trying to cover up how he really feels. The glass, now empty of whisky, lands heavily on the circular white-paper coaster engraved with the hotel's logo. A falcon. I recognise the symbolism. Freedom, vision and victory, but to me the falcon represents something else. Aggression and impulsiveness.

'I would never want to make you feel bad,' I say to appease him. This appeasement has now become a habit. A safety mechanism when he talks to me in a way that suggests I've done something wrong.

'I know the past few months have been difficult, but I thought you could see that I'm trying to help you,' says Michael. 'I know it's not exactly Paris.'

Michael is making it sound as though I was the only person on his mind when he asked me to come with him, and to say that 'it's not exactly Paris' is an understatement. We're in a hotel airport, actually in the airport. The reception staff made an error with the booking and offered Michael an extra night; well, that's what he told me.

No one likes a hotel more than Michael, and I should know that better than anyone, because that's how we met, when we were both staying in a hotel with other people. There were more weekends and random Wednesday evenings after that. Sneaking off to hotels when we were still very much attached to other people. Eventually we left our people, and he became mine, or so I thought. I should have seen the signs; after all, meeting him the way that I did was the biggest of signs. This hotel which is attached to the airport, if you can believe it, has been awarded five stars and has a Michelin-starred restaurant. I hate it. I feel as though I am somewhere but nowhere at the same time. Sitting at this bar, drinking my wine, I have no concept of time. I haven't seen natural light since we drove into the car park on Friday night. We took the lift to the first floor, and then made our way through a covered walkway and entered

the hotel, where warm golden light softly dances over the marble, brass and oak furnishings. Classical music is being piped in through the invisible speakers as we queue patiently to check in. Children run around the fountain to the right of me whilst their parents check in or check out. The soft golden light that fills the hotel is designed to feel natural, but it is harsh and overbearing as it pretends to be something that it's not.

Michael takes his fingers and hooks a strand of my hair around my ear. To people watching, it probably looks romantic. Two lovers reacquainting or saying goodbye, but it's not. Michael takes hold of my hand, and he squeezes it, tightly. A warning. Don't make a scene.

I lean into Michael and kiss him firmly. I feel him relax slightly as the whisky stings my lips.

'How about I book Paris for the weekend after next,' I say after we pull apart. I search his face for any sign of acquiescence, but it doesn't exist.

'I'll have to see,' he says.

'What's there to see? I know your diary. You have nothing booked.'

Shit. I've said too much. Far too much. I sink back into my seat and become a smaller version of myself as Michael watches and waits for me to tell him what else I've seen. I've remained quiet as he stares at me, but then the intensity of his gaze dissipates like smoke.

Michael pulls out his phone. 'I'm going back to the room,' he says as he swipes and types.

'What—'

I don't complete my question because something – no, some*one* has caught my eye. A woman, her blonde hair now up in a messy bun, has just crossed the hotel foyer and is heading to the lifts.

Forty-five minutes.

That is how long I'm left alone at the hotel bar. It doesn't take

The Falcon Hotel

forty-five minutes to retrieve whatever Michael has left behind in our room. I'm nervous. I try not to question myself, but I know. I just know that he's with her. I'm on my third glass of wine but I'll tell Michael that its only my second if he asks. I can see Michael returning to the bar when an alarm goes off on my phone. It's time for my medication, but I honestly can't remember if I took it this morning, like I was supposed to. I don't think that I did.

'Everything okay?' Michael asks.

I take in his appearance. There is a sheen of sweat on his forehead and his shirt has gathered unevenly around the collar.

'Everything is fine,' I lie as I straighten his shirt. He doesn't thank me.

'I need to get going. I can't miss my flight.'

'You've got over two and a half hours before your flight leaves. Why not have another drink with me? We can look online and find a hotel in Paris. Somewhere with a view of the Eiffel Tower.'

I can hear the desperation in my voice, and I hate it, but I continue. 'You've got more than enough time. You're not going to miss your flight.'

He shakes his head. 'I'd rather not risk it. Not after last time, and anyway, I'll have time to wander around duty free. Get you something nice without rushing. What would you like?'

I lean back in my seat and try to look as though I'm not upset.

'Anything,' I reply as I pick up my wine that has lost its chill under the fake lights. 'I trust you.'

He smiles and the glint of excitement returns to his eyes as he puts his hands in his pockets. His face crinkles slightly in concentration as he comes up empty. He checks another jacket pocket.

'Your passport is in the zipped compartment of your rucksack,' I say, pointing to his leather designer rucksack that he'd dumped recklessly on the floor.

'Ah,' he says once he retrieves his passport and holds it in the air as though it's a prize. 'What would I do without you?'

I leave his question hanging in the air as I sip my wine and try to stop myself from asking one question. *Where is she?*

'Are you going to be okay on your own?' he asks as though he's just remembered that I've got one night left in this place.

'I'll be fine. I'll have a shower. Order room service and watch Netflix. Maybe have another spa treatment.'

'Don't finish *The Diplomat* without me,' he warns playfully as he takes hold of my hand, pulls me to my feet and hugs me. There's no warmth or feeling in the hug. It feels empty.

'Call me as soon as you land,' I say once we part.

'I'll probably text you. The time difference and all. I don't want to wake you.'

'What about the room? The extra charges?'

'Don't worry about it. It's all covered. They'll just refund me the difference if there is any. Have fun tonight. They've got a spa. This is a luxury. Enjoy it.'

Have fun? I look around the hotel bar with its fake ambience and wonder how on earth I am supposed to have fun on my own.

'And you might as well take this. You know what you're like with room cards.'

Michael takes out his gold hotel key card, which is in a black paper wallet embossed with a gold-foiled falcon, and places it on the bar. He kisses me again quickly and then grabs the handle of his suitcase and walks away. He doesn't look back. I watch him as he makes his way towards the hotel doors. It doesn't take long before someone recognises him. He stops, chats in that effortless way that he has with people, poses for a selfie, and then he turns the corner and disappears, taking the life I used to have with him. I'm annoyed with myself and signal to the waiter for another glass of wine. I've allowed myself to be played by him. I look around me as I wait. More people are checking in and checking out, and there are groups of families and couples sitting in the restaurant behind me, making their way to the row of boutiques outside, acting as

The Falcon Hotel

though being here in this airport hotel, with no sense of time or day, is absolutely normal. It is not. The sense of falsehood hangs heavy in the air, but also the sense that this is the perfect place to hide your secrets. The barman smiles at me, with what looks to me like pity, as he places the second glass of wine and a fresh bowl of mixed nuts in front me. I could go home, but the idea of spending ninety minutes on the motorway on a Saturday night doesn't fill me with relief.

My phone vibrates lightly in my pocket as a man sits down next to me. There's not much space between us and I can smell him, but not in a bad way. He smells clean. I can smell the shampoo that's in the bathrooms of all the hotel rooms, but his cologne that he's wearing soothes me. It's not the same cologne that Michael has been wearing every single day for the past six months. It's heavy, spicy and smoky, and I hate it. I try and brush away the thought that I always have when I breathe Michael in: that he's wearing the cologne for someone else and not for me. I bend down and reach for my bag, which is hanging on a hook under a bar.

As I straighten up and place my bag in front of me, I accidently knock over the drink that the barman had placed in front of the man a minute earlier.

'I am so sorry,' I say as I grab a fistful of napkins and frantically clear away at the liquid.

'Better the whisky landed on the bar and not me,' the man says with no hint of annoyance, as he picks up the ice cube that has slid along the bar and places it back into the glass.

'Let me get you another.'

'No, you really don't have to do that.'

'Please, let me. It was entirely my fault,' I say as I signal to the barman who is attending to another customer. 'What were you drinking?'

The man smiles. 'A Macallan.'

I smile back. 'Same as my husband. Which year? Not that I can even tell the difference. In fact, I'm not sure that he can either.'

'I pretend that I can. The twelve will do.'

I settle back into my chair and remove my phone from my bag. There are two notifications on the screen. The first from the news app that I cannot bring myself to unsubscribe from, and a message from Michael. I open Michael's message, and a photograph immediately fills the screen. A woman, who I do not know, is standing in a brightly lit store holding up two beautiful silk scarves: one a kaleidoscope of light blues and pinks, and the other cream with pale red ribbons. There's a message.

Which one?

I type back quickly and immediately see the speech bubbles appear under my reply. The bubbles disappear and are replaced with a thumbs-up emoji.

'So where are you off too?' the man asks as he sips his whisky.

'What do you mean?' I ask as I replace the phone in my hand with my glass of wine.

'You're here in this hotel. You must be going somewhere?'

I smile tightly. I cannot think of a more pathetic situation than the one I'm in right now. A woman, with no destination, sitting at an airport hotel bar, alone, with the full knowledge that her husband is lying to her.

'Nowhere,' I say as I put the keycard that Michael gave me in my bag and signal the barman for another drink. 'I'm going nowhere.'

It's her.

The woman in the car park. The woman who had my husband's hand around her throat has just walked past me. I must be so insignificant to her. She must know that I'm here. Watching.

She lowers her head as though she's distracted, or she could be intentionally avoiding me, but her avoidance of me is not what grabs my attention. A silk scarf. A kaleidoscope of light blues and

The Falcon Hotel

pinks that was hanging loosely around her neck has fallen to the ground. It's the same scarf that was in the photograph Michael sent me. It's the scarf that I chose. I pull out my phone, open WhatsApp, and scroll to the chat with Michael. My reply, telling him that I would like the blue scarf, is there, but the original message and the photograph have been deleted. The anger and betrayal overwhelm me.

'Madam, would you like to pay now, or should I charge your treatment to the room?'

The receptionist's voice pulls me away from my phone, and when I look up, she is gone, and the scarf is gone.

'Can you charge it to the room,' I say.

She nods and moves away to deal with another customer as I check my phone again. No, I am not going mad. The message and the photograph have been deleted. I close the app and call Michael. At this moment he should be sitting in the departure lounge, taking advantage of the complimentary food and drinks. The call goes directly to voicemail, and I listen to an automated message. I check that I have called the correct Michael. There are three in my phone, but no. I haven't made a mistake. I have called my husband, and his phone is off, which is strange for two reasons. Michael never allows his phone to run out of charge, he lives for his phone; and two, I've lost count of the number of times Michael has been told off by cabin crew for not turning his phone off during take-off. He acts as though airplane mode is a breach of his human rights. So, entitled. Where is he and where is she?

I walk quickly to the spot where she dropped her scarf. My scarf. Directly ahead of me are the toilets and to the right is the bar. I make my way to the bar entrance and scan the room. The man whose drink I spilled is still there, but he's now talking to another man. I turn around and go to the toilets. There are four cubicles. Three of the cubicles have their doors open, but the door to the

cubicle on the far right is closed. I'm wearing new ballet pumps, and the leather soles squeak on the clean tiled floor. I cannot hear anything except the occasional pump releasing air-freshener overhead. I place my hand on the toilet door and press. It's firmly locked. I hear a rustling and then a cough. I stand back and fold my arms. I should have confronted her months ago, but I'm going to do it now. Right here. The dial on the toilet door turns and switches from red to green. I know exactly what I'm going to say as I anchor myself. The door opens and a woman in her mid-sixties and dressed expensively in an emerald-green Chanel suit glares at me. I feel my skin grow hot as her eyes trace every part of me, from my head to my feet, as if scanning to see if I am literally worth not only talking to, but being in her presence. She brushes past me and walks out of the toilets without washing her hands. My forehead is prickling with sweat and the scent from the air-freshener has grown in intensity and is making me sick. I turn around and I'm shocked by my appearance. My eyes look wild, and my skin has taken on a yellow hue. I turn the tap to cold, close my eyes and splash water onto my face, not caring that my make-up may streak. I need to cool down. I need time to think.

Where is she? Why is my husband ghosting me? Why is she wearing my gift?

The seconds pass and I hear the door open. A woman and young child have entered. I can hear the woman's voice gently coaching her son to use the toilet. I open my eyes and look up. I feel better, but then something in my gut tells me to look down and to my left. Blood. The first drops of blood have been diluted by the water that has escaped from my sink, but the blood grows darker as my eyes track the drops from the crystal-white countertop and into the sink. Blood has pooled in the bottom of the sink and there are scrunched-up balls of bloodstained tissue. I hear the mother cheering her son, who I assume has successfully used the toilet. I would have walked away and left the trauma behind me, but there is something

The Falcon Hotel

else in the sink. I pinch a piece of tissue paper that hasn't been stained by blood and move it to the side. The blue silk scarf is wet and plastered against the porcelain sink. As I pull, blonde strands of hair stick to my fingers, and I realise that what I have in my fingers is only pieces of a scarf. The edges are frayed as though it has been torn in half, and the flowers on the scarf that were once a beautiful blush pink have been stained with spilled blood.

The hotel foyer is busy. I'm surrounded by couples, lone travellers and clusters of families. There has been an influx of flight arrivals and people snake from the main entrance to the reception desk. Every single person seems lost in the minutiae of their lives. They're all acting as though a woman has not been hurt. Yes, even in my own ears, my words sound confusing and contradictory. This woman has interrupted my marriage, but the fact is that I have seen her blood and have traces of it on my fingers. I saw my husband's hand around her throat. He left me for forty-five minutes. I cannot move through this hotel as though nothing is happening.

I'm forced out of my thoughts by a suitcase hitting my shin. A man dressed in a black designer tracksuit looks at me, as though I am the problem.

'Qu'est-ce qui ne va pas chez toi? Salope stupide,' he says in French.

'Je suis desolée,' I reply.

The man looks at me and reddens slightly, because he knows that I know that he called me a bitch.

I lick my finger and wince as I wipe away the blood. I straighten up, and it feels as though the room has lost oxygen. My chest is tight, heat is flooding my body, and I can feel my skin prickling with sweat. I feel lightheaded as I press forward. My heat is beating fast, too fast as I approach the bank of lifts and press the button. The lift arrives almost instantly, and I step in. I don't want anyone else in here. I'm still struggling to breathe and there is not enough air in this small glass capsule. I hurriedly press the button for the

third floor and there is a fleeting moment of calm as the door closes. I turn around and press my forehead to the glass. I count to five as the lift ascends. I open my eyes, and I gasp as the lift stops at the first floor. I'm looking down, and I can see the wide gangway that connects the hotel to the airport terminal. The lift door opens but no one gets in, but that's not what has caught my attention. I can see Michael below me. I recognise the rucksack on his back and know his features so well. The soft purple lights that illuminate the space have placed Michael and the woman in front of him in a macabre spotlight. He thinks that he's alone and no one is watching, because he has his hand around her throat. I bang on the glass wall and scream out his name, but they can't hear me, and suddenly the lift jerks as though someone has violently grabbed the pulleys. I fall onto the ground as everything goes black. The lights have gone out. I sit on the lift floor and blink in the darkness. A few seconds pass, then the lights are suddenly turned on. I pull myself to my feet and press my face against the glass. I'm searching the space where Michael and the woman should have been. The lights were out for only a few seconds. They should still be there. Somewhere along the gangway, my husband should be there, but there is no sign of him as the lift continues its journey to the third floor.

I did not imagine these things. I pull out my phone and I call him, but there is nothing.

'Shit,' I say when I see that I have no signal. The lift opens and I step out onto the third floor. I swipe through the apps until I find the settings app. There is no Wi-Fi available, not for the hotel or for the airport. I turn the phone off and on again as I make my way to my room. Suddenly, my phone vibrates in my hand, and I look down at the screen. Two missed calls from Michael. I call him back.

'I've been trying to get hold of you,' says Michael.

I don't reply. I'm not listening to his words, but how he sounds.

The Falcon Hotel

There is no laboured breathing. No anxiety. He sounds bright. Excited.

'Babe. Are you there?'

'Yes, I'm here. Where are you?' I ask as I hear the squeaky wheels of a trolley. I turn around and see a housekeeper behind me.

'I'm at the gate.'

'The gate. Are you... I thought I saw you here. At the hotel. A few minutes ago. Just before the lights went out.'

'What are you talking about? Why would I be at the hotel?'

Michael sounds calm. Normal.

'Because I saw you.'

Again nothing. Nothing from Michael. No elevated breathing. No deep sighs or stammering as he fights to find the right words. He's not distracted. He's lying.

'Where is she?' I ask. No. Demand.

There is activity in the background. The Tannoy's screech. Voices warning passengers that gates are closing, flights are departing and passengers with children need to board, but Michael says nothing. I can't even hear him breathing. His silence is loud. His silence is a question.

'How much have you had to drink?' he finally asks, his voice deep with concern, but calm. It's the same calmness in his voice that I heard on the mornings when I could taste stale wine on my breath. I would still be wearing yesterday's clothes when Michael lifted me up from the living-room floor. I would have preferred if he'd shouted at me, but instead he spoke to me in calm tones, but I can always hear it. The undercurrent of frustration.

'Don't do that, Michael.'

'Gia. You're asking questions that are... well they don't make any sense. So, I have to ask. How much have you had to drink?'

'I had one more glass. That's it.'

Michael sighs. It's amazing how an exhalation of air can be filled with both disappointment and suspicion. He's saying so much, but

without actually saying it. *You're lying. You're imagining things. You're looking for something that isn't there.*

'Maybe it was a mistake taking this job and leaving you. If I'd thought that you... I mean, Gia. Seriously. How could you possibly have seen me a few moments ago when I'm at the departure gate.'

'Michael, I know what—'

'Have you ever tried to leave the departure lounge after you've cleared security?'

'No. I haven't.'

'Exactly. No one does that. Why would I do that.'

'What about the WhatsApp message that you sent me when you were in duty free?'

'So now I'm sending you messages from duty free at the same time you saw me in the hotel lobby?'

'No, not in the lobby; but—'

'Gia. Can you hear yourself. Are you in back in the room?'

'No. I'm not.'

'Sweetheart, go back to the room. Have a long shower. Drink some tea. Have a nap. You'll sober up.'

'I'm not drunk, Michael,' I shout. My voice travels along the hallway, and the housekeeper at the end of the hall turns around and stares at me, before turning her back and pulling her trolley into a room.

'What about the scarf? You sent me a photo in duty free,' I ask, placing the phone in the crook of my neck as I prise open my bag.

'Not again. I can't believe that it's happening again.'

He sounds disappointed in me. I can hear the panic in my voice as I fall to my knees and spill the contents of my bag onto the burgundy carpet. Why can't I find it?

'They're calling us to board,' Michael says. 'Sober up. Do it for me. If not for yourself, do it for me.'

The call ends.

The Falcon Hotel

His parting words burn like acid on my skin.

Michael has left me again.

The phone falls to the ground and lands amongst the debris from my bag. Purse. Tissues. Make-up bag. Hand cream. My medication. Room cards. Hairbrush.

I pull at the lining of my bag and check the zipped compartment, but it's not there. I sit back on my heels and push my hands into my pockets, but there is nothing but lint. I did not imagine it. I felt the wet material between my fingers. I saw the blood, her blood in the sink.

I look down at the contents of my bag scattered on the floor.

I know what I saw. I know what I felt, but I can't see it. Where is the scarf?

My eyes are burning with frustrated tears as I retrace my steps. I saw her in the hotel foyer, and she disappeared into the bathroom. I saw her blood and the scarf. I know that I picked up that shredded piece of material, part of a gift that I thought belonged to me, and put it in my bag. Foyer. Lifts. I saw Michael and then the lights went out.

'Is everything okay, miss? Do you need help?' she asks as she crouches down to help me.

'I'm fine. Really. Thank you.'

I'm scrambling to collect my things but I'm too late. I can tell from the look on her face, as she picks up the slim white cardboard box with the peeling label that contains my personal details, that she knows what my medication is for.

She yelps like a frightened kitten as my fingernails scrape across the back of her hand as I grab the box. She stands up and walks quickly away down the hallway as the lights flicker.

A heat suddenly sweeps my body as though I'm standing in front of a fan heater set to full. This was supposed to be a moment for new beginnings, to reset the clock on our relationship, but every minute in this hotel has made me question who I am, who my

337

husband is, and if I saw her. I pick up the keycard. Maybe Michael was right. I need to take a shower, rest and get my head together.

The light flashes red on the door handle. I press the key card against the panel for a second but it's the same response. The small rectangular panel flashes red twice. No entry.

I step back.

Our room number is 303, and it's the number engraved on the black slate next to the door. This is my room, our room. There's clearly a problem with the card, but as I'm placing the card back into the cheap paper wallet, I see it. Three wrong numbers.

521.

This doesn't make any sense. Why have I got a key to another room in my hand? But then I remember.

I take out my purse from my bag and open it. It's there where I left it for safekeeping, because I know what I'm like, or it's the case that Michael told me what I'm like. Unreliable. Unstable. My hotel key. I pull it out. The number 303 is written clearly on the wallet, but the card that Michael gave me is for a different room.

I steady my breathing as I place the keycard against the door handle. The green light appears and there's a click. I turn the handle, but I hesitate. There are too many red flags. Too many questions, but how can I not enter? I've already rolled the dice.

The room is a mirror image of my room. And the smell – it's impossible for me to ignore it. The room smells of Michael. The room hasn't been turned over yet, because it is in disarray. The TV is on and there are clothes and lingerie on the floor. The pristine bedsheets are a crumpled mess. I can't remember the last time that Michael and I had sex. I tried to initiate it last night, but Michael said that he was tired after using the gym. I sit on the bed, pick up the pillow and bring it to my nose. I don't need to inhale too

The Falcon Hotel

deeply. Michael is all over this bed. I throw the pillow across the room in disgust.

Where is she?

She hasn't left with Michael, because the last time I saw her she was running away. Bleeding. Distress. I get up and slide the walnut-coloured wardrobe doors open. A small overnight bag is open on the lower shelf. A change of clothes. Pyjamas that still have the label on them. Her coat is on the hanger. I push my hand into the pocket, searching for any other signs of him and his betrayal. My fingers curl around something cold and metallic, and my heart skips a beat. I don't need to see it to know what it is. I'm feeling the compass pendant of the necklace that I thought I lost last month. I pull out the chain and hold it to the light that is streaming from the bathroom. The compass spins gently, but there is something else that catches my eye. On the bathroom floor.

A sharp knocking at the door jolts me into action. I have to get out. Out of this room.

There's knocking for a second time, and then the door opens. I turn around to find myself facing the same housekeeper who tried to help me.

'Housekeeping?' she asks nervously as her fearful eyes track down my body, and then rest where my left hand is stuffing the ragged half of the scarf that I lost into my bag.

She stumbles as I push her aside in my effort to get out of the room. This poor woman has come to harm twice in my presence. The key to room 521 is in my pocket. I didn't force my way in. I may have harmed her, but she has no reason to believe that I am a thief, and she should have no reason to think that I've caused harm to anyone else. She has no choice but to believe that this is my room.

The door closes silently behind me but I'm on edge, which isn't helped by a young family in the hallway. Two young children, a boy and girl, are screaming excitedly as they chase each other. Their

parents are behind them, both looking exhausted and lacking the energy to tell their children to behave. The mother, almost drowning in an oversized hoodie, and with her arm intertwined with her husband's arm, looks at me and mouths *sorry* as she passes. I'm not sure what the apology is for. Her children running chaotically in a hotel hallway? Or has she recognised something in my face? The look of a woman who is trying to make sense of the fragments of her life. My phone beeps and vibrates in my pocket as I take the lift back down to the third floor. It's an alert. Michael's flight has departed.

I arrive back outside room 303. Our room, and with the correct keycard in my hand. There is one unanswered question as I open the door and step into the room. I know that I saw him harming that woman. I know that he lied to me. I know that someone is hurt, badly. I have the proof, again, in my bag. The scarf that the sales assistant was holding in her hand, in the photograph that Michael deleted but denied sending. His hand around her throat.

What is he trying to do to me?

Why is he always doing this to me?

I close the door behind me, and it hits me as I'm stepping out of my shoes. I can feel it. The air has changed in the room. The air has changed, but not because of a turn-down service. It's changed because something has happened in this room. The curtains have been drawn back, and I'm standing in front of floor-to-ceiling windows that look out onto the same entrance to the hotel where I'd seen Michael with her. I can see everything. People dragging their luggage to and from the hotel. A young man dressed in a navy suit, leaning over the car-hire desk talking to a woman who regularly tucks her hair behind her ears as he talks to her. The glass is one-way. They see nothing when they look at the pane of glass that stretches the length of the hotel. People walking past have no idea what is on the other side of the window. No idea what secrets are

The Falcon Hotel

being held and what memories, good or bad, are being created. Even though I know that no one can see me, I feel exposed and quickly cross the room, but I don't reach the window. Something sharp has pierced the soft flesh of my foot. I fall back onto the bed, my foot burning with pain. I raise my foot and see a piece of glass embedded in the soft flesh of my sole. I wince as I put my fingers on the shard and pull. There's a sharp whistle that I realise has come from me as I try to withstand the pain and breathe in and out sharply. The blood pours freely, and I reach over and grab a towel that has been left on the bed and press it to my foot. The minutes pass as I try to stop the flow of blood. After a while, the pain dissipates. I straighten up and take in the room. What has changed?

There were two tall glasses on the desk. The bottle of water is half empty but is lying on its side. The second glass is missing. I look down and see that my blood has left a trail on the cream carpet. There is no sign of the missing glass or that anything has broken. I don't understand. Something has happened in this room. I would never leave a dirty towel on the bed, and neither would Michael. The black-and-white photograph of London's Southbank is lopsided on the wall. I know for a fact that I did not leave the curtains open. I kept them closed even though I knew that I could not be seen. Something has happened in this room.

I hobble to my feet, move to the window and start to draw the first set of curtains. I try to think. To make sense of it all. There is only one explanation. Michael has hurt her, but why here? Why in this airport hotel that is its own self-contained universe? There are too many whys. In my job, I was trained to never ask why. The why pushes a door open into the unknown. But why here? Why now? Why has Michael chosen now to give me so much freedom, when he usually controls every detail of my life. From the way I wear my hair to the clothes I wear, the wine I drink and the medication that I take. Why is it now that he's chosen to loosen the reins on me?

To have me wander freely in this hotel? Why has he put me in a position to see things in the shadows and to ask questions?

My husband is pulling the strings in this show, and I don't know why.

That's not until I move to draw the curtains on my right. I stop and step closer to the window.

They can't see in, but I can see out.

I can see her.

The same woman who has haunted my stay in this hotel. The same woman who Michael has kissed and hurt. She's clearly distressed. Her hair is a mess and she's pointing at her neck.

I can see her but she's not alone. The housekeeper is with her, comforting her, while she talks to a policeman. My chest tightens as she points.

I can see out, but they can't see in.

I know this to be true, but it doesn't explain why the woman who had my husband's hand around her throat is pointing at my window, straight at me.

Arlene

William Boyle

Gravesend, Brooklyn
September 1989

Frances opened the window to let in some fresh air. Her best friend, Arlene, was lying on the bed in the centre of the room, skin pale and splotchy, having thrown off the blankets, burning up with a high fever. Arlene's husband, Angelo, and their two kids, Max and Gina, ages eight and six, were downstairs. Angelo had called Frances an hour ago, panicked. Frances rushed over – she lived a couple of houses down the block with her parents. She promised that she wouldn't leave them. Angelo wanted to call their doctor or take Arlene to the hospital, but she'd refused, insisting it would pass.

Frances knew Arlene since they met at the park when they were four, and they were thirty now. They went to kindergarten and grade school at St Mary's and high school at Bishop Kearney together. They worked at the same doctor's office right across from Victory Memorial Hospital. She and Arlene even looked alike – both with dark black hair and olive skin, both five-seven. Enough so that people often mistook them for sisters, sometimes twins. Frances was secretly envious of Arlene in most ways. Frances was shy, and Arlene was a leader. Arlene met Angelo when they were twenty-one, and they were married within six months and had

their kids over the next few years. Frances had never even had a serious boyfriend.

Frances was at Arlene's bedside now, watching her sleep, heavy eyelids fluttering, a wet washcloth draped on her forehead. Her breaths were slow and ragged. Frances placed her hand on Arlene's hand. It was so hot. She'd given her some Tylenol when she got there but it hadn't helped.

Arlene and Angelo's bedroom was a bit antiseptic. The walls were painted bone white. The dresser was an antique, something out of a country décor magazine. Pictures of Angelo and the kids lined Arlene's vanity table. The bed looked soft and cool even with Arlene burning up in the middle of it. Frances had never slept on sheets that looked so crisp. She imagined Arlene and Angelo tangled on the bed, Angelo who shaved every day and got haircuts every other week at Russo's barbershop on Cropsey Avenue.

Arlene's eyes opened as if she'd been shocked awake.

'You okay?' Frances asked.

'He isn't always true,' Arlene said.

'Who isn't true?' Frances asked, confused. She wondered if Arlene was hallucinating.

'Go get Angelo.' A desperate edge to Arlene's voice.

Frances went downstairs. Angelo, Max and Gina were sitting in front of the television. Angelo looked nervous. The kids were fine, not worried at all about their mom, who must've seemed immortal to them.

'Arlene wants you,' Frances said to Angelo.

He stood, his pants crumpled, his wrinkled shirt untucked, hair messy. Frances knew that everyone – even the most presentable and put-together folks – looked wrecked now and again, but she'd never seen that side of Angelo. Even in sweats on a lazy Saturday morning, he was pristine. He worked on Wall Street. Frances didn't really know the nature of his work, but she knew he did well. Arlene often worried about the women he worked with, the way he went

Arlene

out to bars with some of them on Fridays after work, obsessed that he might be cheating. Frances always talked her down. 'Who would cheat on *you*?' she'd say. But she'd read Arlene's diary. She knew Arlene had grown increasingly paranoid about Angelo's fidelity in recent months. *He isn't always true.* Was she talking about Angelo?

'She feeling any better?' Angelo asked now.

'Still really hot,' Frances said. 'She wants you.'

Angelo followed Frances upstairs. They both kneeled at Arlene's bedside, close, almost touching. Arlene had closed her eyes again.

Angelo clasped Arlene's hand. 'We're going to have to call the doctor,' he said.

Arlene opened her eyes. 'Who are you *really*?' she said.

'What are you saying, sweetheart?' Angelo turned to Frances. 'Frances, can you call Dr Savoca? His number's on the fridge.'

Frances nodded and stood. She walked out of the room as Arlene and Angelo whispered dramatically to each other.

Back downstairs, Frances went to the kitchen and dialled Dr Savoca's number, waiting as the line rang. He was a family friend. He answered and said he'd be over within the hour.

She hung up and went to the kids. She asked if they wanted to play cards. They said they did. Gina shut off the television and found a deck of cards on top of Arlene's magazines. They played five rounds of rummy. Max asked how high fevers could get. Frances said she wasn't sure. She said she'd had a one-hundred-and-five fever as a baby and they'd taken her to the hospital and put her in an ice bath and that was the first memory she had, her parents worrying over her as she burned up in a hospital tub. She said it was much more dangerous for a baby than a healthy adult. The kids nodded.

When Dr Savoca got there, he saw something they didn't see and had Arlene rushed to the hospital. Frances stayed with the kids while Angelo went with Arlene in the ambulance. Frances felt like

a bundle of nerves. The kids continued to be fine. She ordered pizza for them, and they watched the ABC Sunday Night Movie, which she missed the name of. She stared at the piece of pizza on her plate and waited for an update from Angelo.

When it finally came, the news was bad. Angelo didn't fully understand what was going on, but the doctors were saying that Arlene was very sick. An internal infection or something. Angelo asked if Frances could stay with Max and Gina – if not, no problem, he could ask his parents or Arlene's parents – but Frances said of course, she'd be happy to.

After the movie, Frances got the children ready for bed. She knew the routine. She'd spent enough time there. They went back upstairs, and Frances oversaw the brushing of teeth and the combing of hair and the changing into pyjamas. Frances tucked Max and Gina into their beds, which were in opposite corners of the same room, and then helped them say their prayers. They started with their mom.

They were beginning to get anxious. They sensed that something was off.

'You think she'll be home by midnight?' Gina asked, as Frances settled on a rickety wooden chair in the centre of the room, equidistant from the two beds.

'I hope so,' Frances said. 'If not, she'll probably stay the night and come home tomorrow.'

'Will we have to go to school?' Max asked.

'Maybe not,' Frances said. 'I'm going to have to miss work. I'll stay here with you.'

'I wish I could call Mom and say goodnight,' Gina said.

Frances sang them a song, which is what Arlene did every night. Arlene had a few go-to Beatles songs, but the only thing that Frances could think of to sing was Carole King's 'You've Got a Friend' because she knew all the words. It was a song that reminded her of Arlene.

Arlene

The kids were very tired – it was well past their bedtime – and they fell asleep on Frances's second pass through the song.

Frances got up, made sure both nightlights were on, and then shut the door on the way out of the room. She went into Angelo and Arlene's bedroom, noticing Arlene's imprint on the messy bed and the wet washcloth she'd left behind.

She walked into Arlene's closet and looked at her clothes, packed tight, shoes stacked on a rack beneath them. She touched the shiny sleeves of dresses worn once, fingered a row of sequins on a sweater she'd bought on sale, breathed in the smell of Arlene. Her various perfumes and powders and lotions.

She looked down at her own clothes. Sweatpants and a red St John's T-shirt. No bra. She felt ashamed that she'd been around Angelo in these clothes, but she'd rushed over, and it couldn't be helped. It was a stupid thing to think about anyway.

She took off her shirt and tossed it on the bed. She stepped out of the sweatpants and kicked them aside. She stood there in front of Arlene's wardrobe in her underwear. She'd always wanted to try on some of Arlene's clothes. Arlene was weird about people wearing her clothes, even her best friend. Frances felt a little psychotic for doing it under these circumstances, but when else would she have a chance?

A floral maxi dress with a cutout back caught her eye. She was with Arlene at Alexander's when she'd picked it out. She'd worn it to some dinner in the city with Angelo. Frances took it off the hanger and pulled it on over her head. She went to the floor mirror next to Arlene's vanity and looked at herself, smiling at her reflection. She felt beautiful in it. She took off the dress and put it away.

Next, she tried on a green mini dress. Then there was a little pink chiffon bridesmaid number from Angelo's sister Theresa's wedding.

She asked herself why she was doing this. She didn't know. Maybe it was a way of coping.

She put the dresses back as they were, smoothing down edges and fitting hangers into tight positions on the drooping rod. She closed the closet door, still only in her underwear, and went to Arlene's dresser. She opened the top drawer and saw Arlene's neatly folded, wispy slips. She took one out, satin, brass-coloured, and pulled it on over her head. It was cold and lovely against her skin. It smelled, somehow, of peaches.

Under the slips was a pack of cigarettes. Merit Ultra Lights Menthol 100s. Arlene had quit smoking before the kids were born, but she still had one now and then when the stress of parenthood and marriage and work were too much. Frances had never smoked. She tried in high school and didn't like it. The design on the package was green. She ran her finger along the edge. Beside the cigarettes were Arlene's birth control pills in a rhinestone case and her diary, a red book with a clasp that resembled a ledger. Next to that, an antique pearl-handled knife in its leather sheath; Arlene had confided to Frances that Angelo liked when she held it to his neck while they were making love. She'd used that exact term, *making love*, a twinkle in her eye like some seductive contestant on a dating game show. Frances had read about their lovemaking in the diary, too. Reading Arlene's diary had become something of a ritual for her. It wasn't always in this drawer. Sometimes, Arlene simply left it out and about, seeming to beg for Frances to discover it. Frances figured Arlene knew, maybe even enjoyed it.

Frances closed the drawer, went back to the bed, and stripped the sheets. She'd bring them down to the washing machine in the cellar first thing tomorrow, put them in on a delicate cycle, and then hang them on the line in the yard to dry. That would be helpful. No one wanted to come home to sickbed sheets. She balled up the sheets and pillowcases and the wet washcloth and stuffed them in the laundry hamper behind the door.

She sat down on the bed. She could feel her eyes getting heavy.

Arlene

This had been a difficult night. She let herself fall onto the bare mattress. She drifted off to sleep.

When she woke up, she wasn't sure how much time had passed, but Max was lying next to her, curled close, sleeping soundly. She felt awful that she was still in Arlene's slip. She got up, changed back into her sweats and T-shirt, and put the slip away as she had found it, on top of the cigarettes, knife, pill case and diary. She placed a pillow under Max's head, shut off the light, picked up the hamper, and left the room.

Back downstairs, she checked the time. After two in the morning. She set the hamper down by the cellar door so she'd remember to put the wash on first thing in the morning, sat on the couch, turned on the television and waited, anticipating the feeling of relief that would come when Angelo called to report that Arlene would be fine.

It wasn't Angelo who called Frances early the next morning, soon after she had crawled off the couch, brought the bedding down to the cellar, and loaded the machine. It was Arlene's mother, Val, in hysterics. She said that Arlene had died. Something about that goddamn infection. They didn't want Max and Gina to know yet. Frances was in shock. She couldn't imagine that she'd have to keep it from them when they woke up. More than that, she couldn't imagine that her best friend in the world, the best friend she'd ever have, was gone for keeps.

Max and Gina slept late because Frances didn't wake them for school. She went to the bathroom upstairs and vomited twice into the toilet. She took a hot shower. So hot that she nearly scalded her skin. She used Arlene's towel to dry off. She smelled Arlene on it. She'd never smell Arlene again, not really, only smell what traces of her were left behind on clothes and towels and in the air of the spaces that she'd existed in.

She tried to picture Arlene in a casket. She couldn't.

She looked at herself in the fogged mirror. She wished she had died instead of Arlene. A single woman with no kids. She'd be missed, sure, but it wouldn't be as tragic.

A soft knock fell on the door, and then the knob turned. Frances wrapped the towel around herself. The door opened inwards. Gina stood there, yawning, her arms stretched over her head. 'Mom, what time is it?' she said. The poor kid had forgotten.

'Your mom's not home yet,' Frances said, drying her eyes with the heels of her hands.

Gina gazed through the steam. 'Aunt Frances?'

'Remember your mom got sick and went to see a doctor?'

'When's she coming home?'

'I don't know, sweetie. You can go back to bed or put the TV on downstairs. I'll start breakfast in a sec. Is Max up?'

'Nope. We're not going to school?'

'Not today.'

Gina nodded, yawned again, and pulled the door closed. Frances used Arlene's hairdryer and then put back on her same old clothes. She went downstairs and found Gina in front of the television. Max soon joined her. Frances made them toasted bagels with cream cheese, and they ate while watching cartoons.

Angelo arrived home two hours later. His eyes were bloodshot. Frances looked at him and started crying. He didn't even have to say anything. He held back his own tears until he started to talk to Max and Gina, who had asked when their mom was coming home and hadn't expected anything other than 'She's on her way' or 'Very soon'. He choked on the words. He tried to explain that sometimes life blindsided you, that one minute someone wasn't ill and the next something inside of them had gone wrong.

The kids had no context for death. Their grandparents were all alive. They'd never had a pet to lose. Frances was sure they'd never even gone to a funeral. When they started crying and screaming, when they began to grasp what he was saying, Angelo really lost

Arlene

it too. They clung to each other, both children wrapping their arms around their father's neck. Frances went to them and joined the hug.

Maybe she shouldn't have. Maybe it was out of line. But she had been friends with Arlene for almost her whole life. She'd been her maid of honour when she married Angelo. She'd been there for the births of Max and Gina. She thought they'd grow old together.

Angelo wrapped an arm around her and drew her in closer. They heaved against each other.

'She can't be dead,' Max said.

'She's in heaven,' Angelo said.

'What if there's no heaven?' Gina asked.

'There is,' Angelo said. 'Mom's there. She's watching over you. She'll always be watching over you.'

Frances knew Arlene's mixed feelings about heaven, about religion in general. They'd both grown up immersed in Catholicism, but by high school had traded heavily in doubt and treated it all as nonsense. When Arlene had kids, she leaned back into the Church and wanted to believe, wanted to do the things that would make her family and Angelo's family – since he was also Catholic – happy. Frances was more reluctant to return to the fold. She went to church with her parents often but – in her heart of hearts – she didn't think there was a God or a heaven. She thought it was all pageantry, a way of coping with death. Now she understood why it was so necessary.

The next few days passed in a blur of grief. The wake and the funeral mass. Tears and more tears. Frances delivered Arlene's eulogy, almost unable to make coherent sentences. Then they caravaned out to St John Cemetery in Queens, where Arlene would be buried. Everyone lost it as her casket was lowered into the ground.

Afterwards, they went for a subdued meal at Gargiulo's on Coney Island. Frances thought she'd go home with her parents but found

herself once again returning to Angelo's. Arlene's parents were still there.

Val wrapped her in a desperate hug. 'Oh, Frances,' she said. 'Your words at the church were beautiful. Arlene loved you so much.' She kissed Frances on the cheek. She smelled of flowers and mothballs and stale coffee.

Arlene's father, Larry, came over and kissed Frances next. His moustache bristled against her cheek.

The kids were on the couch. Frances went to them, kneeled, and hugged them both simultaneously, one arm around Max and one around Gina, pulling them close. They wept against her shoulders. The tears soaked through the sheer white fabric of her blouse, making it cling to her skin. She didn't cry now. She was all cried out. She wanted to be strong for the kids.

'Can you stay with us, Aunt Frances?' Max asked.

'Probably not tonight,' Frances said.

'Please.'

'We're not staying over,' Val said from across the room. 'I need my own bed. I haven't slept in days.'

'What about Angelo's folks?' Frances asked.

'They went back to Long Island already.'

'Well, then, maybe I will stay,' Frances said to Max and Gina. 'Let me ask your dad. Where is he?'

'In his room,' Max said.

Frances disentangled gently from the children and stood. 'Is it okay if I go check on Angelo?' she asked Val.

'Of course,' Val said.

Frances went upstairs and knocked on the bedroom door. 'Angelo?' she said, leaning her forehead against the wood. 'It's Frances.'

'Come in,' Angelo said from the other side of the door.

She turned the knob and went into the room. It was dark. The light from the hallway was enough to see that Angelo was sitting on the edge of the bed, still in his suit. The mattress was bare, just

Arlene

as she'd left it after Arlene had been rushed to the hospital. He'd probably been sleeping on it that way, if he'd slept all. She realised then that she'd forgotten to hang the washing. The sheets and pillowcases and that one lone washcloth had been sitting clean and wet in the machine since Monday morning. They'd have to be washed again.

Frances sat next to Angelo and put a hand on his back. 'How are you holding up?' she asked.

Angelo shrugged. 'I don't know,' he said.

She moved her hand around on his back in a circle, static passing from his black jacket to her palm. 'I keep hoping it's a bad dream.'

'The kids need her more than they'll ever need me. It's not fair.'

'You'll put one foot in front of the other.' Frances paused. 'Max and Gina want me to stay tonight. Is that okay with you?'

'Wouldn't have it any other way,' he said.

Frances wasn't expecting it, but Angelo buckled against her, his head on her shoulder, his body pressed against hers. She could feel the wet spots on her blouse, already soaked from Max and Gina's tears. She put her arm around Angelo. With her other hand, she stroked his hair. He wept into her lap. 'I'm so sorry,' she said. 'I'm here.'

When Val and Larry left, Frances went down to the cellar, put detergent in the machine, and rewashed the stuff from Arlene's sickbed. It was too late to hang it all in the yard, but she'd pin it on the makeshift cellar clothesline that ran from the oil burner to the workbench in the corner. Arlene's method on rainy days. Frances drew an X on the back of her hand with a pen she found on a nearby bookshelf, a reminder not to forget to come back down in an hour and deal with the washing.

After that, she got Max and Gina ready for bed. Angelo remained in his room.

She tucked the kids in and read them a book. Exhausted, they

fell fast asleep within ten minutes. She made sure their nightlights were on and closed the door behind her as she left the room.

She knocked again on Angelo's door.

'Come in,' he said.

She entered. He was standing now, in front of Arlene's dresser. He was looking through her things. Those slips. Her underwear and bras. The hidden cigarettes. Her birth control pills. The knife. Her diary. He pressed one of the slips to his cheek – it was the very one Frances had tried on when she still thought Arlene's illness was nothing to really worry about – and then rubbed it over his whole face, closing his eyes and breathing it in.

Frances went to Angelo. She hugged him. He let the slip fall from his hand. It lay coiled on the floor like a soft chain.

'You should get out of this suit and go take a shower,' Frances said.

Angelo nodded.

'You hungry? The fridge is full of trays folks from the block brought over. Should I heat up some ziti?'

'I can't eat,' he said.

'If you change your mind, just let me know.'

Frances left the room while Angelo changed and showered. She went down to the cellar and hung the washing on the line.

On a slim bookshelf, behind a retired baby carriage with a bad wheel, Frances found a handful of novels from English classes she and Arlene had taken together, as well as their Bishop Kearney senior yearbook. She took out the yearbook and opened it, flipping to the Bs. Arlene's married name was Sciarrino, but her maiden name was Barravecchio. The quote under Arlene's picture was from Theodore Dreiser's *Sister Carrie*, which they'd read in Honours English junior year with Mrs Calixte: 'Her heart was troubled by a kind of terror.' Arlene had thought it was a hilarious quote to put in the yearbook.

Frances traced her finger over young Arlene's face and remembered

Arlene

the way her best friend wore her Catholic schoolgirl uniform, one button too many undone on her blouse, the plaid skirt always shorter somehow than it was supposed to be, daring the nuns to give her a demerit or detention or even suspend her.

Frances looked at her own picture now, one row above Arlene. A sister-sameness, sure, but she also had a bland quality. It was that quality that had made Frances feel invisible while Arlene thrived. The small print below her half-smiling face: *Barone, Frances. Honours Society; Drama Club.* No quote. Drama Club had been a joke; she'd butchered monologues along with the other wannabes while Sister Miriam snuck whiskey. She remembered more about Arlene from high school than she remembered about herself. She placed the yearbook back on the shelf.

She went upstairs and sat at the kitchen table.

Angelo came down, wearing gym shorts and a Mets T-shirt. He sat across from her. 'Thanks for being so great,' he said.

She didn't know how to respond.

'You know,' Angelo continued, 'we weren't perfect, me and Arlene. People thought we were, but we had our troubles.'

Frances figured Angelo was just interrogating every misstep, every regret. Besides, she knew all of Arlene's torments and worries. They'd talked about everything. She knew the diary tangents inside out. She figured it was best to ignore the comment. 'Everyone's going to help,' she said. 'Your folks. Arlene's folks. Me.'

'They need their Aunt Frances more than ever. Their "real" aunt, my sister, Theresa, she means well, but she's just not good with them.' He paused. 'I wish I had more time with Arlene. It happened so fast. I wish we had a chance to at least say goodbye. She was out of it at the hospital.'

'I don't even remember what our last conversation was about,' Frances said. 'Before that night, I mean.'

'When she first said she felt sick, I told her she was overreacting. I just thought she needed a break from the kids.'

'None of it's fair.'

'What are we gonna do?' Angelo asked.

She knew it was a rhetorical question, but she was happy that he'd said *we*. They were a team. He was Arlene's husband, and she was Arlene's best friend, and they were going to get through this tragedy together. He went up to his room, and she made herself a bed on the couch.

The next morning things began to collapse. Angelo and the kids were in disarray. Screaming at each other. Unhinged. The loss of Arlene was impacting them in new ways. So much had been bottled up initially. Decorum dictated that they keep their anger under wraps during the wake and at the funeral and burial. Now Max told his father he hated him, that he wished he had died instead of Arlene. Angelo said he wished the same thing. Tears flowed. Doors slammed.

Frances tried to be a calming presence. Around noon, she took the kids for a walk up to Eighty-Sixth Street. They got slices at Lenny's. The kids nibbled at the edges, thumbed at the melted mozzarella sliding onto the grease-stained paper plate. She got them ices at Villabella, thinking that might cheer them up for a second, but it was too soon for anything to cheer them up. Nothing could bring Arlene back.

It wasn't healthy to stay in the house all day, but the outside world felt wrong. Eventually, Frances figured, the kids would go back to school, Angelo would go back to work, she'd go back to work, and the mechanisms of life would resume. Something would be missing, not normal, but they would plough ahead.

When they returned to the house, the kids wanted to zone out in front of the television. Angelo had settled at the kitchen table with a small metal bin full of papers. He was going through everything he needed to go through. Arlene had life insurance. He said something about her will. Frances lost track of what he was talking about.

Arlene

Again, she watched television with the kids. For dinner she made them frozen waffles, and then there was more television. Around nine, she took them through their bedtime routine.

After a while, Max and Gina drifted off to sleep, depleted.

Before going home, Frances intended to get the sheets and pillowcases from the clothesline and put them on the bed. She did that – they were dry, thankfully – carrying them up to Angelo's room curled over her arm. She knocked on Angelo's door. He had retired to his room when she'd taken the kids to bed. He told her to come in.

Frances nudged the door open. Angelo was standing over by the window, looking through the blinds down at the street. He was wearing pyjama pants and a white tank top.

'I just wanted to make the bed,' Frances said, showing him what was in her arms.

'I wondered what happened to the sheets,' he said, turning back from the window. 'I've just been sleeping on it like that.'

'At the time, I didn't know how sick Arlene was. I didn't know if she was contagious. I figured I'd better wash everything. You probably have plenty of other sheets – I wasn't thinking.'

'I wasn't either.'

She placed the washcloth on Arlene's dresser, set everything else on a nearby chair, and then got to work on stretching the fitted sheet over the mattress. Angelo helped. She put the top sheet on, tucking the sides in. She slid the pillows into their cases and lined them up neatly by the headboard.

Angelo sat on the bed, crinkling the fresh sheets.

'I should go,' Frances said. 'Call me if you need anything.'

'Don't leave,' Angelo said, and it was the last thing she'd expected him to say.

She hesitated but then she said, 'Okay.'

'You knew Arlene better than anybody. She really loved you.'

'We were friends a long time.'

'It's so strange to be in this house with her gone. I don't think we would've survived the last few days without you, Frances.'

'I wish I could do more.'

Angelo turned and looked at Frances. 'I see her in you. Almost twins. People always said that.'

Frances gazed down at her lap, ashamed. 'I was always copying her. Since we were little. I wanted to be her. We already looked alike, and we spent so much time together, it wasn't hard for me to pick up her mannerisms and vocal inflections. Sometimes I felt like an actress learning a role.'

'You loved her. Wanting to be her was just an extension of that love.'

A strange thought struck Frances then. She said it out loud before she fully knew what she was saying. 'I could be her now. You could say the things you didn't get to say.'

As soon as the words left her mouth, she felt as if she had betrayed Arlene. This was Arlene's bedroom. This was Arlene's husband. She was not Arlene. She had crossed a line.

But Angelo didn't look disgusted or angry.

She blushed. Tears rimmed her eyes. She waited for Angelo to respond and then she worried that he'd simply ignore her, thinking it better for them both to act as if she hadn't made the proposition she'd made.

'Okay,' he finally said. And then he started talking to Arlene.

They talked for hours. At some point, they collapsed back onto the bed, and Frances put her head on Angelo's chest, her right hand over his heart, and he wrapped his arm around her. She worried that one of the kids would walk in. Angelo wept and she wept, and the grief and love passed between them. She imagined it like paint on a palette. They were two different colours but now had been blended to make one. Becoming Arlene was the artifice that had allowed it to happen. It wasn't difficult for Frances. She could sound just like her best friend. She knew Arlene's speech

Arlene

patterns intimately, could lower her voice to make it dusky, knew the things that Arlene would say because she had studied her anthropologically for almost three decades.

This became their routine for the next several days, for the first full weekend without Arlene. During the day, she was Aunt Frances, tending to the kids, helping them survive, trying to get them used to the idea of going back to school the following week, cooking, cleaning, doing the wash, going grocery shopping, paying bills with cheques signed by Angelo. But, at night, after the kids had gone down, she became Arlene. They learned to lock the door so Max and Gina couldn't walk in without knocking. Only once did Max pound on the door, and Angelo guided him to the bathroom to pee and then straight back to bed.

It was just talking at first. A little touching. That hand over his heart. Angelo stroking her hair. It became more than that on the third night. With his eyes closed, Angelo asked her to whisper into his ear. He was very specific. He wanted her mouth close so that, as she spoke, her lips would only just brush against his ear. He wanted her to talk about the locker room at Bishop Kearney. He wanted her to describe herself – as Arlene, of course – showering and changing in that sea of Catholic schoolgirls.

Another line had been crossed. Frances knew it, and yet she was elated.

She spoke slowly and carefully. She had been in that locker room. She only had to describe what she'd seen, what had been imprinted on her brain. Arlene's great confidence. The other girls fawning over her, their postures, their pertness, the damaging brightness of so many smiles and such jubilant chaos. Locker doors slamming. Voices pitched high. Steam and shouting.

Her hand moved down his body until it arrived at a place it never should have arrived. He didn't seem hesitant at all. She touched him, and he said, 'Oh, Arlene.' She was Arlene touching him and that made it okay.

She continued to speak in Arlene's voice as her hand moved. Angelo was all sighs and tremors. It had been the most difficult week of his life, and he was momentarily melting into the tenderness she was showing him. She was happy to make him happy.

They kissed and then slept.

She felt guilty the next day. Angelo acted as if nothing had happened. Her guilt turned to nausea. She had conversations with herself where she was both Frances and Arlene. She imagined herself being stoned on the street corner by scandalised neighbours.

She went home for a few hours. Her mother said it was nice that she was helping Angelo and the kids, but she was over there far too much. It wasn't right. Sleeping over there especially.

Her father agreed. 'What will people think?' he said.

'I don't care what people think,' Frances said. 'Arlene wouldn't want me to abandon her family.'

'I'm not saying abandon them,' her father said. 'Go over for a while, that's fine, but don't live over there.'

'In a few days I'll be back at work, Max and Gina will be back at school, and Angelo will be back at his job. Then I won't be staying the night anymore.'

'Do what you want,' her father said, waving his hand through the air. 'Long as you know you're not his wife or their mother. Don't get any whacked-out ideas.'

'I won't,' she said, but the truth of the matter was that she knew no one would ever understand what kind of transformation she was undergoing.

She rested and then returned to Angelo.

That night, Arlene put on one of her slips, a little red number, and Angelo asked her to dance for him. She sometimes danced for him. He enjoyed it. He thought she didn't know about the clubs he went to in the city, how he was thinking about the women in those clubs when she danced for him. She'd followed him many times.

Arlene

Angelo was sitting on the bed, smiling, tears in his eyes. 'There she is,' he said. 'There's my girl.'

Arlene went to him on the bed and straddled him. He pushed her slip up and slid out of his pants. She helped him inside her.

Angelo stopped her, withdrew. He went to Arlene's dresser and opened the top drawer and got the knife. He unsheathed it and rushed back over, stretching out next to her. He handed her the knife. The blade glimmered. 'I want you on top of me,' he said. 'Hold the knife against my neck as we make love. Dig it in deep. Blood's okay.'

Arlene nodded. Part of their routine. Angelo liked the pain and the tension. He thought the knife kept him from coming too fast. He'd returned home from the city one night with a fresh cut on his neck. She knew about the women from his office.

She got back on top of him, holding the knife against his neck as she moved. She pressed the sharp edge of the blade against his skin until a slight stitching of blood appeared. She moved slowly, engulfing him. As things got more heated, she let the knife fall to the sheets. She tried to stay so quiet, not wanting to wake the kids. She was good at staying quiet.

'Oh, Arlene,' Angelo said.

When he finished, she collapsed forward onto him and kissed the spot where the knife had been, tasting blood. He cried. She hadn't come. She flipped off him onto her back and touched herself until she did, her body bucking. He watched her, still crying.

Arlene stood and straightened the slip over her hips. She picked up the knife, dotted with Angelo's blood, and went to the dresser. She set the knife on the dresser and dug around in the still-open top drawer, taking out her cigarettes. She was relieved to find a book of matches nestled in the half-full pack. She lit a cigarette and blew a stream of smoke toward the ceiling.

'Can I tell you something?' Angelo asked, sitting up, touching his neck where she'd cut him.

She remained silent, stoic. Nodded.

He got to his feet and came over, wrapping his arms around her. 'I always liked you, Frances,' he said. 'Always wondered what it'd be like to be with you. You're so much like Arlene but so different, too. That was intense.'

A heavy feeling of anger washed over Arlene. *Frances.* Her best fucking friend. She perched her cigarette on the edge of the dresser and picked up the knife. 'Are you even sad I'm dead?' she asked.

'What?'

'Who are you *really*?'

'What are you saying?'

'I know. I *see*.' Arlene imagined Max and Gina sleeping soundly in their room. They'd be safe with her parents. She snapped the knife at Angelo and plunged it between two ribs on his right side. A slot opened in his skin. A glow seemed to emanate from somewhere inside him. She was thinking about the many ways he'd betrayed her, the way he betrayed her now with this Frances body, Frances betraying her too, and she felt as if she could die all over again.

Angelo fell to his knees, shock in his face, the knife protruding from his midsection, his hands gripping it and removing it. Blood fountained out like a sizzling spray of fireworks. 'Frances, what the fuck?' he asked.

'I'm Arlene,' she said, picking up the cigarette with its dangling ash and taking a drag.

Author Biographies

Guy Adams is an author, scriptwriter and film critic. A prolific novelist, he has also written audio drama for Audible, BBC Radio 4 and Big Finish productions, and comics for *2000 AD*. He is a regular contributor to extras for Arrow Video and Radiance Films. He lives a life of screwball comedy on the south coast with his wife, Alexandra, and their daughters (one human, the other hairy and canine) Verity and Dame Margaret Rutherford.

Alexandra (A K) Benedict is an award-winning writer of bestselling novels, short stories and scripts. As Alexandra Benedict, she writes Golden Age-inspired mysteries with a darker, contemporary edge. *The Christmas Murder Game* was longlisted for the Gold Dagger Award and both *Murder on the Christmas Express* and *The Christmas Jigsaw Murders* are international bestsellers. As A K Benedict, Alexandra writes high-concept speculative fiction, short stories, and audio drama. Shortlisted for the BBC Audio Drama Award for *Children of the Stones* (BBC Sounds/Radio 4) and other awards, she won the Scribe Award for her Doctor Who audio drama *The Calendar Man* (Big Finish). Her debut novel, *The Beauty of Murder* (Orion), was nominated for the eDunnit Award, and her metafictional thriller *Little Red Death* (Simon & Schuster) has to date been sold into twelve

Author Biographies

territories. Alexandra lives by the sea in Eastbourne, UK, with writer Guy Adams, their daughter, Verity, and dog, Dame Margaret Rutherford.

Anne Billson is a writer, film critic and photographer. Her horror novels include *Suckers*, *The Ex* and *The Coming Thing*; non-fiction includes *Billson Film Database*, *Cats on Film* and monographs on John Carpenter's *The Thing* and Tomas Alfredson's *Let the Right One In*. She was selected in 1993 as one of Granta's Best Young British Novelists Under 40. She has lived in London, Tokyo, Paris and Croydon, and now lives in Belgium. www.multiglom.com

William Boyle is the author of eight books set in and around the southern Brooklyn neighbourhood of Gravesend, where he was born and raised. His most recent novel is *Saint of the Narrows Street*. His books have been nominated for the Hammett Prize, the John Creasey (New Blood) Dagger Award, and the Grand Prix de Littérature Policière, and they have been included on best-of lists in *Washington Post*, *CrimeReads*, and more. He currently lives in Oxford, Mississippi. Find him online at williammichaelboyle.com

Xan Brooks is a British novelist and journalist, specialising in film. He began his career at the *Big Issue* magazine and is a former associate editor at the *Guardian*. His debut novel, *The Clocks in This House All Tell Different Times* (2017), was listed for the Costa Prize, the Desmond Elliott Prize, the Author's Club Award and the Walter Scott Prize. His second novel, *The Catchers* (2024), is a tale of the first American music scouts, set against the backdrop of the 1927 Mississippi flood.

Jerome Charyn's most recent novels are *Big Red* and *Ravage & Son*. His latest novel, *Maria: La Divina*, about Maria Callas, will be published in October 2025. His work has appeared in *Ellery*

Author Biographies

Queen, Esquire, The Atlantic, The Paris Review, and other magazines. He was named a Commander of Arts and Letters by the French Minister of Culture. He has written a suite of twelve novels about Police Commissioner-Mayor-President Isaac Sidel.

Lee Child is the international bestselling author of the Jack Reacher novels, and is also heavily involved with the highly successful Amazon Prime TV series based on the books as well as future spin-offs. Initially from Birmingham in the UK, Lee lived in America for many years, but returned to to the UK following President Trump's inauguration, and despite his own stellar success has always been at the forefront of supporting new crime writing talent with infallible generosity. He has won most of the awards the field has to offer, including the CWA Diamond Dagger.

S A Cosby is an award-winning writer from south-eastern Virginia. His short fiction has appeared in numerous anthologies and magazines. His short story 'The Grass Beneath My Feet' won the Anthony Award for best short story in 2019. He is the author of several novels, including the award-winning *Blacktop Wasteland* and *Razorblade Tears*. His latest novel, *King of Ashes*, is in development with Netflix. When he isn't writing, he is an avid gardener, hiker and connoisseur of both fine and cheap whiskeys.

M W Craven is a *Sunday Times* bestselling author who, for his Washington Poe series, is the recipient of the 2019 Crime Writers' Association Gold Dagger, the 2022 Ian Fleming Steel Dagger and the 2023 Theakston Old Peculier Crime Novel of the Year. The series has been translated into twenty-nine languages. His US-set series featuring Ben Koenig, the man unable to feel fear, was the subject of a Hollywood bidding war and will soon be a major TV series. His most recent book is *Nobody's Hero*. Website: mwcraven.com

Author Biographies

James Grady's first novel was *Six Days of the Condor* of movie and TV fame. His new 2025 novel is *American Sky*. In 2008, London's *Daily Telegraph* named Grady as one of '50 crime writers to read before you die'. In 2024, *Publishers' Weekly* compared Grady to Larry McMurtry. In 2015, the *Washington Post* compared Grady to George Orwell and Bob Dylan.

Sophie Hannah is a *New York Times*, *Sunday Times* and Amazon Kindle UK No. 1 bestselling writer of crime fiction, whose books are published in 51 countries and have sold millions of copies worldwide. She won the National Book Awards Crime Thriller of the Year prize in 2013, and the Dagger in the Library Award in 2023. She is the author of the new series of Hercule Poirot mysteries, commissioned by Agatha Christie's family. Sophie's murder mystery musical, *The Mystery of Mr E*, is available on Amazon Prime and Apple TV now. She is also a bestselling poet who has been shortlisted for the T S Eliot Award, a self-help writer, creator and host of the podcast *How to Hold a Grudge*, and the founder of the Dream Author coaching programme for writers. She lives in Cambridge, England, where she is an Honorary Fellow of Lucy Cavendish College. Her latest book is *No One Would Do What the Lamberts Have Done* – a twisty literary thriller about an ordinary family that does the unthinkable.

Maxim Jakubowski is a British writer and editor who has worked for several decades in book publishing. He is the author of twenty-three novels; the latest are *Just a Girl with a Gun* (2023), *The Exopotamia Manuscript* (2024) and *Manhattan Death Ballad* (2025). He has also issued five collections of his short stories, the medium which he much prefers! He has edited over 100 anthologies, and stories from his anthologies have won the CWA Short Story Dagger five times and garnered numerous nominations and selections in Best of Year collections. Under a pen name he has written a *Sunday Times*-bestselling series of ten novels. He is a winner of the Karel,

Author Biographies

Anthony, Red Herrings and David L. Goodis awards, and a past chair of the Crime Writers' Association and an inveterate movie fan, having worked and consulted for several film festivals. He lives in London with too many books.
 maximjakubowski.co.uk

Ragnar Jónasson is an award-winning Icelandic author, with five million copies sold across thirty-seven territories. A lifelong fan of Alfred Hitchcock, his stories have been said to have 'shades of Hitchcock' by critics. Ragnar was also an executive producer of the CBS Studios TV series *The Darkness*, based on the first novel in his Hulda series, and his novel *Outside* is being developed for the screen by Ridley Scott. *The Times* selected *The Darkness* as one of the 100 Best Crime Novels and Thrillers since 1945, and *Snowblind* has been selected as one of Top 100 Crime Fiction of all time. His books have been on bestseller lists across Europe and the USA, and have won multiple prizes. He has also won a special jury recognition for his poetry in Iceland. Ragnar has furthermore translated fourteen of Agatha Christie's novels into Icelandic, starting at the age of seventeen. Ragnar has a law degree and teaches copyright law at Reykjavik University. Ragnar is the co-founder and co-chair of the literary festival Iceland Noir, held annually in Reykjavik.

Vaseem Khan is the author of two award-winning crime series set in India and the upcoming *Quantum of Menace*, the first in a series featuring Q from the James Bond franchise. His debut, *The Unexpected Inheritance of Inspector Chopra*, was selected by the *Sunday Times* as one of the forty best crime novels published 2015–2020. In 2021, *Midnight at Malabar House*, the first in the Malabar House novels set in 1950s Bombay, won the CWA Historical Dagger. Vaseem was born in England, but spent a decade working in India. His latest book is the thriller *The Girl in Cell A*. His website: www.vaseemkhan.com

Author Biographies

Joe R Lansdale is the author of fifty novels and four hundred shorter works, including stories, essays, reviews, film and TV scripts, stage plays, introductions and magazine articles, as well as a book of poetry. His work has been made into films, animation, comics, and he has won numerous awards including the Edgar, Raymond Chandler lifetime award, numerous Bram Stoker Awards, Lifetime Horror Award and the Spur Award. He lives in Nacogdoches, Texas with his wife, Karen, and pit bull, Rudy.

Keith Lansdale has written comics, film scripts, novels and short stories, including films such as *The Pale Door*, *The Projectionist* (in production) and *Christmas with the Dead* (adapted for the screen and the stage). He has also written multiple comics including *Red Range*, *Hoot Goes There* (*X-Files*), *Prisoner of Violence*, *Crawling Sky*, *Vampirella*, and several others. He also wrote the novel *Big Lizard* with Joe R Lansdale, as well as the short story 'Hoppity White Rabbit Done Broke Down', appearing in the recent collection *The Drive-In: Multiplex*. As well as the story 'It Goes with Everything,' found in the anthology *About That Snowy Evening*, which Keith also co-edited. He co-edited *Son of Retro Pulp Tales*, published by Subterranean Press. He also co-wrote the children's story 'The Companion' when he was twelve with his younger sister, which was picked up by the TV show *Creepshow*, and co-authored the children's book *In Waders From Mars*.

Peter Lovesey has been writing crime fiction since 1970 and has won many awards for his short stories and novels, as well as the lifetime honours of the Crime Writers Association Diamond Dagger and the Mystery Writers of America Grand Master. His work has been adapted for radio, TV and film. His latest, *Against the Grain*, concluded his twenty-two-book series featuring Bath detective Peter Diamond. Peter Lovesey died early in 2025, shortly after writing his story for this collection. His website is www.peterlovesey.com

Author Biographies

Nadine Matheson is the author of the Detective Inspector Anjelica series. Her debut crime fiction novel, *The Jigsaw Man*, was published in 2021 and received recognition by being shortlisted for an International Thriller Writer Award and was included in the *Evening Standard*'s list of 'The Best Crime Novels to Read in 2022'. The latest additions to the series are *The Binding Room* and *The Kill List*. Nadine Matheson has dedicated twenty years of her career to criminal law, both as a solicitor and lecturer. She is also the host of the podcast *The Conversation with Nadine Matheson Podcast*. She lives in London and is the current Chair of the Crime Writers' Association.

Denise Mina is the author of nineteen novels, four plays, three graphic novels and a bucket and a half of short stories. You could barely fit them into one car. Having won the John Creasey Dagger for her first novel, *Garnethill*, she has won the CWA Short Story Dagger twice, and the Theakstons Crime Novel of the Year twice. She won the Gordon Burns Prize for *The Long Drop*, for which she also won the McIlvanny Scottish Crime Novel of the Year. Prizes up the wazoo, in short. You're in fairly safe hands here. She has recently begun to write historical fiction and true crime and can't believe she is getting away with following her nose and interests. How often does that happen in middle age to chubby women?

Donna Moore is the author of crime fiction and historical fiction. Her first novel, a Private Eye spoof called *Go to Helena Handbasket*, won the Lefty Award for most humorous crime fiction novel, and her second novel, *Old Dogs*, was shortlisted for both the Lefty and Last Laugh Awards. Her historical crime fiction novels, *The Unpicking* and *The Devil's Draper*, are set in Glasgow from the 1870s to the 1920s. Her short fiction has appeared in numerous anthologies and includes her Edgar-nominated 'First You Dream, Then You Die'. www.donnamooreauthor.com

Author Biographies

Kim Newman is a critic, author and broadcaster. His books about film include *Nightmare Movies*, *Kim Newman's Video Dungeon* and BFI Classics booklets on *Cat People*, *Doctor Who* and *Quatermass and the Pit*. His fiction includes the Anno Dracula series, *A Christmas Ghost Story*, *Something More Than Night* and *Model Actress Whatever*. He has written for television (*Mark Kermode's Secrets of Cinema*), radio (*Afternoon Theatre: Cry-Babies*) and the theatre (*The Hallowe'en Sessions*), and directed a tiny film (*Missing Girl*).

Jeff Noon was born in Manchester, England. He trained in the visual arts and was active on the post-punk music scene before becoming a playwright and then a novelist. His science fiction books include *Vurt* (Arthur C Clarke Award), *Pollen*, *Automated Alice*, *Falling Out of Cars*, and a collection of stories called *Pixel Juice*. He has written two crime novels, *Slow Motion Ghosts* and *House with No Doors*. The four Nyquist Mysteries (*A Man of Shadows*, *The Body Library*, *Creeping Jenny* and *Within Without*) explore the shifting intersections between SF and crime. His latest books are *Gogmagog* and *Ludluda*, two alternative-world fantasy novels created in collaboration with Steve Beard. X: @jeffnoon.

Ana Teresa Pereira is a Portuguese writer and translator. She is the author of more than twenty novels, novellas and short story collections. A reader of Henry James, Jorge Luis Borges, Truman Capote and Cornell Woolrich, she likes to think of her stories as 'abstract crime fiction'. Her novel *Karen* won the Brazilian Oceanos Award (best book in Portuguese language published in 2016). Her last book, *Como Numa História de William Irish*, was inspired by Alfred Hitchcock's *Vertigo*. She lives in Funchal.

Lily Samson studied English at Oxford University and works in publishing. She divides her time between London, where she cares for her father, and Paris, where her French partner resides. In her

Author Biographies

spare time, she enjoys watching Hitchcock movies and moonlighting as a freelance artist. *The Switch*, her debut thriller, was published in 2024; her next book, *Watch Me Watch You*, a thriller about voyeurism and blackmail, will follow in 2025. Under her real name of Sam Mills, she is the author of the much-praised novels *The Quiditty of Will Self* and *The Watermark*, as well as a memoir cum study of bisexuality *Uneven*.

Peter Swanson is the *Sunday Times* and *New York Times* bestselling author of twelve novels, including *The Kind Worth Killing*, winner of the New England Society Book Award, and finalist for the CWA Ian Fleming Steel Dagger, *Her Every Fear*, an NPR book of the year; and his most recent, *Kill Your Darlings*. His books have been translated into over thirty languages, and his stories, poetry, and features have appeared in *Asimov's Science Fiction*, *The Atlantic Monthly*, *Measure*, the *Guardian*, *The Strand Magazine* and *Yankee Magazine*. A graduate of Trinity College, the University of Massachusetts at Amherst, and Emerson College, he lives on the North Shore of Massachusetts with his wife and two cats. His favourite Alfred Hitchcock film is *The Lady Vanishes*. You can find out more on his website, peter-swanson.com

David Thomson published two novels in the early 1970s – *A Bowl of Eggs* and *Hungry as Hunters* – and then in 1985 he delivered the meta-novel *Suspects*, in which the characters were people from movies. That project was extended in *Silver Light* (1990) and *Connecticut* (2023). All three are available from Oldcastle. In addition, he is the author of *Showman: The Life of David O. Selznick* and *The New Biographical Dictionary of Film*, now in its sixth edition.

NO EXIT PRESS
More than just the usual suspects

CWA DAGGER — AWARDED BEST CRIME & MYSTERY PUBLISHER

'A very smart, independent publisher delivering the finest literary crime fiction' ***Big Issue***

MEET NO EXIT PRESS, an award-winning crime imprint bringing you the best in crime and suspense fiction. From classic detective novels, to page-turning spy thrillers and literary writing that grabs the attention. Our books are carefully crafted by some of the world's finest writers and delivered to you by a small, but passionate, team.

In over 30 years of business, we have published award-winning fiction and non-fiction including the work of a Pulitzer Prize winner, the British Crime Book of the Year, numerous CWA Dagger Awards, a British million-copy bestselling author, the winner of the Canadian Governor General's Award for Fiction and the Scotiabank Giller Prize, to name but a few. We are the home of many crime and noir legends from the USA whose work includes iconic film adaptations and TV sensations. We pride ourselves in uncovering the most exciting new or undiscovered talents. New and not so new – you know who you are!

We are a proactive team committed to delivering the very best, both for our authors and our readers.

Want to join the conversation and find out more about what we do?

Catch us on social media or sign up to our newsletter for all the latest news from No Exit Press.

f fb.me/noexitpress **X** @noexitpress

noexit.co.uk